# Sexuality & Space

Beatriz Colomina, editor

Jennifer Bloomer

Victor Burgin

Elizabeth Grosz

Catherine Ingraham

Meaghan Morris

Laura Mulvey

Molly Nesbit

Alessandra Ponte

Lynn Spigel

Patricia White

Mark Wigley

PRINCETON PAPERS ON ARCHITECTURE

*Sexuality and Space* is the first volume in the series
**Princeton Papers on Architecture**
Princeton University School of Architecture
Princeton, New Jersey 08544-5264

Editor: Beatriz Colomina
Copy Editor: Phil Mariani
Designer: Ken Botnick
Project Coordinator: Lisa A. Simpson

Published by
Princeton Architectural Press
37 East 7th Street
New York, New York 10003
212.995.9620

Library of Congress Cataloging-in-Publication
Data
Sexuality & Space / Beatriz Colomina, editor.
    p.  cm. — (Princeton papers on architecture: 1)
    Proceedings of a symposium, held at
Princeton University School of Architecture
March 10-11, 1990.
    ISNB 1-878271-08-3 (paper) : $14.95
    1. Space (Art)—Congresses. 2. Space
(Architecture)—Congresses. 3. Sexuality in
art—Congresses. 4. Arts, Modern—20th
century—Congresses. I. Colomina, Beatriz. II.
Title: Sexuality and space. III. Series.
NX650.S8S48 1992
720'.1—dc20                          91-40146
                                          CIP

# Contents

# Preface

THROUGHOUT THE SEVENTY-TWO YEAR HISTORY of the School of Architecture at Princeton University, its faculty, students, and visitors have participated in a dynamic probing for the boundaries of architecture. It is interesting to note that the work of the many architects and scholars who have visited the School is generally well known, yet very little of what is actually seen and spoken here is recorded. An awareness of this situation led to the decision last year to undertake a project to publish the full range of activities taking place at the School.

This book is the first of a series, the *Princeton Papers on Architecture*, which will chronicle the full range of activities at the School. The series will trace the issues being discussed at the School. Our intentions are to inspect the limits of architectural discourse, uncover hidden possibilities for better understanding of architecture and architects, and to document discussions and images generally left out of the architectural mainstream. If we are successful we will contribute to the widening of the architect's intellectual and artistic boundaries in the face of the particular cultural and environmental challenges facing us as we approach the turn of the century.

A symposium titled "Sexuality and Space" was held in the School's Betts Auditorium on March 10 and 11, 1990. The symposium was organized by Beatriz Colomina, Assistant Professor of Architecture, who is also the editor of this book. The School is indebted to her for her extraordinary insight, the efforts put into organizing the symposium, and the editing of this book.

It is most fitting that the symposium and the publication of this book have been sponsored by the Jean Labatut Memorial Fund and the Hobart Betts Publication Fund. The late Professor Jean Labatut, often referred to as the "dean of teachers," initiated the cultural interests that have always pervaded the School, and the Betts family has consistently stood behind the School with their generous support and commitment to quality education.

Ralph Lerner
Dean, School of Architecture

# Introduction

IN MARCH 1991, after much debate, Princeton University approved a new policy giving domestic partners of gay and lesbian graduate students access to university housing, a right previously granted only to the partners of married students. This measure, which is based on the addition of the words *sexual orientation* to the university's Equal Opportunity Policy in 1985, represents the first practical acknowledgment of lesbian and gay students. In a way, you could say that this is their first "admission," in the legal and spatial sense of the term–and admission is arguably the central function of any university. It is significant that this admission occurred around the highly symbolic issue of housing. Deprived of the right to be housed, the students were not really "let in," "allowed entrance or access," or "made room for in an enclosed space," as the dictionary defines *admission*. Sexuality was, at least officially, left at the door. But as the dictionary argues, *admission* is also a question of acknowledging, recognizing, accepting as valid. To be admitted is to be represented. And space is, after all, a form of representation.

The politics of space are always sexual, even if space is central to the mechanisms of the erasure of sexuality. I have used the above event as an example not because it has any more to do with sexuality than anything else, but because the concern of this symposium was to identify precisely these kinds of close relationships between sexuality and space hidden within everyday practices, many of which appear to be concerned neither with space or sexuality.

In recent years much contemporary critical theory has been appropriated by architectural theorists. At the same time, a number of leading critical theorists have focused on architecture. But in spite of the growing reciprocity in the exchange of ideas, the issue of sexuality remains a glaring absence. All the different kinds of work on representation and desire developed over the last fifteen years by feminist theorists have been conspicuously ignored in architectural discourse and practice. This is obviously part of a more general repression of sexuality in most "critical" discourses, about which Meaghan Morris and Rosalyn Deutsche, among others, have recently written. The symposium "Sexuality and Space" was an attempt to address this absence, not simply by importing the work on sexuality into architectural discourse, but by setting up some kind of interdisciplinary exchange in which theories of sexuality are reread in architectural terms and architecture is reread in sexual terms.

The concern of the symposium was not with space as yet another symptom of sexuality, repressed or otherwise. It is not a question of looking at how sexuality acts itself out in space, but rather to ask: How is the question of space already inscribed in the question of sexuality? This formulation required that we abandon the traditional thought of architecture as object, a bounded entity addressed by an independent subject and experienced by a body. Instead, architecture must be thought of as a system of representation in the same way that we think of drawings, photographs, models, film, or television, not only because architecture is made available to us through these media but because the built object is itself a system of representation. Likewise, the body has to be understood as a political construct, a product of such systems of representation rather than the means by which we encounter them.

To simply raise the question of "Sexuality and Space" is, therefore, already to displace Architecture. In the end, this book is but the documentation of a small event in the larger project of this displacement.

I am very grateful to all the people with whom I have discussed this project at different times and whose advice has informed it: Victor Burgin, who should also be credited with the title, Rosalyn

Deutsche, Mark Wigley, Constance Penley, Andrew Ross, Diana Fuss, Tony Vidler, Tom Keenan, Silvia Kolbowski, Phil Mariani, and Jane Weinstock.

Of course, the symposium and this publication would not have been possible without the support and labor of many people. I am very grateful to both Dean Robert Maxwell and his successor Dean Ralph Lerner for their enthusiastic endorsement. To Pat Morton, who assisted in the organization of the event as well as in the initial publication coordination. To Phil Mariani, who edited the texts, and Lisa Simpson, who assumed responsibility for production of the book. To Silvia Kolbowski, who designed a memorable poster, and John Nichols, who printed it. To Diana Agrest, Diana Fuss, and Mark Wigley, who acted as moderators. To the students of Princeton University who offered their time. And to Irene McElroy, Dorothy Rothbard, Cynthia Nelson, and Doreen Simpson, without whom nothing would happen.

Beatriz Colomina

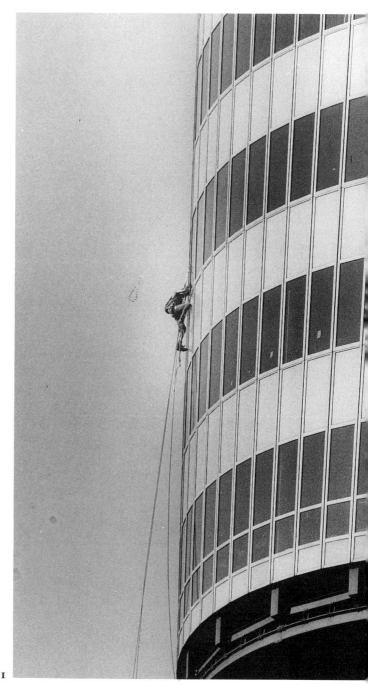

# Great Moments in Social Climbing: King Kong and the Human Fly

## Meaghan Morris

… the fact that many philosophies (including tendencies in Marxism) have imagined themselves to be metanarratives does not make the fantasy true. As Marx once quipped, "One does not judge an individual by what he thinks about himself." There is not now nor has there ever been a metanarrative or a transcendental space. Theory exists everywhere in a practical state.

Warren Montag[1]

· · · · · · · · · · · ·

1   Warren Montag, "What is at Stake in the Debate on Postmodernism?" in *Postmodernism and Its Discontents: Theories, Practices,* ed. E. Ann Kaplan (London: Verso, 1988), pp. 95–96.

SINCE MY ARGUMENT in this paper is marked by recent debates in Cultural Studies rather than Architecture–debates about the methods appropriate to studying popular culture, about the value of textual analysis and of basing generalizations on readings of local objects–I want to begin with a few rather abstract remarks in order to clarify the argument's structure.

My paper has three parts. The first is a brief discussion of two models of "the tower" as *metaphor,* one of which is corporate-populist, the other academic, and neither of which is grounded in a psychoanalytic discourse in any serious sense. Since I then go on to analyze two social spectacles involving actual towers, it would be easy to frame my material with a thematics of the gaze (and thence, of surveillance). Instead, I'm going to be concerned with summits, points, and climaxes.

Next, the tower spectacles are analyzed as *events.* The second and third parts of the paper concern two incidents that happened in downtown Sydney during the huge real estate boom of the late 1980s. One was a "King Kong" theme promotion of some very expensive office space in a renovated building, and I analyze a comic that was part of the campaign. The other was a kind of critical "stunt," in which a young man climbed the tallest building in the city, Sydney Tower (a tourist-telecommunications tower which is around a thousand feet high) while his friends filmed him doing it. The video that resulted (*A Spire*) was later shown on national TV.

In spite of the popularity of references to *King Kong* in cultural production today, from cinema and homemade video to custom-ized postcards and fiction, I think that only the second of these events would qualify as "popular" culture in any of the currently accepted senses of that term, including the one that I prefer to use, Michel de Certeau's notion of the popular as a *modus operandi*–a way of doing things characterized by an art of *timing,* rather than by a topological relation to some other "zone" (whether "high," or "elite," or "mass") of cultural space. However I shall read *both* events, both moments of social climbing, as engaging two differ-ent concepts of simulation (one deriving from Jean Baudrillard, the other from Gilles Deleuze)–and thus as entailing different models of intellectual, though not necessarily "academic," prac-tice. In terms of tower metaphors and historic acts of social climb-

ing, my paper could perhaps have been subtitled "*Faust,* King Kong, and the Human Fly," except that a Faustian model of intellectual aspiration is, I shall argue, precisely what the King Kong campaign and *A Spire* were not, and are not, about.

If this already sounds allegorical, I must admit straight away that it is. Allegory gives me a convenient way to use these two events to frame a critique of a narrowly *metonymic* argument quite prevalent in Cultural Studies today, whereby a singular form in the built environment ("*the*" tower) is taken, by a process of inflation and conflation, to be emblematic not only of a general condition of culture (a tendency in Baudrillard's work which has now been extensively criticized), but also of a historic intellectual "place" of enunciation–which "advanced" or "postmodern" theory today would then require that we renounce.[2] I also want to suggest that a gestural renunciation of "altitude," "overview," and the (fantasmal) position of "totalizing master-planning" is not necessarily adequate to the problems of committed intellectual practice in the places and times that I, at least, inhabit.

In relation to places and times, I should say here what I shall mean in this paper by "space." Again, I draw on de Certeau to assume that space is not a prior condition of something else ("place"), but rather an outcome, the *product* of an activity, and so it necessarily has a temporal dimension. Reversing the customary assumption that "place" is a structured space, "space," says de Certeau, "is a *practiced place.*"[3]

However I am more concerned with the problems of historicizing particular spatial practices. My interest in space emerges from a larger project about half a dozen spaces in the Australian tourist-consumption economy, spaces produced primarily, though not exclusively, by women's work and the practices of women's everyday lives (Sydney Tower, three suburban shopping malls, a motel, a memorial park), studied over a ten-year period.

. . . . . . . . . . . .

2   I discuss these issues in detail in "At *Henry Parkes* Motel," *Cultural Studies* 2, no. 1 (1988), and "Metamorphoses at Sydney Tower," *New Formations* 10 (1990).

3   Michel de Certeau, *The Practice of Everyday Life,* trans. Steven F. Rendall (Berkeley and Los Angeles: University of California Press, 1984), p. 117. All subsequent page references appear in the text in parentheses, and this system of citation is used throughout the essay.

Part of my method is to refuse a morphological description of the sites of that economy ("the" tower, "the" mall, "the" freeway) in favor of a historical analysis attuned both to socioeconomic contexts and to the individuating local intensities (*this* tower, *this* mall) that Deleuze and Guattari, adapting an old philosophical concept, call "haecceities."[4] But the broader framework of these analyses does involve a deconstructive turning of the *home/voyage* opposition which has worked so hard for so long to gender our understanding of the relations between movement (conceptualized as masculine, then related by ideologies of development to linear models of time) and location (conceptualized as feminine, and related to static or cyclic temporalities).

Following from this, to clarify the terms of my concern with sexuality and the ways I connect it to space, I should make it explicit that my argument is organized by a shift, but not an opposition, between, on the one hand, a *penis/phallus* relation (predicated by both the corporate and academic discourses that I discuss), and on the other, a *face/faciality* relation (that I predicate for critical purposes defined by that discussion). "Faciality" is the name of Deleuze and Guattari's theory in *A Thousand Plateaus* of the figure of White Man, or "the typical European"–a figure of majority. In their work, a human face can, but certainly need not, entail "faciality," just as in psychoanalysis the penis can, usually does, but need not, represent the phallus. In a first instance, the face can form in any white wall/black hole system:[5] it is a mecha-

. . . . . . . . . . . . .

4   Gilles Deleuze and Félix Guattari, *A Thousand Plateaus,* trans. Brian Massumi (Minneapolis: University of Minnesota Press, 1987), pp. 260–265.

5   Deleuze and Guattari, *A Thousand Plateaus,* chapter 7, "Year Zero: Faciality." The face can also form in a black blotch/white hole (Rorschach) system, but the dominance of the white wall/black hole image in their account is best explained like this:

"The face is not a universal. It is not even that of the white man: it is White Man himself, with his broad white cheeks and the black hole of his eyes. The face is the typical European, what Ezra Pound called the average sensual man ... Not a universal, but *facies totius universi*. Jesus Christ superstar: he invented the facialization of the entire body and spread it everywhere (the Passion of Joan of Arc, in close-up). Thus the face is by nature an entirely specific idea, which did not preclude its acquiring and exercising the most general of functions: the function of ... binarization" (176).

nism situated at the intersection of a semiotics of *signifiance* (a para-noid, despotic regime of interpretation which is "never without a white wall upon which it inscribes its signs and redundancies"), and a semiotics of *subjectification* ("never without a black hole in which it lodges its consciousness, passion and redundancies," a passional, or "monomaniac," authoritarian regime of prophecy)(167).[6]

An excellent example of the "social production of face" (181) is the kind of relentlessly redundant and self-signifying corporate architecture represented here by the golden turret on the shaft of Sydney Tower (figure 1)–along with those hyperbolic interpretive discourses devoted to describing the "face" of the postmodern Metropolis throughout the 1980s. It is all the more appropriate to refer the concept of faciality to a tourist-telecommunications monument like Sydney Tower in that the face has, "as a correlate of great importance," the formation of *landscape* (172). Tourist towers, with their revolving restaurants and observation decks, not only exist to create a landscape for consumption, but they also, in their role as "must-see" *objects* dominating the tourist city, help to "populate" with faces the landscape they create.

My purpose in using the concept of "face" is not to claim that it gives us a *better* way of thinking about the imperial economy of corporate architecture than do the psychoanalytic concepts com-monly used in contemporary theory. One could perhaps defend such a claim, especially given the difficulties of thinking sex with race and class in a psychoanalytic framework (although in my view, the polemical address *to* psychoanalysis in their *Anti-Oedipus* should not lead us to ignore the way that Deleuze and Guattari's work often involves an irritably para-sitic use *of* psychoanalytic theory, rather than a simple opposition to it).[7]

. . . . . . . . . . . .

6   See also chapter 5, "On Several Regimes of Signs," esp. pp. 120–121.

7   The polemical relation that Deleuze and Guattari maintained with psychoanalysis in the 1970s is all too well known (and all too likely to frame and to limit current readings of their work), and it is certainly the case that in theorizing "facialization" as a mixed semiotic of *signifiance and* subjectification, paranoia *and* monomania, interpretation *and* passionality, Deleuze and Guattari have the practice of psychoanalysis itself in mind, amongst other examples (125). But this is hardly surprising, since the lines connecting interpretation delirium, theorization, and psychoanalytic desire were first drawn (as Deleuze and Guattari are perfectly well aware) by Freud himself.

But I have no intention of structuring a feminist essay around a rivalry between two monumental "faces" on the horizon of modern European thought. In introducing a *shift* between a penis/phallus relation and a face/faciality relation, I shall be attempting to analyze a critical act in popular culture (the making of *A Spire*) which seems to require some such shift before I can discuss its political significance in the context in which it occurred. By saying this, I am affirming my own qualified commitment to the value of analyzing individuated "texts" in popular culture: problems in doing so arise, it seems to me, not at the level of epistemology or of a conflict between aesthetic and sociological constructions of culture ("text" versus "audience," for example), but as a function of the *political* issue of how and why we construct our contexts of reading, and the practices that ensue.

This leads me to my final introductory remark. In my own work in Cultural Studies, I do not find it useful to construct an unmediated mirror exchange between a given theoretical discourse on the one hand, and an object or practice of popular culture on the other ("Here's a bit of *A Thousand Plateaus,* there's a building ... GEE WHIZ!"). Just as I want to insist on a historical analysis of tourist spaces, so I prefer to begin "in the middle" (or "in the *milieu,*" as Deleuze and Guattari say) created by the *popular* theories developing about, and because of, tourist places. This does not mean effacing my intellectual class position and identifying in fantasy with "the people." It does mean trying to define my problems in relation to those locally circulating discourses in which the significance of my objects of study, and thus the political stakes involved in studying them, may be defined in a first instance.

So I want to begin now with a quotation from a Sydney-based property developer, John Bond, who said, one day in 1987, through clenched teeth on Sydney radio:

I

*The tower is not an ego thing.*
*You don't spend a billion dollars on ego.*[8]

...............

8   Cited in Michael Laurence, "Now, the billion-dollar game comes to the boil," *Sydney Morning Herald,* August 15, 1987.

Now, after avidly following the saga of Donald Trump in New York, I have a suspicion that in spite of his pugnacious claim to be asserting one of the universals of capitalist common sense, John Bond was also expressing a profoundly unAmerican assumption. In a culturally comparable milieu of corporate USA, it seems almost to go without saying (at least, it did in the late 1980s) that if you *have* a billion dollars to spend on ego, you do it in a very big way.

While this kind of casual comparison is certainly dubious cultural analysis, it does raise questions of local resonance–and this is my point. What is John Bond disavowing in Sydney, and why? What is at stake in his refusal to conflate a building form with a concept in pop psychology? One way of approaching these problems is to interrogate a little more closely the terms of Bond's assertion. My first question, however, is not "what *is* 'the tower,' if it isn't an ego thing?" (he has already replied: an investment), but "what, in that case, is an *ego* thing? What is it that the tower is not?"

One thing that was certainly at stake for John Bond in 1987 was a chance to hit back at critics. In insisting that "ego" was not the prime mover in his plans to put a 97-story "Skytower" into a patch of high Victoriana still left in downtown Sydney, Bond was responding to one of the most persistent, reductive, and satisfying insults of urban popular criticism: a big tall building asserts a big male ego; but if he needs to assert it ... it can't really be *big*.

On this occasion, an aspersion had been cast against the ego things of a whole gang of "cowboy" developers by Andrew Briger, a former Deputy Lord Mayor of Sydney. When Briger said that "there is something to do with personal ego among this new breed that perhaps they think they can swing it," he was questioning their claims of having the power to break the city's planning codes, rather than the formal thrust of their buildings. Another property boom was beginning, one which turned out to be the biggest yet in Sydney's wildly speculative history, and which would leave CBD office space, at the end of 1989, the fifth most expensive in the world after Tokyo, London City, London West End, and Hong Kong. "Skytower" was only one of the megatower projects arousing media attention, and not the largest at that: corporations were dreaming once again of spires equipped with

launching pads and airship docking facilities; developers were bragging openly of their intimacies with a sympathetic (Labor) State government. One proposed to build 115 stories above some two-story working-class houses in the oldest part of the city.[9]

Many developers were under attack. But for John Bond, son of Alan Bond—now broke, but in 1987 still a beer baron, a media mogul, and the owner of a company called BIG (Bond International Gold)—dealing personally with castration threats was a routine PR affair. One Skytower cartoon expressed the desires of many Sydney citizens toward the Bond dynasty by having the father's huge Swan Lager tourist blimp (curse of suburban skies at the time) fly splat into the quivering side of the son's enormous urban protrusion.[10]

Popular mockery of the tower form as a (male) "ego" thing involves some ambiguities. It is *vaguely* antiphallic: while it assumes that a tower is a "phallic symbol" (in this code, a penis extension), the force of the insult is that someone's *ego* is also a penis extension: in the vernacular, "that bloke thinks with his dick." (This, presumably, is partly what Bond was denying on his own behalf, rather than that desire can be invested in making a lot of money.) But at the same time, a controlled and controlling "masculinity" is reaffirmed as the norm of public conduct. An ego thing is shameful because too prominent, too visible to others; one is *caught,* or exposed, at "doing" an ego thing; it's a form of unseemly display, and thus a sign of effeteness (why else should Bond deny it?)—like carrying a poodle, or sporting a personalized number plate on an ostentatious car.

The ambiguities arise with the cultural possibility of those

. . . . . . . . . . . . .

9   This proposal was finally rejected ("Carr cuts skyscraper plans down," *Sydney Morning Herald,* August 31, 1987). On the history of property speculation in Sydney, see M. T. Daly, *Sydney Boom, Sydney Bust* (Sydney: Allen & Unwin, 1982), and Leonie Sandercock, *Cities for Sale* (Melbourne: Melbourne University Press, 1977). On the more recent impact of the Pacific Rim tourist and construction industries on Australian cities, see Abe David and Ted Wheelwright, *The Third Wave: Australia and Asian Capitalism* (Sydney: Left Book Club, 1989).

10   In fact, Skytower failed to "get up," as Australians say; the site was sold to Bond's Japanese partner and, at the time of writing, it remains a hole in the ground pending floorspace transfer negotiations affecting other city sites.

associations, rather than with the theoretically well-grounded feeling that an overt or "unveiled" penile display is something other, and something less, than phallic.[11] On the one hand, such mockery works as a form of reductive magic: tall buildings shrivel to the status of minor social pretensions and personality defects; the awesome corporate power that they represent, and that they generate, is denied significance, in the kind of gesture that Andrew Ross calls "no respect."[12] On the other hand, this popular one-liner also seems to act as a form of bad timing: it misses the point about the role of the "urbanization of capital" in creating economic and social inequities, precisely at a time when its operations in our cities are reaching new heights of intensity and savagery.[13]

But is it just bad timing? In its Australian usage, the urban comedy of castration relies for its effect not just on phallus jokes (transnational signifiers of a problem of power) but on the codes of an old egalitarian vernacular—one massively mocked by 1980s megatower developments, but fluently and effectively spoken by populist entrepreneurs like the Bonds. For to scorn a tower as the projection of a pretentious personality, you have to accept that *showing* ego is undesirable anyway: having it is one thing, flaunting it another. You need to be able to find it comic that a subject of wealth and power should presume himself superior to others, and then advertise his position. "Ego," in this context, is an *act* of *exhibiting* an unfortunate subjectivity ("making a spectacle of oneself").

. . . . . . . . . . . .

11  Jane Gallop, *The Daughter's Seduction: Feminism and Psychoanalysis* (Ithaca: Cornell University Press, 1982), chapter 3.
12  Andrew Ross, *No Respect: Intellectuals and Popular Culture* (New York: Routledge, 1989).
13  See David Harvey, *The Urbanization of Capital* (Oxford: Basil Blackwell, 1985). This essay is not directly concerned with the political economy of the 1987–89 property boom. It is about the politics of spectacle that played a small part in the boom. However it is important to know that among the short-term contributing factors (which included a huge shift of investment interest to assets acquisition after the 1987 stock market crash and the subsequent easing of interest rates, as well as the reintroduction of negative gearing for rental properties by the federal government) was a boom in *tourism* associated with the Australian Bicentenary in 1988. The eviction of low-income tenants to make way for hotels and luxury accommodation to "spectacularize" the city for *visitors* was one of the direct causes of homelessness in Sydney during this period.

This is, of course, a traditional populist way to miss the point about wealth and power. Egalitarian culture in Australia could always imply a policing of appearances ("levelling") without a politics of reform. If *showing* one's claim to distinction was a solecism ("sticking out like a sore thumb"), *having* one might be accepted, like a penis, as a perfectly natural fact. To this day, a hostile term for the act of attacking the rich, the privileged, or the powerful in Australia is "cutting down tall poppies." This metaphor was used in 1989 by Alan Bond himself in a speech at the Australian National Gallery to open an exhibition of six paintings from his collection–including his prize possession, Van Gogh's *Irises*. Comparing his own financial and legal troubles with Van Gogh's artistic struggles, Bond claimed affinity with the impressionists because both he and they had persisted despite the "criticism and mockery" their respective aspirations had received. [14]

> ... *not all towers are frozen objects of purity;*
> *not all distance is aesthetic.*
>
> Peter Cryle [15]

Now, in professional discourses on high-rise towers and the city, there is or should be no question of denying the complexity and heterogeneity of the forces transforming urban skylines, nor of conflating a building form with a putative psychosexual cause. One would expect most critics to share with John Bond some version of Ada Louise Huxtable's basic premise that the tall building form is not only a celebration of modern technology but "a product of zoning and tax law, the real-estate and money markets, code and client requirements, energy and aesthetics, politics and speculation. Not least ... it is the biggest investment game in town." [16]

Yet some recent cultural theory, not necessarily concerned

. . . . . . . . . . . .

14   See Sylvia Lawson, "Art in Bondage," *Australian Society* 8, no. 8 (August 1989): 52–53, and Stuart Macintyre, "Tall Poppies," *Australian Society* 8, no. 9 (September 1989): 8–9.

15   Peter Cryle, *The Thematics of Commitment: The Tower and The Plain* (Princeton: Princeton University Press, 1985), p. 9.

16   Ada Louise Huxtable, *The Tall Building Artistically Reconsidered: The Search for a Skyscraper Style* (New York: Pantheon Books, 1984), p. 8.

with the actualities of spatial restructuring in particular places, has also developed a habit of magically shrinking towers. In spite of their manic proliferation in city and regional centers all over the world in the 1980s, some writers found ways to declare the new towers *archaic*; not simply "old-fashioned," but ontologically *residual*, mere leftovers from an earlier phase of development. Instead of being an "ego" projected in space, the tower form figures as an afterimage of a previous moment of collective advance through *time*–one now left behind in the long march of the commodity through culture.

In any work inspired by Robert Venturi, for example, "the *new* monumentality" is represented not as "tall and imposing" but as "long and low," following an opposition that privileges those regional landscapes in which, for whatever mix of demographic, economic, historic, and cultural factors, mall-freeway systems prevail over tower-freeway systems (the symbiotic relations of which are ignored). Long and lowness then becomes a more "true" expression in space of the *temporal* development of an essential Being of Capital. This is explicit in Jean Baudrillard's *America*, where the "real" America is located not in "vertical" New York, but in the desert (the zero degree of long-and-lowness) and on the freeway. In another version, Paul Virilio provides a much more subtle myth of tower archaism with his notion that all "urban sites" are in themselves a mode of persistence or *inertia* in face of the shattering impact of advanced technologies. The new monumentality is not long and low but *invisible*; it can be read only in "the monumental wait for service in front of machinery." The position of overview here is no longer a matter of altitude, but of an opto-electronic interface operating in real time.[17]

Most interestingly for my purposes, Robert Somol announces (without leaving monumental old Chicago) "that today a new mode of power operates and ... verticality is its first casualty."[18] In a witty reading of Helmut Jahn's State of Illinois Center as an urban ruin, Somol ironically proclaims verticality "dead" in the sense that the city is now literally made of phantoms–its post-

. . . . . . . . . . . . .

17 Jean Baudrillard, *America* (London: Verso, 1989); Paul Virilio, "The Overexposed City," *Zone* 1/2 (1986): 14–31.
18 Robert Somol, "'You Put Me in a Happy State': The Singularity of Power in Chicago's Loop," *Copyright* 1 (1987): 98–118.

modern towers regressive "time machines" or "stylistic second comings" concerned with replicating time, rather than conquering space, in a process of self-referential "cloning." This logic actually leads Somol's deliberately hyper-theoreticist discourse back around to restating that fundamental popular insult: "Jahn's simulacrul tower" he says "has nothing to do with verticality and vigor"–it is "a prosthesis, a *dildo*" (100, emphasis mine).

There now seems to be a parallel between the arts of populist bad timing and theoreticist wishful thinking. In both acts of comic reduction (tower to penis, tower to dildo), the critical discourse affirms its own performative powers ("saying makes it so"). Somol, furthermore, uses a version of Fredric Jameson's familiar thesis on the "collapse of critical distance" under postmodernism in order to claim that in the implosive space of our simulacral cities ("collapsing into their dead centers of rehabilitation"), it is always already impossible to distinguish critique from affirmation. So discourse can only be effective *as* performance–"a subtle ambiguity, a style that will ... usually go unnoticed" (115).

A problem arises, however, in the form of a difference over "style" between simulacral and popular criticism. From the latter's perspective, it's not at all clear that a dildo would have "nothing to do" with verticality or vigor. Indeed, a dildo might well be considered the ideal form of both: while any object can of course be diverted to other uses, being vertical and vigorous is pretty much what dildos are *for* in a first instance, and prostheses are often treated as comic in popular culture because of their *unequivocality* compared to the ambiguities, and the frailties, of flesh. A dildo in this context represents purity of function and singularity of purpose, unlike the penis, which is mixed, and multiple. To mock a tower-phallus as "really" a penis is thus to emphasize the vulnerability of the penis. To mock a tower-phallus as "really" a *dildo* is to predicate, on the contrary, the greater power of the (absent) penis as the ideal phallic form. Somol's joke assumes that a dildo can only be a "phantom" substitute for "the real thing," the penis-phallus: it depends on the organicist "depth" nostalgia shared by Baudrillard's theory of simulation and Jameson's concept of critical distance, and in this it is quite distinct from a populist emphasis on controlling surface appearance.

Finally, I would note that towers are in some disfavor these

days as representing the privileged place of annunciation not only of "Faustian" modernity in general, but also of totalizing theory, and "metanarrative," in particular. In an influential gesture repeatedly cited today, Michel de Certeau in *The Practice of Everyday Life* described coming down from the top of the World Trade Center as an act of leaving behind the solitary, gridding, voyeuristic, stasis-imposing, abstracting "theoretical" position of master-planning, in order to walk forth into a bustling, tactile space of practice, eventfulness, creativity, and anecdote—the street (91–96).

This is also a story, I think, about walking away from a certain "vision" of structuralism. Yet de Certeau's move from summit to street involves a troubling reinscription of a theory/practice opposition—semantically projected as *"high"* versus *"low"* ("elite" versus "popular," "mastery" versus "resistance"), *"static"* versus *"dynamic"* ("structure" versus "history," "metanarrative" versus "story"), *"seeing"* versus *"doing"* ("control" versus "creativity," and ultimately, "power" versus "know-how")—which actually blocks the possibility of walking away at all.[19] In fact, de Certeau's visit to the World Trade Center is a way of mapping all over again the "grid" of binary oppositions within which so much of the debate *about* structuralism was conducted (by Sartre and Lévi-Strauss, among others). "The tower" here serves as an allegory of the structural necessity for a politics of resistance based on a bipolar model of power to maintain the imaginary position of mastery it must then endlessly disclaim.

My problem has more to do with town planning than structuralism. Reading de Certeau's text, along with the others I've mentioned, I experience now a revulsion of common sense, an urge to retort that we are *not* now living in a great age of "master" planning (nor, for that matter, of general theory in cultural criti-

. . . . . . . . . . . . .

**19**   While it is consistent with his critique in *The Practice of Everyday Life* of the work of Michel Foucault—whom in that book de Certeau mistakes, like many commentators today, for an exponent rather than a critic of the concept of "total" power (62–63)—this strange pull back toward the grounding categories of an antitheoretical populism is quite at odds with de Certeau's own, practically Foucauldian, efforts to theorize the historical emergence of "popular culture" as an object of study, and the matrix of power-knowledge relations still defining such study today (131–164). See also "The Beauty of the Dead: Nisard" and the two essays on Foucault in *Heterologies* (Minneapolis: University of Minnesota Press, 1986).

cism), and that this should make a difference to the terms we're going to use, and the "spatial stories" we tell. Whatever else one might want to say about it, the entrepreneurial city of the 1980s was not *la ville radieuse*. Indeed, de Certeau himself made the move "down" from the symbolic position of Planning quite a long time ago now precisely in order to note that "the Concept-city is decaying" (95).

So I want to turn now to some spatial stories from my own entrepreneurial city, and some discourses about towers which were also active during the real estate boom, but which did not involve either a populist reduction ("cutting things down to size") or an intellectual ritual of renouncing the heights ("getting down"). The first of these involves the classic figure in which myths of altitude, property, and archaism may converge:

II

> *Contrary to popular belief, King Kong did not die during that embarrassing incident on New York's Empire State Building. Instead, with assistance from Fay Gray [sic]... he migrated to Sydney, Australia. However, they had not anticipated on one thing ...*

> "KONG, YOU'RE NOT SAFE HERE, SPIRALLING RENTALS OUT OF CONTROL, INFLATION, WHERE WILL YOU STAY?..."
> "King Kong: The Moment of Final Decision"[20]

In June 1989, the "PM Advertising" agency launched a King Kong theme promotion of office space for sale in a building in downtown Sydney. PM declared that the concept was "perfect for the AWA Building since it shares a lot in common ... with New York's Empire State Building." The concept was also ambitious. Built in 1939, a mildly ornate office block with a vague reminiscence of the Eiffel Tower on top (a radio tower that better resembles the RKO Pictures logo), the Amalgamated Wireless (Australasia) Ltd. Building—once, it is true, Sydney's tallest—is thirteen stories high (figure 2).

. . . . . . . . . . . .

20 *The Australian Financial Review,* June 15, 1989, pp. 47–49. I assume that "Fay Wray" becomes "Fay Gray" for legal reasons. As always, the interesting thing is the use of the first name of the "original" actress to identify the *role* of King Kong's female other.

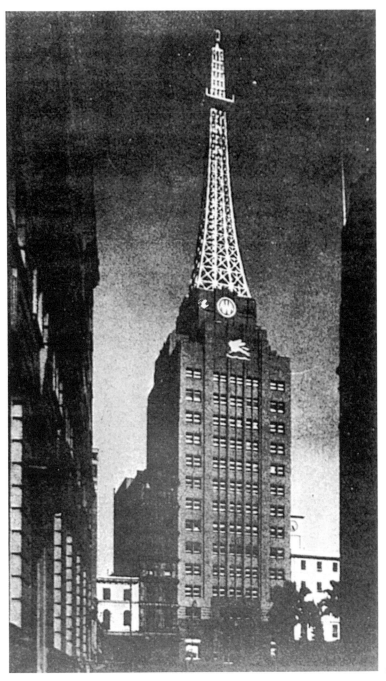

2

The Kong campaign was an elaborate affair. One columnist saw in its extravagance a sign that the crash was coming: for "In The Know" (*Weekend Australian,* June 24–25), such "bizarre" efforts to publicize space worth $7,000 per square meter meant the panic of pending downturn, not the frenzy of a boom. A huge advertisement spilled across the investment pages of every major newspaper in Australia. Its main feature was "King Kong: The Moment of Final Decision," a comic strip printed on two consecutive right-hand pages to heighten the narrative tension. On the first page, the comic was framed by two photographs and two simulated news reports–one about the King Kong theme's success in attracting investor attention, the other about the "increasing demand" for owner-occupier space, as rentals in the CBD reached $1,000 per square meter. A close reading of the text couldn't miss its rigid binary structure. Its overelaboration was also a little bit puzzling; the design was very messy, the ad poorly differentiated from unrelated copy occupying the rest of the page (figure 3). But on scanning the comic across both pages, the clutter of pairs on the first page eventually made sense.

The comic begins with the famous couple in Sydney. Clinging to the top of the AWA tower, Kong and Fay consider their options. Fay has a conservative view of real estate, and a nostalgic image of Kong. She wants to run away from the city and take him Back to Nature ("a BIG ROCK not too far away"). Her dream home is Uluru (Ayers Rock) in the central desert. But Kong is a natural real estate animal ("this building looks even better than the other one with a tower"); with one glance at the quality finish and fabulous views of his prime CBD location, he knows he's sitting on a good investment. So Fay, ever fainthearted, issues an ultimatum from the bottom right-hand corner of the page: "Well KONG. It's the AWA Building or me. What's it going to be? ..." And when we turn over, King Kong's "natural" decision is:

KING KONG DROPS FAY GRAY

In fact, the plunging lines of the drawing imply that King Kong *throws* Fay Gray; a reading confirmed in one of the vertical blocks of fine-print filler ("Poor Fay, thrown over for a more attractive proposition worth really big bananas in the future") that, by flanking and supporting the central image of the tower, act visually to enhance its soaring, phallic singularity (figure 4).

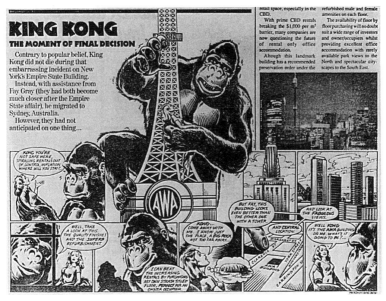

3

With this clear designer solution to the bothersome clutter of couples, Kong as corporate beast takes the hard decisions and regains his killer instinct—and when the Beast at last kills Beauty, Fay's domesticated values of "security" go with her. For Fay is not just a typical tourist seeking, with Baudrillard et al., authenticity in long and lowness in the desert. Her vision of making a *home* at Uluru in the "heart" of the continent is a prime suburban fantasy of a stable tradition of meaning. Famous as "solid rock/sacred ground" in a late 1970s pop song for Aboriginal land rights (but just as "Solid Rock" in a simultaneously appearing finance company billboard), Ayer's Rock is the center of a classic (white) national imaginary.[21] In rejecting this "suburban" escapist tradition, Kong knows he'll be more at home in the tough environment of rampant speculation. If his final decision is an act of passion, rather than reason, then the entrepreneurial (or in Castells' phrase, the "wild") city really is Kong's natural habitat; and as the fine

· · · · · · · · · · · ·

**21**  Some of the power of this imaginary can be deduced from the hysteria surrounding the Lindy Chamberlain case (an alleged maternal infanticide at the Rock), narrated in Fred Schepisi's film with Meryl Streep, *A Cry in the Dark*.

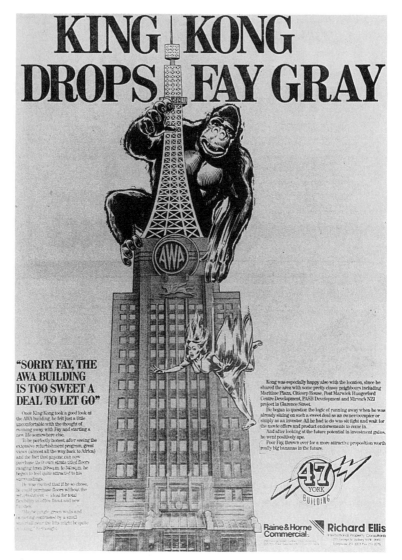

4

print again makes clear, if push comes to shove, Kong can survive a crisis by trading on his reputation—"all he had to do was sit tight and wait for the movie offers and product endorsements to come in."

The invitation to take this story allegorically is almost irresistible, beginning with the arrival of Kong and Fay as emblems of mobile investment capital flying around the Pacific Rim. In its brutal explicitness, this ad is a blaring manifesto for real estate speculation, and the striation of space it entails—the dividing of city space by enclosure and bordering, the segmenting of populations, a monumental centralizing of corporate wealth and power ("not to hegemonize the city in the fashion of the great modernist buildings," as Mike Davis points out, "but rather to polarize it into radically antagonistic spaces").[22] In more conventional terms, simply by identifying Fay with all the explicit social referents of her image—anxious "housewives," struggling "homeowners," nostalgic suburban dreamers, even Aboriginal people, all the *inhabitants* of a place—this image of Fay's expulsion from King Kong's urban paradise celebrates the consignment of large numbers of people to the status of "waste products" of spatial restructuring.[23] "The Moment of Final Decision" is a comedy of displacement, eviction, homelessness, the feminization of poverty—and of the end of egalitarianism as a slogan for everyday life.

It is also, though more obliquely, about "gentrification" and the role of that layer of intellectuals whom Scott Lash and John Urry call, following Pierre Bourdieu, "the new cultural petite-bourgeoisie"—workers in all occupations involving presentation, representation, and the supply of "symbolic" goods and ser-

· · · · · · · · · · · ·

22   Mike Davis, "Urban Renaissance and the Spirit of Postmodernism," in *Postmodernism and Its Discontents: Theories, Practices,* ed. E. Ann Kaplan (London: Verso, 1988), p. 87.

**23**   Patricia Mellencamp, "Last Seen in the Streets of Modernism," *East-West Film Journal* 3, no. 1 (1988): 45–67. Australia has historically enjoyed high levels of home ownership. Owning a house is a *working-class* ideal and figures as such in national mythology. The "struggling homeowner" is therefore not equivalent to the affluent or comfortable suburbanite of American urban history. She represents one of the most vulnerable targets of economic and spatial restructuring today. On the architectural history of "home ownership," see Robin Boyd, *Australia's Home* (Harmondsworth: Penguin, 1978).

vices.[24] For if one were to read "The Moment of Final Decision" allegorically with any honesty, the potential social positioning (and "homemaking" practices) of many intellectuals–including feminist theorists–today would be, whatever our commitments and however much our hearts may be with Fay, in fact more like that of the gorilla. However it is not a matter of simply noting (and perhaps aestheticizing) a cynical celebration of our role as the avant-garde of the urban real estate business (recently a subject of criticism, from Yvonne Rainer's *The Man Who Envied Women* to Julie Burchill's *Ambition*). The critical question is what *kind* of positioning "The Moment of Final Decision" ascribes to the "cultural" petite bourgeoisie.

It's tempting to see it simply as a story of self-interested apes in their rehabbed ivory towers. A great tradition could support this interpretation. In his famous analysis of Goethe's *Faust,* Marshall Berman describes the "tragedy of development" partly as a progression from one place of elevation ("an intellectual's lonely room … an abstracted and isolated realm of thought") to another, the "observation tower" from which Faust oversees a world of production and exchange, "ruled by giant corporate bodies and complex organizations."[25] Reductive and parodic as "The Moment of Final Decision" may be, it does draw on this tradition. King Kong flinging Fay from the tower is not only repeating the gesture of Faust's abandonment of Gretchen (destroying the woman who helped make him what he was, and so, destroying his past), but also, in the process, he is transforming his cultural status.

King Kong was classically a *victim* of Enlightening intellectuals (explorers, filmmakers, geologists). King Kong, in his affinity with savages and women, was the *counter*-Faustian figure of tradition, archaism, and myth. Flipping Fay back into that role (Woman as nature, nostalgia, "home"), and then rejecting her appeal, has the effect of installing Kong as doubly faithless to his

. . . . . . . . . . . .

**24**   Scott Lash and John Urry, *The End of Organized Capitalism* (Madison: University of Wisconsin Press, 1987), pp. 295f. Lash and Urry are less pessimistic about this development than is Bourdieu, and prefer to see the "new petit bourgeois" as a member of the lower echelons of the service class.

**25**   Marshall Berman, *All That Is Solid Melts Into Air: The Experience of Modernity* (London: Verso, 1983), pp. 39, 67–68.

origins. He becomes not only a snob ("happy ... [to share] the area with some pretty classy neighbours"), and an aesthete ("maybe jungle green walls and carpeting contrasted by a small waterfall near the lifts might be quite relaxing"), but a class traitor–in short, a yuppie.

There is a problem with this, however. While Kong contemplates the city from Faust's special place–the top of the tower–he is not in the *position* of the developer. This King Kong is a *consumer*: a "new" consumer, an active and discriminating reader of advertising images ("Well, take a look at this ..."), a speculator in signs. (This is why Kong, rather than Fay, provides a figure of my own activity inscribed in the image, a *mise en abyme* of my reading so far.) The solitary Faustian position here has been disseminated into a bustling network of cultural producers, "ideas people"–property developers, real estate agents, marketing experts, advertisers and promoters, city planners, architects, builders, interior designers. Above all, this *text,* rather than the urban situation it operates within (to make a crucial distinction), is not a tragedy but a crazy comedy of boom and bust which, in its material context of grim headlines about imminent property market collapse, said to and of King Kong the new consumer: climb now, crash later.

It may seem fanciful to assimilate a marketing campaign to any discourse on intellectuality. However there is a minor figure in the Kong assemblage, one invisible in the image but a key player in the story. One of the "news" reports on the first page notes that a special "launch function" was held on a rooftop opposite the AWA Building with Bill Collins, a celebrity film critic. "In the Know" revealed that Collins' task was to "*resurrect* the story" of King Kong, while a 13-meter model was hung from the AWA radio tower. Bill Collins is a "nostalgia buff," a popular film historian known in Sydney for decades as the TV host of *The Golden Years of Hollywood.* So in taking his place in the network of *animateurs* at the PM launch, Collins the Hollywood-revivalist was literally embodying the self-promotional strategy by which Lash and Urry define the "cultural petite bourgeoisie." Always threatened with downward mobility, they (we) encourage "symbolic rehabilitation projects" that "give (often postmodern) cultural objects new status as part of rehabilitation strategies for their own careers" (295).

*... the architecture of redevelopment constructs the built
environment as a medium, one we literally inhabit, that
monopolizes popular memory by controlling the representation of
its own history. It is truly an evicting architecture.*

Rosalyn Deutsche[26]

Having taken an allegorical reading of a postmodern "cultural" object to the point where it must question its own social function, I now want to ask whether "rehabilitation" and "resurrection" is really what we're dealing with in eviction maneuvers like "The Moment of Final Decision," and whether these terms are sufficient to whatever it is about "postmodern objects" that we *are* dealing with when confronting commercial rhetorics so explicit about *their* social, as well as economic, function. It is too easily assumed that once "images *rather than* products have become the central objects of consumption" (Lash and Urry, 290), then a reality once ontologically distinct from the image has undergone some kind of *death*–and that the language of necromancy is more apt to deal with the results than cultural history or political activism.

Robert Somol's necromantic reading of the State of Illinois Center is a case in point: its terms lead to the conclusion that "we must ... abandon the language of struggle (and the concomitant notion of liberation) which only tightens the tourniquet of power (and futility) around us" (115). The only response left is "style," a mode of aestheticized knowingness. But as Rosalyn Deutsche points out, the architecture of redevelopment is precisely about struggle, and *displacement*. Other versions of popular memory, other representations of history, other "styles" of experiencing the built environment are violently expelled by the forces of redevelopment as *part of the process* of excluding and impoverishing people, of colonizing and "abstracting" urban space.

I think it is crucial to choose carefully the terms we use to conceptualize the semiotic aspect of that process (and thus, resistance to it). Serious consequences follow for cultural politics: if one phantom city seems much like any other, if each instance of redevelopment is made interchangeable with every other, social criticism and political opposition alike are soon caught up (by this

. . . . . . . . . . . .
**26** Rosalyn Deutsche, "Architecture of the Evicted," *Strategies* 3 (1990):
176.

logic) in a circuit of redundancy, and reduced to routine gestures. One problem with the necromantic model of simulation so popular in the 1980s is an incapacity to make distinctions that "ghosts," albeit parodically, the process of abstraction it describes. I want to argue this briefly by entering the permanently present citational network within which PM Advertising was operating. King Kong is a useful figure for considering the question of cultural (re)production, precisely because in *cinema* history he has "died" (and been reborn in his own image, the ideal simulacrum) in so many places and times.

For example, at the end of his 1977 essay "Touche pas à la femme blanche," Yann Lardeau agrees with PM Advertising that King Kong survived his fall from the Empire State Building.[27] Kong's "real" death probably occurred on the footpaths of Paris, during the publicity campaign to launch John Guillermin's 1976 remake of *King Kong* in France. A 16-meter, six-and-a-half-tonne King Kong model was assembled by 30 technicians, animated by electronic wiring and hydraulic pumps, and laid out flat on the Champs-Elysées for passersby to file past on a platform above.

For Lardeau, this scene of banalized tourist vision and technologically programmed dreaming (the scene of the simulacrum) is funereal. What lay on the footpath was something material and "*verifiable*" that contradicted the "life" represented by the primal cinematic *King Kong* made by Schoedsack and Cooper in 1933. In that film—so powerful a myth that all later versions refer to it as their origin—Kong was a force of mystery, terror, and above all, monstrous uncertainty. Neither man nor beast, he *was* the ambivalence of the border between Past and Present, Nature and Culture (and therefore, a figure of incest). Kong is drastically changed, Lardeau argues, by the ecologically conscious farce of Guillermin's Oil Crisis remake. Merely a big, vegetarian gorilla hopelessly in love, Kong in 1976 was no longer a border figure (or, like some of his descendants in *Son of Kong, Super Kong, Baby Kong,* etc, a parody of one), but a "site" of confrontation between ecologists and an oil company, between a science of conservation (zoology) and a science of development (geology). This Kong dies by default, not necessity—he should have been put in the zoo.

The Champs-Elysées robot is just an extension of the technical

. . . . . . . . . . . .

**27**  Yann Lardeau, "Touche pas à la femme blanche," *Traverses* 8 (May 1977): 116–124. Translations mine.

credits of Guillermin's film. So Lardeau wonders if King Kong is still the subject of *King Kong*: pretextual rather than prehistoric, emptied of all ambivalence, he may now be just an occasion for displaying the power of technological expertise. This fits with the cardinal difference between the original and the remake, the shift from the Empire State Building to the World Trade Center (where Kong dies in 1976). For Lardeau, the latter "corresponds to a new phase of capitalist development, in which a bipolar power is redoubled on itself, referring only to itself in a space beyond all content" (123); leaping between the twin towers, Kong is caught in the play of feedback, and so is already finished as a primal force long before he falls.

What could this argument make of 1987 Rehab Kong hanging from a renovated Sydney office block which was only ever a degraded copy of a New York skyscraper? Nothing much, I suspect, or nothing specific (although PM Kong could easily reflect a "third" phase of capitalism in which the postwar system of bipolar power has now been replaced by a *multi*centered system representable not by any one monument, but by the flows of information that constitute the ad). In fact, the bipolar structure of Lardeau's own frame of reference–original/remake, image/reproduction, reality/technique–can say surprisingly little about the comic positivity of Oil Crisis Kong, except to inscribe in him, as a *non sequitur,* the loss of an older cinema. Lardeau offers an illuminating and poignant reading of Schoedsack and Cooper's film, but his is a structure of comparison that in the end can operate only to generate signs of lack in the present, and to find the present lacking.

Given such a framework, it is correspondingly hard to imagine what to *make* of the diverse King Kongs circulating now in popular culture, except to reduce them, improbably, to examples of the Same: a pop art Kong in a subway T-shirt wanders past the Empire State Building, while a bored "Fay," brushing her hair, holds a mirror as he holds her; a richly colored "Ethnic Arts" card (Mola, Cuna Indians, San Blas Islands, Panama) has KINGON, arms curving round Fay like butterfly wings, surrounded by leaves and flowers; a postcard from a small Midwestern town stamps on a *King Kong* panorama of 1933 New York, GREETINGS FROM CHAMPAIGN-URBANA. What can nostalgia for the origin *make* of a scene from *King Kong No Gyakushu* (1967), in which the "real" King Kong does battle with his own simulacrum (a mining-company robot) (figure 5)?

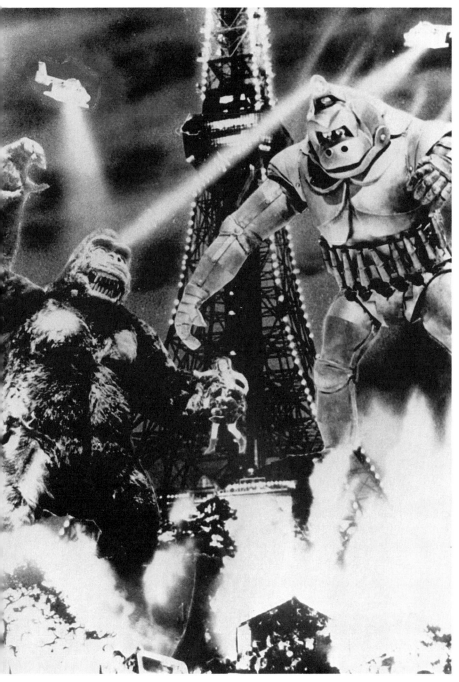

Japanese King Kong has a history of his own, which I'm not qualified to enter into. For my reading here, however, the image of King Kong confronting "Mechni-Kong" offers a useful alternative to the original/remake (and *"real* thing"/dildo) schemata I've discussed so far. I think that the status of the (second-degree) "original" King Kong in *King Kong No Gyakushu* can be defined quite differently from that of the (original) "original" King Kong for Yann Lardeau. The titans blitzing each other near the Eiffel Tower in 1967 do not represent Nature (organic Kong) and Culture (Mechni-Kong), nor the problem of the border between them, but rather a conflict between *mixity* (the hair-covered King Kong model as cyborg) and *purity* (the smoothly unequivocal robot, the dildo). The heroic stature of "mixity" within the terms of this opposition may explain why King Kong, with his ambivalent relationship to power, is most persistently a *penis,* and not a phallus, myth (hence the proliferation of an arcane literature about the size of King Kong's organ).[28]

An inability to specify such images as potential events (that is, to read them productively) inhibits the possibility of theorizing cultural practice. An ability to read them repetitively as signs of an Absent Image precludes the thought of "practice" altogether. It is curious, then, that Baudrillard's concept of simulation (death of difference, reference, history, and the real in commodification) remains most influential today through the writings of marxists like Fredric Jameson and David Harvey, who use it to describe aspects of postmodern culture while discarding its political quietism. Yet this concept precisely depends on a theory of intertextuality that cannot imagine *change*: it recognizes only apocalyptic, thus singular, rupture (and that in the form of its impossibility as present or future event). For this reason, it is a theory most ill-equipped to come to terms with that *form* of change that Jacques Attali describes in *Noise* as "the minor modification of a precedent"–in other words, with the technique specific to contemporary semiotic economies of serial recurrence.[29]

. . . . . . . . . . . . .

28   This question is insistent in the iconography of Guillermin's *King Kong,* not only in Kong's love scenes with "Dwan" (Jessica Lange), but also in gross close-ups of a huge bolt closing the village gate. See also Robert Anton Wilson, "Project Parameters in Cherry Valley by the Testicles," *Semiotext(e)* 14 (1989): 337–343.

29   Jacques Attali, *Noise: The Political Economy of Music* (Minneapolis: University of Minnesota Press, 1985). I discuss Jameson's use of

But if we turn instead to Judith Mayne's 1976 essay on "King Kong and the Ideology of Spectacle"–in its own way an "Oil Crisis" text, discussing the appeal of *King Kong* to American audiences during the Depression–it is possible to see a real difference, a historical change, in King Kong mythology effected by PM's "Moment of Final Decision." In her fine analysis of the workings (rather than the "fact") of sexism and racism in Schoedsack and Cooper's film, Mayne argues that the figure of the Other in the text is defined as an object of spectacle. The white woman, the island natives, and King Kong himself are not only constructed as "other" in ways specific to the conventions of 1930s Hollywood cinema, they are also brought into narrative equivalence as creatures to be *filmed* ("*King Kong* is a film about ... the making of a film that never is finished") by Carl Denham, the director and "petit-bourgeois entrepreneur."[30]

As a result, socioeconomic *class* comes to function as "the unrepresentable as such" in this imperial economy of spectacle. In Mayne's account, the problem outside the wall or beyond the border in *King Kong* is not to do with incest or impossible congress or with an "untouchable" (white) female sex: "race and sex are convenient means ... of forgetting–or repressing–what class is all about" (379). When the petit-bourgeois "cultural" entrepreneur rescues Ann Darrow (Fay Wray) from poverty in New York, a narrative *displacement* occurs from the scene of the American Depression to a spectacle of exotic sex. The closing scenes of King Kong rampaging through a glittering, prosperous New York (a city as "other" in its way to American Depression audiences, Mayne argues, as the woman, the natives, and Kong) conclude this process of displacement by showing what happens when the entrepreneur loses control of the spectacle: the "laws of representation" are broken down by "this brute reality–so gigantesque that it is unreality itself–that is Kong." But this is not the return of social class to the scene of representation. On the contrary, it "reflects the most fundamental process of displacement operative in *King Kong*." The urban crisis appears (like the Depression for most economists

. . . . . . . . . . . . .

Baudrillard in my essay "Panorama: The Live, The Dead and The Living," in *Island in the Stream,* ed. Paul Foss (Sydney: Pluto Press, 1988), reprinted in the catalogue for *Paraculture,* an exhibition curated by Sally Couacaud (Artspace, Sydney/Artists Space, New York), 1990.

30  Judith Mayne, "King Kong and the Ideology of Spectacle," *Quarterly Review of Film Studies* 1, no. 4 (1976): 373–387.

at the time) as something "not fashioned by human beings, but the raw force of nature itself" (384).

Apart from its interest (and its force as a reminder that a "new" cultural class did not pop up overnight), Mayne's reading gives me a basis for defining what *doesn't* happen in 1989 when KING KONG DROPS FAY GRAY. First, the "corporate beast" now has no need to "naturalize" his actions by opposing savage predation to (economic) reason: the joke is that we know they're the same. Second, "The Moment of Final Decision" is, as the trade critics sensed, a *prediction* of imminent crisis, not an imaginary resolution of one: the "crash" is accepted, not denied, as logical to finance capitalism. Third, "The Moment of Final Decision" is a representation *of,* as well as an exercise in, the process of displacement: by rejecting the "exotic" appeal of "spectacles" of sex and race (Fay's Uluru dreaming), it classifies them as distractions from the real thrills of class conflict and economic passion. Fourth, King Kong now *is* Carl Denham: there is no crisis *of* representation for the cultural entrepreneur, only crisis *in* representation as he waits for the "movie offers and product endorsements" to secure his shaky future. This is, of course, his big mistake (and the biggest joke of the story): the fact that "image" *is* capital for Kong is why he *will* crash sooner or later, and why the "*cultural* petite bourgeoisie" is the subject of the narrative (and the author of the text)—but not the addressee of the sales pitch.

PM Advertising's exercise in "simulation" brings the figure of King Kong into the rhetorical and *ethical* field constituted by a privileged trope of 1980s entrepreneurial (or bull market) culture that I would call "the *brutal truth.*" This was an ideology of spectacle that rested on the claim that there *is* no "unrepresentable"—no limit now beyond which one cannot go, no desire requiring repression, no conduct, no matter how predatory, that needs to be disavowed. (The mock-shock effect of the slogan KING KONG DROPS FAY GRAY is thus in Australian terms not only the "brutal truth" that it tells about class, but the way it makes a mockery of the codes requiring our society to maintain a "classless" *appearance.*) In globally circulating American media culture, *Wall Street's* Gordon Gekko was perhaps in his heyday the most famous practitioner of the art of brutal truth ("Greed is good. Greed purifies. Greed works"). In the small world of cultural theory, the rococo

writing of Baudrillard–dependent as it was on that formula of per-
petual inflation, "ever more $x$ than $x$" (the principle of hyper-
reality)[31]–functioned not so much in complicity with such plain
speaking as in counterpoint, an elaborate accompanying rhetoric
that could only confirm, by its critical helplessness, that bull mar-
ket "truth" was by *nature* an incontestable *law*.

King Kong, however, was not the only cultural entrepreneur
dreaming of towers in Sydney at the height of the property boom:

### III

THEY TOLD HIM FROM THE START THAT IT WAS A SUICIDE
CLIMB–DANGEROUS ENOUGH DURING THE DAY, EVEN FOR THE MOST
EXPERIENCED CLIMBER . . . BUT DEADLY, IMPOSSIBLE AFTER SUNDOWN!

*The Human Fly: Castle in the Clouds!*

After February 1, 1987, Sydney media were buzzing with
reports of a "mystery climber" who had made it to the top of Syd-
ney Tower–and promptly disappeared. TV called him "The
Human Fly": newspapers had him dangling 300 meters above
"certain death" ("clad in a flame-red climbing suit"), and pub-
lished dramatic pictures of a tiny figure crawling up the thick
cables supporting the Tower's turret. The pictures had come from
a "stunned onlooker" who happened to be hanging about with a
camera on the roof of a nearby building.

Weeks later, a magazine revealed that the Fly was 26 years old,
had an engineering degree, worked as a traffic planning consultant
and "reckons he's a pretty normal bloke," while "stunned
onlooker" evolved into "Glen Kirk," who was "filming a sunrise
at the time" that he saw the Fly on the Tower.[32] Then, at the begin-
ning of August 1988–just as the property boom in Sydney was
nearing its peak–the ABC-TV national network screened *A Spire,*
a half-hour documentary by Chris Hilton and Glenn Singleman.
The first film of a series (*I Can't Stop Now*) about people with

. . . . . . . . . . . . .

**31**  I discuss this in "Room 101 or A Few Worst Things in the World," in
*The Pirate's Fiancée: Feminism, Reading, Postmodernism* (London: Verso, 1988),
pp. 187–211.

**32**  "Sydney's Human Fly," *Daily Mirror,* February 2, 1987; "Exclusive:
The Human Fly," *People,* March 23, 1987.

obsessions, *A Spire* was the story of how and why Chris Hilton had scaled Sydney Tower after six years of planning and preparation; how a mountaineer's fantasy had intensified into an idea of making "a personal statement ... about the urban environment," and how meeting Glenn Singleman in 1986 had transformed the plan to climb the Tower into a project to make a film about doing it. This project had two components and two goals. One was to ensure that Chris could climb the Tower *without* risk of "certain death" for himself or anyone else (Singleman recalls in the film how he had to be convinced it would be "absolutely safe"). The other was making *A Spire* itself.

So this is a double adventure story with two separate happy endings, structured by a time-lapse and a spatial shift between the two (the ascent and the broadcast, the city Tower and the national network). There is a further complication. My object of analysis is actually a text produced *during* the lapse of time between the two conclusions. *A Spire* exists in two versions, the first of which was a 43-minute film made without ABC assistance, but in the hope of persuading a network to buy it. For my second model of social climbing, I want to begin with this "original" version, which can circulate as an independent video.

But at this stage, "beginning" isn't easy. *A Spire* is of course impossible to reproduce as accompaniment for an essay. It would also be difficult metonymically to describe "the plot," or to analyze a crucial passage that might "give an idea" of the film, which I must assume most readers won't have seen. However this problem—familiar to all noncanonical film study (and all criticism of temporal arts)—does allow me to define something unusual about *A Spire* as an adventure story. In contrast to the "punchline" structure of King Kong's *Moment of Final Decision*—a narrative relentlessly directed, like any one-liner, towards its eventual "singular" outcome—*A Spire* is a narrative of ascent which is neither linear, nor simply "climactic."

Instead, several stories combine in a composite history. Along with footage of the actual climb, there are stories about different people involved (especially Mark Spain, who climbed part of the way up the Tower before deciding to go back down); about the process of researching the Tower's construction, then inventing and testing the climbing tools that might be appropriate to it;

about the months of physical and mental preparation in "natural" and urban environments–the Sydney sea cliffs, a car-park, the tree in an inner-city backyard. These stories drift easily into chat and interview footage: rock climbers discuss the difference between falling on something "soft," like trees or water, or something "hard," like glass and steel; an Everest climber compares the scaling of Sydney Tower to Christo wrapping an island; various critical responses (from people in the street, a lawyer, an adventurer, a psychiatrist, an architect, a mythologist, an art historian) prolong the *event* of the climb by expanding its significance.

So while *A Spire* is narratively unified by footage from the climb, the extensions and digressions intertwine with it in such a way that the progress of the ascent is constantly *interrupted* by scenes from other stories, and by others' lines of thought. I say "interrupted" and not "*dis*rupted": a lot of tension builds up in *A Spire,* since most of the footage is from the last, most difficult, and least predictable phase of the climb. What is rather unusual in an "action" adventure is that the tension is *not* relieved by attaining the obvious goal of the quest (Chris reaching the top of the Tower), but only with its "anticlimactic" result (once he gets there, nothing happens) and final outcome (he walks away in the street). In fact, the moment of reaching the summit to some extent appears as one "interruption" among others in a fairly smooth process of traveling away from, and then back to, the city streets. I shall return later to the ending of *A Spire,* and to how it represents "overview" not as a position, but as part of a process.

First, I want to situate the film in the context of my discussion so far. There is a form of argument influential, perhaps even predominant, in Cultural Studies that would require me now to frame *A Spire* as an allegory of *resistance.* As a project ongoing throughout the 1987–89 property boom and its attendant social disruptions, the making of *A Spire* (including the "profilmic" event of the climb) inscribes a refusal of entrepreneurial aspirations to dominate and divide up city space. Acting *in* that space, between John Bond's grandiose Skytower dreams and PM Advertising's cynical reason, it should not only bear witness to popular opposition, but provide us with terms of riposte.

Now I think *A Spire* does do this: it will be clear that I do regard it as an act of social criticism and, more strongly, as entail-

ing a political practice of opposition and transformation. While there should always be debate about the kind and the scope of political "effectivity" to be claimed for symbolic actions, I do accord them a productive, not a decorative or "aestheticizing," role. That is to say, I don't want to flout the generic expectations that the structure of my essay has created. But I also want to *learn* something from *A Spire,* to respond to and extend its productivity. Instead of reading it as a confirmation of the general models of action–resistance, opposition, critique–already available to Cultural Studies, I want to read it as inventing a *practice* for a particular time and place.[33]

One model of action that immediately seems pertinent to *A Spire* as a critique of entrepreneurial space is Michel de Certeau's powerful distinction in *The Practice of Everyday Life* between "strategy" and "tactics" (xix–xx, 34–39). "Strategy" is the name of a mode of action specific to regimes of *place*: it is "the calculus of force-relationships which becomes possible when a subject of will and power (a proprietor, an enterprise, a city, a scientific institution) can be isolated from an 'environment.'" It also requires, and produces, an Other: strategy "assumes a place that can be circumscribed as *proper* (*propre*) and thus serve as the basis for generating relations with an exterior distinct from it ... Political, economic and scientific rationality has been constructed on this model." PM Advertising's image of the spatial and *social* relations involved in "dropping Fay Gray" is in fact an excellent projection of de Certeau's concept of strategy.

A "tactic," in contrast, is a mode of action determined by *not* having a place of one's own. It is "a calculus which cannot count on a 'proper' (a spatial or institutional localization), nor thus on a border-line distinguishing the other as a visible totality." However this does not imply a dystopian *state,* or condition, of placelessness; for de Certeau, "the place of a tactic belongs to the other." In other words, as a way of operating available to people displaced and

. . . . . . . . . . . .

33 Such learning is in my view one of the purposes of textual analysis, which is not hostile to general models (on which it depends for its materials), nor to the abstraction required by theorization, but which does assume that the objects we read can provide–through their own more specialized form of "resistance" to easy or streamlined analysis–terms for questioning and revising the models we bring to them.

excluded as "Other" by the bordering-actions of strategy, a tactic maintains an *active* relationship to place by means of what he calls an art of "insinuation." Tactics are opportunist: they involve seizing the chance to take what de Certeau calls a "turn" (*un tour*) through the other's terrain, and so depend for their success on a "clever utilization of *time*" (39).

The notion of tactics is not as romantic as it can sound. For one thing, it is parasitic on the notion of "strategy": if this means that "tactics" cannot of itself sustain a theory of autonomy for strategically "othered" people, it also means that it cannot be used to ground an ontology of Otherness (and that individuals cannot be treated holistically as full subjects of either strategy or tactics). Furthermore, the distinction itself is not a way of deeming it a privilege to be marginalized, but a way of asking what kinds of action are possible once people historically *have been* marginalized by a specific regime of "place." This is why the distinction could underpin, for de Certeau, a theory of popular cultural *practice*. The "popular" could be conceptualized as a "way of operating" and an "art of timing" precisely because of its tactical relationship to the so-called "consumer society" and its strategic installations (supermarkets, television, freeways, high-rise towers ...).

If we turn to *A Spire* with this distinction in mind, it can help us to read quite closely how the whole project worked. For example, both the climb and the film were products of an art of very careful "timing." Chris Hilton began what turned out to be a nine-hour climb around midnight on a Saturday, so as to be a long way up the cables around the shaft supporting the turret by sunrise Sunday morning. This meant that the little red Fly could be most advantageously filmed approaching the top of the golden turret with a bright blue sky for backdrop. However the timing's immediate aim was to avoid alerting the police for as long as possible (hence also the quietest morning in the week for the "visible" part of the climb).

Scaling a corporate monument without permission is, of course, highly illegal ("trespassing, disturbing the peace, public nuisance," smiles Lesley Power, lawyer), and Sydney Tower is fully *strategic* in de Certeau's sense. Historically if not aesthetically one of the inaugural buildings of the "architecture of redevelopment" in Sydney–a tourist tower opened on top of a shopping

complex in 1981 to attract people "back to the City to shop"[34] –Sydney Tower is a place entirely "proper" to the life-assurance company that owns it (the Australian Mutual Provident Society), to the administration that inhabits it, and to the security organizations that maintain it and police its relation to the "exterior" created by the residents and tourists of Sydney.

So Chris Hilton's "turn" on the Tower involved a risk not only of being arrested at the end, but also of forcible "rescue" halfway up. This has consequences for the narrative tactics of the film. Since so much of the narration insists on the advance elimination of any real danger that Chris might fall, or *need* to be rescued, the "site" of tension is displaced from those images of a tiny figure dangling in vast space which could, and in action adventures usually would, invite us to anticipate death for the hero, and still expect a happy ending. While such images in *A Spire* are indeed awesome, there is just as much anxiety about what happens *after* the climb. The tension is *stretched* across the accumulation in time of delays, hitches, and moments of frustration as the sun rises higher in the sky. The climb takes three hours longer than planned: time to negotiate Mark Spain's descent, time to force a too-tight hanger inch by inch along rusted beams, time to edge around the base of the turret to find an unblocked window-cleaning track –enough time for there to be a guard in the turret looking out as the Fly crawls past the window. This is one reason why the sense of climax overflows the moment of reaching the summit. There is still the problem of escape, of getting *away* from the other's terrain.

There is another sense in which *A Spire* can be seen as a tactical response to constraints imposed by "strategy." In a speech to the camera near the beginning, Chris Hilton names the *genre* problem that the film will have to negotiate: "if this was a tale about climbing a mountain in some wild mountain range of the world, it would be a *boys' own adventure* story, a tale of survival against all the odds ..." These days a rather dismissive generic term for any bland all-male adventure, the phrase "boys' *own*" points to the formal constraints that not only define the "place" of the genre in Western action cinema–a relative or absolute exclusion of women, the iso-

. . . . . . . . . . . .

**34**  See my "Sydney Tower," *Island Magazine* 9/10 (1982): 53–61, reprinted in *Transition: Discourse on Architecture* 25 (1988): 13–22.

lation of (white) males as "proper" subjects of action, and the exteriorization of Nature (and Natives) as "other" to Man—but that may also now frame in advance our expectations of any film in which, as in *A Spire,* a young man *does* have an adventure, and survives against the odds.

As a way of preempting this response, Chris Hilton claims that shifting the scene from mountain to tower can modify the genre ("But this building is in the middle of the city," he continues, "so it brings to bear a whole lot of other aspects ..."). Other speakers insist that "natural" and built environments are continuous, not opposed or external to each other, and scenes of men and women rock-climbing make the same point visually when one image includes the spires of the city rising just across the water from the cliffs. More strongly, I think, the boys' own adventure is modified by a series of questions in the film about the distinctions that *do* exist socially between nature and the city, questions that *follow* from deciding to treat them as the same: "The legal aspects, issues of social responsibility, issues of the built environment and what it's for ... who owns the outside of a building? Is it the public, whose visual space it dominates? Or is it the owner of the building?"

In this way, something that may be called a *critical* difference is introduced to the "boys' own adventure." This difference is "critical" in the simple sense that it involves insinuating a space of social analysis into the place of heroic action, but also in the more complicated sense that questioning the *proprieties* of the climb itself (those "legal aspects") immediately leads the film to question what counts socially as "proper" representation: "Is it responsible to climb a building and put your life at risk in front of others? Will it encourage young children to climb buildings and put their lives in danger? Is that a bad thing? People that come to try and rescue you, will it endanger their lives? Will it deface the building? All these sorts of things ..." What helps to make this a "tactical" *use* of the boys' own adventure (rather than a "critique" from the genre's outside) is Chris Hilton's reluctance throughout to claim the place of the outlaw, propriety's easy opposite: "All these sorts of things are *issues,* because I'm not a criminal and I don't want to break laws and be locked up in jail." Climbing the Tower is never presented as violation or trangression, but as a use of the "place" of the other for purposes alien to it.

Related to this, finally, is the aesthetic practice of the film. If *A Spire* is not a wham-bam action adventure, neither is it an avant-gardist experiment declaring its own deconstructiveness. It presents itself modestly as a fun documentary with talking heads, and amazing scenes. Yet this is why the adventure simply can't be "boys' *own.*" The editing-in of side stories and interviews quite casually guarantees a collective production of the whole *A Spire* adventure. A network of "ideas people" actually figures in the film, some discussing issues of ethics, law, and aesthetics after the event, while others work in advance on the problems of danger and safety (there are a couple of scenes of slide shows, in which a group uses photographs of the Tower to talk through tactics for climbing it). On the level of the *filmmaking* adventure, this use of what is now a fairly conservative documentary method (with strong links to the great tradition of Australian social realism) probably helped to "insinuate" an independent film that cheerfully confesses, theorizes, and depicts a symbolic crime against property into the state-owned broadcasting network.

At this point, it is useful to ask, "So what?" The strategy/ tactics distinction can show how a critical practice may bypass various obstacles to succeed "against the odds"; it is pragmatic in the best sense of the term. It also gives me a way of arguing that *A Spire* counts as popular culture while "The Moment of Final Decision" does not; a claim which itself risks populist essentialism, but which has the virtue of taking its model of action not from the ethos and practices of postmodern corporate culture, but from critical resistance to them. It also has the strength of showing how resistance may follow a different logic to that which it resists. This is why I have not reduced *A Spire* to the status of neat binary *opponent* to PM Advertising's vision of the city, although it can be done in a number of ways—grabbing a place *versus* reclaiming space, ownership *versus* tenancy, eviction *versus* infiltration, investment *versus* enjoyment, exchange value *versus* use value, cynical vanguardism *versus* utopian collective practice and, most profoundly, brutality and cruelty *versus* care and respect for life.

Yet without some way of bringing all this back home to concrete social situations, some way of showing how and why a "different" logic can *matter* and what its local inflections might be, criticism is confined to, at best, rehearsing a list of oppositional

values, or at worst, producing pious but empty reassurances that
there's something happening somewhere.[35] I'm not sure that the
strategy/tactics distinction can always tell us very much about
what is at stake, or what has been achieved, in a given set of cir-
cumstances. So I want to move on from it now to ask what *follows*
from reading *A Spire* as a tactical operation of temporarily occu-
pying, rather than territorially claiming, that much contested
position at the top of a high-rise tower. What kind of "aspiration"
did *A Spire* involve? What *kind* of practice does it entail? The very
title of the film can carry overtones of a small business slogan, or
the enterprise ethos of the "pioneer" school of Outward Bound
adventure, or the improving profiles of personal success produced
by the Sunday tabloids. So what *kind* of "popular" critique did *A
Spire* produce of the terrain on which it took place?

> *I wanted to make a personal statement by climbing it, about the urban envi-
> ronment. I thought it would be a nice image to climb, that people would get a
> kick out of seeing someone scale down the tallest building in Sydney to a
> human scale—just one individual, under their own power, bringing down a
> massive building which sets itself up as being huge, and impenetrable, and
> intimidating.*

<div align="right">Chris Hilton</div>

The Human Fly is an unusual superhero. Unlike Spiderman,
Batman et al., he is not a paranoid crime fighter but (in Deleuze
and Guattari's terms) a "passional monomaniac" with a social con-
science. He just likes to climb and do stunts, but he keeps on get-
ting involved in other people's problems (and gives the money he
makes to charity). This eccentric relation to the Law was always
part of his identity as a Marvel Comics creation. In *Castle in the
Clouds!* (3, 1977), readers' letters on the "Fly Papers" page make

. . . . . . . . . . . .

35 Susan Ruddick also points out that one problem with the strategy/
tactics distinction is that "in the long durée tactics disappear from view
without a trace" ("Heterotopias of the Homeless: Strategies and Tactics of
Placemaking in Los Angeles," *Strategies* 3 [1990]: 184–201). While she finds
it useful for describing how the homeless make use of "spaces that have
been strategically organized by other actors," she suggests that it needs
refinement to allow for the *relative permanence* in particular places that can
be gained by this use of space: "the homeless, simply by their presence in a
particular place, change its symbolic meaning."

sure that we don't miss the point: "The Fly is not a neurosis-ridden 'everyman' stumbling into a radioactive accident, thus gaining super-powers. His 'sense of responsibility' doesn't tell him to go out and fight crime as a way of serving humanity … The first issue in which I see the Fly patrolling New York looking for bad guys is the last issue I buy" (Rich Fifield, Monterey, California).

Reassuring Rich and other readers, editor Archie Goodwin underlines another of the Fly's distinctive features: "We have no plans of turning the Human Fly into a crime-fighter–simply because in *real* life, he *isn't* one!" While carrying the standard disclaimers of similarity intended to any person "living or dead," the Human Fly comics also insist that their hero has as his *counterpart* a "real-life death-defier" (in fact, "we … will see what we can do to have the *real* Human Fly appear in this mag with his two-dimensional *other self*"). Always already double, originally both "model" and "copy," the Human Fly further evolves as simulacrum (a copy of a copy of a copy) in peculiarly unstable ways.

It's not a matter of endless remakes. According to comics expert Michael Dean, the Fly does seem to have started out in the 1970s as a real person (who had prosthetic surgery after an accident and then kept on doing stunts) before becoming the Marvel hero who became a media "model" for other real climbers who may, or may not, have known the "original" Fly. A media image of one of these crawling up the Sears Building figures briefly in *A Spire* as a model for Chris Hilton ("I looked in the newspaper and I read an article about a guy who climbed a building in America"). By the time the media in 1987 could shout about SYDNEY'S HUMAN FLY, the question of the original and the copy is academic–in the popular sense. All it takes to read that headline is an everyday knowledge that "Human Fly" historically is the name of an action genre in which real people and media images are productively mixed up.

An interesting corollary of the doubled character of the Human Fly is that he is also *corporeally* "mixed." In name and in physical capacity a man-insect, a hybrid of nature, the Fly is in body a cyborg, a product of science ("Someday I'll have to thank the **docs** for boosting my **skeletal** structure with steel …"). He cannot be a figure of the dividing-line *between* "Man" and "Other," like the original, oneiric King Kong. On the contrary, his

mixity is often treated as a sign of his human frailty. As soon as the Fly mentally thanks the docs for giving him fingers to dig into cliffs ("and … I'm the one who was supposed to be **crippled** for **life!**"), he is attacked by a giant condor, a "ROBOT-DRONE." In a clash that recalls the battle scene from *King Kong No Gyakushu*, the Fly's hybrid vulnerability is challenged by the impervious purity of a mechanical bird of prey: "the frail **manchild** clinging to the ledge … is all too **human** –out of his **element**–and his metallic **attacker** is incapable of feeling any **pain!**"

Images of extra-ordinary humanoid figures doing battle with metal monsters abounded, of course, in Cold War mass culture, and if it is possible now to redeem them as projecting a "real man's" difference from a relentlessly phallic consistency, it can be argued that they now have a dated air–a vulnerability to the practices of nostalgia that perhaps makes it possible to reread them in sympathetic ways. From this point of view, the industrial robot has been replaced by the cybernetic *replicant*; the principle of difference is no longer denied to Man's Other, but made internally constitutive of otherness in such a way, and to such a degree, that Man becomes other to himself, and can no longer be sure what he is. *Blade Runner* is commonly taken to be a vanguard manifesto of this shift, which for some metonymically represents a whole new era in history.[36]

However my interest here is rather in the modes of living-on effected by older legends (a question of *change* to be addressed by any "historical" approach to culture), and so I want to consider in more detail the Human Fly's original status as hybrid model/copy. A moment ago, I called the simulacrum "a copy of a copy of a copy …," the dots signifying infinite potential for (differential) repetition. They could also signify my elision of the crucial element of *closure* in the usual definition of the simulacrum as, in Brian Massumi's words, "a copy of a copy whose relation to the model has become so attenuated *that … it stands on its own as a copy without a*

· · · · · · · · · · · ·

**36**  See Eric Alliez and Michel Feher, "Notes on the Sophisticated City," *Zone* 1/2 (1986): 40–55, and Giuliana Bruno, "Ramble City: Postmodernism and *Blade Runner,*" *October,* no. 41 (1987): 61–74. For a metonymic reading (which, curiously, changes the plot of the film), see David Harvey, *The Condition of Postmodernity* (Oxford: Basil Blackwell, 1989), pp. 309–314.

*model.*"[37] The most influential form of this proposition is Bau-
drillard's neorealist rewriting of the *"image"* as that which now
"bears no relation to any reality whatever: it is its own pure sim-
ulacrum."[38] The closure here is not simply syntactic, but logical
(the differential therefore ceases to operate) and purportedly his-
torical (the era of difference is over, sameness and stasis rule).

Brian Massumi has argued that Gilles Deleuze's essay "Plato
and the Simulacrum" offers the beginnings of another way of
thinking about mass media simulation, because it takes the inade-
quacy of the model/copy distinction as a point of departure, not a
conclusion. In Massumi's terms, "beyond a certain point, the dis-
tinction is no longer one of degree. The simulacrum is less a copy
twice removed than a phenomenon of a different nature alto-
gether; it undermines the very distinction between copy and
model" (Massumi 91).

The key phrase here is *beyond a certain point.* In his reading of the
Platonic theory of Ideas, Deleuze suggests that the "infinitely
slackened resemblance" implied by the process of copying log-
ically leads to the idea of a "copy" so removed from the original
(the Idea) that it is no longer a poor or weak "true" copy, but a *false*
copy—a simulacrum, which may externally feign resemblance but
is constructed by dissimilarity.[39] The important distinction for
Plato, therefore, is not between the model and the copy, but
between the copy and the simulacrum. The "false" copy is dan-
gerous because in its constitutive difference from any model
(including the Idea of Difference), it throws into question the val-
idity of the model/copy distinction—and thus the theory of Ideas.
The simulacrum is thus the internal enemy, or the "irony," of Pla-
tonism; its philosophical figure is the Sophist. Simulation is not, as
it is for Baudrillard, a closure of history (a crisis of hypercopying)
but, on the contrary, an *action* (like a productive practice of read-
ing; Deleuze's reading of Plato is "simulated" in this sense). This is
why for Deleuze, the Platonic project depends on a "dialectic of

. . . . . . . . . . . . .

**37** Brian Massumi, "Realer than Real: The Simulacrum According to
Deleuze and Guattari," *Copyright* 1 (1987): 90–97.

**38** Jean Baudrillard, *Simulations,* trans. Paul Foss, Paul Patton, and Philip
Beitchman (New York: Semiotext(e), 1983), p. 11.

**39** Gilles Deleuze, "Plato and the Simulacrum," trans. Rosalind Krauss,
*October,* no. 27 (1983): 48. This essay appeared in French as an appendix to
*Logique du sens* (Paris: Minuit, 1969), pp. 292–307.

*rivalry*" (46). True copies compete with false ones; the task of the philosopher is to unmask "false" copies – in order to deny the difference of the simulacrum.

Building on this, Brian Massumi suggests that it is "*masked difference,*" and not "manifest resemblance" (however hyperreal) that makes the simulacrum uncanny, and gives it productive capacity to "break out of the copy mold." Hence, for Massumi as for others, the allegorical power of *Blade Runner*. The replicant in the end is no longer a "more perfect than perfect" copy-human, but a different form of life–capable of entering into new combinations *with,* if not necessarily subsuming, human beings.

Now in these terms, the King Kong and Human Fly combat scenes I've discussed may belong not only to the "robot" imaginary, but to the Platonic scene of rivalry. In *King Kong No Gyakushu,* a true copy of King Kong fights "Mechni-Kong," the false; even if their confrontation does pit mixity against purity, the penis against the dildo, the basic question once again is simply "who is to be master?" Although the Robot Condor/Human Fly encounter is complicated by a lack of external resemblance (and by a certain "masked difference" that gives the "frail manchild" his edge), the issue of mastery is still at stake. On the other hand, it's hard to say what *counts* as the Fly's masked difference: is it the steel-bone skeleton, which makes him doubly a false copy, a cyborg disguised as a man who imitates an insect, or is it the organic intelligence that fools his mechanical cousin, a robot disguised as a bird?

I think the significant answer is that it doesn't matter very much. Interrogating the identity of any one media icon may always lead to the scene of rivalry and legitimacy, a choice between true and false, or "truer" and "falser"; at the end of the argument I've just rehearsed, we are merely deciding whether *Blade Runner*'s replicant is more true an "illustration" of Deleuze's model of simulation than the Human Fly of *Castle in the Clouds!* This is not to say, of course, that all opposition, duality, or "combat" can be reduced to *Platonic* rivalry. The aim of Massumi's contrast between two versions of simulation is, like my own, to differentiate them not in terms of their relative legitimacy as "descriptions" of the present, but in terms of their competing political logics, and the outcomes (i.e., the futures) to which they give rise.

In this context, the significant point about the history of the Human Fly is that *since* his original hybridity conforms to the logic of the double and thus to the scene of the robot (the "two-dimensional" figure and his "real-life" counterpart), it *therefore* unleashes what Deleuze calls "the *positive* power which negates both original and copy, both model and reproduction." In other words, "of the at least two divergent series interiorized in the simulacrum, neither can be assigned as original or copy" (Deleuze 53). It follows from this that the Human Fly, interiorizing from the beginning a human climber series and a media image series that pretend to copy each other, only *simulates* conformity to the logic of the double. This is why trying to assign logical priority or a greater degree of reality to either the series of *human* Human Flies or the series of *media* Human Flies at any stage of their subsequent relationship is—like closing the series by *fiat* or pursuing the long-lost original—supremely futile.

One more point needs to be made about the Deleuzian simulacrum. It is really the name of a process (not a product nor a "state" of affairs) which tends in principle toward infinity. So it implies a kind of limitlessness—"great dimensions, depths, and distances which the observer cannot dominate" (49). Deleuze calls this distance *vertigo*. But this is not the vertigo of Faust, overwhelmed, at the top of a tower, by the endless expanse of territory offered up to boundless ambition. It is the vertigo of Plato, discovering "in the flash of an instant as he leans over its abyss" that the simulacrum, the "other" that his philosophy strategically creates, can destroy his philosophy's foundations. It is the vertigo of a *critical* distance, in which "the privileged point of view has no more existence than does the object held in common by all points of view. There is no possible hierarchy ..."(53). Because the figure of the observer (Plato leaning over the abyss) is *part* of the simulacrum, the hierarchy abolished in vertigo is not only that which regulates the divisions between the Origin and the first-, second-, third-order copies, determining authenticity. It is also the secular projection of that process in hierarchical myths of space (the top of the tower) and time (metanarrative).

Back in the homelier world of superheroes, it is worth noting that while the Human Fly is no stranger to the ordinary vertigo of cliff tops and ocean depths, he has an unusual allegiance to what

we might call collective practice. Many heroes have sidekicks and a strong community spirit, but the Fly's "frail manchild" vulnerability demands a lot of interdependence. He isn't invincible, he gets afraid, he needs help. There is a certain elitism of the body involved in his mythology, but no authoritarian structure of command. During stunts, he is surrounded and protected by friends (in planes, on the ground, back at the base) with whom he consults by two-way radio. The Fly is a media creature: he uses radio to orchestrate his stunts, then he constructs his stunts as *messages* ("giving **hope**–through **example**–to thousands of **crippled** and **disabled** kids!"). He is a radical, not a rugged, individualist; he expounds the strength of the weak. Far from being a crime fighter, he is a political performance artist.

*A Spire* in both its components, climbing and filmmaking, works with this mythology. It isn't a matter of conscious or unconscious "influence," of quotation, allusion, or copying, but of *resonance* between the divergent series constructing the simulacrum, and of the external effects of *resemblance* that simulation can produce. For that reason, I don't think it is important to dwell on the many points of "resemblance": the Fly's relationship to the friends and the film crew who made the adventure possible; the importance of the two-way radio, used sensitively in the film to narrate without rancor or rivalry the most awkward moment of the climb, when Mark Spain decides to go down; the didactic packaging of a "stunt" as a socially responsible action; the formal use of "personal statement" to further a politics for ordinary people ("I'm so **small** compared to this **monster,** this **monolith** to our civilization," says Chris Hilton of Sydney Tower). These points can be made, not because anyone set out to imitate a forgotten Marvel comic, and not because Hilton casually chose a "flamered climbing suit," but because the myth of the Human Fly (as the Sydney media understood) involves a collective production of knowledge.

For me, the important question is what can follow from this. As a visual element in *A Spire,* the Human Fly effect–emphasized by the use of a telescopic lens and the editing of long shots and close-ups–has far from casual consequences. Sydney Tower first appears in the film as the usual postcard "phallus" rearing above the city. Then as the climb proceeds, slowly but surely the Tower

becomes a *face*. After figuring as a distant urban peak, the turret turns into a *surface*, its flat windows and thinly grooved walls becoming an extension of the cliff-face surfaces that were used to prepare for the climb. Precisely because the film's argument is to refuse the cultural construction of difference between natural and built environments, and to defy the prohibition on treating big buildings as fully public space, to speak of the tower becoming a "face" is not just a handy pun, but a response to an actual *literalism* produced by Chris Hilton's persona on screen.[40] Dressed as the Human Fly, he visibly becomes not a Marvelous superhero who can rival the phallic spire, but (especially in long shot) something quite familiar and "natural" to Australians—an insect crawling on its face (figure 1).

This is one way in which *A Spire* does in the vernacular sense "bring down" Sydney Tower, and mock its forbidding pretensions. It makes the Tower *tangible* to people (and it is important that in the interview I quoted above, Chris Hilton speaks of reducing the Tower to "a human *scale*," not of "cutting it down to size"). But is that all? By itself, this action need be nothing more than a stylish, daring, but ultimately pointless reassertion of the old egalitarian ethos—and its "boys' own" concern with appearances. If that were the case, to make too much out of the pun on *face*—to read *A Spire* as simply exposing a social production of faciality by inscribing a sign of the "little man" on a great white Majority wall —would be to return the film to the very dialectic of rivalry that I think it succeeds in escaping. In fact, a whole series of changes follows from this "slight dodge in the real image" (Xavier Audouard's phrase for a perceptual shift that pulls in the observer to construct the simulacrum)[41] which has the man becoming an insect while the Tower becomes a face.

As Massumi points out, the concept of "double becoming" in *A Thousand Plateaus* provides a way of theorizing a positive force of simulation without reference to models and copies. The term "becoming," often taken by hasty critics to mean the silly idea that you can do whatever you want, designates a concept with a

. . . . . . . . . . . . .

40  On literalism, see Paul Willemen, "Cinematic Discourse–The Problem of Inner Speech," *Screen* 22, no. 3 (1981): 63–93.
41  Cited by Deleuze, "Plato and the Simulacrum," p. 49.

quite precise structure, and a process with specific limitations. First, becoming must always involve at least *two* terms, not one in isolation, swept up in a process that transforms them both; if a man is becoming-insect, the insect is also changing. Second, double becoming involves an "aparallel evolution," not a specular or dualistic structure, connecting heterogeneous terms[42]; when a man is becoming-insect, the insect is not becoming "man," but something else (to take up one of the unfortunate examples favored by Deleuze and Guattari, while the warrior is becoming-woman, the woman may be becoming-animal).

Third, a man does not become a "real" insect, but becoming is not a fiction that he does; becoming is "real," but what is *real* is the becoming–the process, or the *medium,* in-between terms. Fourth, this medium of becoming is always minoritarian: "in a way, the subject in a becoming is always Man, but only when he enters a becoming-minoritarian that rends him from his major identity" (291). This is the most important sense in which becoming is *double,* since there are "two simultaneous movements, one by which a term (the subject) is withdrawn from the majority, and another by which a term (the medium or agent) rises up from the minority."[43] Becoming, then, is by definition an undoing of Man, and an unmaking of the Face which is "the form under which man constitutes the majority, or rather the standard on which the majority is based" (292).

Now, I suggested that in *A Spire,* two distinct becomings are produced by the "slight dodge in the real image" of Chris Hilton climbing the turret. In a first phase, a man is becoming-fly as the tower is becoming-face. However in Deleuze and Guattari's terms, a becoming-Man, and thus a becoming-Face, is impossible. Moreover, the homely Australian face on which a fly crawls

. . . . . . . . . . . .

42 Deleuze and Guattari, *A Thousand Plateaus,* p. 10. On becoming, see chapter 10 ("Becoming-Intense, Becoming-Animal, Becoming-Imperceptible ..."), pp. 232–309.

43 For Deleuze and Guattari, "minoritarian," as becoming or process, is strictly to be distinguished from "minority" as an aggregate or state (*A Thousand Plateaus,* p. 291). Terms like "ethnic minority" are treated with considerable scorn in their work, where the term "minor" has primarily a musical connotation. See their *Kafka: Toward a Minor Literature,* trans. Dana Polan (Minneapolis: University of Minnesota Press, 1986).

(and from which Hilton euphorically calls "I feel totally fucking comfortable! I can't believe it! I feel comfortable!") is no longer the awesome panoptic Face that dominates the corporate landscape. Something happens in-between, and I think that it takes a complex form of double becoming: in a second phase, a man is becoming-fly as the fly is becoming-woman, with the Face becoming face as *medium*. One of the satisfying things about this possibility is that it is usually "woman" who provides the fertile ground or medium in which another's becoming can be defined. In Massumi's otherwise wonderful analysis of David Cronenberg's remake of *The Fly*, for example, the woman left pregnant after Brundle-Fly's fabulous trajectory passively represents "the powers that be" who "squelch" his hopes for creating a new form of life (94–95). There is no speculation as to whether her reluctance to play madonna to a race of "overmen as superflies" might involve a becoming of her own.

Why speak of a becoming-woman of the Fly in *A Spire* in the first place? The concept of "becoming-woman" certainly does not interest me, here or anywhere else, in the guise of a general Good Thing. However I do think that beyond the "image" of the Fly on the face of Sydney Tower (and sweeping it up in a becoming), there is a narrative *process* of simulation in *A Spire* by which, as Chris Hilton is becoming the Human Fly, *the Human Fly becomes "Fay Gray"*–that is to say, a figure of "home," but also displacement, of residency, but also of being evicted, of settlement, but also of fugitive status ... the bearer, in other words, of an amalgamated Otherness created by corporate strategy, and supposed to be excluded from its place.

I think this happens toward the end of the climb, as the moment of arrival is approaching. Once the Fly starts crawling up the turret, it looks more and more likely that he'll make it ("This is **very exposed** ... I feel strangely **calm,** though–it's not much **higher** than a **tree**"). At the same time, the sound track shifts our attention to the impropriety of his being there and to the question of his descent: "I wonder if there'll be any people in the observation deck when I get there?" There are people; we see them see him; he whoops "they're all looking bloody amazed!" and keeps on crawling toward one of the most amazing climaxes to an adventure I have seen. As one stunned onlooker put it to me after watching the video, "boy climbs tower–and falls in."

Chris heaves himself over the ledge, half-somersaults, kicking wildly in the air–and then can't shake his boots from their straps. In the place of a generically appropriate shot of the conquerer standing upright proudly to possess the view, there is a comically repeated little sequence of two disembodied red legs flailing diagonally against the sky, struggling furiously with floating green ribbons. The legs finally disappear over *into* the top of the Tower, two hands appear on the ledge, and then a head–which gazes not out at the landscape, but directly down the ropes still brushing against the turret's face. The camera goes down the rope ("Well I'm at the top and there's no-one here to meet me, over …"), back up the rope, and then for a brief freeze-frame the head at the top of the Tower looks straight down the rope as it drops ("They should be arriving soon, I'd say").

This is not a Faustian moment. There is no overview from the Tower: instead, a wonderful aerial sequence, circling the Tower on a horizontal plane with the turret, celebrates his achievement (and discreetly shows those unfamiliar with Sydney what its magnitude has been). No one comes to take him away, throw him out of the Tower or punish his appropriation of the heights: "Well, I've been here fifteen minutes now and no one's come to get me and yet a security guard saw me in there, so I'm just going to go down the stairs now, I've found a way in, so I'll see what happens …" What happens is completely banal: he walks out of the building, his ropes in his bag, and saunters away up the street. An interview ends the story: "So I just walked sort of nonchalantly off, I was feeling quite calm, I wasn't feeling agitated, so I just strolled as if I owned the place and caught a taxi in Pitt Street."

I want to make three points in conclusion.

"*I just strolled as if I owned the place*": it would be easy now to read the Human Fly's cool, controlled descent allegorically as Fay Gray's getaway–a riposte to the proprietorial violence structuring the imaginary of King Kong's *Final Decision*. By appropriating the symbolic high-point of corporate power in the city, the Fly becoming-Fay could assert, with an act of temporary occupation ("*as if* I owned the place"), that residents' action, and a residents' politics, can sometimes succeed "against all the odds."

Yet that would be one of the edifying little tales of resistance with which criticism perhaps too often rests content. More point-

edly, I think, *A Spire* asserts its residents' politics by redefining the "voyage/home" opposition that determines so much about sexuality and space under capitalism (and of which the story of King Kong remains, in all its variants, a classic and haunting expression). In the space of a boys' own adventure, "home" is the feminized place of stasis that functions as beginning and end. The voyage, a masculinized phase of change and development, is the action in between. On the other hand, Deleuze and Guattari's concept of becoming turns this model inside out. Since "the in-between" of becoming is always a minoritarian process, and since a becoming moves toward another minor term that is also involved in becoming, *Man* is the name of the term that is simply left behind.

PM Advertising's yuppie King Kong follows the boys' own logic when he refuses to make a "home" with Fay and foreclose his financial adventures. Throwing her off the tower is just his way of saying he isn't ready to settle down. If *A Spire* had followed this logic, the space and time of the "voyage" to the top of the turret should clearly be distinguished from the worlds of "home" and street. That doesn't happen, but neither are we launched into a process of perpetual transformation. What happens in *A Spire* is more like a polemical expansion of the public space of the street to include the top of the Tower, and an extension of the temporality of "home" to incorporate the voyage. Chris Hilton follows a "smooth" trajectory—into a bus, up the Tower, down the stairs, into a taxi—that, far from defining a *break* from the setting of everyday life, extends the hours of labor inventing and testing homemade tools, talking with friends, practicing in the backyards, the cliffs, and the car-parks available round the city. The logical consequence is that since the concept of "home" now subsumes "adventure" (dynamism, change, thus time as well as space), it is no longer interiority and enclosure alone, but also exteriority and surface.

"Home" in this sense does not mean a state of "domesticity," nor does it signify "ownership." It is a version of the active principle that de Certeau calls "practicing place." My second point follows from this. It is possible that my analysis is overly fanciful, a *paranoid* reading, and that nothing as serious as a rethinking of ideologies of "home" and "voyage" can really be at stake in a short

video about an eccentric and inconsequential episode in the his-
tory of the inner city—the story of what one interviewee in *A Spire*
calls "just another mad person in Sydney."

Yet the very elements that I've just mentioned were sufficiently
"serious" for the ABC-TV *broadcast* version of *A Spire* to eliminate
them. There are several differences between the independent
video I've been discussing, and the broadcast version. Primarily,
the series framework *I Can't Stop Now* pulled the story closer to
the "passional monomaniac" aspect of the adventure; there was
more emphasis on the "black hole" of personal obsession, and less
on the "white wall" of inscribing social criticism. The film was
shortened by fifteen minutes, chunks of the "digressive" discus-
sion footage removed, and more biographical information pro-
vided. This is to be expected with professionalization, and not
remarkable in itself.

What is interesting, however, is a small step taken in the TV
version that is not really required by the codes of "broadcast qual-
ity." In the "original" video, there are no significant images of
anyone "left at home" while Hilton climbs the tower. There is a
quick goodbye at the bus stop, we hear the voices on the two-way
radio, but there are so many participant others intercut with the
scenes of the Fly on the tower, and they are so dispersed in space
and time, that there is no place constructed to be occupied by a
singular Other to the Man on the Voyage. The TV version restores
that place. Partly because it cuts out several talking heads in order
to condense the action, extra emphasis is thrown on two new
scenes included for broadcast, involving a quite new figure. A
young woman—whom the logic of *narrative* then invites us to see as
wife/girlfriend/sister—is represented remembering her feelings
about the idea of the climb, then sending messages and advice
from the climber's home base. Maria Maley on screen is a woman
of great dignity and sang-froid who completely fails to create an
impression of "feminine" anxiety. But with this one *formal* ges-
ture, the man/voyage, woman/home structure of the boy's own
adventure is reimposed on the film, and the spatial hierarchy
dividing the top of the Tower from "everyday" space is rees-
tablished. However I don't think that this spoils the film or distorts
or co-opts its "message." As a half-hour TV program about the
built environment, the broadcast version of *A Spire* still works

extremely well. What interests me about the changes is rather what they suggest about the cultural context in which *A Spire* appeared, and thus its critical impact within it.

In spite of its long association in theoretical discourse with a problem of (white) Femininity, it was class that represented the unrepresentable for Judith Mayne in her analysis of 1933, American Depression, *King Kong*. Class was also, if not unrepresentable, then certainly *unmentionable* in the "popular" culture of Australian egalitarianism–the proprieties of which were so shamelessly flouted in the 1980s by the brutal truths of postmodern corporate culture. Yet, in one gesture of routine editing to brighten *A Spire* for broadcast, there is a very clear definition of something still "unrepresentable," or out of bounds, in Australian public media in 1989. It is neither class, nor the feminine sex, nor any classic figure of the Other, but, quite simply, the possibility of a *non*climactic and "homely" boys' adventure. What the broadcast version restores to *A Spire* is more than an anchoring image of woman, and a conventional distinction between home and the voyage. It restores what depends on these–a sense of the place of a "proper" masculinity. The fabulous Human Fly becoming Fay Gray is more simply and more normally Chris Hilton, a man "in a flame-red climbing suit."

Yet my last point is not so pessimistic. If the TV version of *A Spire* restored to it some proprieties, this is an indication of the extent to which both films, indeed the whole "adventure," were successful as a critique of the assumptions about masculinity, spectacle, and city space asserted by John Bond in the quotation from which I began. ABC-TV's revision of the Human Fly's fabulous becoming as Chris Hilton's "personal obsession" was made possible, perhaps necessary, by the degree to which *A Spire* proclaims the Tower "an ego thing"–in the sense that John Bond disavowed.

Chris Hilton made a spectacle of himself, and then helped make a film about it. He produced a social analysis with an act of exhibitionism and then exhibited his analysis in public. In practicing this mode of (very athletic) effeteness, he brought down the Tower not by renouncing the heights, but by reaching them instead. In this way, he invented a form of vernacular criticism which does *not* miss the point about the kind of wealth and power

invested in urban towers—but rather, makes a spectacle about that very point.

. . . . . . . . . . . .

My thanks to Michael Dean, Chris Hilton, Gil Rodman, Michael and Rachel Taussig, and Paul Willemen for research materials that made it possible to write this essay.

1 Ingrid Bergman as Alicia Hoberman in Alfred Hitchcock's *Notorious*, 1946. The woman's look: the look of curiosity.

# Pandora:
# Topographies of the Mask and Curiosity

# Laura Mulvey

*Outside and inside form a dialectics of division, the obvious geometry of
which blinds us as soon as we bring it into play in the metaphorical
domains. It has the sharpness of the dialectics of yes and no, which decides
everything. Unless one is careful, it is made into the basis of all thoughts of
the positive and negative.*

*Chests, especially small caskets, over which we have more complete
mastery, are objects that may be opened. When a casket is closed, it is
returned to the general community of objects; it takes its place in exterior
space. But it opens! For this reason a philosopher mathematician would say
it is the first differential of discovery. From the moment the casket is opened
the dialectics of inside and outside no longer exist. The outside is effaced
with one stroke, an atmosphere of novelty and surprise reigns. And, quite
paradoxically, even cubic dimensions have no more meaning, for the reason
that a new dimension has just opened up.*

Gaston Bachelard[1]

. . . . . . . . . . . . .

1   Gaston Bachelard, *The Poetics of Space* (New York: Orion, 1964).

WHEN I STARTED to work on my paper for this conference, I was looking forward to developing some new ideas about representations of femininity and cinematic space. Gradually I became conscious of a dawning sense of *déjà vu*. While thinking I was mapping out new ground, I found myself back with themes that had frequently figured in my work before: for instance Greek myth, Hitchcock, psychoanalytic theory as an instrument of feminist criticism, the look in cinema. And then I remembered how important the spaces of narrative and *mise-en-scène* had been in my own filmmaking, that some of the ideas that I was presenting to myself as new had already figured explicitly and implicitly in *Riddles of the Sphinx* (Peter Wollen and Laura Mulvey, 1978), and finally, that Gaston Bachelard's *Poetics of Space* has been a sporadic but recurring influence on my theoretical writing and on my films. So the "mapping out of new ground" metaphor had to be abandoned in favor of a "new turn of the kaleidoscope" metaphor, transforming, I hoped, familiar themes into a different configuration. And the new metaphor also promised to transform the project's image from that of following a path to one of figuring out a pattern.

The desire to shift the focus of my thinking about space and gender in cinema away from the relation between narrative and *mise-en-scène* into another, phantasmatic dimension, and then back again, lies behind the main body of this paper. To begin with, I would like to sketch in some critical background and distinguish between narrative space, the space of the *mise-en-scène,* and the space of the frame on the screen. My thinking about cinematic space and representations of gender has been particularly influenced by Thomas Elsaesser's essay "Tales of Sound and Fury,"[2] in which he showed how the specific motifs associated with a genre carry aesthetic imperatives and ideological constraints that both determine and are realized within narrative space and *mise-en-scène*. Elsaesser demonstrated that, within the aesthetics of melodrama, the formal elements that characterize the genre were closely effected by the constraints of both narrative space and place. The melodrama takes place in the literal and psychological space of home and family, turning the narrative space inward, lift-

. . . . . . . . . . . . .

2    Thomas Elsaesser, "Tales of Sound and Fury," in *Movies and Methods,* vol. 2, ed. Bill Nichols (New York: Columbia University Press, 1985), p. 177.

ing the roof off the American home, like the lid off a casket, opening its domestic space into a complex terrain of social and sexual significance, the opposition, for instance, between upstairs/ private and downstairs/public space, the connotations of stairs, bedroom, kitchen. And this "interior" also contains within it "interiority," the psychic spaces of desire and anxiety, and the private scenarios of feelings, a female sphere of emotion within the female sphere of domesticity. Elsaesser argues that the characters' difficulty in articulating or externalizing their emotions overflows into the expressive nature of the *mise-en-scène*. Thus in the melodrama, the home is the container of narrative events and the motifs that characterize the space and place of the genre. But its emotional reverberations and its gender specificity are derived from and defined in opposition to a concept of masculine space: an outside, the sphere of adventure, movement, and cathartic action in opposition to emotion, immobility, enclosed space, and confinement. The depiction of generic space is, in this sense, overdetermined by the connotations implicit in the masculine/feminine binary opposition.

There are two points I would like to make, in passing, about the gendering of narrative space in the western. The western, perhaps more than any other genre of Hollywood popular cinema, retains residues of the narrative structure of the folk tale in which the space of the plot, its pattern, sequence, and type of events, match the spatial organization of the narrative's formal structure. The influence of narratology, particularly the revival of interest in and application of Propp's *Morphology of the Folktale* to some areas of cinema, has illuminated the gendering of both the narrative structure of the western genre and its typical narrative landscape. According to Gerald Prince in *A Grammar of Narrative,* a minimal story must follow a certain established pattern. It begins with a point of stasis. A home characteristically marks the formal space of departure for the narrative, the stasis which must be broken or disrupted for the story to acquire momentum and which also marks the sexual identity of the hero, both male and Oedipal, as he leaves the confines of the domestic, settled sphere of his childhood for the space of adventure and self-discovery as an adult male. The horizontal, linear development of the story events echo the linearity of narrative structure. The two reach a satisfying

point of formal unity in the literal linearity of the pattern drawn by the hero's journey, as he follows a road or path of adventure, until he comes to root in a new home, a closing point of the narrative, a new point of stasis, marked by the return of the feminine and domestic space through (as Propp has demonstrated) the function marriage.

Both the melodrama and the western assume an aesthetic and ideological imbrication between the place of the home and the space or sphere of the feminine and their attendant antinomies. My second point, in this digression, is concerned with the ideological and aesthetic representation of these gendered spaces within the portrayal of colonial wars against indigenous peoples, in which the colonialism of the United States is represented more as a movement of settlement than conquest. Narrative momentum is generated not so much by the simple departure of the hero alone, but by a need to transform the terrain of adventure and discovery into a land in which settlement, and consequently the sphere of the feminine, can be established. A home or homestead as signifier of stable space, the sphere of the family and the feminine acquires another dimension of meaning in binary opposition to the nomadism of the indigenous people. And so the aesthetic conventions of narrative space, their realization through the ideologies of gendered place, are enlisted in the playing and replaying of the settlement mythologies that haunt the western genre, without closing off the hero's chance to reject the feminine and the stability of the home and family, remaining asocial and asexual in the perpetual limbo of liminality.

The visual language of the cinema, although confined within the rectangular space of the screen frame, strains toward sequentiality in its depiction of narrative. It flourishes on juxtapositions and metonymies, on the reflection of drama in *mise-en-scène* carried forward in editing or camera movement and gradually unfolding the proximities of people and things into a connotative chain of associated meanings. The cinema's articulation of its own space carries with it a momentum that is subsumed into the linear pattern of narrative and overflows onto the narrative's dramatic figurations. And these linear patterns of narrative space, transmuted into characters in the drama on the screen, are inevitably themselves informed by the ideologies and aesthetics of gendered place.

I want to give an illustration of these points with an extract, the opening sequence of Alfred Hitchcock's film *Notorious,* made for David O. Selznick in 1946. And I also want to use the extract to move away from a consideration of the gendered space of narrative and *mise-en-scène* into a discussion of phantasmagoric space that may be conjured up out of an image of woman as mystery. In this case, I will argue, the inside/outside polarization is not derived from the connotations implicit in the male/female binary opposition but from something else: a disturbance, iconographically represented in images of the female body, symptomatic of the anxieties and desires that are projected onto the feminine within the patriarchal psyche. Feminist film theory has argued that in patriarchal culture the image of femininity is a multipurpose signifier (bearing out Lacan's vision of the signifier's inherent slipperiness). I want to consider the image of the female body as a sign and try to analyze it in terms of space. That is, as a topography, as a phantasmagoric projection which attempts to conceal, but in fact reproduces, the relation of the signifier "the female body" to psychic structures. At the same time, I want to consider the influence that Freudian psychoanalytic theory has had on feminist theory, while attempting to make use of both for the purposes of my argument.

The opening sequence of *Notorious* is constructed around a chain of signifiers that connote active looking and active looking as the prerogative of masculinity. The very first shot of the film, after the opening title, is an extreme close-up of a camera with flash; the camera pans up to reveal a line of newspaper reporters, all male, as it were, lying in wait for the story. The camera continues upwards to show that the scene is taking place outside a courthouse, under the aegis, that is, of the law. The next shot concentrates the theme of the look onto the figure of a man peeping through the crack of a nearly closed door. According to the logic of curiosity and cinematic convention, the spectator's desire to see inside the closed space is inevitably aroused. And according to the logic of the masculine/feminine distribution of the voyeuristic drive, our expectation is that the man is peeping at a scene in which a woman is the spectacle. However the next shot disappoints the codes and conventions of cinematic visual pleasure. We see a courtroom, from a distant fourth-wall-type camera position,

bereft of the camera movement that has led the development of the sequence so far. Curiosity is frustrated and expectation of pleasure denied. The shot lengthily establishes that a foreign spy has just been condemned by the court. A cut brings back the lookout still peeping through the crack of the door. At last, he turns to announce "Here she comes," also setting up, by the repetition, the sequence's symmetry. The camera movement then repeats in reverse, in a rhyming movement, its trajectory in the opening shot. But this time the instruments of voyeuristic investigation on the screen, the reporters and their cameras, and the curiosity of the spectators in the auditorium have all found an appropriate object for their gaze. Ingrid Bergman, playing the spy's daughter, is filmed with the privileged codes and conventions that Hollywood cinema has reserved, regardless of stylistic changes, for the female star. However, as the reporters subject her to an aggressive barrage of questions, other visual and narrative connotations emerge. She is foreign, the daughter of the condemned spy, tainted with culpability and illicit secrets. Her silence, ignoring the flashes of the cameras and the pointed questions, adds mystery to her beauty. The shot ends as the camera tracks forward into close-up on a man who looks after her as she exits the screen space; his look rhymes with the close-up of the camera in the opening image of the sequence. As he then dispatches another man to keep her under surveillance ("Let us know if she tries to leave town"), he also seems to pass on or transfer the earlier signifiers of the investigative look into the film's narrative, directed now at the figure of a woman depicted as enigmatic in her femininity and threatening to the law.

Enigmas and secrets generate the image of closed hidden spaces which generate in turn the divided topography of inside and outside. If a certain image of femininity is associated with mystery, its attendant connotations of a phantasmagoric division between an inside and an outside effects the iconography of the female body. Although my point of departure in this paper has been the depiction of gendered space in the cinema and thus in the twentieth century, this phantasmagoric topography has haunted representations of femininity across the ages, not consistently manifest, but persisting as an intermittent strand of patriarchal mythology and misogyny. It is an image of female beauty as arti-

fact or mask, as an exterior, alluring, and seductive surface that conceals an interior space containing deception and danger. In Hollywood cinema this image is most clearly associated with the film noir genre: Rita Hayworth as *Gilda* or *The Lady From Shanghai,* for instance. It has been further argued that the cinema has, through specific properties, enhanced the image of feminine seductiveness as a surface that conceals. That is to say, the codes and conventions of Hollywood cinema refined the representation of femininity, heightened by the star system, to the point where the spectator's entrancement with the effects of the cinema itself became almost indistinguishable from the draw exerted by an eroticized image of woman. It is as though the scopophilic draw of the cinema, the flickering shadows, the contrasts between light and dark became concentrated in and around the female form. Framing, makeup, and lighting stylized the female star, inflecting the tendency of representations of female sexuality to slip into "to-be-looked-at-ness," into the ultimate screen spectacle. The luminous surface of the screen reinforces the sense of surface radiated by the mask of femininity, flattening the image, so that its usual transparency, its simulation of a window on the world, becomes opaque.

I want to use the story of Pandora to illustrate how the topolography of seductive surface and concealed threat make up the iconography of the femme fatale. Pandora was the first woman of Greek mythology, sent by the gods to seduce and destroy Prometheus in revenge for his theft of fire from heaven. She was an artifact, a living trick, and all the gods contributed to creating her extraordinary beauty. In her book *Monuments and Maidens,* Marina Warner describes Pandora in the following manner: "a most subtle, complex, and revealing symbol of the feminine, of its contradictory compulsion, peril, and loveliness"; "artifact and artifice herself, Pandora installs the woman as the eidelon in the frame of human culture, equipped by her unnatural nature to delight and to deceive"; "These myths have assisted the projection of immaterial concepts onto the female form, in both rhetoric and iconography."[3]

. . . . . . . . . . . . .

3   Marina Warner, *Monuments and Maidens* (London: Weidenfeld and Nicholson, 1985), pp. 214-215.

The story of Pandora's creation, and the story of the purpose behind her creation, also install her as a mythic origin of the surface/secret polarity that gives a spatial or topographical dimension to this phantasmagoric representation of female seductiveness and deceit. There is, first of all, a dislocation between Pandora's appearance and her meaning. She is a Trojan horse, a lure and a trap, a *trompe l'oeil*. Her appearance dissembles her essence. The very attraction of the visible surface suggests an antinomy, a "dialectics of inside and outside," a topography that reflects the attraction/anxiety ambivalence exerted by the iconography of femininity as mask. This split is crucial. To my mind, the recurring division between inside and outside is central not only to understanding representions of femininity in socially constructed fantasy, but also illustrates the uses of psychoanalytic theory for feminism. It is because of the kind of problem posed by the Pandora phenomenon that feminist aesthetics has turned to semiotics and psychoanalysis, to transform the work of criticism into a work of decipherment. The signifiers of the anxieties installed in the patriarchal psyche in its rendering of the symbolization of sexual difference have to be decoded, not through the image of tearing away a veil, but in figuring out the displacements at stake in a particular mythology. Psychoanalytic and semiotic theory influenced feminist theory to work with the decoding of signifiers, enabling a shift away from utopian longings for a long lost femininity to be unveiled and recuperated in a virgin state. These influences brought feminists to approach the analysis of images of women as one might a rebus, a puzzle that contains its clues within its text and its formal structure, subject to the distortions that characterize the language of the unconscious, condensation and displacement. In these terms, the topography associated with Pandora is an important clue for deciphering the fantasy. And understanding the significance of the "dialectics of inside and outside" is a possible point of departure.

Pandora inaugurates a long line of female androids–such as Olympia, the False Maria in *Metropolis,* Hadaly in *The Eve of the Future*–who all personify the fantasy of female beauty as artifice. This artifice is mimicked, for instance, by a film star's elaborate and formulaic makeup, the mask masquerading as femininity and masking the anxiety that femininity can provoke. The space

behind the mask exerts the draw of all secret and forbidden spaces, irresistibly asking to be unveiled and revealed but also warning "Danger–Keep Out." I am suggesting that while we try to peer "inside" the phantasmatic space of the mystery, we will be struck with the fascination and frustration of the look in its literalness, seeing but unable to understand. The problem, then, is how to transform Pandora so that her spatial structure can be approached as a rebus, how to transform her being as image into being as symptom. This symptom, concocted out of the unconscious by the processes of condensation and displacement, shares with the unconscious mind a tendency to conceal its workings in the guise of spatial imaginary, with a strongly delineated pattern.

In classical mythology, Pandora had with her an iconographical attribute, a large jar, which contained all the evils of the world. In their book *Pandora's Box,* Dora and Irwin Panofksy have shown how, during the Renaissance, the jar shrank into another version of the attribute, a small box that Pandora generally carried in her hand.[4] The jar and the box are metonymically linked: both are containers; both, in this story, carried a forbidden secret locked away; and both are subject to "the dialectics of inside and outside." These motifs also suggest a metaphoric representation of myths associated with the female body, and extend the image of concealment, the container, and secrecy. The motif of secrecy that is associated with the female body is discussed by Ludmilla Jordanova in the following terms: "Veiling implies secrecy. Women's bodies, and, by extension, female attributes, cannot be treated as fully public, something dangerous might happen, secrets be let out, if they were open to view. Yet in presenting something as inaccessible and dangerous, an invitation to know and to possess is extended. The secrecy associated with female bodies is sexual and linked to the multiple associations between women and privacy."[5] And Jordanova continues later with this theme, saying "in the Pandora story secrecy is reified as a box."[6] The metonymy that links the space of a box to the female body with connotations of secrecy

. . . . . . . . . . . . .
**4**   Dora Panofsky and Irwin Panofsky, *Pandora's Box* (New York: Pantheon Books, 1956), p. 17.
**5**   Ludmilla Jordanova, *Sexual Visions* (London: Harrester Wheatsheaf, 1989), p. 92.
**6**   Ibid., p. 93.

and sexuality suggested by Jordanova, reminded me of the follow-
ing exchange between Freud and Dora. They are analyzing Dora's
"first dream":

> "Does nothing occur to you in connection with the jewel-case? So
> far you have only talked about jewelry and said nothing about the
> case."
> "Yes, Herr K. had made me a present of an expensive jewel-case a
> little time before."
> "Then a return present would have been very appropriate. Perhaps
> you do not know that 'jewel-case' [*Schmuckkastchen*] is a favorite
> expression for the same thing that you alluded to not so long ago by
> means of the reticle you were wearing—for the female genitals, I
> mean."
> "I knew you would say that."[7]

In her discussion of this dream,[8] Jane Gallop picks up the
theme, as other feminist critics have, too, of Freud's interest in
unveiling Dora's secrets through dream analysis, in which he uses
both theory and the "vulgar" associations of certain words to
reveal their latent sexual significance. The metaphor referred to by
Freud is, as it were, confirmed by its general use. However, the
motif of the female body as container may also refer to womb, the
enclosing space inside the mother's body that provides an instant
source of connotation and a "poetics of space" quite common in
culture. Here, I think, the sphere of metonymy returns. The
womb is not subject to the same taboos as the female genitalia,
unmentionable except in vulgar speech, and where a whole range
of metaphoric terms exist as substitutes, either erotic or deroga-
tory. In Freud's example, the jewel case, although strictly speaking
a metaphor, carries with it connotations of space and the "dialec-
tics of inside and outside," so that it, too, seems to be tinged with
metonymy.

Iconographically, the figure of a woman can be identified as
Pandora by the presence of her box and a box can gain mystery and

. . . . . . . . . . . . .

7  Sigmund Freud, "Fragment of an Analysis of a Case of Hysteria," in
*The Standard Edition of the Complete Psychological Works of Sigmund Freud,* vol.
4 (London: Hogarth Press, 1953), pp. 69, 76-77.
8  Jane Gallop, "Keys to Dora," in *In Dora's Case,* ed. Charles Bernheimer
and Claire Kahane (London: Virago Press, 1985), pp. 200–220.

allure by association with Pandora. (The matches lying on my desk, for instance, have the brand name Pandora's Box.) Iconographical associations are usually formed by juxtaposing characters with the most significant object associated with her figure or her story. We can only identify Hercules by his club or Saint Catherine by her wheel through awareness of cultural convention and familiarity with the relevant details of the story. This is also true, on one level, of Pandora and her box. However, I would suggest that her attribute has an added significance, taking it beyond the realm of iconography and into the wider terrain of symbolism. In addition to representing her story, the box has a spatial structure that relates back to the topography of Pandora herself: her exterior mask of beauty concealing an interior of combined mystery and danger. The mask and the box: each conceal a secret that is dangerous to man. The Panofskys record two examples of Pandora iconography in which the sexual significance of the box is made explicit. One, an engraving by Abraham van Diepenbeek dating from the mid-seventeenth century, shows Pandora "holding the fateful pyxis as a fig-leaf" and the accompanying contemporary text by Michel de Marolles points out that Pandora is "holding her box in her right hand, lowered to that part, which she covers, from which has flowed so many of the miseries and anxieties that afflict man, as though the artist wished to show that there is always something bitter in the midst of a fountain of pleasure and that the thorn pricks among the flowers." The second example is a drawing by Paul Klee, dating from 1936, *Die Busche der Pandora als Stilleben,* "representing the ominous receptacle . . . as a kantharis-shaped vase containing some flowers but emitting evil vapors from an opening clearly suggestive of the female genitals."[9] The reverberations of connotation between Pandora and her box depend on contiguity: both the juxtaposition of the figure to the box and the topography of the female body as an enclosing space link metonymically to other enclosing spaces. But the reverberations also depend on substitution. The box can, itself, stand as a representation of the enigma and threat generated by the concept of female sexuality in patriarchal culture.

Pandora is now better known for her curiosity than for her ori-

. . . . . . . . . . . . .

9   Panofsky, *Pandora's Box,* pp. 77n and 113.

gins as artifact and lure. Although she was forbidden to open the box and warned of the danger it contained, she gave way to her curiosity and released all the evils into the world. Only hope remained. In Nathaniel Hawthorne's version of the myth, told for children in *Tanglewood Tales,* Pandora's story is a warning of the dangers of curiosity. And this theme also links her story to Eve, the first woman of Christian mythology, who persuaded Adam to eat the apple of knowledge. The Panofskys point out that this parallel was noted by late medieval mythographers wanting to use classical precedent to corroborate the Christian story of the fall of man. Although Eve's story highlights the knowledge theme—the "epistemophilia," as it were, inherent in the drive of curiosity—the myth associates female curiosity with forbidden fruit rather than with forbidden space. The motif of space and curiosity can be found again symptomatically in the fairy tale "Bluebeard." The story is about his last wife, a young girl who is given the free run of his vast palace with the exception of one room, which her husband forbids her to enter. Its little key begins to excite her curiosity until she ignores the luxury all around her and thinks of nothing else. Then one day, when she thinks her husband is away, she opens the door and finds the bodies of all his former wives still bleeding magically from terrible wounds and tortures. Her husband sees the blood stain that cannot be removed from the key and tells her that the punishment for breaking his prohibition, for curiosity, is death alongside his former wives, who he explains had also been irresistibly drawn to the little room. Angela Carter retells this story in *The Bloody Chamber,* and compares the room with Pandora's box and the heroine with Eve.

I want to return briefly, with another extract, to *Notorious.* In my article "Visual Pleasure and Narrative Cinema,"[10] I argued that the pleasure of looking in the cinema was structured, in most genres of Hollywood studio cinema, around a voyeuristic gaze, active and male, and, in binary opposition, the image of woman was produced as spectacle, to-be-looked-at. Since then, looking for counter examples, I was struck by the way that the power of the look in *Notorious* is "handed" to the heroine after the opening

. . . . . . . . . . . .

10  Laura Mulvey, "Visual Pleasure and Narrative Cinema," in *Visual and Other Pleasures* (Bloomington: Indiana University Press, 1989), pp. 14-26.

sequence I discussed earlier. As she herself becomes a spy, she becomes the investigating force that carries the narrative forward. She is only empowered momentarily: once she is found out, she no longer acts as the means of discovering information and conveying information to the audience. As a spy, she has to investigate a house of spies. Disguised largely by her beauty (she compares herself ironically to Mata Hari: "she makes love for the secrets"), she has to seduce Claude Rains to gain access to the house, in the first place, and then to its private area, the upstairs, by means, as it were, of the bedroom, and then to its locked doors, the cupboards, the cellar. It is as though the signifiers of the male gaze established in the first sequence had been transformed into the female look of curiosity. This impression is enhanced by the *mise-en-scène*. The heroine's masquerade, her seductive surface conceals her secret, her duplicity, and this inside/outside opposition is echoed in the spatial motifs of the *mise-en-scène,* which is concentrated on the signifiers of the spatiality of secrets, most particularly doors and keys. The camera itself emphasizes the look of curiosity, tracking with Ingrid Bergman's point of view as she surreptitiously and inquisitively looks for clues. Again, the chain of signifiers builds up metonymically, linking together the images of space and enclosure from the house itself, the double clanging shut of the front door, to the montage of cupboards that she looks into. I would argue that the topography of the *mise-en-scène* enhances the spatial implications of the look of curiosity and also reflects the spatial figuration of the heroine's masquerade.

My interest in the Pandora myth stemmed originally from a wish to consider the aesthetics of curiosity. Here, I want to bring together three main themes, implicit in my argument so far, that are relevant to a feminist analysis of curiosity: first, an active look, associated with the feminine; second, the drive of decipherment, directed towards riddles or enigmas; third, a topography of concealment and investigation, the space of secrets. Curiosity describes the desire to know something that is concealed so strongly that it is experienced like a drive, leading to the transgression of a prohibition. The desire to see may be connected with the desire to know, but it may not lead to enlightenment. I want to use the myth of Pandora to argue that the desire to know by seeing with one's own eyes needs to be transmuted into a pleasure of

decipherment so that the process of uncovering is similar to the exercise of riddle- or puzzle-solving. Feminist critics have frequently commented on Freud's characterization of femininity as a riddle, and the representation of femininity as a mask restates, as it were, this concept of the mysterious, the secret, the something hidden. Pandora combines the iconography of mystery with a narrative of curiosity. If, as I suggested earlier, the box is a reification and displaced representation of female sexuality as mystery and threat, Pandora's curiosity about its contents may be interpreted as a curiosity about the mystery that she herself personifies. And her desire can be rerepresented as a self-reflexive desire to investigate femininity itself.

The point, then, is to recast the figure of Pandora, her action and its fearful consequences in such a way that the literal topography of her structure can shift from the register of the imaginary and the iconic into the register of the symbolic. To my mind, there are two "cliché" motifs, of the kind that characterize mythic thinking, that are central to Pandora's iconography: (a) femininity as enigma, concealed behind a mask of seductiveness, and (b) female curiosity as transgressive and dangerous. I would like to try to reformulate these motifs, to illuminate the tautology, as follows: (a) Pandora's curiosity represents a transgressive desire to investigate the enigma of femininity; and (b) feminist curiosity is an investigation of the enigma, which is, in the process, transformed into an investigation of the slippages between signifier and signified, that characterize both the structure of the individual psyche and the shared fantasies of a common culture.

Freud used the concept of a topography to convey the structure of the psyche, the relation, that is, between the unconscious, preconscious, and conscious minds. He used spatial imagery to visualize the dream work, describing the manifest content as a façade, concealing the latent dream thoughts. The image of concealment, of veiling, seems to imply that one lies, like a layer, behind the other. The spatial imagery, however, as so often is the case, tends to be overevocative. The latent thought can only be discovered and analyzed by means of its presence in the signifiers of the manifest dream text, distorted by condensation and displacement. In psychoanalytic terms, representations act as a mask or disguise for presentations of something in the unconscious. In

formal terms, the dislocation is caused by the processes of censorship that control the flow of unconscious material as it struggles to achieve consciousness: a traumatic memory revived, libido, an instinctual cathexis. The process of repression allows an unconscious idea to remain outside time, like a mnemic image, preserved in readiness for any eventual return. Should a similar instinctual, libidinal, or traumatic experience be encountered by the psyche, the unconscious formation will try to avoid censorship and the anxiety it provokes in consciousness, and transform itself by finding a disguise, deceiving the conscious mind and severing all possible links with the original idea. So symptoms, or the dislocated images of a dream, emerge as signifiers that have lost logical links with their signifieds. As the disguise is never arbitrary but minutely structured according to the specific individual patterns of a particular psyche, the riddles presented by the unconscious mind can be deciphered by means of psychoanalysis.

Feminist film theory turned to psychoanalytic theory in order to perform the same kind of work for the psychopathology of patriarchy. Implicitly or explicitly, feminist criticism has revealed how psychic formations, first charted by Freud in his observation and theorization of individual case histories, have also been manifest in the artifacts of popular culture. So perhaps a crucial function of stories, scenarios, jokes, myths, images, and so on, is to supply a collective pool of imagery, like a bank or a resource, that provides a release for the individual psyche, unable to express itself "in so many words." The ability of the collective representations of popular culture to perform this work would depend, not on any essential or ahistorical shared human psyche, but on shared social formations that install ideals and taboos in the individual and then mark and mold the consequent desires and anxieties that characterize a shared culture. Some legendary figures and stories persist through history, preserving their original identity and multiplying through other images and references, for instance, the Medusa's head. These figures and emblems come to form part of the psychic vocabulary both of the individual and the collective culture, so long as the apposite psychic formations are at work. These images persist through history, giving private reverie a shortcut to a gallery of collective fantasy, inhabited by monsters and heroes, heroines and femme fatales. To my mind, these

images and stories function like collective mnemic symbols, and allow ordinary people to stop and wonder or weep, desire or shudder, resurrecting for the time being long lost psychic structures. The cinema, with its strange, characteristic dislocation between word and image, fulfills this psychic function beautifully, drawing on preexisting connotations, metaphors, and metonymies to achieve a level of recognizable, but hard to articulate, emotional resonance that evades the precision of language and then materializes amorphous anxieties and desires into recognizable figures who will gain strength and significance from repetition. If Pandora is a prototype of the femme fatale, she found new life in the movies.

Although on the face of it, representations of female eroticized beauty, such as Pandora, celebrate male pleasure in the female body as object of gaze and sexual enjoyment, in psychoanalytic terms the female body is also a source of anxiety, constantly threatening to return the subject to an original, traumatic, repressed memory of castration. In Freud's theory of castration, the "sight" of the female anatomy will indicate that the penis is not a necessary and ever-present part of the human anatomy. Furthermore, this sight may well be of the mother's body, already the first locus of erotic feelings but also of disgust, the point where the subject first finds the need to draw lines of bodily separation and autonomy. Freud argues that, if the trauma is too severe, the male psyche may react to the anxiety with an excessive response, erecting a complex defense mechanism in compensation. These processes of disavowal give rise to fetishism. An appropriate object is substituted to stand in for the missing penis and protect the subject from the fearful intimation of castration. Fetishism does, in this sense, depend on a kind of topography of the psyche. The distortion of signification produces a signifier that has to function as a mask, a means of concealment, that veils and covers over the traumatic moment that cannot be signified. As the traumatic moment was itself born out of a perception of lack, of absence, the fetish object that is "concealing nothing" is a screen, protecting a void, simultaneously reassuring and terrifying. Nothing is there, so there is nothing to be afraid of, but it is nothingness, the void, that is the source of anxiety. It is as though the structure of fetishism exemplifies the way in which the psyche attempts to construct an

imaginary topography, and where a mnemic image is literally screened by the processes of denial and defense, the dislocation between signifier and signified becomes a structural element, echoed in the formal characteristics of its imagery. In this sense, the image of femininity as mask facilitates the fetishistic fantasy, neutralizing and reproducing its anxiety. And the echoed spatial structure of the false signifier as a false mask—fascinating, alluring, and overvalued—suggests that "the dialectics of inside and outside" have a particular function, acting as a nodal or transit point. In a footnote to his account of Dora's first dream, Freud comments:

> Now, in a line of associations, ambiguous words (or, as we call them, "switch-words") act like points at a junction. If the points are switched across from the position in which they appear to lie in a dream, then we find ourselves moved onto another set of rails; and along this track run the thoughts we are in search of but still lie concealed behind the dream.[11]

Since, in Pandora's case, the spatial structure of her iconography is repeated in the box, it is perhaps arguable that the signifying chain circulating through these images of concealment and enclosure makes use of the recurring topography to displace and condense ideas. Psychoanalytic theory transforms these fascinating images with their overdetermined "poetics of space" back into symptoms, within a symbolic system, deciphering signifiers rather than unveiling phantasmatic space. Similarly, feminist criticism has been concerned with the way that the fetishized image of woman as a mask reduplicates the masking topography of the fetish object, and feminist analysis has always attempted to use semiotics to alter understanding of an image. And, I am arguing that the totality, the whole topography, should be seen to be a riddle, the solution of which points to the phantasmagorias generated by male castration anxiety. The mask of femininity, constructed as an object of desire and spectacle, covers over the problematic aspects of the female body, draping it in a reassuringly luminous garment of beauty. But at the same time, the logic of binary oppo-

. . . . . . . . . . . .

11 Freud, "Fragment of an Analysis of a Case of Hysteria," p. 65n.

sition and the psyche's acknowledgment of its own processes of disavowal project anxiety toward the "concealed space."

While curiosity is a compulsive desire to see and to know, to investigate what is secret and reveal the contents of a concealed space, fetishism, on the other hand, is born out of a refusal to see, a refusal to know, and a refusal to accept the difference that the female body symbolizes. Out of this series of turning away, of covering over, not the eyes but understanding, of looking fixedly at any object that holds the gaze, female sexuality is bound to remain a mystery, condemned to return as a mnemic symbol of anxiety while overvalued and idealized in imagery. Hollywood cinema has built its appeal and promoted its fascination by emphasizing the erotic allure of the female star. Cinematic pleasure is invested with voyeuristic pleasure, but its voyeuristic pleasure is concentrated on a highly stylized and artificial presentation of femininity. The masquerade is exaggerated by the glossy finish of the cinematic medium, comparable to the surface gloss of fetishism. In her article "On the Eve of the Future,"[12] Annette Michelson discusses the beautiful, soulless android, Hadaly, who features in Villiers de l'Isle-Adam's novel, *L'Eve future*. The fetishized image of the fake but perfect woman, created by Edison just before the dawn of cinema, like a proto-cinematic image illustrating the imbrication of desire and the machine, elicits the same whisper from its admirer as from the cinema spectator: "I know, but all the same. . ."

I want to return, finally, to Pandora's gesture of opening the box. Her curiosity is represented literally, directed towards the forbidden enclosed space, and has to be transformed and deciphered to become the self-reflexive gesture that I have claimed for it. However, the gesture is also evocative of the divisions within female subjectivity, divided in image, constantly subjected to ideological contradiction, incarnating irreconcilable mythologies and fantasies. In terms of feminist critical practice, this fragmentation allows heterogeneity and flexibility to be valued over and above a single critical perspective. Feminist theory and criticism and, indeed, feminist art make use of this fragmentation, avoiding the blinkered vision of a single, anthropomorphic per-

. . . . . . . . . . . .

12   Annette Michelson, "On the Eve of the Future," *October*, no. 29 (Summer 1984): pp. 3-20.

spective. The deciphering that feminist theory has undertaken in order to analyze the female body as sign has revealed the literal realities of spaces and images to be as elastic as the forms of metaphor and metonymy themselves. There is nothing behind the mask, no veil to tear away, not even an emptiness to be revealed, only the traces of disavowal and denial, the shifting signifiers that bear witness to the importance that psychoanalysis and semiotics have had for feminist criticism.

2  Ingrid Bergman as Alicia Hoberman and Leopoldine Konstantin as Mrs. Sebastian in Alfred Hitchcock's *Notorious*, 1946.

# The Split Wall: Domestic Voyeurism

## Beatriz Colomina

**1  Moller House.**
The staircase leading from the entrance hall into the living room.

"To LIVE IS TO LEAVE TRACES," writes Walter Benjamin, in discussing the birth of the interior. "In the interior these are emphasized. An abundance of covers and protectors, liners and cases is devised, on which the traces of objects of everyday use are imprinted. The traces of the occupant also leave their impression on the interior. The detective story that follows these traces comes into being. ... The criminals of the first detective novels are neither gentlemen nor apaches, but private members of the bourgeoisie."[1]

There is an interior in the detective novel. But can there be a detective story of the interior itself, of the hidden mechanisms by which space is constructed as interior? Which may be to say, a detective story of detection itself, of the controlling look, the look of control, the controlled look. But where would the traces of the look be imprinted? What do we have to go on? What clues?

There is an unknown passage of a well-known book, Le Corbusier's *Urbanisme* (1925), which reads: "Loos told me one day: 'A cultivated man does not look out of the window; his window is a ground glass; it is there only to let the light in, not to let the gaze pass through.'"[2] It points to a conspicuous yet conspicuously ignored feature of Loos' houses: not only are the windows either opaque or covered with sheer curtains, but the organization of the spaces and the disposition of the built-in furniture (the *immeuble*) seems to hinder access to them. A sofa is often placed at the foot of

. . . . . . . . . . . .

1 Walter Benjamin, "Paris, Capital of the Nineteenth Century," in *Reflections,* trans. Edmund Jephcott (New York: Schocken Books, 1986), pp. 155–156.

2 "Loos m'affirmait un jour: 'Un homme cultivé ne regarde pas par la fenêtre; sa fenêtre est en verre dépoli; elle n'est là que pour donner de la lumière, non pour laisser passer le regard.'" Le Corbusier, *Urbanisme* (Paris, 1925), p. 174. When this book is published in English under the title *The City of To-morrow and its Planning,* trans. Frederick Etchells (New York, 1929), the sentence reads: "A friend once said to me: No intelligent man ever looks out of his window; his window is made of ground glass; its only function is to let in light, not to look out of" (pp. 185–186). In this translation, Loos' name has been replaced by "a friend." Was Loos "nobody" for Etchells, or is this just another example of the kind of misunderstanding that led to the mistranslation of the title of the book? Perhaps it was Le Corbusier himself who decided to erase Loos' name. Of a different order, but no less symptomatic, is the mistranslation of "laisser passer le regard" (to let the gaze pass through) as "to look out of," as if to resist the idea that the gaze might take on, as it were, a life of its own, independent of the beholder. This could only happen in France!

2  **Flat for Hans Brummel, Pilsen, 1929.**
Bedroom with a sofa set against the window.

3  **Müller House, Prague, 1930.**
The raised sitting area in the *Zimmer der Dame* with the window
looking onto the living room.

a window so as to position the occupants with their back to it, fac-
ing the room (figure 2). This even happens with the windows that
look into other interior spaces–as in the sitting area of the ladies'
lounge of the Müller house (Prague, 1930) (figure 3). Moreover,
upon entering a Loos interior one's body is continually turned
around to face the space one just moved through, rather than the
upcoming space or the space outside. With each turn, each return
look, the body is arrested. Looking at the photographs, it is easy
to imagine oneself in these precise, static positions, usually indi-
cated by the unoccupied furniture. The photographs suggest that
it is intended that these spaces be comprehended by occupation,
by using this furniture, by "entering" the photograph, by inhabit-
ing it.[3]

. . . . . . . . . . . .

3  The perception of space is not what space *is* but one of its
representations; in this sense built space has no more authority than
drawings, photographs, or descriptions.

In the Moller house (Vienna, 1928) there is a raised sitting area off the living room with a sofa set against the window. Although one cannot see out the window, its presence is strongly felt. The bookshelves surrounding the sofa and the light coming from behind it suggest a comfortable nook for reading (figure 4). But comfort in this space is more than just sensual, for there is also a psychological dimension. A sense of security is produced by the position of the couch, the placement of its occupants, against the light. Anyone who, ascending the stairs from the entrance (itself a rather dark passage), enters the living room, would take a few moments to recognize a person sitting in the couch. Conversely, any intrusion would soon be detected by a person occupying this area, just as an actor entering the stage is immediately seen by a spectator in a theater box (figures 1, 5).

Loos refers to the idea of the theater box in noting that "the smallness of a theater box would be unbearable if one could not look out into the large space beyond."[4] While Kulka, and later Münz, read this comment in terms of the economy of space provided by the *Raumplan,* they overlook its psychological dimension. For Loos, the theater box exists at the intersection between claustrophobia and agoraphobia.[5] This spatial-psychological device could also be read in terms of power, regimes of control inside the house. The raised sitting area of the Moller house provides the occupant with a vantage point overlooking the interior. Comfort in this space is related to both intimacy and control.

This area is the most intimate of the sequence of living spaces, yet, paradoxically, rather than being at the heart of the house, it is

. . . . . . . . . . . .

**4**  Ludwig Münz and Gustav Künstler, *Der Architekt Adolf Loos* (Vienna and Munich, 1964), pp. 130–131. English translation: *Adolf Loos, Pioneer of Modern Architecture* (London, 1966), p. 148: "We may call to mind an observation by Adolf Loos, handed down to us by Heinrich Kulka, that the smallness of a theatre box would be unbearable if one could not look out into the large space beyond; hence it was possible to save space, even in the design of small houses, by linking a high main room with a low annexe."

**5**  Georges Teyssot has noted that "The Bergsonian ideas of the room as a refuge from the world are meant to be conceived as the 'juxtaposition' between claustrophobia and agoraphobia. This dialectic is already found in Rilke." Teyssot, "The Disease of the Domicile," *Assemblage* 6 (1988): 95.

**4  Moller House, Vienna, 1928.**
The raised sitting area off the living room.

**5  Moller House.**
Plan of elevated ground floor, with the alcove drawn more narrowly
than it was built.

**6  Moller House.**
View from the street.

placed at the periphery, pushing a volume out of the street façade, just above the front entrance. Moreover, it corresponds with the largest window on this elevation (almost a horizontal window) (figure 6). The occupant of this space can both detect anyone crossing-trespassing the threshold of the house (while screened by the curtain) and monitor any movement in the interior (while "screened" by the backlighting).

In this space, the window is only a source of light (not a frame for a view). The eye is turned towards the interior. The only exterior view that would be possible from this position requires that the gaze travel the whole depth of the house, from the alcove to the living room to the music room, which opens onto the back garden (figure 7). Thus, the exterior view depends upon a view of the interior.

**7 Moller House.**
Plan and section tracing the journey of the gaze from the raised sitting
area to the back garden.

The look folded inward upon itself can be traced in other Loos
interiors. In the Müller house, for instance, the sequence of spaces,
articulated around the staircase, follows an increasing sense of pri-
vacy from the drawing room, to the dining room and study, to the
"lady's room" (*Zimmer der Dame*) with its raised sitting area,
which occupies the center, or "heart," of the house (figures 3, 8).[6]
But the window of this space looks onto the living space. Here,
too, the most intimate room is like a theater box, placed just over
the entrance to the social spaces in this house, so that any intruder
could easily be seen. Likewise, the view of the exterior, towards
the city, from this "theater box," is contained within a view of the
interior. Suspended in the middle of the house, this space assumes
both the character of a "sacred" space and of a point of control.
Comfort is paradoxically produced by two seemingly opposing
conditions, intimacy and control.

This is hardly the idea of comfort which is associated with the
nineteenth-century interior as described by Walter Benjamin in
"Louis-Philippe, or the Interior."[7] In Loos' interiors the sense of

. . . . . . . . . . . . .

6   There is also a more direct and more private route to the sitting area, a
staircase rising from the entrance of the drawing room.
7   "Under Louis-Philippe the private citizen enters the stage of history. ...
For the private person, living space becomes, for the first time, antithetical
to the place of work. The former is constituted by the interior; the office is

**8 Müller House.**
Plan of the main floor.

security is not achieved by simply turning one's back on the exterior and immersing oneself in a private universe—"a box in the world theater," to use Benjamin's metaphor. It is no longer the house that is a theater box; there is a theater box inside the house, overlooking the internal social spaces. The inhabitants of Loos' houses are both actors in and spectators of the family scene—involved in, yet detached from, their own space.[8] The classical distinction between inside and outside, private and public, object and subject, becomes convoluted.

. . . . . . . . . . . .

its complement. The private person who squares his account with reality in his office demands that the interior be maintained in his illusions. This need is all the more pressing since he has no intention of extending his commercial considerations into social ones. In shaping his private environment he represses both. From this spring the phantasmagorias of the interior. For the private individual the private environment represents the universe. In it he gathers remote places and the past. His drawing room is a box in the world theater." Walter Benjamin, "Paris, Capital of the Nineteenth Century," in *Reflections*, p. 154.
**8** This calls to mind Freud's paper "A Child Is Being Beaten" (1919) where, as Victor Burgin has written, "the subject is positioned both in the

**9  Müller House.**
The library.

The theater boxes in the Moller and Müller houses are spaces marked as "female," the domestic character of the furniture contrasting with that of the adjacent "male" space, the libraries (figure 9). In these, the leather sofas, the desks, the chimney, the mirrors, represent a "public space" within the house–the office and the club invading the interior. But it is an invasion which is confined to an enclosed room–a space which belongs to the sequence of social spaces within the house, yet does not engage with them. As Münz notes, the library is a "reservoir of quietness," "set apart from the household traffic." The raised alcove of the Moller house and the *Zimmer der Dame* of the Müller house, on the other hand, not only overlook the social spaces but are exactly positioned at the end of

. . . . . . . . . . . .

audience *and* on stage–where it is both aggressor *and* aggressed." Victor Burgin, "Geometry and Abjection," *AA Files,* no. 15 (Summer 1987): 38. The *mise-en-scène* of Loos' interiors appears to coincide with that of Freud's unconscious. Sigmund Freud, "A Child Is Being Beaten: A Contribution to the Study of the Origin of Sexual Perversions," in *The Standard Edition of the Complete Psychological Works of Sigmund Freud,* vol. 17, pp. 175–204. In relation to Freud's paper, see also: Jacqueline Rose, *Sexuality in the Field of Vision* (London, 1986), pp. 209–210.

the sequence, on the threshold of the private, the secret, the upper rooms where sexuality is hidden away. At the intersection of the visible and the invisible, women are placed as the guardians of the unspeakable.[9]

But the theater box is a device which both provides protection and draws attention to itself. Thus, when Münz describes the entrance to the social spaces of the Moller house, he writes: "Within, entering from one side, one's gaze travels in the opposite direction till it rests in the light, pleasant alcove, raised above the living room floor. Now we are really inside the house."[10] That is, the intruder is "inside," has penetrated the house, only when his/her gaze strikes this most intimate space, turning the occupant into a silhouette against the light.[11] The "voyeur" in the "theater box" has become the object of another's gaze; she is caught in the act of seeing, entrapped in the very moment of control.[12] In framing a view, the theater box also frames the viewer. It is impossible to abandon the space, let alone leave the house, without being seen by those over whom control is being exerted. Object and subject exchange places. Whether there is actually a person behind either gaze is irrelevant:

. . . . . . . . . . . .

**9**   In a criticism of Benjamin's account of the bourgeois interior, Laura Mulvey writes: "Benjamin does not mention the fact that the private sphere, the domestic, is an essential adjunct to the bourgeois marriage and is thus associated with woman, not simply as female, but as wife and mother. It is the mother who guarantees the privacy of the home by maintaining its respectability, as essential a defence against incursion or curiosity as the encompassing walls of the home itself." Laura Mulvey, "Melodrama Inside and Outside the Home," *Visual and Other Pleasures* (London, 1989).

**10**   Münz and Künstler, *Adolf Loos,* p. 149.

**11**   Upon reading an earlier version of this manuscript, Jane Weinstock pointed out that this silhouette against the light can be understood as a screened woman, a veiled woman, and therefore as the traditional object of desire.

**12**   In her response to an earlier version of this paper, Silvia Kolbowski pointed out that the woman in the raised sitting area of the Moller house could also be seen from behind, through the window to the street, and that therefore she is also vulnerable in her moment of control.

I can feel myself under the gaze of someone whose eyes I do not even see, not even discern. All that is necessary is for something to signify to me that there may be others there. The window if it gets a bit dark and if I have reasons for thinking that there is someone behind it, is straightway a gaze. From the moment this gaze exists, I am already something other, in that I feel myself becoming an object for the gaze of others. But in this position, which is a reciprocal one, others also know that I am an object who knows himself to be seen.[13]

Architecture is not simply a platform that accommodates the viewing subject. It is a viewing mechanism that produces the subject. It precedes and frames its occupant.

The theatricality of Loos' interiors is constructed by many forms of representation (of which built space is not necessarily the most important). Many of the photographs, for instance, tend to give the impression that someone is just about to enter the room, that a piece of domestic drama is about to be enacted. The characters absent from the stage, from the scenery and from its props –the conspicuously placed pieces of furniture (figure 10)–are conjured up.[14] The only published photograph of a Loos interior which includes a human figure is a view of the entrance to the drawing room of the Rufer house (Vienna, 1922) (figure 11). A male figure, barely visible, is about to cross the threshold through a peculiar opening in the wall.[15] But it is precisely at this threshold, slightly off stage, that the actor/intruder is most vulnerable, for a small window in the reading room looks down onto the back

. . . . . . . . . . . . .

**13**  Jacques Lacan, *The Seminar of Jacques Lacan: Book I, Freud's Papers on Technique 1953–1954,* ed. Jacques-Alain Miller, trans. John Forrester (New York and London: W. W. Norton and Co., 1988), p. 215. In this passage Lacan is refering to Jean-Paul Sartre's *Being and Nothingness.*

**14**  There is an instance of such personification of furniture in one of Loos' most autobiographical texts, "Interiors in the Rotunda" (1898), where he writes: "Every piece of furniture, every thing, every object had a story to tell, a family story." *Spoken into the Void: Collected Essays 1897–1900,* trans. Jane O. Newman and John H. Smith (Cambridge, Mass., and London: MIT Press, 1982), p. 24.

**15**  This photograph has only been published recently. Kulka's monograph (a work in which Loos was involved) presents exactly the same view, the

**II  Rufer House, Vienna, 1922.**
Entrance to the living room.

**10  Adolf Loos' flat, Vienna, 1903.**
View from the living room into the fireplace nook.

of his neck. This house, traditionally considered to be the proto-
type of the *Raumplan,* also contains the prototype of the theater
box.

In his writings on the question of the house, Loos describes a
number of domestic melodramas. In *Das Andere,* for example, he
writes:

> Try to describe how birth and death, the screams of pain for an
> aborted son, the death rattle of a dying mother, the last thoughts of a
> young woman who wishes to die ... unfold and unravel in a room by
> Olbrich! Just an image: the young woman who has put herself to
> death. She is lying on the wooden floor. One of her hands still holds
> the smoking revolver. On the table a letter, the farewell letter. Is the
> room in which this is happening of good taste? Who will ask that? It
> is just a room![16]

One could as well ask why it is only the women who die and
cry and commit suicide. But leaving aside this question for the
moment, Loos is saying that the house must not be conceived of as
a work of art, that there is a difference between a house and a
"series of decorated rooms." The house is the stage for the theater
of the family, a place where people are born and live and die.
Whereas a work of art, a painting, presents itself to critical atten-
tion as an object, the house is received as an environment, as a
stage.

To set the scene, Loos breaks down the condition of the house
as an object by radically convoluting the relation between inside
and outside. One of the devices he uses is mirrors which, as Ken-
neth Frampton has pointed out, appear to be openings, and open-
ings which can be mistaken for mirrors.[17] Even more enigmatic is
. . . . . . . . . . . .
same photograph, but without a human figure. The strange opening in the
wall pulls the viewer toward the void, toward the missing actor (a tension
which the photographer no doubt felt the need to cover). This tension
constructs the subject, as it does in the built-in couch of the raised area of
the Moller house, or the window of the *Zimmer der Dame* overlooking the
drawing room of the Müller house.

16   Adolf Loos, *Das Andere,* no. 1 (1903): 9.
17   Kenneth Frampton, unpublished lecture, Columbia University, Fall
1986.

the placement, in the dining room of the Steiner house (Vienna, 1910) (figure 12), of a mirror just beneath an opaque window.[18] Here, again, the window is only a source of light. The mirror, placed at eye level, returns the gaze to the interior, to the lamp above the dining table and the objects on the sideboard, recalling Freud's studio in Berggasse 19, where a small framed mirror hanging against the window reflects the lamp on his work table. In Freudian theory the mirror represents the psyche. The reflection in the mirror is also a self-portrait projected onto the outside world. The placement of Freud's mirror on the boundary between interior and exterior undermines the status of the boundary as a fixed limit. Inside and outside cannot simply be separated. Similarly, Loos' mirrors promote the interplay between reality and illusion, between the actual and virtual, undermining the status of the boundary between inside and outside.

This ambiguity between inside and outside is intensified by the separation of sight from the other senses. Physical and visual connections between the spaces in Loos' houses are often separated. In the Rufer house, a wide opening establishes between the raised dining room and the music room a visual connection which does not correspond to the physical connection. Similarly, in the Moller house there appears to be no way of entering the dining room from the music room, which is 70 centimeters below; the only means of access is by unfolding steps which are hidden in the timber base of the dining room (figure 13).[19] This strategy of physical separation and visual connection, of "framing," is repeated in many other Loos interiors. Openings are often screened by curtains, enhancing the stagelike effect. It should also be noted that it is usually the dining room which acts as the stage, and the music room as the space for the spectators. What is being framed is the traditional scene of everyday domestic life.

. . . . . . . . . . . . .

**18**   It should also be noted that this window is an exterior window, as opposed to the other window, which opens into a threshold space.

**19**   The reflective surface in the rear of the dining room of the Moller house (halfway between an opaque window and a mirror) and the window on the rear of the music room "mirror" each other, not only in their locations and their proportions, but even in the way the plants are disposed in two tiers. All of this produces the illusion, in the photograph, that the threshold between these two spaces is virtual—impassable, impenetrable.

12　**Steiner House, Vienna, 1910.**
　　View of the dining room showing the mirror beneath the window.

13　**Moller House.**
　　View from the music room into the dining room. In the center of the
　　threshold are steps that can be let down.

But the breakdown between inside and outside, and the split between sight and touch, is not located exclusively in the domestic scene. It also occurs in Loos' project for a house for Josephine Baker (Paris, 1928) (figures 14, 15)–a house that excludes family life. However, in this instance the "split" acquires a different meaning. The house was designed to contain a large top-lit, double-height swimming pool, with entry at the second-floor level. Kurt Ungers, a close collaborator of Loos in this project, wrote:

> The reception rooms on the first floor arranged round the pool–a large salon with an extensive top-lit vestibule, a small lounge and the circular café–indicate that this was intended not for private use but as a *miniature entertainment centre*. On the first floor, low passages surround the pool. They are lit by the wide windows visible on the outside, and from them, thick, transparent windows are let into the side of the pool, so that it was possible to watch swimming and diving in its crystal-clear water, flooded with light from above: an *underwater revue*, so to speak.[20] [author's emphasis]

As in Loos' earlier houses, the eye is directed towards the interior, which turns its back on the outside world; but the subject and object of the gaze have been reversed. The inhabitant, Josephine Baker, is now the primary object, and the visitor, the guest, is the looking subject. The most intimate space–the swimming pool, paradigm of a sensual space–occupies the center of the house, and is also the focus of the visitor's gaze. As Ungers writes, entertainment in this house consists in looking. But between this gaze and its object–the body–is a screen of glass and water, which renders the body inaccessible. The swimming pool is lit from above, by a skylight, so that inside it the windows would appear as reflective surfaces, impeding the swimmer's view of the visitors standing in the passages. This view is the opposite of the panoptic view of a theater box, corresponding instead to that of the peephole, where subject and object cannot simply exchange places.[21]

. . . . . . . . . . . .

20   Letter from Kurt Ungers to Ludwig Münz, quoted in Münz and Künstler, *Adolf Loos*, p. 195.
21   In relation to the model of the peepshow and the structure of voyeurism, see Victor Burgin's project *Zoo*.

**14 Project for a house for Josephine Baker in Paris, 1928.**
Model.

**15 Josephine Baker House.**
Plans of first and second floors.

The *mise-en-scène* in the Josephine Baker house recalls Christian
Metz's description of the mechanism of voyeurism in cinema:

> It is even essential ... that the actor should behave as though he were
> not seen (and therefore as though he did not see his voyeur), that he
> should go about his ordinary business and pursue his existence as
> foreseen by the fiction of the film, that he should carry on with his
> antics in a closed room, taking the utmost care not to notice that a
> glass rectangle has been set into one of the walls, and that he lives in a
> kind of aquarium.[22]

But the architecture of this house is more complicated. The
swimmer might also see the reflection, framed by the window, of
her own slippery body superimposed on the disembodied eyes of
the shadowy figure of the spectator, whose lower body is cut out
by the frame. Thus she sees herself being looked at by another: a
narcissistic gaze superimposed on a voyeuristic gaze. This erotic
complex of looks in which she is suspended is inscribed in each of
the four windows opening onto the swimming pool. Each, even if
there is no one looking through it, constitutes, from both sides, a
gaze.

The split between sight and the other physical senses found in
Loos' interiors is explicit in his definition of architecture. In "The
Principle of Cladding" he writes: "the artist, the *architect,* first
senses the *effect* [author's emphasis] that he intends to realize and
sees the rooms he wants to create in his mind's eye. He senses the
effect that he wishes to exert upon the *spectator* [author's emphasis].
... homeyness if [it is] a residence."[23] For Loos, the interior is pre-
Oedipal space, space before the analytical distancing which lan-
guage entails, space as we feel it, as clothing; that is, as clothing
before the existence of readymade clothes, when one had to first
choose the fabric (and this act required, or I seem to remember as
much, a distinct gesture of looking away from the cloth while feel-
ing its texture, as if the sight of it would be an obstacle to the
sensation).

. . . . . . . . . . . .

22   Christian Metz, "A Note on Two Kinds of Voyeurism," in *The
Imaginary Signifier* (Bloomington: Indiana University Press, 1977), p. 96.
23   Adolf Loos, "The Principle of Cladding" (1898), in *Spoken into the
Void,* p. 66.

**16 Diagram from the *Traité de Passions* of René Descartes.**

Loos seems to have reversed the Cartesian schism between the perceptual and conceptual (figure 16). Whereas Descartes, as Franco Rella has written, deprived the body of its status as "the seat of valid and transmissible knowledge" ("In sensation, in the experience that derives from it, harbours error"),[24] Loos privileges the bodily experience of space over its mental construction: the architect first senses the space, then he visualizes it.

For Loos, architecture is a form of covering, but it is not the walls that are covered. Structure plays a secondary role, and its primary function is to hold the covering in place:

> The architect's general task is to provide a warm and livable space. Carpets are warm and livable. He decides for this reason to spread one carpet on the floor and to hang up four to form the four walls. But you cannot build a house out of carpets. Both the carpet on the floor and the tapestry on the wall require a structural frame to hold them in the correct place. To invent this frame is the architect's second task.[25]

· · · · · · · · · · · ·

**24** Franco Rella, *Miti e figure del moderno* (Parma: Pratiche Editrice, 1981), p. 13 and note 1. René Descartes, *Correspondance avec Arnould et Morus,* ed. G. Lewis (Paris, 1933): letter to Hyperaspistes, August 1641.
**25** Loos, "The Principle of Cladding," p. 66

**17 Adolf Loos' flat.**
Lina Loos' bedroom.

The spaces of Loos' interiors cover the occupants as clothes cover the body (each occasion has its appropriate "fit"). José Quetglas has written: "Would the same pressure on the body be acceptable in a raincoat as in a gown, in jodhpurs or in pajama pants? ... All the architecture of Loos can be explained as the envelope of a body." From Lina Loos' bedroom (this "bag of fur and cloth") (figure 17) to Josephine Baker's swimming pool ("this transparent bowl of water"), the interiors always contain a "warm bag in which to wrap oneself." It is an "architecture of pleasure," an "architecture of the womb."[26]

But space in Loos' architecture is not just felt. It is significant, in the quotation above, that Loos refers to the inhabitant as a spectator, for his definition of architecture is really a definition of theatrical architecture. The "clothes" have become so removed from the body that they require structural support independent of it. They become a "stage set." The inhabitant is both "covered" by the space and "detached" from it. The tension between sensation of comfort and comfort as control disrupts the role of the house as

. . . . . . . . . . . . .

26  José Quetglas, "Lo Placentero," *Carrer de la Ciutat,* no. 9–10, special issue on Loos (January 1980): 2

a traditional form of representation. More precisely, the traditional system of representation, within which the building is but one of many overlapping mechanisms, is dislocated.

Loos' critique of traditional notions of architectural representation is bound up with the phenomenon of an emergent metropolitan culture. The subject of Loos' architecture is the metropolitan individual, immersed in the abstract relationships of the city, at pains to assert the independence and individuality of his existence against the leveling power of society. This battle, according to Georg Simmel, is the modern equivalent of primitive man's struggle with nature, clothing is one of the battlefields, and fashion is one of its strategies.[27] He writes: "The commonplace is good form in society. ... It is bad taste to make oneself conspicuous through some individual, singular expression. ... Obedience to the standards of the general public in all externals [is] the conscious and desired means of reserving their personal feelings and their taste."[28] In other words, fashion is a mask which protects the intimacy of the metropolitan being.

Loos writes about fashion in precisely such terms: "We have become more refined, more subtle. Primitive men had to differentiate themselves by various colors, modern man needs his clothes as a mask. His individuality is so strong that it can no longer be expressed in terms of items of clothing. ... His own inventions are concentrated on other things."[29]

Significantly, Loos writes about the exterior of the house in the same terms that he writes about fashion:

· · · · · · · · · · · ·

27  "The deepest conflict of modern man is not any longer in the ancient battle with nature, but in the one that the individual must fight to affirm the independence and peculiarity of his existence against the immense power of society, in his resistance to being levelled, swallowed up in the social-technological mechanism." Georg Simmel, "Die Grosstadt und das Geistleben" (1903). English translation: "The Metropolis and Mental Life," in *Georg Simmel: On Individuality and Social Forms,* ed. Donald Levine (Chicago, 1971), pp. 324–339.
28  Georg Simmel, "Fashion" (1904), ibid.
29  Adolf Loos, "Ornament and Crime" (1908), trans. Wilfried Wang in *The Architecture of Adolf Loos* (London, 1985), p. 103.

> When I was finally given the task of building a house, I said to myself: in its external appearance, a house can only have changed as much as a dinner jacket. Not a lot therefore. ... I had to become significantly simpler. I had to substitute the golden buttons with black ones. The house has to look inconspicuous.[30]

> The house does not have to tell anything to the exterior; instead, all its richness must be manifest in the interior.[31]

Loos seems to establish a radical difference between interior and exterior, which reflects the split between the intimate and the social life of the metropolitan being: outside, the realm of exchange, money, and masks; inside, the realm of the inalienable, the nonexchangeable, and the unspeakable. Moreover, this split between inside and outside, between senses and sight, is gender-loaded. The exterior of the house, Loos writes, should resemble a dinner jacket, a male mask; as the unified self, protected by a seamless façade, the exterior is masculine. The interior is the scene of sexuality and of reproduction, all the things that would divide the subject in the outside world. However, this dogmatic division in Loos' writings between inside and outside is undermined by his architecture.

The suggestion that the exterior is merely a mask which clads some preexisting interior is misleading, for the interior and exterior are constructed simultaneously. When he was designing the Rufer house, for example, Loos used a dismountable model that would allow the internal and external distributions to be worked out simultaneously. The interior is not simply the space which is enclosed by the façades. A multiplicity of boundaries is established, and the tension between inside and outside resides in the walls that divide them, its status disturbed by Loos' displacement of traditional forms of representation. To address the interior is to address the splitting of the wall.

Take, for instance, the displacement of drawing conventions in Loos' four pencil drawings of the elevation of the Rufer house (fig-

............

30   Adolf Loos, "Architecture," ibid., p. 107.
31   Adolf Loos, "Heimat Kunst" (1914), in *Trotzdem* (essays 1900–1930) (Innsbruck, 1931).

**18    Rufer House.**
Elevations.

ure 18). Each one shows not only the outlines of the façade but also, in dotted lines, the horizontal and vertical divisions of the interior, the position of the rooms, the thickness of the floors and the walls. The windows are represented as black squares, with no frame. These are drawings of neither the inside nor the outside but the membrane between them: between the representation of habitation and the mask is the wall. Loos' subject inhabits this wall. This inhabitation creates a tension on that limit, tampers with it.

This is not simply a metaphor. In every Loos house there is a point of maximum tension and it always coincides with a threshold or boundary. In the Moller house it is the raised alcove protruding from the street façade, where the occupant is ensconced in the security of the interior, yet detached from it. The subject of Loos' houses is a stranger, an intruder in his own space. In Josephine Baker's house, the wall of the swimming pool is punctured by windows. It has been pulled apart, leaving a narrow passage surrounding the pool, and splitting each of the windows into an internal window and an external window. The visitor literally inhabits this wall, which enables him to look both inside, at the pool, and

outside, at the city, but he is neither inside nor outside the house. In the dining room of the Steiner house, the gaze directed towards the window is folded back by the mirror beneath it, transforming the interior into an exterior view, a scene. The subject has been dislocated: unable to occupy the inside of the house securely, it can only occupy the insecure margin between window and mirror.[32]

Like the occupants of his houses, Loos is both inside and outside the object. The illusion of Loos as a man in control of his own work, an undivided subject, is suspect. In fact, he is constructed, controlled, and fractured by his own work. In the *Raumplan*, for example, Loos constructs a space (without having completed the working drawings), then allows himself to be manipulated by this construction. The object has as much authority over him as he has over the object. He is not simply an author.[33]

The critic is no exception to this phenomenon. Incapable of detachment from the object, the critic simultaneously produces a new object and is produced by it. Criticism that presents itself as a new interpretation of an existing object is in fact constructing a completely new object. On the other hand, readings that claim to be purely objective inventories, the standard monographs of Loos—Münz and Künstler in the 1960s and Gravagnuolo in the 1980s—are thrown off-balance by the very object of their control. Nowhere is this alienation more evident than in their interpretations of the house for Josephine Baker.

Münz, otherwise a wholly circumspect writer, begins his appraisal of this house with the exclamation: "Africa: that is the image conjured up more or less firmly by a contemplation of the model," but he then confesses not to know why he invoked this image.[34] He attempts to analyze the formal characteristics of the

. . . . . . . . . . . .

32   The subject is not only the inhabitant of the space but also the viewer of the photographs, the critic and the architect. See in this respect my article "Intimacy and Spectacle: The Interior of Loos," *AA Files,* no. 20 (1990): 13–14, which develops this point further.

33   Loos' distrust for the architectural drawings led him to develop the *Raumplan* as a means of conceptualizing space as it is felt, but, revealingly, he left no theoretical definition of it. Kulka noted: "he will make many changes during construction. He will walk through the space and say: 'I do not like the height of this ceiling, change it!' The idea of the *Raumplan* made it difficult to finish a scheme before construction allowed the visualization of the space as it was."

34   Münz and Künstler, *Adolf Loos,* p. 195.

project, but all he can conclude is that "they look strange and exotic." What is most striking in this passage is the uncertainty as to whether Münz is referring to the model of the house or to Josephine Baker herself. He seems unable to either detach himself from this project or to enter into it.

Like Münz, Gravagnuolo finds himself writing things without knowing why, reprimands himself, then tries to regain control:

> First there is the charm of this gay architecture. It is not just the dichromatism of the facades but–as we shall see–the spectacular nature of the internal articulation that determines its refined and seductive character. Rather than abandon oneself to the pleasure of suggestions, it is necessary to take this "toy" to pieces with *analytical detachment* if one wishes to understand the mechanism of composition.[35] [author's emphasis]

He then institutes a regime of analytical catgories ("the architectural introversion," "the revival of dichromatism," "the plastic arrangement") which he uses nowhere else in the book. And he concludes:

> The water flooded with light, the refreshing swim, the voyeuristic pleasure of underwater exploration–these are the carefully balanced ingredients of this gay architecture. But what matters more is that the invitation to the spectacular suggested by the theme of the house for a cabaret star is handled by Loos with discretion and *intellectual detachment,* more as a poetic game, involving the mnemonic pursuit of quotations and allusions to the Roman spirit, than as a vulgar surrender to the taste of Hollywood. [author's emphasis]

Gravagnuolo ends up crediting Loos with the "detachment" (from Hollywood, vulgar taste, feminized culture) in "handling" the project that the critic himself was attempting to regain in its analysis. The insistence on detachment, on reestablishing the distance between critic and object of criticism, architect and building, subject and object, is of course indicative of the obvious fact that Münz and Gravagnuolo have failed to separate themselves from the object. The image of Josephine Baker offers pleasure but

- - - - - - - - - - - -

35  Benedetto Gravagnuolo, *Adolf Loos* (New York: Rizzoli, 1982), p. 191.

also represents the threat of castration posed by the "other": the image of woman in water—liquid, elusive, unable to be controlled, pinned down. One way of dealing with this threat is fetishization.

The Josephine Baker house represents a shift in the sexual status of the body. This shift involves determinations of race and class more than gender. The theater box of the domestic interiors places the occupant against the light. She appears as a silhouette, mysterious and desirable, but the backlighting also draws attention to her as a physical volume, a bodily presence within the house with its own interior. She controls the interior, yet she is trapped within it. In the Baker house, the body is produced as spectacle, the object of an erotic gaze, an erotic system of looks. The exterior of this house cannot be read as a silent mask designed to conceal its interior; it is a tattooed surface which does not refer to the interior, it neither conceals nor reveals it. This fetishization of the surface is repeated in the "interior." In the passages, the visitors consume Baker's body as a surface adhering to the windows. Like the body, the house is all surface; it does not simply have an interior.

In the houses of Le Corbusier the reverse condition of Loos' interiors may be observed. In photographs windows are never covered with curtains, neither is access to them hampered by objects. On the contrary, everything in these houses seems to be disposed in a way that continuously throws the subject towards the periphery of the house. The look is directed to the exterior in such deliberate manner as to suggest the reading of these houses as frames for a view. Even when actually in an "exterior," in a terrace or in a "roof garden," walls are constructed to frame the landscape, and a view from there to the interior, as in a canonic photograph of Villa Savoye (figure 19), passes right through it to the framed landscape (so that in fact one can speak about a series of overlapping frames). These frames are given temporality through the *promenade*. Unlike Adolf Loos' houses, perception here occurs in motion. It is hard to think of oneself in static positions. If the photographs of Loos' interiors give the impression that somebody is about to enter the room, in Le Corbusier's the impression is that somebody was just there, leaving as traces a coat and a hat lying on the table by the entrance of Villa Savoye (figure 20) or some bread and a jug on the kitchen table (figure 21; note also that the door here has been left open, further suggesting the idea that we have just missed some-

19 **Villa Savoye, Poissy, 1929.**
*Jardin suspendu.*

20 **Villa Savoye.**
View of the entrance hall.

**21   Villa Savoye.**
View of the kitchen.

body), or a raw fish in the kitchen of Garches (figure 22). And even
once we have reached the highest point of the house, as in the ter-
race of Villa Savoye in the sill of the window which frames the
landscape, the culminating point of the promenade, here also we
find a hat, a pair of sunglasses, a little package (cigarettes?) and a
lighter (figure 23), and now, where did the *gentleman* go? Because
of course, you would have noticed already, that the personal
objects are all male objects (never a handbag, a lipstick, or some
piece of women's clothing). But before that. We are following
somebody, the traces of his existence presented to us in the form of
a series of photographs of the interior. The look into these photo-
graphs is a forbidden look. The look of a detective. A voyeuristic
look.[36]

. . . . . . . . . . . .

36   For other interpretations of these photographs of Le Corbusier's villas
presented in the *Oeuvre complète* see: Thomas Schumacher, "Deep Space,
Shallow Space," *Architectural Review* (January 1987): 37–42; Richard
Becherer, "Chancing it in the Architecture of Surrealist Mise-en-Scène,"
*Modulus* 18 (1987): 63–87; Alexander Gorlin, "The Ghost in the Machine:
Surrealism in the Work of Le Corbusier," *Perspecta* 18 (1982); José Quetglas,
"Viajes alrededor de mi alcoba," *Arquitecture* 264–265 (1987): 111–112.

22 **Villa Garches, 1927.**
View of the kitchen.

23 **Villa Savoye.**
View of the roof garden.

In the film *L'Architecture d'aujourd'hui* (1929) directed by Pierre Chenal with Le Corbusier,[37] the latter as the main actor drives his own car to the entrance of Villa Garches (figure 24), descends, and enters the house in an energetic manner. He is wearing a dark suit with bow tie, his hair is glued with brilliantine, every hair in place, he is holding a cigarette in his mouth. The camera pans through the exterior of the house and arrives at the "roof garden," where there are women sitting down and children playing. A little boy is driving his toy car. At this point Le Corbusier appears again but on the other side of the terrace (he never comes in contact with the women and children). He is puffing his cigarette. He then very athletically climbs up the spiral staircase which leads to the highest point of the house, a lookout point. Still wearing his formal attire, the cigarette still sticking out of his mouth, he pauses to contemplate the view from that point. He looks out.

There is also a figure of a woman going through a house in this movie. The house that frames her is Villa Savoye. Here there is no car arriving. The camera shows the house from the distance, an object sitting in the landscape, and then pans the outside and the inside of the house. And it is there, halfway through the interior, that the woman appears in the screen. She is already inside, already contained by the house, bounded. She opens the door that leads to the terrace and goes up the ramp toward the roof garden, her back to the camera. She is wearing informal clothes and high heels and she holds to the handrail as she goes up, her skirt and hair blowing in the wind. She appears vulnerable. Her body is fragmented, framed not only by the camera but by the house itself, behind bars (figure 25). She appears to be moving from the inside of the house to the outside, to the roof garden. But this outside is again constructed as an inside with a wall wrapping the space in which an opening with the proportions of a window frames the landscape. The woman continues walking along the wall, as if

. . . . . . . . . . . . .

37  A copy of this film is held in the Museum of Modern Art, New York. About this movie see J. Ward, "Le Corbusier's Villa Les Terrasses and the International Style," Ph.D. dissertation, New York University, 1983, and by the same author, "Les Terrasses," *Architectural Review* (March 1985): 64–69. Richard Becherer has compared it to Man Ray's movie *Les Mystères du Château du Dé* (setting by Mallet-Stevens) in "Chancing it in the Architecture of Surrealist Mise-en-Scène."

24   **Villa Garches.**
Still from *L'Architecture d'aujourd'hui*, 1929.

25   **Villa Savoye.**
Still from *L'Architecture d'aujourd'hui*. "Une maison ce n'est pas une
prison: l'aspect change à chaque pas."

protected by it, and as the wall makes a curve to form the solarium, the woman turns too, picks up a chair, and sits down. She would be facing the interior, the space she has just moved through. But for the camera, which now shows us a general view of the terrace, she has disappeared behind the plants. That is, just at the moment when she has turned and could face the camera (there is nowhere else to go), she vanishes. She never catches our eye. Here we are literally following somebody, the point of view is that of a voyeur.

We could accumulate more evidence. Few photographs of Le Corbusier's buildings show people in them. But in those few, women always look away from the camera: most of the time they are shot from the back and they almost never occupy the same space as men. Take the photographs of *Immeuble Clarté* in the *Oeuvre complète,* for example. In one of them, the woman and the child are in the interior, they are shot from the back, facing the wall; the men are in the balcony, looking out, toward the city (figure 26). In the next shot, the woman, again shot from the back, is leaning against the window to the balcony and looking at the man and the child who are on the balcony (figure 27). This spatial structure is repeated very often, not only in the photographs but also the drawings of Le Corbusier's projects. In a drawing of the Wanner project, for example, the woman in the upper floor is leaning against the veranda, looking down at her hero, the boxer, who is occupying the *jardin suspendu*. He looks at his punching bag. And in the drawing *Ferme radieuse,* the woman in the kitchen looks over the counter toward the man sitting at the dining room table. He is reading the newspaper. Here again the woman is placed "inside," the man "outside," the woman looks at the man, the man looks at the "world."

But perhaps no example is more telling than the photo collage of the exhibit of a living room in the *Salon d'Automne 1929,* including all the "equipment of a dwelling," a project that Le Corbusier realized in collaboration with Charlotte Perriand. In this image which Le Corbusier has published in the *Oeuvre complète,* Perriand herself is lying on the *chaise-longue,* her head turned away from the camera. More significant, in the original photograph employed in this photo collage (as well as in another photograph in the *Oeuvre complète* which shows the *chaise-longue* in the horizontal position),

**26  Immeuble Clarté, Ginebra, 1930–32.**
View of the interior.

**27  Immeuble Clarté.**
The terrace.

**28    Charlotte Perriand in the *chaise-longue* against the wall.**
*Salon d'Automne 1929.*

**29    *Chaise-longue* in the horizontal position.**

one can see that the chair has been placed right against the wall. Remarkably, she is facing the wall. She is almost an attachment to the wall. She sees nothing (figures 28, 29).

And of course for Le Corbusier–who writes things such as "I exist in life only on condition that I see" (*Précisions*, 1930) or "This is the key: to look ... to look/observe/see/imagine/invent, create" (1963), and in the last weeks of his life: "I am and I remain an impenitent visual" (*Mise au Point*)–everything is in the visual.[38] But what does *vision* mean here?

We should now return to the passage in *Urbanisme* which opens this paper ("Loos told me one day: 'A cultivated man does not look out of the window ...'") because in that very passage he has provided us with a clue to the enigma when he goes on to say: "Such sentiment [that of Loos with regard to the window] can have an explanation in the congested, disordered city where disorder appears in distressing images; one could even admit the paradox [of a Loosian window] before a sublime natural spectacle, too sublime."[39] For Le Corbusier the metropolis itself was "too sublime." The look, in Le Corbusier's architecture, is not that look which would still pretend to contemplate the metropolitan spectacle with the detachment of a nineteenth-century observer before a sublime, natural landscape. It is not the look in Hugh Ferriss' drawings of *The Metropolis of Tomorrow*, for example.[40]

In this sense, the penthouse that Le Corbusier did for Charles de Beistegui on the Champs-Elysées, Paris (1929-31) becomes symptomatic (figures 30, 31). In this house, originally intended not to be inhabited but to serve as a frame for big parties, there was

. . . . . . . . . . . .

**38** Pierre-Alain Crosset, "Eyes Which See," *Casabella* 531–532 (1987): 115.

**39** "Un tel sentiment s'explique dans la ville congestionnée ou le désordre apparaît en images affligeantes; on admettrait même le paradoxe en face d'un spectacle natural sublime, trop sublime." Le Corbusier, *Urbanisme*, pp. 174–176.

**40** Le Corbusier makes reference to Hugh Ferriss in his book *La Ville radieuse* (Paris: Vincent, Freal & Cie., 1933), when he writes as caption accompanying a collage of images contrasting Hugh Ferriss and the actual New York with the Plan Voisin and Notre Dame: "The French tradition–Notre Dame and the Plan Voisin ('horizontal' skyscrapers) versus the American line (tumult, bristling, chaos, first explosive state of a new medievalism)." *The Radiant City* (New York: Orion Press, 1967), p. 133.

30   Apartment Charles de Beistegui, Paris, 1929–31.

31   Apartment Beistegui.
View from the living room toward the dining room.

**32    Apartment Beistegui.**
Terrace.

no electric lighting. Beistegui wrote: "the candle has recovered all
its rights because it is the only one which gives a *living* light."[41]
"Electricity, modern power, is invisible, it does not illuminate the
dwelling, but activates the doors and moves the walls."[42]

Electricity is used *inside* this apartment to slide away partition
walls, operate doors, and allow cinematographic projections on
the metal screen (which unfolds automatically as the chandelier
rises up on pulleys), and *outside,* on the roof terrace, to slide the
banks of hedges to frame the view of Paris: "En pressant un bou-
ton électrique, la palissade de verdure s'écarte et Paris apparaît"[43]

. . . . . . . . . . . .

**41** Charles de Beistegui interviewed by Roger Baschet in *Plaisir de France*
(March 1936): 26–29. Cited by Pierre Saddy, "Le Corbusier chez les riches:
l'appartement Charles de Beistegui," *Architecture, mouvement, continuité,* no.
49 (1979): 57–70. About this apartment, see also "Appartement avec
terrasses," *L'Architecte* (October 1932): 102–104.
**42** "L'électricité, puissance moderne, est invisible, elle n'éclaire point la
demeure, mais actionne les portes et déplace les murailles...." Baschet,
interview with Charles de Beistegui, *Plaisir de France* (March 1936).
**43** Pierre Saddy, "Le Corbusier e l'Arlecchino," *Rassegna* 3 (1980).

(figure 32). Electricity is used here not to illuminate, to make *visible*, but as a technology of framing. Doors, walls, hedges, that is, traditional architectural framing devices, are activated with electric power, as are the built-in cinema camera and its projection screen, and when these modern frames are *lit*, the "living" light of the chandelier gives way to another living light, the flickering light of the movie, the "flicks."

This new "lighting" displaces traditional forms of enclosure, as electricity had done before it.[44] This house is a commentary on the new condition. The distinctions between *inside* and *outside* are here made problematic. In this penthouse, once the upper level of the terrace is reached, the high walls of the *chambre ouverte* allow only fragments of the urban skyline to emerge: the tops of the Arc de Triomphe, the Eiffel Tower, the Sacré Coeur, Invalides, etc. (figure 33). And it is only by remaining inside and making use of the periscope camera obscura that it becomes possible to enjoy the metropolitan spectacle (figure 34). Tafuri has written: "The distance interposed between the penthouse and the Parisian panorama is secured by a technological device, the periscope. An 'innocent' reunification between the fragment and the whole is no longer possible; the intervention of artifice is a necessity."[45]

But if this periscope, this primitive form of prosthesis, this "artificial limb," to return to Le Corbusier's concept in *L'Art décoratif d'aujourd'hui,* is *necessary* in the Beistegui apartment (as also was the rest of the *artifice* in this house, the electrically driven framing devices, the other prostheses) it is only because the apart-

. . . . . . . . . . . .

44  Around the time that the Beistegui apartment was built, *La Compagnie parisienne de distribution d'électricité* put out a publicity book, *L'Electricité à la maison,* attempting to gain clients. In this book, electricity is made *visible* through architecture. A series of photographs by André Kertesz present views of interiors by contemporary architects, including A. Perret, Chausat, Laprade, and M. Perret. The most extraordinary one is probably a closeup of a "horizontal" window in an apartment by Chausat, a view of Paris outside and a fan sitting on the sill of the window. The image marks the split between a traditional function of the window, ventilation, now displaced into a powered machine, and the modern functions of a window, to illuminate and to frame a view.

45  Manfredo Tafuri, *"Machine et mémoire*: The City in the Work of Le Corbusier," in *Le Corbusier,* ed. H. Allen Brooks (Princeton: Princeton University Press, 1987), p. 203.

**33   Apartment Beistegui.**
"La chambre à ciel ouvert."

**34   Apartment Beistegui.**
Periscope.

ment is *still* located in a nineteenth-century city: it is a penthouse in the Champs-Elysées. In "ideal" urban conditions, the house itself becomes the artifice.

For Le Corbusier the *new* urban conditions are a consequence of the media, which institutes a relationship between artifact and nature that makes the "defensiveness" of a Loosian window, of a Loosian system, unnecessary. In *Urbanisme,* in the same passage where he makes reference to "Loos' window," Le Corbusier goes on to write: "The horizontal gaze leads far away. ... From our offices we will get the feeling of being look-outs dominating a world in order. ... The skyscrapers concentrate everything in themselves: machines for abolishing time and space, telephones, cables, radios."[46] The inward gaze, the gaze turned upon itself, of Loos' interiors becomes with Le Corbusier a gaze of domination over the exterior world. But why is this gaze horizontal?

The debate between Le Corbusier and Perret over the horizontal window provides a key to this question.[47] Perret maintained that the vertical window, *la porte fenêtre,* "reproduces an impression of *complete* space" because it permits a view of the street, the garden, and the sky, while the horizontal window, *la fenêtre en longueur,* diminishes "one's perception and *correct* appreciation of the landscape." What the horizontal window cuts from the cone of vision is the strip of the sky and the strip of the foreground that sustains the illusion of perspectival depth. Perret's *porte fenêtre* corresponds to the space of perspective. Le Corbusier's *fenêtre en longueur* to the space of photography. It is not by chance that Le Corbusier continues his polemic with Perret in a passage in *Précisions,* where he "demonstrates" scientifically that the horizontal window illuminates better. He does so by relying on a photographer's chart giving times of exposure. He writes:

> I have stated that the horizontal window illuminates better than the
> vertical window. Those are my observations of the reality. Neverthe-

. . . . . . . . . . . .

**46** Le Corbusier, *Urbanisme,* p. 186.

**47** About the debate between Perret and Le Corbusier see: Bruno Reichlin, "The Pros and Cons of the Horizontal Window," *Daidalos* 13 (1984), and Beatriz Colomina, "Le Corbusier and Photography," *Assemblage* 4 (1987).

less, I have passionate opponents. For example, the following sen-
tence has been thrown at me: "A window is a man, it stands upright!"
This is fine if what you want are "words." But I have discovered
recently in a photographer's chart these explicit graphics; I am no
longer swimming in the approximations of personal observations. I
am facing sensitive photographic film that reacts to light. The table
says this: ... The photographic plate in a room illuminated with a
horizontal window needs to be exposed four times less than in a
room illuminated with two vertical windows. ... Ladies and gentle-
men ... We have left the Vignolized shores of the Institutes. We are at
sea; let us not separate this evening without having taken our bear-
ings. First, architecture: the pilotis carry the weight of the house
above the ground, up in the air. *The view of the house is a categorical view,
without connection with the ground.*[48] [author's emphasis]

The erected man behind Perret's *porte fenêtre* has been replaced
by a photographic camera. The view is free-floating, "without
connection with the ground," or with the man behind the camera
(a photographer's analytical chart has replaced "personal observa-
tions"). "The view from the house is a *categorical* view." In framing
the landscape the house places the landscape into a system of cate-
gories. The house is a mechanism for classification. It collects
views and, in doing so, classifies them. The house is a system for
taking pictures. What determines the nature of the picture is the
window. In another passage from the same book the window itself
is seen as a camera lens:

When you buy a camera, you are determined to take photographs in
the crepuscular winter of Paris, or in the brilliant sands of an oasis;
how do you do it? *You use a diaphragm.* Your glass panes, your hori-
zontal windows are all ready to be diaphragmed at will. You will let
light in wherever you like.[49]

If the window is a lens, the house itself is a camera pointed at
nature. Detached from nature, it is mobile. Just as the camera can
be taken from Paris to the desert, the house can be taken from

. . . . . . . . . . . .

48   Le Corbusier, *Précisions sur un état présent de l'architecture et de l'urbanisme*
(Paris: Vincent, Freal & Cie., 1930), pp. 57–58.
49   Ibid., pp. 132–133.

Poissy to Biarritz to Argentina. Again in *Précisions,* Le Corbusier describes Villa Savoye as follows:

> The house is a box in the air, pierced all around, without interruption, by a *fenêtre en longueur.* ... The box is in the middle of meadows, dominating the orchard. ... The simple posts of the ground floor, through a precise disposition, cut up the landscape with a regularity that has the effect of suppressing any notion of "front" or "back" of the house, of "side" of the house. ... The plan is pure, made for the most exact of needs. It is in its right place in the rural landscape of Poissy. But in Biarritz, it would be magnificent. ... I am going to implant this very house in the beautiful Argentinian countryside: we will have twenty houses rising from the high grass of an orchard where cows continue to graze.[50]

The house is being described in terms of the way it frames the landscape and the effect this framing has on the perception of the house itself by the moving visitor. The house is in the air. There is no front, no back, no side to this house.[51] The house can be in any place. The house is *immaterial.* That is, the house is not simply constructed as a material object from which, then, certain views become possible. The house is no more than a series of views choreographed by the visitor, the way a filmmaker effects the montage of a film.[52]

. . . . . . . . . . . .

50   Ibid., pp. 136–138.

51   This erasure of the front, despite the insistence of traditional criticism that Le Corbusier's buildings should be understood in terms of their façades, is a central theme of Le Corbusier's writings. For example, about the project for the Palace of the Nations in Geneva he wrote: "Alors, me dira-t-on inquiet, vous avez construit des murs autour ou entre vos pilotis afin de ne pas donner l'angoissante sensation de ces gigantesques bâtiments en l'air? Oh, pas du tout! Je montre avec satisfaction ces pilotis qui portent quelque chose, qui se doublent de leur reflet dans l'eau, qui laissent passer la lumière sous les bâtiments *supprimant ainsi toute notion de ⟨devant⟩ et de ⟨derrière⟩ de bâtiment." Précisions,* p. 49 (my emphasis).

52   Significantly, Le Corbusier has represented some of his projects, like Villa Meyer and Maison Guiette, in the form of a series of sketches grouped together and representing the perception of the house by a moving eye. As has been noted, these drawings suggest film story boards, each of the images a still. Lawrence Wright, *Perspective in Perspective* (London: Routledge and Kegan Paul, 1983), pp. 240–241.

This is also evident in Le Corbusier's description of the process followed in the construction of the *petite maison* on the shores of Lake Leman:

> I knew that the region where we wanted to build consisted of 10 to 15 kilometers of hills along the lake. A fixed point: the lake; another, the magnificent view, frontal; another, the south, equally frontal.
>
> Should one first have searched for the site and made the plan in accordance with it? That is the usual practice.
>
> I thought it was better to make an exact plan, corresponding ideally to the use one hoped from it and determined by the three factors above. This done, to go out with the plan in hand to look for a suitable site. [53]

"The key to the problem of modern habitation" is, according to Le Corbusier, "to inhabit first," "placing oneself afterwards." ("Habiter d'abord." "Venir se placer ensuite.") But what is meant here by "inhabiting" and "placement"? The "three factors" that "determine the plan" of the house—"the lake, the magnificent frontal view, the south, equally frontal"—are precisely the factors that determine a photograph. "To inhabit" here means to inhabit that picture. "Architecture *is made in the head,*" then drawn. [54] Only then does one look for the site. But the site is only where the landscape is "taken," framed by a mobile lens. This photo-opportunity is at the intersection of the system of communication that establishes that mobility, the railway, and the landscape. [55] But even the landscape is here understood as a 10 to 15 kilometer strip,

. . . . . . . . . . . .

**53**   Le Corbusier, *Précisions,* p. 127.
**54**   Ibid., p. 230.
**55**   "The geographical situation confirmed our choice, for at the railway station twenty minutes away trains stop which link up Milan, Zurich, Amsterdam, Paris, London, Geneva and Marseilles ..." Le Corbusier, *Une Petite maison* (Zurich: Editions d'Architecture, 1954), p. 8. The network of the railway is understood here as *geography*. The "features or arrangement of place" ("geography" according to the Oxford Dictionary) are now defined by the communication system. It is precisely within this system that the house moves: "1922, 1923 I boarded the Paris-Milan express several times, or the Orient Express (Paris-Ankara). In my pocket was the plan of a house. A plan without a site? The plan of a house in search of a plot of ground? Yes!" Le Corbusier, *Une Petite maison,* p. 5.

**35** *On a découvert le terrain.*
*Une Petite maison,* 1954.

rather than a *place* in the traditional sense. The camera can be set up anywhere along that strip.

The house is drawn with a picture already in mind. The house is drawn as a frame for that picture. The frame establishes the difference between "seeing" and merely looking. It produces the picture by domesticating the "overpowering" landscape:

> The object of the wall seen here is to block off the view to the north and east, partly to the south, and to the west; for the ever-present and overpowering scenery on all sides has a tiring effect in the long run. Have you noticed that *under such conditions one no longer "sees"?* To lend significance to the scenery one has to restrict and give it proportion; the view must be blocked by walls which are only pierced at certain strategic points and there permit an unhindered view.[56]

It is this domestication of the view that makes the house a house, rather than the provision of a domestic space, a *place* in the traditional sense. Two drawings published in *Une Petite maison* speak about what Le Corbusier means by "placing oneself." In one of them, *On a découverte le terrain* (figure 35), a small human figure appears standing and next to it a big eye, autonomous from the figure, oriented towards the lake. The plan of the house is between

. . . . . . . . . . . . .

**56**  Ibid., pp. 22–23.

36   *Le Plan est installé....*
*Une Petite maison*, 1954.

them. The house is represented as that between the eye and the lake, between the eye and the view. The small figure is almost an accessory. The other drawing, *Le Plan est installe* (Figure 36), does not show, as the title would indicate, the encounter of the plan with the site, as we traditionally understand it. (The site is not in the drawing. Even the curve of the shore of the lake in the other drawing has been erased.) The drawing shows the plan of the house, a strip of lake, and a strip of mountains. That is, it shows the plan and above it, the view. The "site" is a vertical plane, that of vision.

Of course, there is no "original" in the new architecture, because it is not dependent on the specific place. Throughout his writings, Le Corbusier insists on the relative autonomy of architecture and site.[57] And in the face of the traditional site he constructs an "artificial site."[58] This does not mean that this architec-

...........

57   For example, in Le Corbusier and François de Pierrefeu, *La Maison des hommes* (Paris: Plon, 1942), he writes: "Aujourd'hui, la conformité du sol avec la maison n'est plus une question d'assiette ou de contexte immédiat," p. 68. It is significant that this and other key passages of this book were omitted in the English translation, *The Home of Man* (London: Architectural Press, 1948).

58   About his project for Rio de Janeiro, he writes: "Here you have the idea: here you have *artificial sites,* countless new homes, and as for traffic–the Gordian knot has been severed." Le Corbusier, *The Radiant City,* p. 224.

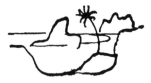

Ce roc à Rio-de-Janeiro est cé-
lèbre.

Autour de lui se dressent des mon-
tagnes échevelées ; la mer les baigne.

Des palmiers, des bananiers; la
splendeur tropicale anime le site. On
s'arrête, on y installe son fauteuil.

Crac! un cadre
tout autour.
Crac! les quatre
obliques d'une pers-
pective! Votre
chambre est ins-
tallée face au site.
Le paysage entre
tout entier dans
votre chambre.

Le pacte avec la nature a été scellé! Par des dispositifs d'urbanisme, il est possible
d'inscrire la nature dans le bail.
Rio-de-Janeiro est un site célèbre. Mais Alger, mais Marseille, mais Oran, Nice et toute
la Côte d'Azur, Barcelone et tant de villes maritimes ou continentales disposent de paysages
admirables!

60

37  **Rio de Janeiro.**
The view is constructed at the same time as the house. *La Maison des
hommes*, 1942.

ture is independent from place. It is the concept "place" that has changed. We are not talking here about a site but about a sight. A sight can be accommodated in several sites.

"Property" has moved from the horizontal to the vertical plane. (Even Beistegui's primary location from a traditional point of view, the *address*–Champs-Elysées–is completely subordinated by the *view*.[59]) The window is a problem of urbanism. That is why it becomes a central point in every urban proposal by Le Corbusier. In Rio de Janeiro, for example, he developed a series of drawings in vignette that represent the relation between domestic space and spectacle:[60]

> This rock at Rio de Janeiro is celebrated.
> Around it range the tangled mountains, bathed by the sea.
> Palms, banana trees; tropical splendor animates the site.
> One stops, one installs one's armchair.
> Crack! a frame all around.
> Crack! the four obliques of a perspective. Your room is installed before the site. The whole sea-landscape enters your room.[61]
> (figure 37)

First a famous sight, a postcard, a picture. (And it is not by chance that Le Corbusier has not only drawn this landscape from a postcard but has published it alongside the drawings in *La Ville radieuse*).[62] Then, one inhabits the space in front of that picture, installs an armchair. But this view, this picture, is only constructed at the same time as the house.[63] "Crack! a frame all around it. Crack! the four obliques of a perspective." The house is installed *before* the site, not *in* the site. The house is a frame for a view. The window is a gigantic screen. But then the view *enters* the house, it is literally "inscribed" in the lease:

. . . . . . . . . . . . .

59  In *Précisions* he writes: "La rue est indépendante de la maison. La rue est indépendante de la maison. Y réfléchir," p. 62. But it must be noted that it is the street that is independent from the house and not the other way around.

60  About the association of the notion of spectacle to that of dwelling, see Hubert Damisch, "Les tréteaux de la vie moderne," in *Le Corbusier: une encyclopédie* (Paris: Centre Georges Pompidou, 1987), pp. 252–259. See also Bruno Reichlin, "L'Esprit de Paris," *Casabella* 531–532 (1987): 52–63.

61  Le Corbusier and Pierrefeu, *The Home of Man*, p. 87.

62  Le Corbusier, *The Radiant City*, pp. 223–225.

63  Cf. Damisch, "Les tréteaux de la vie moderne," p. 256.

**38   Rio de Janeiro.**
The highway, elevated 100 meters, and "launched" from hill to hill
above the city. *La Ville radieuse,* 1933.

The pact with nature has been sealed! By means available to town
planning it is possible to enter nature in the lease. Rio de Janeiro is a
celebrated site. But Algiers, Marseilles, Oran, Nice and all the Côte
d'Azur, Barcelona and many maritime and inland towns can boast of
admirable landscapes.[64]

Again, several sites can accommodate this project: different
locations, different pictures (like the world of tourism). But also
different pictures of the same location. The repetition of units
with windows at slightly different angles, different framings, as
happens when this cell becomes a unit in the urban project for Rio
de Janeiro, a project which consists on a six-kilometer strip of
housing units under a highway on pilotis, suggests again the idea
of the movie strip (figure 38). This sense of the movie strip is felt
both in the inside and the outside: "Architecture? Nature? Liners
enter and see the new and *horizontal city*: it makes the site still more
sublime. Just think of this broad *ribbon of light,* at night ..."[65] The
strip of housing is a movie strip, on both sides.

For Le Corbusier, "to inhabit" means to inhabit the camera.
But the camera is not a traditional place, it is a system of classifica-
tion, a kind of filing cabinet. "To inhabit" means to employ that
system. Only after this do we have "placing," which is to place the
view in the house, to take a picture, to place the view in the filing
cabinet, to classify the landscape.

. . . . . . . . . . . .

**64**   Le Corbusier and Pierrefeu, *The Home of Man,* p. 87.
**65**   Le Corbusier, *The Radiant City,* p. 224.

This critical transformation of traditional architectural think-
ing about place can also be seen in *La Ville radieuse* where a sketch
represents the house as a cell with a view (figure 39). Here an
apartment, high up in the air, is presented as a terminal of tele-
phone, gas, electricity, and water. The apartment is also provided
with "exact air" (heating and ventilation).[66] Inside the apartment
there is a small human figure and at the window, a huge eye look-
ing outside. They do not coincide. The apartment itself is here the
artifice between the occupant and the exterior world, a camera
(and a breathing machine). The exterior world also becomes arti-
fice; like the air, it has been conditioned, landscaped–it *becomes*
landscape. The apartment defines modern subjectivity with its
own eye. The traditional subject can only be the *visitor,* and as
such, a temporary part of the viewing mechanism. The humanist
subject has been displaced.

The etymology of the word *window* reveals that it combines
*wind* and *eye*[67] (ventilation and light in Le Corbusier's terms). As
Georges Teyssot has noted, the word combines "an element of the
outside and an aspect of innerness. The separation on which
dwelling is based is the possibility for a being to install himself."[68]
But in Le Corbusier this installation splits the subject itself, rather
than simply the outside from the inside. Installation involves a
convoluted geometry which entangles the division between inte-
rior and exterior, between the subject and itself.

It is precisely in terms of the *visitor* that Le Corbusier has writ-
ten about the occupant. For example, about Villa Savoye he writes
in *Précisions:*[69]

. . . . . . . . . . . .

**66**  Whereas Loos' window had split sight from light, Le Corbusier's splits
*breathing* from these two forms of *light.* "A window is to give light, not to
ventilate! To ventilate we use machines; it is mechanics, it is physics." Le
Corbusier, *Précisions,* p. 56.
**67**  E. Klein, *A Complete Etymological Dictionary of the English Language*
(Amsterdam, London, New York, 1966). Cited by Ellen Eve Frank in
*Literary Architecture* (Berkeley: University of California Press, 1979), p. 263,
and by Georges Teyssot in "Water and Gas on all Floors," *Lotus* 44 (1984):
90.
**68**  Ibid.
**69**  Le Corbusier had recommended that Madame Savoye leave a book for
guests to sign by the entrance: she would collect many signatures, as La
Roche had. But La Roche was also a gallery. Here the house itself became
the object of contemplation, not the objects inside it.

39   Sketch in *La Ville radieuse*, 1933.

The visitors, till now, turn round and round in the interior, asking themselves what is happening, understanding with difficulties the reasons for what they see and feel; they do not find anything of what is called a "house." They feel themselves in something entirely new. And ... I do not think they are bored![70]

The occupant of Le Corbusier's house is displaced, first because he is disoriented. He does not know how to place himself in relation to this house. It does not look like a "house." Then because the occupant is a "visitor." Unlike the occupant of Loos' houses, both actor and spectator, both involved and detached from the stage, Le Corbusier's subject is detached from the house with the distance of a visitor, a viewer, a photographer, a tourist.

In a photograph of the interior of Villa Church (figure 40), a casually placed hat and two open books on the table announce that somebody has just been there. A window with the traditional proportions of a painting is framed in a way that makes it read also as a screen. In the corner of the room a camera set on a tripod appears. It is the reflection on the mirror of the camera taking the photograph. As viewer of this photograph we are in the position of the photographer, that is, in the position of the camera, because the photographer, as the visitor, has already abandoned the room. The subject (the visitor of the house, the photographer, but also the viewer of this photograph) has already left. The subject in Le Corbusier's house is estranged and displaced from "his" own home.

The objects left as "traces" in the photographs of Le Corbusier's houses tend to be those of a (male) "visitor" (hat, coat, etc.). Never do we find there any trace of "domesticity," as traditionally understood.[71] These objects also could be understood as standing for the architect. The hat, coat, glasses are definitely his own. They play the same role that Le Corbusier plays as an actor in the movie *L'Architecture d'aujourd'hui,* where he passes through the house rather than inhabits it. The architect is *estranged* from his work with the distance of a visitor or a movie actor. "The stage

. . . . . . . . . . . .

70  Le Corbusier, *Précisions,* p. 136.
71  It is not a casually placed cup of tea that we find, but an "artistic" arrangement of objects of everyday life, as in the kitchens of Savoye and Garches. We may speak here about "still lifes" more than about domesticity.

40   Villa Church, Ville d'Avray, 1928–29.

actor identifies himself with the character of his role. The film
actor very often is denied this opportunity. His creation is by no
means all of a piece; it is composed of many separate perfor-
mances."[72] Theater knows necessarily about emplacement, in the
traditional sense. It is always about presence. Both the actor and
the spectator are fixed in a continuous space and time, those of the
performance. In the shooting of a movie there is no such continu-
ity. The actor's work is split into a series of discontinuous, mount-
able episodes. The nature of the illusion for the spectator is a result
of the montage.

The subject of Loos' architecture is the stage actor. But while
the center of the house is left empty for the performance, we find
the subject occupying the threshold of this space. Undermining its
boundaries. The subject is split between actor and spectator of its
own play. The completeness of the subject dissolves as also does
the wall that s/he is occupying.

. . . . . . . . . . . .

72   Walter Benjamin, "The Work of Art in the Age of Mechanical
Reproduction," in *Illuminations,* trans. Harry Zohn (New York: Schocken
Books, 1969), p. 230.

The subject of Le Corbusier's work is the movie actor, "estranged not only from the scene but from his own person."[73] This moment of estrangement is clearly marked in the drawing of *La Ville radieuse* where the traditional humanist figure, the inhabitant of the house, is made incidental to the camera eye: it comes and goes, it is merely a visitor.

The split between the traditional humanist subject (the occupant or the architect) and the *eye* is the split between *looking* and *seeing,* between *outside* and *inside,* between *landscape* and *site.* In the drawings, the inhabitant or the person in search of a site are represented as diminutive figures. Suddenly that figure *sees.* A picture is taken, a large eye, autonomous from the figure, represents that moment. This is precisely the moment of *inhabitation.* This inhabitation is independent from *place* (understood in a traditional sense); it turns the outside into an inside:

> I perceive that the work we raise is not unique, nor isolated; that the air around it constitutes other surfaces, other grounds, other ceilings, that the harmony that has suddenly stopped me before the rock of Brittany, exists, can exist, everywhere else, always. The work is not made only of itself: the outside exists. The outside shuts me in its whole which is like a room.[74]

"Le dehors est toujours un dedans" (the outside is always an inside) means that the "outside" is a picture. And that "to inhabit" means *to see.* In *La Maison des hommes* there is a drawing of a figure standing and (again), side by side, an independent eye: "Let us not forget that our eye is 5 feet 6 inches above the ground; our eye, this entry door of our architectural perceptions."[75] The eye is a "door"
. . . . . . . . . . . .

73 Pirandello describes the estrangement the actor experiences before the mechanism of the cinematographic camera: "The film actor feels as if in exile–exiled not only from the stage but also from himself. With a vague sense of discomfort he feels inexplicable emptiness: his body loses corporeality, it evaporates, it is deprived of reality, life, voice and the noises caused by its moving about, in order to be changed into a mute image, flickering an instant on the screen, then vanishing into silence." Luigi Pirandello, *Si Gira,* quoted by Walter Benjamin in "The Work of Art in the Age of Mechanical Reproduction," p. 229.
74 Le Corbusier, *Précisions,* p. 78.
75 Le Corbusier and Pierrefeu, *The Home of Man,* p. 100.

to architecture, and the "door" is, of course, an architectural ele-
ment, the first form of a "window."[76] Later in the book, "the
door" is replaced by media equipment, "the eye is the tool of
recording."

> The eye is a tool of registration. It is placed 5 feet 6 inches above the
> ground.
> Walking creates diversity in the spectacle before our eyes.
> But we have left the ground in an airplane and acquired the eyes of a
> bird. We see, in actuality, that which hitherto was only seen by the
> spirit.[77]

The window is, for Le Corbusier, first of all communication.
He repeatedly superimposes the idea of the "modern" window, a
lookout window, a horizontal window, with the reality of the new
media: "telephone, cable, radios, ... machines for abolishing time
and space." Control is now in these media. Power has become
"invisible." The look that from Le Corbusier's skyscrapers will
"dominate a world in order" is neither the look from behind the
periscope of Beistegui or the defensive view (turned towards
itself) of Loos' interiors. It is a look that "registers" the new reality,
a "recording" eye.

Le Corbusier's architecture is produced by an engagement
with the mass media but, as with Loos, the key to his position is,
in the end, to be found in his statements about fashion. Where for
Loos the English suit was the mask necessary to sustain the indi-
vidual in metropolitan conditions of existence, for Le Corbusier
this suit is cumbersome and inefficient. And where Loos contrasts
the *dignity* of male British fashion with the *masquerade* of women's,
Le Corbusier praises women's fashion over men's because it has
undergone *change,* the change of modern time.

> Woman has preceded us. She has carried out the reform of her dress.
> She found herself at a dead end: to follow fashion and, then, give up
> the advantages of modern techniques, of modern life. To give up

. . . . . . . . . . . .

76  Paul Virilio, "The Third Window: An Interview with Paul Virilio," in
*Global Television,* ed. Cynthia Schneider and Brian Wallis (New York and
Cambridge, Mass.: Wedge Press and MIT Press, 1988), p. 191.
77  Le Corbusier and Pierrefeu, *The Home of Man,* p. 125.

sport and, a more material problem, to be unable to take on the jobs that have made woman a fertile part of contemporary production and enabled her *to earn her own living*. To follow fashion: she could not drive a car; she could not take the subway, or the bus, nor act quickly in her office or her shop. To carry out the daily *construction* of a "toilette": hairdo, shoes, buttoning her dress, she would not have had time to sleep. So, woman cut her hair and her skirts and her sleeves. She goes out bareheaded, barearmed, with her legs free. And she can dress in five minutes. And she is beautiful; she seduces us with the charm of her graces of which the designers have admitted taking advantage. The courage, the liveliness, the spirit of invention with which woman has revolutionized her dress are a miracle of modern times. Thank you!

And what about us, men? A dismal state of affairs! In our dress clothes, we look like generals of the "Grand Armée" and we wear starched collars! We are uncomfortable ...[78]

While Loos spoke, you will remember, of the exterior of the house in terms of male fashion, Le Corbusier's comments on fashion are made in the context of a discussion of the interior. The furniture in style (Louis XIV) should be replaced with *equipment* (standard furniture, in great part derived from office furniture) and this change is assimilated to the change that women have undertaken in their dress. He concedes, however, that there are certain advantages to male dressing:

The English suit we wear had nevertheless suceeded in something important. It had *neutralized* us. It is useful to show a neutral appearance in the city. The dominant sign is no longer ostrich feathers in the hat, it is in the gaze. That's enough.[79]

Except for this last comment, "The dominant sign ... is in the gaze," Le Corbusier's statement is purely Loosian. But at the same time, it is precisely that *gaze* of which Le Corbusier speaks that marks their differences. For Le Corbusier the interior no longer needs to be defined as a system of defense from the exterior (the system of gazes in Loos' interiors, for example). To say that "the

. . . . . . . . . . . .

**78**  Le Corbusier, *Précisions,* pp. 106–107.
**79**  Ibid., p. 107.

exterior is always an interior" means, among other things, that the interior is not simply the bounded territory defined by its opposition to the exterior. The exterior is "inscribed" in the dwelling. The window in the age of mass communication provides us with one more flat image. The window is a screen. From there issues the insistence on eliminating every protuding element, "de-vignolizing" the window, suppressing the sill: "M. Vignole ne s'occupe pas des fenêtres, mais bien des ⟨entre-fenêtres⟩ (pilastres ou colonnes). Je dévignolise par: *l'architecture, c'est des planchers éclairés.*"[80]

Of course, this screen undermines the wall. But here it is not, as in Loos' houses, a *physical* undermining, an *occupation* of the wall, but a *dematerialization* following from the emerging media. The organizing geometry of architecture slips from the perspectival cone of vision, from the humanist eye, to the camera angle.

But this slippage is, of course, not neutral in gender terms. Male fashion is uncomfortable but provides the bearer with "the gaze," "the dominant sign," woman's fashion is practical and turns her into the object of another's gaze: "Modern woman has cut her hair. Our gazes have known (enjoy) the shape of her legs." A picture. She sees nothing. She is an attachment to a wall that is no longer simply there. Enclosed by a space whose limits are defined by a gaze.

. . . . . . . . . . . . .

**80**   Ibid., p. 53.

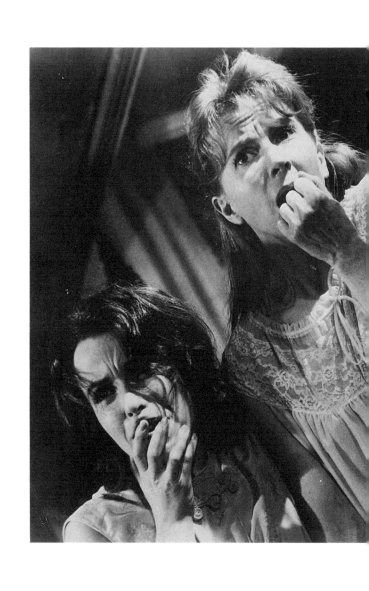

# Female Spectator, Lesbian Specter: *The Haunting*

## Patricia White

FEMINISM HAS SHAPED contemporary film studies in a funda-
mental fashion. Nevertheless it has become increasingly apparent
that discussions of critical issues such as desire, identification, and
visual and narrative pleasure do not automatically encompass the
lesbian subject. The dominance of the heterosexual concept of
"sexual difference" as term and telos of feminist inquiry has
impoverished not only the study of specific film texts, but also the
very theorization of female subjectivity. In this essay I attempt to
trace the ghostly presence of lesbianism in classical Hollywood
cinema, on the one hand, and in feminist film theory, on the other,
through the reading of two texts in which a defense against homo-
sexuality can be detected.

## Genre and Deviance

What have been considered the very best of "serious" Hollywood ghost movies—*Curse of the Cat People* (1944), *The Uninvited* (1944), *The Innocents* (1961; figure 1), and Robert Wise's 1963 horror classic *The Haunting* to name a few—are also, by some uncanny coincidence, films with eerie lesbian overtones. Masquerading as family romance, these films unleash an excess of female sexuality which cannot be contained without recourse to the super-natural. To be more explicit, in the case of *The Haunting,* female homosexuality is manifested in the character of Claire Bloom. Regrettably though perhaps understandably eclipsed by two films directed by Wise just before and after *The Haunting,* namely *West Side Story* and *The Sound of Music,* the film will maintain its place in cinematic history for two reasons. First, it is one of the few Hollywood films that *has* a lesbian character. Claire Bloom appears as what is perhaps the least objectionable of sapphic stereotypes—the beautiful, sophisticated, and above all predatory lesbian. Although not herself a fashion designer, her wardrobe is by Mary Quant; she has ESP, and she shares top billing with Julie Harris, a star who—from her film debut in *The Member of the Wedding* through her incongruous casting as James Dean's love interest in *East of Eden,* to her one-woman show, *The Belle of Amherst*—has insistently been coded "eccentric." The second reason for which *The Haunting* is remembered is its effectiveness as a horror film. Like its source, Shirley Jackson's *The Haunting of Hill House,* the movie is adept in achieving in the spectator what Dorothy Parker on the book jacket calls "quiet, cumulative shudders."[1] At least one reliable source proclaims *The Haunting* "undoubtedly the scariest ghost movie ever made."[2] It is clear that reason number two is related to reason number one—for *The Haunting* is one of the screen's most spine-tingling representations of the disruptive force of lesbian desire.

Though the alliance of horror with lesbianism may leave one uneasy, it should be pointed out that the horror genre has been

. . . . . . . . . . . .

1   Shirley Jackson, *The Haunting of Hill House* (New York: Penguin Books, 1959; reprinted 1987).
2   Michael Weldon, *The Psychotronic Encyclopedia of Film* (New York: Ballantine, 1983), p. 307.

I

claimed by film criticism as a "progressive" one on several grounds. Concerned with the problem of the normal, it activates the abnormal in the "threat" or the figure of the monster. Critic Linda Williams has noted a potentially empowering affinity between the woman and the monster in classic horror films, without exploring the trope of the monster as lesbian. The omission of any mention of lesbian desire is all the more striking given her thesis: "it is a truism of the horror genre that sexual interest resides most often in the monster and not the bland ostensible heroes," or, "clearly the monster's power is one of sexual difference from the normal male."[3]

The horror genre manipulates codes specific to the cinema—camera angles that warp the legibility of the image and the object of the gaze; framing that evokes the terror of what-lies-beyond the frame; sound effects that are not diegetically motivated; unexplained point-of-view shots that align the spectator with the monster—for effect and affect.

In *The Haunting* the two female leads, both "touched by the supernatural" (as it were), are invited to take part in a psychic experiment in a haunted New England mansion. As explicitly deviant women, they are asked to bear witness to an other power, an alternative reality. They join their host Dr. Markway (Richard

. . . . . . . . . . . . .

3  Linda Williams, "When the Woman Looks," in *Re-Vision,* ed. Mary Ann Doane, Patricia Mellencamp, and Linda Williams (Frederick, Md.: University Publications of America and the American Film Institute, 1984), p. 87. The fact that the horror genre is not one traditionally associated with female audiences is nicely illustrated by Williams: "Whenever the movie screen holds a particularly effective image of terror, little boys and grown men make it a point of honor to look, while little girls and grown women cover their eyes or hide behind the shoulders of their dates" (p. 83). The representation of the female gaze within the film, however, is a primary device of horror. As Mary Ann Doane reads Williams' argument: "Female scopophilia is a drive without an object ... what the woman actually sees, after a sustained and fearful process of looking, is a sign or representation of herself displaced to the level of the nonhuman" (*The Desire to Desire* [Bloomington: Indiana University Press, 1986], pp. 141–142). Doane's remarks on the horror film are made within her discussion of the film gothic, a genre which does address a female spectator, and with which *The Haunting* shares an affiliation.

2   Intrepid psychic explorers (from left to right) Claire Bloom, Russ
    Tamblyn, Julie Harris, Richard Johnson, publicity photo for *The
    Haunting* (Robert Wise, 1963).

Johnson), the pompous anthropologist-turned-ghost buster, and
the wisecracking future heir to the house, Luke (Russ Tamblyn),
who is skeptical of any unusual "goings-on"[4] (figure 2). A truly
terrifying sojourn with the supernatural at Hill House leaves the
Julie Harris character dead due to unnatural causes and the specta-
tor thoroughly shaken.

. . . . . . . . . . . . .

4   As one contemporary reviewer summarized the doctor's thesis: "The
occurrences, according to Markway, are 'brought on by the people whom
they affect,'" pointing to the similarity among theories of neurosis,
homosexuality, and "haunting" which I will exploit later (*Film Quarterly* 17
[Winter 1963–64]: 44–46). The review focuses on the specifically filmic
means by which Wise achieves the terrifying effects of *The Haunting*. The
film's press book recounts how Wise was posed with the problem of
filming "nothing," and how he devised an ingenious effect for filming a
"cold spot," thereby allying the director with the doctor.

## Secret Beyond Theory's Door

The lesbian specter can also be said to haunt feminist film theory, and in particular to stalk the female spectator as she is posited and contested in that discourse. The "problem" of female spectatorship has taken on a dominant and, in a sense, quite puzzling position in feminist film theory, which in some instances has denied its very possibility. Laura Mulvey herself, rereading her widely-read "Visual Pleasure and Narrative Cinema" in an essay called "Afterthoughts on Visual Pleasure and Narrative Cinema," explains: "At the time, I was interested in the relationship between the image of woman on the screen and the 'masculinization' of the spectator position, regardless of the actual sex (or possible deviance) of any real live movie-goer."[5] This parenthetical qualifier, "(or possible deviance)," is one of the few references to sexual orientation in the body of film theory. Yet within the binary stranglehold of sexual difference, lesbianism is so neatly assimilated to the "masculinization of the spectator position" as to constitute an *im*possible deviance.

In asserting the female spectator's narcissistic overidentification with the image; in describing her masculinization by an active relation to the gaze; or in claiming that the fantasy of the film text allows the spectator to circulate among identifications "across" gender and sexuality, feminist film theory seems to enact what Freud poses as the very operation of paranoia: the defense against homosexuality.[6] Female spectatorship may well be a theoretical "problem" only insofar as lesbian spectatorship is a real one.[7]

. . . . . . . . . . . .

**5** Laura Mulvey, "Afterthoughts on 'Visual Pleasure and Narrative Cinema' Inspired by *Duel in the Sun* (King Vidor, 1946)," *Framework,* nos. 15/16/17 (1981): 12.

**6** "In all of these cases a defence against a homosexual wish was clearly recognizable at the very centre of the conflict which underlay the disease." Sigmund Freud, "On the Mechanism of Paranoia" (1911), in *General Psychological Theory,* ed. Philip Rieff (New York: Collier Books, 1963), p. 29.

**7** The appearance of the special issue of *Camera Obscura* on "The Spectatrix," 20–21 (May–September 1989), edited by Janet Bergstrom and Mary Ann Doane, signals the continued vigor of these debates. National surveys and a host of individual responses to a series of questions on the theorization and relevance of female spectatorship offer a great deal of information on scholars' research. However, the forum of the survey discouraged the participation of key figures in feminist film theory, most notably Teresa de Lauretis and Tania Modleski.

In *The Desire to Desire: The Woman's Film of the 1940s,* Mary Ann Doane addresses female spectatorship in relation to the film gothic, a (sub)genre which she aptly designates the "paranoid woman's film." Doane argues that the figuration of female subjectivity in the woman's film plays out the psychoanalytic description of femininity, characterized in particular by a deficiency in relation to the gaze, a metonymy for desire itself. Within this framework "subjectivity can ... only be attributed to the woman with some difficulty,"[8] and "female spectatorship ... can only be understood as the confounding of desire,"[9]–or at most as the desire to desire.

The gothic subgenre has a privileged status within Doane's book, corresponding to its ambiguous position within the woman's film genre. Related to the "male" genres of film noir and horror "in [its] sustained investigation of the woman's relation to the gaze," the gothic is both an impure example of the woman's film and a "metatextual" commentary on it.[10] The "paranoid woman's film" is inadvertently privileged in another sense. For, via Freud's definition of paranoia, the specter of homosexuality makes a rare appearance in the text. The process by which it is exorcised is intimately bound up with Doane's definition of female spectatorship.

### Paranoia and Homosexuality

In *The Desire to Desire,* Doane devotes to the gothic two chapters entitled: "Paranoia and the Specular" and "Female Spectatorship and Machines of Projection," offering a compelling analysis of the genre to which my reading of *The Haunting* is indebted. Yet despite a lengthy discussion of the psychoanalytic description of paranoia, she qualifies Freud's identification of paranoia with a defense against homosexuality as the "technical" definition of the disorder.[11] Freud himself was "driven by experience to attribute to the homosexual wish-phantasy an intimate (perhaps an invariable) relation to this particular form of disease."[12] The relevance of

. . . . . . . . . . . .
8  Doane, *The Desire to Desire,* p. 10.
9  Ibid., p. 13.
10  Ibid., pp. 125–126.
11  Ibid., p. 129.
12  Freud, "On the Mechanism of Paranoia," p. 29.

homosexuality to the discussion of paranoia and to the content of film gothics returns as the "repressed" of Doane's argument.[13]

I quote Mary Ann Doane:

> Yet, there is a contradiction in Freud's formulation of the relationship between paranoia and homosexuality, because homosexuality presupposes a well-established and unquestionable subject/object relation. There is a sense in which the very idea of an object of desire is foreign to paranoia.[14]

Homosexuality, it appears, is foreign to the definition of paranoia that Doane wishes to appropriate to describe the gothic fantasy. "Because Freud defines a passive homosexual current as feminine, paranoia, whether male or female, involves the adoption of a feminine position." This assimilation of homosexuality to the feminine effectively forecloses the question of the difference of lesbianism when Doane later turns to Freud's "Case of Paranoia Running Counter to the Psychoanalytical Theory of the Disease."[15] In this case, which is said to run "counter" to psychoanalytic theory on the point of homosexual desire, the fantasy which Freud ultimately uncovers as confirmation of his hypothesis (the homosexual wish betrayed by the discovery of a same-sexed persecutor) is read by Doane as the female patient's "total assimilation to the place of the mother." Desire is elided by identification. Doane writes:

> The invocation of the opposition between subject and object in connection with the paranoid mechanism of projection indicates a precise difficulty in any conceptualization of female paranoia—one which Freud does not mention. For in his short case history, what the woman projects, what she throws away, is her sexual pleasure, a part of her bodily image.[16]

In forming a delusion as defense against a man's sexual advances and breaking off relations with him (whether this shields a defense

. . . . . . . . . . . . .

**13**  For instance the important, lesbian-coded character of Mrs. Danvers is barely mentioned in Doane's discussion of *Rebecca*.

**14**  Doane, *The Desire to Desire*, pp. 129–130.

**15**  Sigmund Freud, "A Case of Paranoia Running Counter to the Psychoanalytical Theory of the Disease" (1915), in *Sexuality and the Psychology of Love*, ed. Philip Rieff (New York: Collier Books, 1963), pp. 97–106.

**16**  Doane, *The Desire to Desire*, p. 168.

against a homosexual wish is here immaterial), the woman is seen to be throwing away her pleasure.

For Doane homosexuality is too locked into the subject/object dichotomy to have much to do with paranoia. Femininity represents a default in relation to the paranoid mechanism of projection—"what [the woman spectator] lacks ... is a 'good throw'"[17] —precisely because the woman cannot achieve subject/object differentiation. The "contradiction" between homosexuality and paranoia, and the "precise difficulty" inherent in female paranoia are related by a series of slippages around a central unspoken term, lesbianism.

"Homosexuality" appears in Doane's text only furtively; female subjectivity is its central focus. Yet, remarkably, it is an account of "lesbian" desire that is used to summarize Doane's position on female spectatorship:

> The woman's sexuality, as spectator, must undergo a constant process of transformation. She must look, as if she were a man with the phallic power of the gaze, at a woman who would attract that gaze, in order to be that woman. ... The convolutions involved here are analogous to those described by Julia Kristeva as "the double or triple twists of what we commonly call female homosexuality": "'I am looking, as a man would, for a woman'; or else, 'I submit myself, as if I were a man who thought he was a woman, to a woman who thinks she is a man.'"[18]

Doane has recourse to what only Kristeva could call "female homosexuality" to support a definition of female spectatorship that disallows homoeroticism completely—lesbianism and female spectatorship are abolished at one "twist." Female subjectivity is analogous to female homosexuality which *is* sexuality only insofar as it is analogous to male sexuality. The chain of comparisons ultimately slides into actual delusion: "a woman who thinks she is a man." In what seems to me a profoundly disempowering proposition, the very possibility of female desire as well as spectatorship

. . . . . . . . . . . .

17  Thus "throwing away her pleasure" describes the process of female spectatorship: "to possess the image through the gaze is to become it. And becoming the image, the woman can no longer have it. For the female spectator, the image is *too* close—it cannot be projected far enough. . . . What she lacks, in other words, is a 'good throw'" (ibid., pp. 168–169).
18  Ibid., p. 157.

is relinquished in the retreat from the ghost of lesbian desire. As we shall see, a similar path is traced in *The Haunting*.

## A House Is Not Her Home

*An evil old house, the kind that some people call haunted,*
*is like an undiscovered country waiting to be explored . . .*

The male voice-over–Dr. Markway's–with which *The Haunting* opens, will have, for some viewers, an uncanny resonance with a description of woman as "the dark continent." This connection between signifiers of femininity and the domicile is unsurprising; in cinema it appears in genres from the western to the melodrama. Mary Ann Doane cites Norman Holland and Leona Sherman's version of the gothic formula as, simply, "the image of woman-plus-habitation."[19] It is the uncanny house that the heroine is forced to inhabit–and to explore.

Freud's essay on the uncanny draws on the literary gothic, particularly the work of E. T. A. Hoffman. In it he associates the sensation with an etymological overlap between the definitions of the uncanny, *das Unheimliche,* and its apparent opposite *das Heimliche* (literally, the homey, the familiar), ultimately identifying this convergence with "the home of all humans," the womb.[20] The woman provokes the uncanny; her experience of it remains a shadowy area.

In the threatening family mansions of the gothic, or in *The Haunting*'s evil old Hill House, a door, a staircase, a mirror, a portrait are never simply what they appear to be, as an image from Fritz Lang's "paranoid woman's film" *Secret Beyond the Door* (1948; figure 3) illustrates. The title sums up the enigma of many of these films, in which a question about the husband's motives becomes an investigation of the house (and of the secret of a woman who previously inhabited it). In *Secret Beyond the Door*, the husband is an

. . . . . . . . . . . .

19   Norman N. Holland and Leona F. Sherman, "Gothic Possibilities," *New Literary History* 8, no. 2 (Winter 1977): 279, cited in Doane, *The Desire to Desire*, p. 124.
20   Sigmund Freud, "The 'Uncanny'" (1919), *Pelican Freud Library*, vol. 14 (Harmondsworth: Penguin, 1985), pp. 335–376.

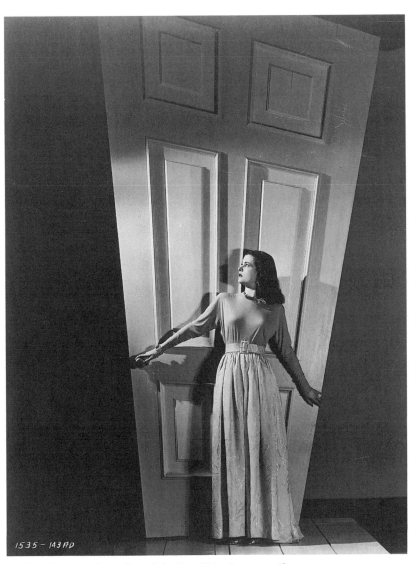

**3** Joan Bennett, *Secret Beyond the Door* (Fritz Lang, 1948).

architect whose hobby is "collecting" rooms in which murders have occurred, one of which is the heroine's bedroom.

Hill House, too, reflects the obsessions of its builder, we are told. "The man who built it was a misfit. ... He built his house to suit his mind . . . All the angles are slightly off; there isn't a square corner in the place." Visitors become lost and disoriented, doors left ajar close unnoticed. The film's montage exploits this as well, disorienting the spectator with threatening details—a gargoyle, a door knob, a chandelier–and unexplained camera set-ups and trick shots. Yet as a house that is "literally" haunted, Hill House poses another secret beyond its doors, one of which the architect himself is unaware. Hill House is "uncanny" *for the woman;* it is a projection not only of the female body, but also of the female mind, a mind which, like the heavy oak doors, may or may not be unhinged. An ad slick for the film (figure 4) uses the image of a female figure trapped in a maze. Architectural elements are integrated into the title design. Thus the aspect of the house, its gaze, are crucial in the film.

### Robbers, Burglars, and Ghosts

The relationship between the representation of woman and the space of the house is not, Teresa de Lauretis tells us in her reading of Jurij Lotman's work on plot typology, a coincidence or simply a generic requirement of the literary or film gothic. De Lauretis analyzes Lotman's reduction of plot types to a mere two narrative functions: the male hero's "entry into a closed space, and emergence from it." Lotman concludes:

> Inasmuch as closed space can be interpreted as "a cave," "the grave," "a house," "woman" . . . entry into it is interpreted on various levels as "death," "conception," "return home" and so on; moreover all these acts are thought of as mutually identical.[21]

. . . . . . . . . . . .

**21** Jurij M. Lotman, "The Origin of Plot in the Light of Typology," cited in Teresa de Lauretis, *Alice Doesn't: Feminism, Semiotics, Cinema* (Bloomington: Indiana University Press, 1984), p. 118.

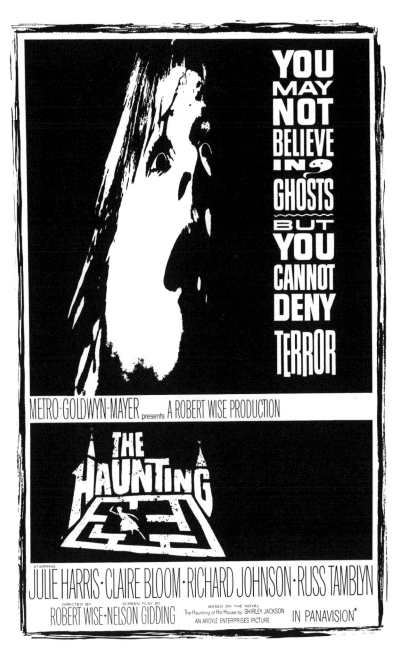

4

And de Lauretis sums up: "the obstacle, whatever its personification, is morphologically female and indeed, simply, the womb."[22] The sinister slippage in the chain of designations from grave to house to woman lends a narrative progression to Freud's uncanny. Given the collapse of "woman" onto the space rather than the subject of narrative, and given the identification of heterosexuality *qua* conception with the very prototype of narrative progression, it is no wonder that the lesbian heroine (and her spectatorial counterpart) are so difficult to envision.

Insofar as the cinema rewrites all stories according to an Oedipal plot, when the woman is the hero of a gothic such as *Rebecca* (1940), her story is told as the female Oedipus.[23] Her conflicting desires for the mother and for the father are put into play only to be "resolved" as the mirror image of man's desire. De Lauretis proposes that as the story unfolds, the female spectator is asked to identify not only with the two poles of the axis of vision—feminist film theory's gaze and image—but with a second set of positions, what she calls the figure of narrative movement and the figure of narrative closure. Of this last, de Lauretis writes: "The female position, produced as the end result of narrativization, is the figure of narrative closure, the narrative image in which the film, as [Stephen] Heath says, 'comes together.'"[24] We can recognize the "narrative image" as fundamentally an image of heterosexual closure, or, in Lotman's equation, death.

. . . . . . . . . . . . .

**22** De Lauretis, *Alice Doesn't*, p. 119.

**23** Tania Modleski, "'Never To Be Thirty-Six Years Old': *Rebecca* as Female Oedipal Drama," *Wide Angle* 5, no. 1 (1982): 34–41, reprinted in *The Women Who Knew Too Much: Hitchcock and Feminist Theory* (New York and London: Methuen, 1988), pp. 43–56. See also de Lauretis, *Alice Doesn't*, pp. 51–55, for a reading of Modleski's article.

**24** De Lauretis, *Alice Doesn't*, p. 140. The notion of "narrative image" is a complex one to which the present discussion cannot do justice. Heath's introduction of the concept had only the suggestion of the overdetermined association with femininity which de Lauretis traces so convincingly. He defined the narrative image as "a film's presence, how it can be talked about, what it can be sold and bought on, ... in the production stills displayed outside a cinema, for example" (*Questions of Cinema* [Bloomington: Indiana University Press], p. 121). For instance, lesbian and gay supporting characters are evicted from the narrative image, from reviews, from plot summaries, from the images on posters. The production stills included in the present context are examples from a film whose narrative image is unrepresentable.

5

It is in relation to the narrative work of classical cinema defined as the playing out of space (the house, the grave, the womb) as the very image of femininity that I wish to situate the story of *The Haunting*. It is an exceptional Hollywood film that would frustrate the hero's "entry into a closed space" and stage a story of deviant female subjectivity, of the *woman's* return home as a struggle with the *topos* of the home. Here (figure 5) an "image of woman = plus = habitation" illustrates this difficulty.

*The Haunting* tells not the story of Theodora (Claire Bloom's character) but of Eleanor (Julie Harris' character), a woman whose sexuality–like that of the heroine of *Rebecca*–is latent, not necessarily, not yet, lesbian. Her journey is articulated as female Oedipal drama almost against her will, and is resolved, with her death, as a victory of, exactly, the house and the grave (perhaps the womb). "Now I know where I am going, I am disappearing inch by inch into this house," she finally recognizes. My reading of the film will attempt to trace the "haunting" of Hill House as it shifts between homosexuality and homophobia.

*The Haunting* as ghost film dramatizes not the lesbian's "deficiency in relation to vision" as feminist film theory would characterize femininity, but a deficiency in relation to visibility or visu-

alization–in *The Haunting* we never see the ghost, but we do see the lesbian. Which is not to say that we "see" lesbian sexuality. *The Haunting* is "not a film about lesbians"; it is (pretends to be) about something else. I would consider "something else" to be a useful working definition of lesbianism in classical cinema.[25] For it is precisely the fact that the "haunting" is unseen, that there are no "special effects," that renders *The Haunting* the "ultimate" ghost film.

> Robbers, burglars and ghosts, of whom some people feel frightened before going to bed . . . all originate from one and the same class of infantile reminiscence. . . . In every case the robbers stood for the sleeper's father, whereas the ghosts corresponded to female figures in white nightgowns.[26]

. . . . . . . . . . . .

**25** Vito Russo notes the homophobic tendency to claim gay-themed movies are about "something else" in his *The Celluloid Closet: Homosexuality in the Movies* (New York: Harper and Row, 1981), p. 126. Yet a standard of "coming out"–the search for the overt, fully realized representation of homosexuality (particularly if the standard is arguably a masculine one) can lead to reductive readings of actual films, as is the case in Russo's discussion of *The Haunting*:

> Unconscious lesbianism is its own punishment . . . for Claire Bloom's neurotic Greenwich Village lesbian in *The Haunting* (1963). She gets her psychosexual jollies by hugging Julie Harris and blaming it on ghosts. But she is not predatory; she is just out of life's running. She professes no interest in actively seducing either Harris *or an attentive Russ Tamblyn. The lesbianism is entirely mental, and her sterility leaves her at a dead end. . . . Lesbianism is rendered invisible because it is purely psychological. And since most lesbians were invisible even to themselves,* their sexuality, *ill-defined in general,* emerged onscreen as a wasted product of a closeted lifestyle (p. 158; emphasis added).

I perceive the Bloom character as, on the contrary, very well adjusted, and I read the very "invisibility" of lesbianism in the film as a strategy of representation. Parker Tyler writes, "it might seem to both readers of the novel and viewers of the film . . . that lesbianism had a role in drawing these unusual ladies closer in the frightening, macabre situation to which they commit themselves and where they must 'cling' to each other" (*Screening the Sexes: Homosexuality in the Movies* [New York: Holt, Rinehart and Winston, 1972], p. 190).
**26** Sigmund Freud, *The Interpretation of Dreams* (New York: Avon, 1965), p. 439.

What is immediately striking in Freud's reading is the dissymmetry between the referents of the two dream symbols. Burglars and robbers stand quite definitively for the father; ghosts are a figure of–a figure. Not "the mother," perhaps a governess, a nurse, or a sister . . .

## "Scandal, Murder, Insanity, Suicide"

Dr. Markway's voice-over resumes after the opening credits of *The Haunting*. The story of Hill House as Dr. Markway envisions it–literally en-visions it, for his narration is accompanied by a bizarre flashback/fantasy sequence–is the story of female death. The mansion, built by one Hugh Crain "ninety-odd–very odd" years ago, is the site of the deaths of four women, which are enacted for us: his two wives, his daughter Abigail who lived to old age in the house, and her paid companion. This prologue sequence supplies us with a surplus of cinema's "narrative image"–female scandal, suicide, murder, and insanity–before the drama even begins to unfold. It is as if all the visual power of cinema (surpassing even Dr. Markway as narrator) is amassed to contain the threat posed by "whatever" it is that haunts Hill House.

Dr. Markway hides his interest in the supernatural under the guise of science; his true object of study, like that of Freud, another "pseudo" scientist, is deviant femininity. He designates one room of the house the "operating room"–"that is, the center of operations," he reassures his female guests. Suave, paternalistic, Dr. Markway is yet somehow lacking in relation to the law–or at least the laws of Hill House. (In contrast is Theodora's ESP, which affords her privileged knowledge of "the haunting" and of Eleanor. She's thus a better analyst as well.) Dr. Markway admits, when asked to reveal the laws of psychic occurrences, "you'll never know until you break them." His laughably inadequate readings of the goings-on in Hill House ("I have my suspicions"), his lectures on the preternatural (that which will some day come to be accepted as natural), his efforts to measure the cold spot, become more and more readable as fumbling attempts to explore the "undiscovered country" of female homosexuality. In this light, his disclaimer on the supernatural–"don't ask me to give a

name to something which hasn't got a name"–is also a disclaimer to knowledge of "the love that dares not speak its name." He rejects the word "haunted," preferring "diseased," "sick," and "deranged," pathologizing, anthropomorphizing, and, I would argue, lesbianizing the haunted house.

When his version of the story of Hill House includes the proclamation, "It is with the young companion that the evil reputation of Hill House really begins," we are prepared, indeed invited, to speculate what the scandal attached to the companion might be. It is onto the fates of the four female characters/ghosts, most crucially that of the companion who is extraneous (subordinate) to the nuclear family, that Eleanor Lance maps her "Oedipal" journey, her crisis of desire and identification.

As narrativity would demand, she starts out in the place of the daughter. Yet she is a grown-up daughter, a spinster, who leaves her family home–her mother has recently died, and as the maiden

6   Eleanor (Julie Harris) and Theo (Claire Bloom)–"Like sisters?"

aunt she lives in her sister's living room–to "return home" to Hill House. Eleanor and Theodora are the remaining two of a select company of persons "touched" by the supernatural who had been invited by Dr. Markway in the hopes "that the very presence of people like yourselves will help to stimulate the strange forces at work here." The doctor's interest in Eleanor's case is sparked by her childhood "poltergeist experience"–a shower of stones that fell on her house for three days. Eleanor at first denies–"I wouldn't know" (about things like that)–what her brother-in-law calls the "family skeleton," the secret of "what [her] nerves can really do." In the internal monologue accompanying her journey to the house (a voice-over that recurs throughout the film, giving the spectator an often terrifying access to her interiority), Eleanor refers to herself as "homeless." She has never belonged within the patriarchal home and its family romance. Her "dark, romantic secret" is her adult attachment to her mother, which she angrily defines as "eleven years walled up alive on a desert island." Eleanor is thrilled at the prospect of "being expected" at her destination; for the first time something is happening to *her*. More is "expected" of her than she dreams . . .

## Things That Go Bump in the Night

When Eleanor arrives at Hill House, she is relieved to meet one of her companions. "Theodora–just Theodora," Claire Bloom's character introduces herself to Eleanor, immediately adding, "The affectionate term for Theodora is Theo." "We are going to be great friends, Theo," responds Eleanor, whose affectionate name "Nell" Theo has already deduced by keen powers of extrasensory perception which are exercised most frequently in reading Eleanor's mind.[27] "Like sisters?" Theo responds sarcastically (figure 6). Theo recommends that Eleanor put on something bright for dinner, sharing with her the impression that it is a good idea

. . . . . . . . . . . .

**27**  The spectator/auditor is also able to "read Eleanor's mind" through the voice-over device, although sometimes Theo seems to have access to Eleanor's unconscious thoughts and desires, as well as to effects of the "haunting" signified to the spectator by other visual and auditory cues.

always to remain "strictly visible" in Hill House. On their way downstairs, they encounter their first supernatural experience, with Eleanor shouting, "Don't leave me, Theo," and Theo observing, "It wants you, Nell." After they have joined the others, Eleanor proposes a toast: "I'd like to drink to companions." Theo responds with obvious pleasure and the camera moves in to frame the two women. "To my new companion," replies Theo with inimitable, elegant lasciviousness. The toast, like their relationship, alas, remains unconsummated, for Eleanor continues—"except I don't drink."

Eleanor clearly is the "main attraction" of both the house and Theo, each finding in her what Theo calls "a kindred spirit" (figure 7). The film, resisting the visualization of desire between women, displaces that desire onto the level of the supernatural, Theo's seduction of Eleanor onto the "haunting."

The process whereby the apparition of lesbian desire is deferred to the manifestation of supernatural phenomena is well illustrated by a sequence depicting the events of the first night spent by the company in Hill House. Theo accompanies Eleanor to the door of her bedroom, and invites herself in, under the pretext of arranging Eleanor's hair. Although Eleanor refuses Theo's advances, the women end up in bed together anyway, but not according to plan. Eleanor, realizing with a mixture of relief and anxiety that she is alone, locks her door ("Against what?" she muses) and drifts off to sleep. A shot of the exterior of the house, and a dissolve to a shot from the dark interior at the base of the main staircase are accompanied by a faint pounding which rises in volume. Eleanor stirs and, half-asleep, knocks in response on the wall above her bed: "All right, mother, I'm coming." When Theo calls out to her in fear, Eleanor realizes her mistake and rushes into Theo's adjoining room. Huddled together in Theo's bed throughout the protracted scene, the women withstand an unbearably loud knocking which eventually comes to the door of the bedroom (figure 8). Finally the sound fades away, and Eleanor runs to the door when she hears Luke and the doctor in the hall. The men enter, explain they had been outside chasing what appeared to be a dog, and ask whether anything has happened. The women burst into laughter, and after catching their breath, sarcastically explain that something knocked on the door with a cannonball. Luke

7

8

remarks that there isn't a scratch on the woodwork–"or anywhere else"–and the doctor soberly intones: "When we are decoyed outside, and you two are bottled up inside, wouldn't you say that something is trying to separate us?" The sequence ends with ominous music and a close-up of Theo.

The knocking that terrorizes the women takes up an element of the film's prologue–the invalid Abigail pounds with her cane on the wall to call the companion who fails to come, sparking malicious town gossip that she had somehow or other murdered her mistress. At this point in the film we are already aware that Eleanor harbors guilt about her own mother's death; what this scene makes explicit is the exact parallel, down to the knocking on the wall, that Eleanor later admits she fears she may have heard and ignored on the fatal night, which puts Eleanor in the position of "companion" vis-à-vis her own mother.

> When a wife loses her husband, or a daughter her mother, it not infrequently happens that the survivor is afflicted with tormenting scruples . . . which raise the question whether she herself has not been guilty through carelessness or neglect of the death of the beloved person. No recalling of the care with which she nursed the invalid, no direct refutation of the asserted guilt can put an end to the torture . . . [28]

Freud concludes in *Totem and Taboo* that a repressed component of hostility toward the deceased is the explanation for these reproaches, and similarly for the "primitive" belief in the malignancy of spirits of dead loved ones: the *projection* of that hostility is feared aggression from the dead. Projection is also a technique of those suffering from paranoia who are "struggling against an intensification of their homosexual trends." In paranoia, Freud tells us, "the persecutor is in reality the loved person, past or present."[29]

Eleanor's psychosexual history is similar to that of the subject of Freud's "Case of Paranoia Running Counter to the Psycho-analytical Theory of the Disease," a thirtyish woman living with her mother who forms a paranoiac delusion to defend herself

. . . . . . . . . . . .

**28**   Sigmund Freud, *Totem and Taboo* (New York: Vintage Books, 1946), p. 80.

**29**   Freud, "A Case of Paranoia . . . ," p. 99.

against the attentions of a man. In both cases, the loved person, the persecutor, is the mother. Much has been made in film theory of the form the patient's delusion took in this case: that of being photographed, sparked by an "accidental knock or tick" which she hears while visiting the man in his apartment. The visual and the auditory, the camera and the click, are the two registers of which the cinema is composed, rendering it analogous to paranoid projection.[30] The noteworthy point of Freud's case history is his reading of the instigating cause of the delusion: "I do not believe that the clock ever ticked or that any noise was to be heard at all. The woman's situation justified a sensation of throbbing in the clitoris. . . . There had been a 'knocking' of the clitoris." "In her subsequent rejection of the man," Freud concludes, "lack of satisfaction undoubtedly played a part."[31]

The knock recurs in this scene from *The Haunting* with the force of a cannonball (proportionate to the force of Eleanor's repression, manifested before in the violence of her "poltergeist" experience) and intervenes precisely at the moment of a prohibition against homosexual desire. It is a knocking which on the manifest level can be read as the ghost of Abigail looking for a companion, or on a latent level as the persecution of Eleanor by her own mother in conjunction with her taking of a new lover. (That is, Theo. If we are reluctant to read this as a quasi-love scene I offer as anecdotal support the fact that, despite its centrality, it was cut from the version I saw on TV.) Like Freud, the men do not believe there had been any noise at all. Love between women is considered unspeakable; it is inaudible; and it doesn't leave a scratch. I do not contend that the laughter Theo and Eleanor share over the men's ignorance is irrecuperable; indeed the scene most literally transforms homosexuality into homo-phobia—replacing sexuality with fear. When the doctor pompously acknowledges that "something" is separating the girls from the boys in Hill House, he resolves to take precautions. "Against what?" Eleanor asks, naively, for the second time in this sequence. For the camera tells us it is Theo, someone, not some thing, who separates the doctor and Eleanor.

. . . . . . . . . . . . .

30   See Doane, *The Desire to Desire*, p. 123.
31   Freud, "A Case of Paranoia . . . ," p. 109.

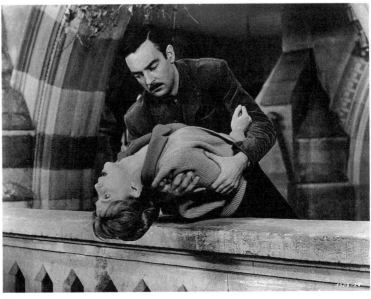

**9**

The next morning Eleanor awakens a little too excited by her first experience of the "supernatural." Over breakfast, her hair arranged in a new style, she claims to be "much more afraid of being abandoned or left behind than of things that go bump in the night." This does not appear to be entirely true, for her feeling of excitement is accompanied by her turning away from Theo as potential love object and towards the doctor, whose paternalistic interest in her Theo calls unfair. When asked what *she* is afraid of, Theo responds, "of knowing what I really want." Her words make Eleanor uncomfortable on several levels. Eleanor misreads her own desire, as I suspect some feminist film critics would, as desire for the man, that is, the father. Theo's attitude toward her demeaning rival is manifested with knowing sarcasm, telling Eleanor she "hasn't the ghost of a chance." A still image depicts Eleanor's relationship to the doctor in an ambivalent embrace (figure 9). Actually, he has just caught her as she is about to fall backwards over the railing. She had been staring up at the turret, and in a rapid zoom from the point of view of the tower window, she has been virtually pushed by the camera, the house itself, and the implied gaze of a (female) ghost. Eleanor's turning towards the father smacks indeed of "a defense against a homosexual wish,"

and she literally begins to see Theo as a persecutor. The very force-fulness of this defense supports a reading of the night of knocking as a seduction scene.

## More than Meets the Eye

The defense against homosexuality is mirrored on the level of the film's enunciation; when the supernatural events of the second night bring the women together, the cinematic apparatus emphat-ically separates them. The women are sleeping in beds pushed next to each other. Dr. Markway (taking precautions) has advised the women to move in together. ("You're the doctor," Theo responds.) When Eleanor wakes to mysterious sobbing noises, she holds on tightly to Theo's hand. She finally manages to turn on the light and the camera pans rapidly to Theo on the opposite side of the room. Eleanor, horrified, realizes it was not Theo's hand she was holding but that of some ghostly companion. It is not the "supernatural" alone that is responsible for this mean trick. The cinema itself renders the women's physical contact (albeit merely handholding) impossible. For we know that Theo's bed is not on the other side of the room. A cinematically specific code–and a disruptive one at that, the swish pan–intervenes to separate the two women from each other and to render the viewer complicit.

In a scene that encapsulates the "Oedipal" drama of Hill House and thus the conflict over Eleanor's proper identification, the cin-ema works *with* the supernatural in allowing a lesbian reading. The four guests literally find their "family portrait" in a massive group statue meant to represent St. Francis curing the lepers, who are all female (figure 10). The women notice that the statue seems to move when they look away, a classic "uncanny" effect. Luke remarks that the configuration reminds him of a family portrait of the historical inhabitants of Hill House, Hugh Crain looming above his wives, his daughter, the companion, and a dog. Theo maps the current group onto the statue and thus onto the original group, designating Eleanor as the companion, herself, tellingly, as the daughter–"grown up"–the doctor as Hugh Crain, and Luke, the ostensible Oedipal hero, as the dog. Luke, startled, indicates with a glance at the women that he has finally caught on to Theo's sexual orientation, commenting that "more than meets the eye" is

going on in Hill House. This phrase, denoting lesbianism, applies equally to the supernatural events of *The Haunting*. Yet, immediately after the group leaves the room, "more" meets the eye of the spectator—the camera zooms into two of the female figures, which seem to have moved so that one clutches the other's breasts. This privileged view is a cinematic flourish, and a key to a reading, implicating Eleanor in a lesbian embrace through the figure to which she corresponds, and suggesting that the female forces of Hill House are beginning to close in on her.

"You're the monster of Hill House," Eleanor finally shouts at Theo, several scenes later, coming closer to the truth than she knows. It is at the culmination of this scene: "Life is full of inconsistencies, nature's mistakes—you for instance," that Mrs. Markway, consistently, makes her entrance. Coming to persuade her husband to give up his nonsense, she embodies the missing element of the family portrait, marking the futility of Eleanor's attempt to identify herself with that position. In another still (figure 11), the psychic importance of the mother to Eleanor is represented by her subordination to Mrs. Markway.

The materialization of the wife at this point in the film seems to be part of the process whereby cinema—like the house itself, which calls Eleanor home through literal writing on the wall—demands its tribute of the heroine. On this "final" night of Eleanor's stay, she imagines she has killed off the wife/mother when Mrs. Markway, because of her skepticism, becomes "deranged" by Hill House, and disappears from her room—the nursery, Abigail's room, "the cold rotten heart of Hill House" that had remained locked before opening spontaneously on the night of her arrival. Mrs. Markway then appears unexpectedly to scare Eleanor (ultimately to scare her to death) on two additional occasions.

First she interrupts Eleanor's intense identification with the place of the companion's suicide, the library. Eleanor's haunting by the wife is quite logically played out over the architecture of the house, which is phantasmatically inflected with Eleanor's own psychic history. Eleanor sums up her subjective crisis: "So what if he does have a wife, I still have a place in this house. I belong." As Eleanor runs through the house, she is frightened by her own reflection; we hear loud creaking and crashing, and the image rocks. She thinks, "the house is destroying itself, it is coming

10   The family portrait.

down around me." Eleanor had been unable to enter the library before, overpowered by a smell she associates with her mother (figure 12), but tonight she seems to be called there; *unheimlich* is transformed to *heimlich*. Eleanor climbs the library's spiral staircase as if induced by the camera, which makes the dreamlike ascent before her. The companion had hung herself from the top of the staircase, and the camera has prefigured these later ascents in the prologue's enactment of this death: "I've broken the spell of Hill House—I'm home, I'm home," Eleanor senses. The doctor "rescues" her when she reaches the top, yet just as she turns to descend, Mrs. Markway's head pops into frame through a trap door above. Eleanor faints, and the screen fades to black.

It is now that the doctor, futilely, decides to send Eleanor away from Hill House. For he misrecognizes (as an hallucination) her recognition of the wife. Yet for once she has actually *seen* something that we, importantly, also see. She is terrorized, at the very moment of her identification with the companion, by the apparition of the heterosexual role model, the wife. Eleanor comprehends the displacement of her Oedipal drama (the substituting of herself for the mother) by the inverted drama of Hill House (the wife's substitution for Eleanor in relation to the house's desire). "I'm the one who's supposed to stay. She's taken my place." And Eleanor dies, ironically, literally in the wife's place.

For the "narrative image" figured in the film's prologue—the death of Hugh Crain's first wife, her lifeless hand falling into the frame, after her horse rears "for no apparent reason"—is now offered as the "narrative image" of the film. The shot is repeated exactly after Eleanor's car crashes into the very same tree, her hand falling into the frame. The first wife died before rounding the corner that would have given her the gothic heroine's first glimpse of the house; Eleanor cannot leave the gaze of Hill House.

She crashes, apparently, to avoid hitting Mrs. Markway, who, for the second time, suddenly runs across her path. Mrs. Markway appears as agent of a deadly variant of heterosexual narrative closure. Eleanor is not allowed to live or die as the companion; incapable of living as the wife, she is tricked into dying in her place.

But, being a ghost film, *The Haunting* goes beyond the image of death. The final image is properly the house—the grave, woman?—accompanied by Eleanor's voice-over (or rather the

**12**  Eleanor pauses at the library door.

voice of Eleanor's ghost) echoing these words from the opening narration: "Whatever walked there, walked alone." Prying the "narrative image" from its Oedipal logic and usurping the authoritative male voice-over, Eleanor transforms the words: "We who walk here, walk alone." Eleanor finally belongs–to a "we" that we know to be feminine and suspect might be lesbian, "we who walk alone"–and the house belongs to her. The "haunting" exceeds the drive of cinema to closure, actually using the material codes of cinema, the soundtrack, to *suggest* something else.

*The Haunting* exceeds the woman's story as female Oedipal drama enacted, Tania Modleski demonstrates, in a gothic such as *Rebecca*.[32] In that genre the protagonist's search for the "secret" of a dead woman is facilitated (or impeded) by a key figure, an older, sometimes sinister character, variously the "housekeeper," the "nurse," or in some other capacity a "companion" to the dead woman. These roles are truly a gallery of the best of lesbian characters in classic cinematic history. Played by the likes of Judith Anderson (Mrs. Danvers in *Rebecca*), or Cornelia Otis Skinner

. . . . . . . . . . . . .

**32**  Modleski, *The Women Who Knew Too Much*, pp. 43–56.

(*The Uninvited*), they are a compelling reason for the young woman, recently married and suspecting it might have been a mistake, to realize that it was one (figures 13, 14). I have discussed the centrality of the companion in the psychic history of Hill House, and will venture that the companion function provides a mapping and an iconography of female homosexuality throughout the gothic genre. In *The Haunting* a crucial transformation has taken place with the manifest appearance of lesbianism. The representation of the dead woman, the object of the heroine's desire ("Rebecca" as precisely unrepresentable in that film), and the function of the companion converge in the figure of Theodora, who is emphatically not the mother.

### The Canny Lesbian

If the nameless heroine of *Rebecca* oscillates between the two poles of female Oedipal desire–desire for the mother and desire for the father–Mrs. Danvers sets the house on fire and dies with it, joining the ghost of Rebecca which, as Modleski reads it, "haunts" her.[33] And if Eleanor's trajectory sums up these two variants, Theo grows up–like Abigail, the daughter before her, and lives to tell of the terrors of Hill House. In developing a feminist film theo-ry which would incorporate Theo, we might recall the model of spectatorship she offers in the film. Telepathy, to lesbians and gay men as historical readers and viewers, has always been an alternative to our own mode of paranoiac spectatorship: "Is it really there?" The experience of this second sight involves the identification of and with Theo as a lesbian. As for *The Haunting*, it's a very scary movie, even a threatening one. As the TV movie guide recommends, "See it with a friend."[34]

Or, perhaps, a "companion."

. . . . . . . . . . . . .

**33**  Ibid., p. 51. In the later version of her essay, Modleski makes explicit the lesbian element with the addition of this phrase, "the heroine continually strives ... to win the affections of Mrs. Danvers *who seems herself to be possessed, haunted, by Rebecca and to have a sexual attachment to the dead woman.*"

**34**  Leonard Maltin, ed., *Leonard Maltin's TV Movies & Video Guide* (New York: Signet, 1989), p. 444.

13   Joan Fontaine and Judith Anderson (as Mrs. Danvers), *Rebecca* (Alfred
Hitchcock, 1940).

14   Cornelia Otis Skinner (far right), *The Uninvited* (Lewis Allen, 1944).

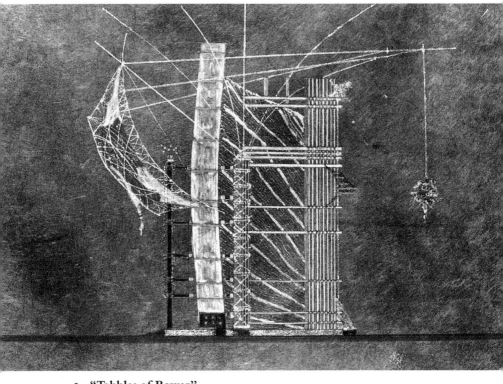

1  **"Tabbles of Bower"**
Project for Chicago Institute for Architecture and Urbanism, 1990.
Dirty drawing: elevation. Metallic inks and watercolor on mulberry
paper. Object: dory hull, maple, polished steel, pre-cast concrete, cow
skin, braided copper wire, woven brass wire, mammoth bones, and
other terrestrial detritus.

# "D'OR"
(For Donnie)

## Jennifer Bloomer

**Hors d'oeuvre**:

*The names of minerals and the minerals themselves do not differ from each other, because at the bottom of both the material and the print is the beginning of an abysmal number of fissures. Words and rocks contain a language that follows a syntax of splits and ruptures. Look at any word long enough and you will see it open into a series of faults, into a terrain of particles each containing its own void.*

Robert Smithson[1]

. . . . . . . . . . . .

1 Robert Smithson, "A Sedimentation of Mind: Earth Projects," in *The Writings of Robert Smithson,* ed. Nancy Holt (New York: New York University Press, 1979), pp. 87–88. By beginning with this piece of writing by Robert Smithson, which sits outside, I have already made connections to Craig Owens' "The Allegorical Impulse: Towards a Theory of Postmodernism" and to Mark Taylor's *Tears,* where it appears, and to a lot of others.

UNDER THE GUISE of au-th-or, I, with no consciousness of it, have exited two recent essays in strangely similar ways. The exits are comprised of an unusual pair of words, one contained within the other, which I now would like to use as an entrance. The last word of "A lay a stone a patch a post a pen the ruddyrun: Minor Architectural Possibilities"[2] (an essay on allegory and architecture, the title of which itself refers to a certain topological exit of text) is "OR." This is the "OR" of the jump-rope rhyme "One Potato, Two Potato," which is a structural armature of my construction. It is an abrupt exit from the text, but also suggests, in the Vichian rhythm of the rhyme, the beginning of the next "One Potato" sequence. The last word of the second essay "Tip Tap Type Tope"[3] is "Dor." This is, of course, *Finnegans Wake*'s self-reference to that certain topological exit of text. Joyce's passage is this:

> For that (the rapt one warns) is what papyr is meed of, made of, hides and hints and misses in prints. Till ye finally (though not quite end-like) meet with the acquaintance of Mister Typus, Mistress Tope and all the little typtopies. Fillstup. So you need hardly spell me how every word will be bound over to carry three score and ten toptypsical readings throughout the book of Doublends Jined (may his forehead be darkened with mud who would sunder!) till Daleth, mahomahouma, who oped it closeth thereof the. Dor.[4]

This door, this exit that is, as exits always are, also an entrance, is a passage or hatch, but also, with its second "o" cut off in a peculiarly Amazonian fashion, it offers itself as a gift. The Greek word *doron,* which means "gift," is the root of the feminine given name, Dora. And now we have opened quite an other door, which I would like to shut quickly. But the naming of the door is a key. And that which is behind it, shut up in silence for oh so long, is getting large and feisty. The keyhole oozes objectionable odors

. . . . . . . . . . . .

**2** To appear in *Papers in Architectural Theory,* ed. John Whiteman and Richard Burdett, Chicago: Chicago Institute for Architecture and Urbanism, forthcoming in 1991.

**3** In *Midgard: The Journal of Theory and Criticism* (University of Minnesota) 2 (1990).

**4** James Joyce, *Finnegans Wake* (1939; New York: Viking Press, 1969), pp. 20.11–18.

and secretions. And now, in the manner of that other opener of a box or jar who couldn't get the lid back on in time (what *was* her name?), I fear that something got out. When a gift is an object of exchange, there is something not funny going on. It probably has nothing to do with the fact that in French, as in many other languages, the words for gift and gold are gendered masculine, but the door, the passage, through which one becomes another is marked feminine.

Let us mine the spaces of or. To do this we have to dig, perhaps "like a dog digging a hole, a rat digging its burrow,"[5] to find one's own *patois,* one's own space. We must go underground, down the hatch, following veins, discovering paths and secreted, encrypted treasures. Or is a lacy network of (g)-litter embedded in rock. Glittering litter disseminated in a great dumping ground. A bower of tabble.[6]

A book, I think, is very like
A little golden door
That takes me into places
Where I've never been before.

It leads me into fairyland
Or countries strange and far.
And, best of all, the golden door
Always stands ajar.[7]

. . . . . . . . . . . .

**5** Gilles Deleuze and Félix Guattari, *Kafka: Toward a Minor Literature* (*Kafka: Pour une littérateur mineure,* 1975), trans. Dana Polan (Minneapolis: University of Minnesota Press, 1986), p. 18.

**6** "Tabby" suggests a woven fabric, a cat, a prying or gossiping woman, and a form of concrete, the aggregate of which consists of cast-off oyster shells, used in the architecture of coastal regions in the South. *"J'appelle un chat un chat."* (A quotation of Jane Gallop quoting Hélène Cixous quoting Sigmund Freud, in Jane Gallop, *The Daughter's Seduction: Feminism and Psychoanalysis* [Ithaca: Cornell University Press, 1982], p. 140. And here, we have opened that particular door mentioned above once more. Slam!)

**7** Adelaide Love, "A Book," in *Storytelling and Other Poems, Childcraft,* vol. 2 (Chicago: Field Enterprises, 1949), p. 11.

## The Golden Section–A Key

The golden mean, first articulated by Theano (a woman), but credited to Pythagoras (her teacher),[8] is a number represented by the division of a line into two segments so that the ratio of the whole to the greater of the two parts is equal to the ratio of the greater part to the lesser part. Plato wrote of its magic power in its relationship to the natural order of the world: when the ratio is manipulated geometrically, it generates a logarithmic spiral. Architects since the Renaissance have used the golden mean, or golden section, as the basis for truthful and pleasing compositions.

Theano and Pythagoras were Dorians.

Helen, an object of exchange, was a Dorian. The Trojan Horse, a gift, was made by Dorians.

The Doric column, or Doric order, stands virtually without ornament. In architectural theory's anthropomorphic tales of origin, the Doric corresponds to the manly man, a step removed from both the Tuscan barbaric man and the Ionic matronly woman.

Adolf Loos, a Viennese, came to Chicago and saw the work of the architect Louis Sullivan, went home, and: (1) wrote diatribes against ornament (which he identified with barbarians and tattooing, and the gold-spattered work of the Secessionists, especially that of Gustav Klimt, a goldsmith's son), demanding a replacement of gold by *white*; and (2) drew a building in the shape of a gigantic black Doric column.

Ludwig Wittgenstein, a Viennese and a friend of Loos, designed a white house for his sister, Margaret Stonborough-Wittgenstein, whose portrait was painted by Klimt. The doors in the house are gigantic metal ones, without mold, bevel, or plate. The rigid, protruding handles are shaped like L's. One of the doors is polished to a mirrorlike sheen so that it looks like where you are going is where you have already been.

. . . . . . . . . . . . .

8   Marilyn French, *Beyond Power: On Women, Men and Morals* (New York: Ballantine Books, 1985), p. 144. French cites Sarah Pomeroy, *Goddesses, Whores, Wives, and Slaves* (New York: Schocken Books, 1975) and Elise Boulding, *The Underside of History* (Boulder, Colo.: Westview Press, 1976) as sources of this information.

A *louis* is a golden coin, an object of exchange, of both pre- and post-Revolutionary France. After the Revolution, its suffix, *d'or,* was dropped.

The *Encyclopaedia Britannica* tells us that gold is

... soft and is the most malleable and ductile of metals. ... [I]n thin sheets, called leaf, it transmits green light. Because this rare metal ... is visually pleasing and workable, ... it was one of the first metals to attract man's attention.[9]

Ore is a mined aggregate from which valuable constituents can be profitably extracted.

Or is the second term of the conjunctival pair either/or. It is a categorizing designator of exclusion based on difference. If a person, place, or idea appears under the aegis of "either," that person, place, or idea may not appear with "or." Or, a contraction of "other," is conventionally the marker of the inferior category. It also refers to indefiniteness or uncertainty.

Let us exit the *section d'or.* (Overheard in the Bon Marché in Paris, the original building of which is frequently cited as the model for Louis Sullivan's Schlesinger and Mayer Store in Chicago: "Now, where's that *sortie* at?") Just go through this passage:

Digressions were born of the grossness of the heroic minds, unable to confine themselves to those essential features of things that were to the purpose at hand, as we see to be naturally the case with the feeble-minded and above all with women.[10]

Writing is the passageway, the entrance, the exit, the dwelling place of the other in me—the other that I am and am not, that I don't know how to be, but that I feel passing, that makes me live—that tears me apart, disturbs me, changes me, who?—a feminine one, a masculine

9 *Encyclopaedia Britannica,* vol. 5, p. 336.
10 Giambattista Vico, *The New Science of Giambattista Vico,* trans. Thomas Goddard Bergin and Max Harold Fisch (Garden City, N.Y.: Anchor Books, 1961), p. 111. Cf. Joyce's flow of words, rivulets upon rivulets all running along, the writing of Annalivia, and note his not infrequent reference to Vico's ideas of historiography and to Vico himself.

one, some?–several, some unknown, which is indeed what gives me
the desire to know and from which all life soars.[11]

Oh-space, *au-delà, au-dehors.* The space of writing is the space
of certain forms of sexuality[12] when they have been backed into
the corner.

When or speaks, it is in cryptic terms. When the other (*allos*)
speaks (*agoreuein*), it is in other (*allos*) terms. The other speaks with
stylish instrument. S/he writes, carves out, incises, digs, mines.
Walter Benjamin notes this crypticity, this secretion of excess:
"[T]here is nothing subordinate about written script; it is not cast
away in reading, like dross. It is absorbed along with what is read,
as its 'pattern.'"[13] There is in this writing the possibility of a hid-
den picture. The oscillation of the allegorical mode between the
visual and the verbal allows us to shuttle back and forth among the
relationships *Other, Writing, Ornament.* But there is one more thing.

"Mademoiselle, la parole 'parure,' est-il masculin ou
feminin?"

Let us consider the second term of the pair "structure or orna-
ment." The structure is a necessary condition. The ornament is
excessive and unnecessary, but sometimes nice to have around. As
Naomi Schor has demonstrated, the space of post-Enlightenment
aesthetics is not sexually neutral. The ornamental has long been
tied to effeminacy and decadence. Schor points out that in neo-
classical aesthetics, the ornamental is equated with "... the femi-
nine, when it is not the pathological–two notions Western culture
has throughout its history had a great deal of trouble
distinguishing."[14]

Thus the ornamental has come to be associated with dishon-
esty, impurity (*ordure*), the improper, and excessiveness or exorbi-

. . . . . . . . . . . . .

11 Hélène Cixous and Catherine Clément, *The Newly Born Woman (La
jeune née,* 1975), trans. Betsy Wing (Manchester: Manchester University
Press, 1986), pp. 85–86. This cite is from Cixous' section called "Sorties,"
which is a writing upon Dora, the subject of Freud's 1905 "Fragment of an
Analysis of a Case of Hysteria." Slam!
12 I refer to forms which are other than the dominant: female, bisexual,
gay, lesbian, i.e., repressed forms of sexuality.
13 Walter Benjamin, *The Origin of German Tragic Drama,* trans. John
Osborne (London: New Left Books, 1977), p. 215.
14 Naomi Schor, *Reading in Detail: Aesthetics and the Feminine* (New York:
Methuen, 1987), p. 45.

tance, characteristics that the Symbolic order has deemed femi-
nine. As in: honest or dishonest, pure or impure, proper or
improper, essential or excessive. Architectural ornament is depen-
dent upon and deferent to the strong armature of architectural
structure. At places where there are catastrophes in the smooth
fabric of Western architectural history, one will find a disturbance
in the proper structure/ornament relationship. (Why does the pro-
fessor skip over Barcelona so quickly? I remind you that the word
"gaudy," a synonym for "ornate," comes from the Latin *gaudere,*
to rejoice. "Hides and hints and misses in prints," indeed.)

One of the prefacing quotations to Schor's *Reading in Detail* is
this:

> I do not doubt but the majesty and beauty of the world are latent in
> any iota of the world. ... I do not doubt there is far more in trivi-
> alities, insects, vulgar persons, dwarfs, weeds, rejected refuse, than I
> have supposed.[15]

These are the words of Walt Whitman, whose work Louis Sul-
livan thought bore an exact correspondence to his own, and with
whom he corresponded for a time.

Louis Henri Sullivan was one of ten architects chosen to design
the buildings for the World's Columbian Exposition in Chicago in
1893, celebrating (a year late) the four hundredth anniversary of
Christopher Columbus' arrival in the so-called New World. Sul-
livan was asked to design the Transportation Building. The build-
ing, in the form of a Roman basilica, is best known for its
entrance, which was known as the Golden Doorway (figure 2). It
consisted of six concentric and receding semicircular arches "puls-
ing with brilliantly colored ornament ... contained within a large
rectangular panel that was itself highly decorated."[16] Although
the Golden Doorway was considered one of the spectacles of the
fair, it was eclipsed historically by the glistening Beaux-Arts clas-
sicism of the White City. After the fair, Sullivan's career fell into a
steep decline.

Architectural historians have posited many superficially dis-

. . . . . . . . . . . . .

**15**   Ibid., p. 1.
**16**   Larry Millett, *The Curve of the Arch* (Minneapolis: Minnesota
Historical Society Press, 1985), p. 44.

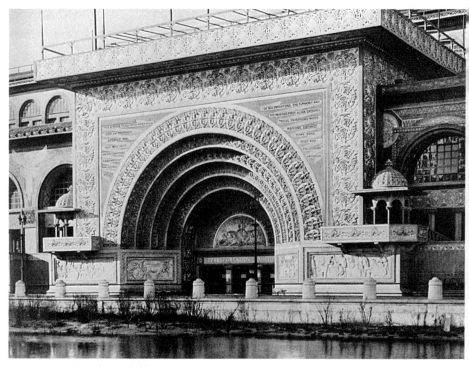

2  **Louis H. Sullivan**
Golden Doorway of the Transportation Building, 1893, Columbian
Exposition.

parate explanations for this, from the White City's effect on popu-
lar taste and Sullivan's failure to keep up with the times, to his split
with his partner, to his difficult personality (he is described as
"intransigent" and "temperamental," "moody and morose"[17]), to
the paucity of architectural commissions in general in the 1890s, to
his difficult marriage ("she had literary aspirations and a taste for
stylish living,"[18] rendering her, we presume, an unsuitable wife
for an architect), to his estrangement from his mother and brother,
to his frequent periods of depression, to his heavy drinking. Sul-
livan is described as handsome, a dandy, a person who cared too
much about his appearance, about clothing, and fabrics: "He also
took considerable pride in his appearance. Always immaculately
groomed, with never a hair out of place, he was, in a word, vain
about his looks."[19]

. . . . . . . . . . . .

17  Ibid., p. 47.
18  Ibid., p. 48.
19  Robert Twombly, *Louis Sullivan: His Life and Work* (New York: Viking
Press, 1986), p. 211.

In those passages from historians who "properly" and "taste-
fully" omit reference to Sullivan's sexuality, he is described in
feminine stereotype. He is made out to be "like a woman" so, one
presumes, we can read between the lines to understand how his
failure was both understandable and deserved.[20] But even Robert
Twombly's 1986 biography of Sullivan, which is sprinkled with
similar phrases, but in a final chapter makes the case for Sullivan's
"homosexuality, if indeed that is what it was,"[21] provides a
strange take:

> [H]is imagery was never entirely masculine.[22]

> In a "macho" environment, it was crucially important that a man be
> a man.[23]

> But if Sullivan married to reclaim his masculinity, the symbol alone
> would not guarantee success.[24]

> His obvious artistic inclinations could have been used to support
> rumors of his lack of manliness.[25]

There is here a bizarre confusion of sexuality with gender-
identification. If a man desires a man, which we must presume is
what is being written here, he is not a man. Were we to fail to read
between the lines in the way that we are of course expected to, we
might come to the conclusion that Louis Sullivan, "the dean of
American architects,"[26] was a woman. Furthermore, "His sexu-
ality informed and is visible in his work . . . it was so repressed he
may not have known it himself."[27]

Twombly here suggests that Sullivan was pathological, writ-
ing his sexuality all over the Midwest without being aware either
of his sexuality or of the fact that he was broadcasting it, writing

. . . . . . . . . . . . .

**20**   This phenomenon of blaming the victim is surely familiar to anyone
who, over the past five years, has read the reportage of the American press
on AIDS.

**21**   Twombly, *Louis Sullivan*, p. 211.

**22**   Ibid., p. 400.

**23**   Ibid., p. 402.

**24**   Ibid.

**25**   Ibid.

**26**   *New York Times*, April 16, 1924, p. 23.

**27**   Twombly, *Louis Sullivan*, p. 399.

so that we could read it, but he could not. This is something like Jacques Lacan's tale of two doors:[28]

> A train arrives at a station. A little boy and a little girl, brother and sister, are seated in a compartment face to face next to the window through which the buildings along the station platform can be seen passing as the train pulls to a stop. "Look," says the brother, "we're at Ladies!" "Idiot," replies his sister, "can't you see we're at Gentlemen?"

Sullivan becomes an historical marker of the significant, thick intersection of homophobia and misogyny. And complexity of difference: "If you will not participate exclusively in the relationships among males which we will absolutely limit to the exchange of women, we will write you as one of them, as woman, as mere ... except that (WHOOPS!) we will NOT write you as sexual object."

Here, as Craig Owens suggested, the logic gives way to reveal a secret: it is bisexuality (the province of women, who cannot cross the Oedipal threshold) which is the most fearful and hated thing. It is this "swinging both ways" which must be repressed at all costs.

Remember: the door marked "Ladies" and the door marked "Gentlemen" are identical objects, but not identical signifieds. (It seems important to note that John Whiteman's *Divisible by Two,* a project which was assembled in Vienna, invaded the sanctity of this fact by presenting a muddying both of the relationships of the signs and signifieds and of the difference between the signifieds. What are we to make of the fact that this little building of two doors, one marked *Damen,* one marked *Herren,* opening into a single space, was destroyed in a mysterious explosion?)

Traditionally, Sullivan's work is characterized by what historians and Sullivan himself term "organicism," that is, the elaboration of forms occurring in nature, particularly plant life. "Remember the seed germ," Sullivan repeatedly writes. Examined closely, there is something at work, especially in the ornamental designs of the years of his falling out of favor, which is not so much formal as technical. And that is a predominance of weaving, in which tendrils from the seed germ interlace each other and

. . . . . . . . . . . .

28   See Gallop, *The Daughter's Seduction,* p. 10.

dip in and out of incisions in tympanic forms in a way that both recalls and writes over Vitruvius' tale of the vine-entwined basket over the burial place of the Corinthian maiden.

It is in woven text-iles that expressions of repressions have traditionally surfaced. Weaving is the invention and activity of the inferior term of the pair, male or female. The origins of weaving lie in Greek culture, in which women had no citizenship and were allowed to play no active part. In providing an explanation for the anomaly of a contribution to culture made by women, Sigmund Freud suggests that women originated weaving by the plaiting of pubic hair in order to mask the absence of the penis and what the penis represents in society: the phallus and the power to prescribe and inscribe lines of legitimacy. Weaving here is a silent substitute for the power of speech. But, as Ann Bergren has demonstrated,[29] there is a paradox at work in the text of weaving (figure 3):

> Greek culture inherits from Indo-European a metaphor by which poets and prophets define themselves as "weaving" or "sewing" words. ... They call their product, in effect, a "metaphorical web." But which, then, is the original and which the metaphorical process? Is weaving a figurative speech or is poetry a figurative web? The question cannot be decided. Weaving as the sign-making activity of women is both literal and metaphorical, both original and derived. It is, like the Muses' speech, ambiguously true speech and an imitation of true speech.
>
> The myth of Tereus, Procne and Philomela provides a good example. It testifies to the regular limitation of women to tacit weaving, while exposing the magical power of a silent web to speak. When Tereus, the husband of Procne, rapes her sister Philomela, he cuts out the woman's tongue to keep her silent, but Philomela, according to Apollodorus (3.14.8), *huphenasa en peploi grammata,* "wove pictures/writing (*grammata* can mean either) in a robe" which she sent to her sister. Philomela's trick reflects *the "trickiness" of weaving, its uncanny ability to make meaning out of inarticulate matter, to make silent material speak* [emphasis mine]. In this way, women's weaving is, as *grammata* implies, a "writing" or graphic art, a silent, material representation of audible, immaterial speech.

. . . . . . . . . . . . .

**29**  Ann L. T. Bergren, "Language and the Female in Early Greek Thought," *Arethusa* 16, no. 1/2 (Spring/Fall 1983): 71–73.

3   **Charles-Amable Lenoir (1861–1932)**
*Poetry,* ca. 1890.

The woven thing, then, is much more than a mere pathetic substitute for a lack. It bears the ability to enable a resurfacing of that which has lain hidden, that which has been repressed. The power of the woven *grammata*, with its slippage between the visual and the verbal, and its power to communicate that which is unspeakable, that which has been secreted behind closed doors, is the power of allegory.

The text of Sullivan invites a rewriting. There are two Chicago works in particular which seem to have opened the door to this: his redesign of the façade of the Gage Building on South Michigan Avenue, by Holabird and Roche, and the ornament of the Schlesinger and Mayer Store (now Carson Pirie Scott) at the corner of State and Madison, in 1898 (figures 4 and 5).

> In several of Sullivan's later buildings one senses that he is especially interested in animating his design by introducing possibilities for alternative readings of the same architectural components. It is true for the lattice of the Carson Pirie Scott Store; it may explain the uncertainty of any definitive reading of the Gage Building, where, however, shifting perceptions of Sullivan's intent do not lock into crisp alternatives, but *slide into perplexity*.[30]

> Through a variety of strategies [at the Schlesinger and Mayer Store], he pushes ornament to the brink of its architectural possibilities, sometimes, to be sure, over the edge of propriety.[31]

> Both [the Bayard and Gage] buildings' columns can be read as part of the geometric male form, but when they exploded into huge decorative symbols of femininity at the Gage, the imagery was almost ejaculatory: the male sexual organ emitting a female form. Had Sullivan meant the male to *support* or *give birth* to the female, he would have violated his own reading of universal truths wherein the female was vital and primary. Rather, the Gage imagery was of the male *becoming* female.[32]

. . . . . . . . . . . .

30   William Jordy, "The Tall Buildings," in *Louis Sullivan: The Function of Ornament*, ed. Wim de Wit (New York: W. W. Norton and Co., 1986), p. 140. The emphasis is mine: the etymology of perplexity suggests the "thoroughly plaited."

31   Ibid., p. 133.

32   Twombly, *Louis Sullivan*, p. 401.

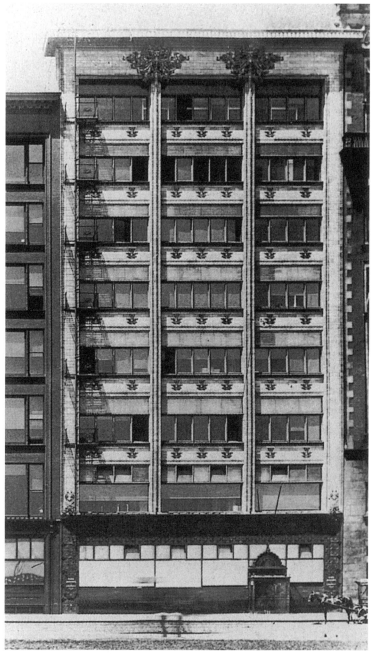

**4 Holabird and Roche**
(Louis Sullivan façade), Gage Building, 1898–99, Chicago.

**5  Louis H. Sullivan**
Schlesinger and Mayer Store, Chicago. Detail over door at corner.

... [H]e topped each of the piers with a gush of foliated ornament.[33]

These two works are characterizable by a pair of motifs, the column (at Gage) and the cartouche (at Schlesinger and Mayer). To make a brocade onto the top of Sullivan's woven thing, his text, is not to kill him, but is, rather, a connecting by writing on top of, into, beneath (like sewing), a move of *topoi*, of *la taupe*— "millions of a species of mole."[34] These moves of undermining are ambiguous, for, although the moves are made through Sullivan, it is not Sullivan who is the object of undermining. Sullivan himself was a tapestry maker, a brocade man. (One will recall that Sullivan's operation on the Gage Building is a weaving onto and into the existing Holabird and Roche building, a building, incidentally, in which a millinery concern was housed.)

Brocade and broach (to make a hole with a pointed rod or pin or needle, to begin to talk about) come from the same word, the Vulgar Latin *brocca*, a spike. Punching holes, undermining, slipping in and out, leaving threads behind. The same move as Theseus in the labyrinth, but for very different uses. There will be no linear backtracking here, for these threads are knotted and joined and criss-cross all over each other. Not the space of Ariadne, but of Arachne. Brocade involves perplexity because perplexity is the technique of its making.

*D'or* (in French) may mean either "of gold" or "of the now," and thus is related in its simultaneous reference to space and time to the Japanese word *ma*. MA is, of course, the acronym of Minor Architecture. Minor Architecture is a something which I have been trying to find for awhile now. The concept of minor architecture is both properly deduced from Manfredo Tafuri's concept of "major architecture" and illegitimately appropriated from Gilles Deleuze's and Félix Guattari's concept of minor literature. Minor literature is that writing which takes on the conventions of a major language and subverts it from the inside. The subject of Deleuze and Guattari is the work of Franz Kafka, a Jew writing in German in Prague in the early part of this century. Minor literatures possess three dominant characteristics:
. . . . . . . . . . . .

**33** Jordy, "The Tall Buildings," p. 138.
**34** Cixous and Clément, *The Newly Born Woman*, p. 65.

1 They are constructed by minorities within major languages, and involve deterritorializations of those languages. Deleuze and Guattari compare Prague German to American Black English.

2 They are intensely political: "[I]ts cramped space forces each individual intrigue to connect immediately to politics. The individual concern thus becomes all the more necessary, indispensable, magnified because a whole other story is vibrating within it."[35] In other words, in minor literatures the distinction between the personal and the political dissolves.

3 Minor literatures are collective assemblages; everything in them takes on collective value.

Deleuze and Guattari describe two paths of deterritorialization. One is: "artificially [to] enrich [the language], to swell it up through all the resources of symbolism, of oneirism, of esoteric sense, of a hidden signifier."[36] This is a Joycean approach. The other is to take on the poverty of a language and take it further, "to the point of sobriety."[37] This is Kafka's approach. Deleuze and Guattari then reject the Joycean as a kind of closet reterritorialization which breaks from the people, and go all the way with Kafka.

In transferring such a concept to architecture, already much more intensely materially simple and with more complex relationships to "the people" and to pragmatics, I believe it necessary to hang onto both possibilities, shuttling between them. This may begin to delineate a kind of shed opening between making architectural objects and writing architectonic texts.

What a minor architecture would be is a collection of practices which follow these conditions. Peter Eisenman has written recently, and quite correctly I think, that architecture will always look like architecture. One of the tasks of a minor architecture is to operate critically upon the dominance of the visual—the image—as a mode of perceiving and understanding architecture. Thus, what a minor architecture looks like is irrelevant outside the condition of its "looking like" architecture. This is not, therefore, a proposal

. . . . . . . . . . . .

**35** Deleuze and Guattari, *Kafka: Toward a Minor Literature*, p. 17.
**36** Ibid., p. 19.
**37** Ibid.

for a style or an *architecture parlante,* but for a revolutionary archi-
tectural criticism, a "criticism from within" which goes deeply
into the within—into the conventions of architecture's collusion
with mechanisms of power. (This is possibly every architectural
convention.) However, the space of minor architecture cannot
stop at the building, with its major entrance, but proliferates
across the lines among drawing and constructing and writing. It
can be entered at many locations.

If we re-enter and keep moving through Joyce's passage as it
takes us back into itself, the framing of the door appears as some-
thing we know. Where does it begin? Where does it end? In hides
and hints and misses (either "shes" or ellipses, voids, holes, things
missing, like the purloined letter which is both a miss and utterly
available to the gaze) in prints. In the seminar on *La lettre volée,*
Lacan takes Freud's story of lack-hiding uncritically when he says
the Minister is "feminine" when he hides the letter in plain sight.

*Is there a purloined letter in this construction? That the place of which
the apostrophe of d'or marks? An ellipsis of ellipse? But the "o" appears
and reappears (and so is in plain view) as door, as initial in the writing. An
elliptical ellipsis. The ellipses are misses in prints, those who are defective,
who have a lack. This is a story of o. Of o-ther. (The phi of philosophy is
an o under erasure.) This architecture is a weaving (a text) of openings, of
orifices, of nooks and crannies, holey spaces. It is a woven proliferation of
this tiny detail, easy to leave out, to leave behind. A construction like coral
reef: a proliferation, made of many small, insignificant bits, resistant to
because accepting of the force of tides, a delicate matrix as strong as the rock
of gibraltar. A barnacly dumping ground.*

There is another story here, which is actually an interweaving
of golden stories, all of which connect, brocadelike, to the text
which has just been read at multiple entrance points. It is the story
of an architectural project which is being planned for Chicago.
The stories are too long to tell, so I must rely on hides and hints.

**Story 1** Long ago. The Story of Hamlet's Mill. Once upon a
long time, the mythical Norse Titan Frodhi owned a giant quern,
or mill, which could only be operated by two giant maidens. It
was a magic mill which ground out gold, peace, and plenty.
Frodhi forced them to grind night and day without speaking

except to recite a certain poem, during which time they could rest. After a time, the maidens grew angry and initiated a sequence of events which caused the mill to grind out salt and be flung to the bottom of the sea, where it both formed the maelstrom and caused the sea to be salt. A great spiraling in a salty body.

**Story 2**  1923. The Story of the *Chicago Tribune* Competition. Once upon a time, the *Chicago Tribune* held a competition for the design of a skyscraper to house its operations. Adolf Loos entered it with drawings of an enormous black Doric column. He did not win, but he vowed, "The great Doric column will one day be built. If not in Chicago, then in another city. If not for the *Chicago Tribune,* then for some other newspaper. If not by me, then by another architect."[38]

**Story 3**  1989. The *Chicago Tribune* building, which was built in neogothic style, contains embedded in its base fragments of stones from buildings and landmarks from all over the globe, in a kind of reverse dissemination. In its basement are encrypted all the casts and molds of all kinds of grotesque ornament.

**Story 4**  1992, one hundred years after the Golden Doorway. Two women set the *Tribune* plug in motion, grinding out objects which fly in the face of Loos, and which constitute a brocaded mantle onto the repressed and mostly obliterated text of Sullivan (and Others) (figures 1 and 6).[39] Dozens of parasitic gaudy grotesque structures appear, chrysalises, attached to the corners of Chicago buildings, suspended and counterweighted at the parapets. They are structures of significance: woven of iron rings and golden rings and pink triangles and hoops, of metaphoric disturbances, of crocheted cable and braided silk, of fetters and stays, of the visual/verbal slippage of condensation and displacement, of tabby and bone, woven by the miming of the technique (not the look) of Louis Sullivan's foliate weaving. Bowers of tabble. They

. . . . . . . . . . . . .

38  Adolf Loos, *Spoken into the Void,* trans. Jane O. Newman and John H. Smith (Cambridge, Mass.: MIT Press, 1982), p. xiii.

39  I refer to a project in progress for the Chicago Institute for Architecture and Urbanism. The two women are Nina Hofer and myself. I have conducted a studio tangential to our project at the University of Florida, in which the students–Bob Heilman, Wendy Landry, Julio LaRosa, Mikesch Muecke, Judy Birdsong, and Dave Karpook–have built full-scale constructions which have also become part of the project.

constitute a mapping and marking of the hystery of Chicago. Hollow and accessible from the street by pull-up ladders which disappear into hidden orifices, they are occupiable. Places for those leftover to rest. Places that accept "both theory and flesh."[40]

P.S. The *sortie* is in the corner.

. . . . . . . . . . . . .

40  Gallop, *The Daughter's Seduction*, p. 150.

**6 "Tabbles of Bower"**
Project for Chicago Institute for Architecture and Urbanism, 1990.
Amulet/generative object, after Louis Sullivan. Cartilage, bone, glass
beads, copper wire.

*"Let's go, Mr. Dreamer, that television set won't help you shovel the walk."*

I

# The Suburban Home Companion: Television and the Neighborhood Ideal in Postwar America

## Lynn Spigel

IN DECEMBER 1949, the popular radio comedy *Easy Aces* made its television debut on the DuMont network. The episode was comprised entirely of Goodman Ace and his wife Jane sitting in their living room, watching TV. The interest stemmed solely from the couple's witty commentary on the program they watched. Aside from that, there was no plot. This was television, pure and simple. It was just the sense of being with the Aces, of watching them watch, and of watching TV with them, that gave this program its peculiar appeal.

The fantasy of social experience that this program provided is a heightened instance of a more general set of cultural meanings and practices surrounding television's arrival in postwar America. It is a truism among cultural historians and media scholars that television's growth after World War II was part of a general return to family values. Less attention has been devoted to the question of another, at times contradictory, ideal in postwar ideology–that of neighborhood bonding and community participation. During the 1950s, millions of Americans–particularly young white couples of the middle class–responded to a severe housing shortage in the cities by fleeing to new mass-produced suburbs. In both scholarly studies and popular literature from the period, suburbia emerges as a conformist-oriented society where belonging to the neighborhood network was just as important as the return to family life. Indeed, the new domesticity was not simply experienced as a retreat from the public sphere; it also gave people a sense of belonging to the community. By purchasing their detached suburban homes, the young couples of the middle class participated in the construction of a new community of values; in magazines, in films, and on the airwaves they became the cultural representatives of the "good life." Furthermore, the rapid growth of family-based community organizations like the PTA suggests that these neo-suburbanites did not barricade their doors, nor did they simply "drop out." Instead, these people secured a position of meaning in the *public* sphere through their new-found social identities as *private* landowners.

In this sense, the fascination with family life was not merely a nostalgic return to the Victorian cult of domesticity. Rather, the central preoccupation in the new suburban culture was the construction of a particular *discursive space* through which the family could mediate the contradictory impulses for a private haven on the one hand, and community participation on the other. By lining up individual housing units on connecting plots of land, the suburban tract was itself the ideal articulation of this discursive space; the dual goals of separation from and integration into the larger community was the basis of tract design. Moreover, as I have shown elsewhere, the domestic architecture of the period mediated the twin goals of separation from and integration into the out-

side world.[1] Applying principles of modernist architecture to the mass-produced housing of middle-class America, housing experts of the period agreed that the modern home should blur distinctions between inside and outside spaces. As Katherine Morrow Ford and Thomas H. Creighton claimed in *The American House Today* (1951), "the most noticeable innovation in domestic architecture in the past decade or two has been the increasingly close relationship of indoors to outdoors."[2] By far, the central design element used to create an illusion of the outside world was the picture window or "window wall" (what we now call sliding glass doors), which became increasingly popular in the postwar period. As Daniel Boorstin has argued, the widespread dissemination of large plate-glass windows for both domestic and commercial use "leveled the environment" by encouraging the "removal of sharp distinctions between indoors and outdoors" and thus created an "ambiguity" between public and private space.[3] This kind of spatial ambiguity was a reigning aesthetic in postwar home magazines which repeatedly suggested that windows and window walls would establish a continuity of interior and exterior worlds. As the editors of *Sunset* remarked in 1946, "Of all improved materials, glass made the greatest change in the Western home. To those who found that open porches around the house or . . . even [the] large window did not bring in enough of the outdoors, the answer was glass—the invisible separation between indoors and out."[4]

. . . . . . . . . . . . .

1   See my article "Installing the Television Set: Popular Discourses on Television and Domestic Space, 1948–55," *Camera Obscura* 16 (March 1988): 11–47; and my dissertation, "Installing the Television Set: The Social Construction of Television's Place in the American Home" (University of California-Los Angeles, 1988).
2   Katherine Morrow Ford and Thomas H. Creighton, *The American House Today* (New York: Reinhold Publishing Co., 1951), p. 139.
3   Daniel J. Boorstin, *The Americans: The Democratic Experience* (New York: Vintage Books, 1973), pp. 336–345. Boorstin sees this "leveling of place" as part of a wider "ambiguity" symptomatic of the democratic experience.
4   *Sunset Homes for Western Living* (San Francisco: Lane Publishing Co., 1946), p. 14.

Given its ability to merge private with public spaces, television was the ideal companion for these suburban homes. In 1946, Thomas H. Hutchinson, an early experimenter in television programming, published a popular book designed to introduce television to the general public, *Here is Television, Your Window on the World*.[5] As I have shown elsewhere, commentators in the popular press used this window metaphor over and over again, claiming that television would let people imaginatively travel to distant places while remaining in the comfort of their homes.[6]

Indeed, the integration of television into postwar culture both precipitated and was symptomatic of a profound reorganization of social space. Leisure time was significantly altered as spectator amusements—including movies, sports, and concert attendance—were increasingly incorporated into the home. While in 1950 only 9 percent of all American homes had a television set, by the end of the decade that figure rose to nearly 90 percent, and the average American watched about five hours of television per day.[7] Television's privatization of spectator amusements and its possible disintegration of the public sphere were constant topics of debate in popular media of the period. Television was caught in a contradictory movement between private and public worlds, and it often became a rhetorical figure for that contradiction. In the following pages, I examine the way postwar culture balanced these contradictory ideals of privatization and community involvement

. . . . . . . . . . . .

**5** Thomas H. Hutchinson, *Here is Television, Your Window on the World* (1946; New York: Hastings House, 1948), p. ix.

**6** For more on this, see my article "Installing the Television Set: Popular Discourses on Television and Domestic Space, 1948–55" and my dissertation, "Installing the Television Set: The Social Construction of Television's Place in the American Home."

**7** The data on installation rates vary slightly from one source to another. These estimations are based on Cobbett S. Steinberg, *TV Facts* (New York: Facts on File, 1980), p. 142; "Sales of Home Appliances," and "Dwelling Units," *Statistical Abstract of the United States* (Washington, D.C., 1951–56); Lawrence W. Lichty and Malachi C. Topping, *American Broadcasting: A Source Book on the History of Radio and Television* (New York: Hastings House, 1975), pp. 521–522. Note, too that there were significant regional differences in installation rates. Television was installed most rapidly in the Northeast; next were the central and western states, which had relatively similar installation rates; the South and southwest mountain areas were considerably behind the rest of the country. See "Communications,"

through its fascination with the new electrical space that television provided.

Postwar America witnessed a significant shift in traditional notions of neighborhood. Mass-produced suburbs like Levittown and Park Forest replaced previous forms of public space with a newly defined aesthetic of prefabrication. At the center of suburban space was the young, upwardly mobile middle-class family; the suburban community was, in its spatial articulations, designed to correspond with and reproduce patterns of nuclear family life. Playgrounds, yards, schools, churches, and synagogues provided town centers for community involvement based on discrete stages of family development. Older people, gay and lesbian people, homeless people, unmarried people, and people of color were simply written out of these community spaces–relegated back to the cities. The construction and "red-lining" policies of the Federal Housing Administration gave an official stamp of approval to these exclusionary practices by ensuring that homes were built for nuclear families and that "undesirables" would be "zoned" out of the neighborhoods. Suburban space was thus designed to purify communal spaces, to sweep away urban clutter, while at the same time preserving the populist ideal of neighborliness that carried America through the Depression.

Although the attempt to zone out "undesirables" was never totally successful, this antiseptic model of space was the reigning aesthetic at the heart of the postwar suburb. Not coincidentally, it had also been central to utopian ideals for electrical communication since the mid-1800s. As James Carey and John Quirk have shown, American intellectuals of the nineteenth century foresaw an "electrical revolution" in which the grime and noise of industrialization would be purified through electrical power.[8] Electricity, it was assumed, would replace the pollution caused by factory

· · · · · · · · · · · ·

in *Statistical Abstract of the United States* (Washington, D.C., 1959); *U.S. Bureau of the Census, Housing and Construction Reports,* Series H-121, nos. 1–5 (Washington, D.C., 1955–58). Average hours of television watched is based on a 1957 estimate from the A. C. Nielsen Company printed in Leo Bogart, *The Age of Television: A Study of Viewing Habits and the Impact of Television on American Life* (1956; New York: Frederick Unger, 1958), p. 70.

8   James W. Carey and John J. Quirk, "The Mythos of the Electronic Revolution," in *Communication as Culture,* ed. James W. Carey (Boston: Unwin Hyman, 1989), pp. 113–141. For related issues, see Leo Marx, *The*

machines with a new, cleaner environment. Through their ability to merge remote spaces, electrical communications like the telephone and telegraph would add to this sanitized environment by allowing people to occupy faraway places while remaining in the familiar and safe locales of the office or the home. Ultimately, this new electrical environment was linked to larger concerns about social decadence in the cities. In both intellectual and popular culture, electricity became a rhetorical figure through which people imagined ways to cleanse urban space of social pollutants; immigrants and class conflict might vanish through the magical powers of electricity. As Carolyn Marvin has suggested, nineteenth-century thinkers hoped that electrical communications would defuse the threat of cultural difference by limiting experiences and placing social encounters into safe, familiar, and predictable contexts. In 1846, for example, *Mercury* published the utopian fantasies of one Professor Alonzo Jackman, who imagined a transcontinental telegraph line through which "all the inhabitants of the earth would be brought into one intellectual neighborhood and be at the same time perfectly freed from those contaminations which might under other circumstances be received." Moreover, as Marvin suggests, this xenophobic fantasy extended to the more everyday, local uses of communication technology: "With long-distance communication, those who were suspect and unwelcome even in one's neighborhood could be banished in the name of progress." Through telecommunications it was possible to make one's family and neighborhood into the "stable center of the universe," eliminating the need even to consider cultural differences in the outside world.[9]

Although Marvin is writing about nineteenth-century communication technology, the utopian fantasy that she describes is also part and parcel of the twentieth-century imagination. Indeed,

. . . . . . . . . . . .

*Machine in the Garden: Technology and the Pastoral Ideal in America* (New York: Oxford University Press, 1964); John F. Kasson, *Civilizing the Machine: Technology and Republican Values in America, 1776–1900* (New York: Penguin, 1977); Wolfgang Schivelbusch, *Disenchanted Night: The Industrialization of Light in the Nineteenth Century,* trans. Angela Davies (Berkeley: University of California Press, 1988).

**9** Carolyn Marvin, *When Old Technologies Were New: Thinking About Communications in the Late Nineteenth Century* (New York: Oxford University Press, 1988), pp. 200–201.

the connections between electrical communications and the puri-
fication of social space sound like a prototype for the mass-
produced suburbs. Throughout the twentieth century, these con-
nections would be forged by utility companies and electrical
manufacturers who hoped to persuade the public of the link
between electricity and a cleaner social environment. Then too,
the dream of filtering social differences through the magical
power of the "ether" was a reigning fantasy in the popular press
when radio was introduced in the early 1920s. As Susan Douglas
has shown, popular critics praised radio's ability to join the nation
together into a homogeneous community where class divisions
were blurred by a unifying voice. This democratic utopia was,
however, imbricated in the more exclusionary hope that radio
would "insulate its listeners from heterogeneous crowds of
unknown, different, and potentially unrestrained individuals."[10]
Thus, broadcasting, like the telephone and telegraph before it, was
seen as an instrument of social sanitation.

In the postwar era, the fantasy of antiseptic electrical space was
transposed onto television. Numerous commentators extolled the
virtues of television's antiseptic spaces, showing how the medium
would allow people to travel from their homes while remaining
untouched by the actual social contexts to which they imag-
inatively ventured. Television was particularly hailed for its ability
to keep youngsters out of sinful public spaces, away from the
countless contaminations of everyday life. At a time when juvenile
delinquency was considered a number one social disease, audience
research showed that parents believed television would keep their
children off the streets.[11] A mother from a Southern California
survey claimed, "Our boy was always watching television, so we
got him a set just to keep him home." Another mother from an

. . . . . . . . . . . .

**10** For discussions about electricity see Carey and Quirk, "The Mythos
of the Electronic Revolution" and "The History of the Future," in
*Communication as Culture,* pp. 173–200; Andrew Feldman, "Selling the
'Electrical Idea' in the 1920s: A Case Study in the Manipulation of
Consciousness" (Master's Thesis, University of Wisconsin-Madison, 1989);
Susan J. Douglas, *Inventing American Broadcasting, 1899–1922* (Baltimore:
Johns Hopkins University Press, 1987) p. 308.
**11** For a detailed study of the widespread concern about juvenile
deliquency, see James Gilbert, *A Cycle of Outrage: America's Reaction to the
Juvenile Delinquent in the 1950s* (New York: Oxford University Press, 1986).

Atlanta study stated, "We are closer together . . . . Don and her boyfriend sit here instead of going out, now."[12] Women's home magazines promoted and reinforced these attitudes by showing parents how television could limit and purify their children's experiences. *House Beautiful* told parents that if they built a TV fun room for their teenage daughters they would find "peace of mind because teenagers are away from [the] house but still at home."[13] Television thus promised to keep children away from unsupervised, heterogeneous spaces.

But television technology promised more than just familial bliss and "wholesome" heterosexuality. Like its predecessors, it offered the possibility of an intellectual neighborhood, purified of social unrest and human misunderstanding. As NBC's president Sylvester "Pat" Weaver declared, television would make the "entire world into a small town, instantly available, with the leading actors on the world stage known on sight or by voice to all within it." Television, in Weaver's view, would encourage world peace by presenting diverse people with homogeneous forms of knowledge and modes of experience. Television, he argued, created "a situation new in human history in that children can no longer be raised within a family or group belief that narrows the horizons of the child to any belief pattern. There can no longer be a We-Group, They Group under this condition. Children cannot be brought up to laugh at strangers, to hate foreigners, to live as man has always lived before." But for Weaver, this democratic utopian world was in fact a very small town, a place where different cultural practices were homogenized and channeled through a medium whose messages were truly American. As he continued, "it [is] most important for us in our stewardship of broadcasting to remain within the 'area of American agreement,' with all the implications of that statement, including however some acknowledgement in our programming of the American heritage of dissent." Thus, in Weaver's view, broadcasting would be a cultural filter that purified the essence of an "American" experience, relegating social and ideological differences (what he must have meant by the "American heritage of dissent") to a kind of pro-

. . . . . . . . . . . .

**12**    Edward C. McDonagh et al., "Television and the Family," *Sociology and Social Research* 40, no. 4 (March–April 1956): 116, and Raymond Stewart cited in Bogart, *The Age of Television*, p. 100.

**13**    *House Beautiful* (October 1951): 168.

gramming ghetto. Moreover, he went on to say that "those families who do not wish to participate fully in the American area of agreement" would simply have to screen out undesirable programming content by overseeing their children's use of television. [14]

The strange mix of democracy and cultural hegemony that ran through Weaver's prose was symptomatic of a more general set of contradictions at the heart of utopian dreams for the new antiseptic electrical space. Some social critics even suggested that television's ability to sanitize social space would be desirable to the very people who were considered dirty and diseased. They applauded television for its ability to enhance the lives of disenfranchised groups by bringing them into contact with the public spaces in which they were typically unwelcome. In a 1951 study of Atlanta viewers, Raymond Stewart found that television "has a very special meaning for invalids, or for Southern Negroes who are similarly barred from public entertainments."[15] One black respondent in the study claimed:

> It [television] permits us to see things in an uncompromising manner. Ordinarily to see these things would require that we be segregated and occupy the least desirable seats or vantage point. With television we're on the level with everyone else. Before television, radio provided the little bit of equality we were able to get. We never wanted to see any show or athletic event bad enough to be segregated in attending it.[16]

. . . . . . . . . . . .

14  Sylvester L. (Pat) Weaver, "The Task Ahead: Making TV the 'Shining Center of the Home' and Helping Create a New Society of Adults," *Variety,* January 6, 1954, p. 91. The hope for a new democratic global village was also expressed by other industry executives. David Sarnoff, chairman of the board of RCA, claimed, "When Television has fulfilled its destiny, man's sense of physical limitation will be swept away, and his boundaries of sight and hearing will be the limits of the earth itself. With this may come a new horizon, a new philosophy, a new sense of freedom and greatest of all, perhaps, a finer and broader understanding between all the peoples of the world." Cited in William I. Kaufman, *Your Career in Television* (New York: Merlin Press, 1950), p. vii.

15  Stewart's findings are summarized here by Bogart, *The Age of Television,* p. 98.

16  Respondent to Stewart's study is cited in Bogart, *The Age of Television,* p. 98.

Rather than blaming the social system that produced this kind of degradation for African Americans, social scientists such as Stewart celebrated the technological solution. Television, or more specifically, the private form of reception that it offered, was applauded for its ability to dress the wounds of an ailing social system. As sociologist David Riesman claimed, "The social worker may feel it is extravagant for a slum family to buy a TV set on time, and fail to appreciate that the set is exactly the compensation for substandard housing the family can best appreciate—and in the case of Negroes or poorly dressed people, or the sick, an escape from being embarrassed in public amusement places."[17] Riesman thus evoked images of social disease to suggest that disempowered groups willed their own exclusion from the public sphere through the miraculous benefits of television.

Although social critics hailed television's ability to merge public and private domains, this utopian fantasy of space-binding revealed a dystopian underside. Here, television's antiseptic spaces were themselves subject to pollution as new social diseases spread through the wires and into the citizen's home. Metaphors of disease were continually used to discuss television's unwelcome presence in domestic life. In 1951, *American Mercury* asked if television "would make us sick . . . or just what?" Meanwhile, psychologists considered television's relation to the human psyche. Dr. Eugene Glynn, for example, claimed that certain types of adult psychoses could be relieved by watching television, but that "those traits that sick adults now satisfy by television can be presumed to be those traits which children, exposed to television from childhood . . . may be expected to develop."[18] More generally, magazine writers worried about the unhealthy psychological and physical effects that television might have on children. Indeed, even if television was hailed by some as a way to keep children out of dangerous public spaces, others saw the electrical environment as a threatening extension of the public sphere.[19] Most typically, television was

. . . . . . . . . . . .

17 David Riesman, "Recreation and the Recreationist," *Marriage and Family Living* 16, no. 1 (February 1954): 23.

18 Eugene David Glynn, M.D., "Television and the American Character—A Psychiatrist Looks at Television," in *Television's Impact on American Culture,* ed. William Y. Elliot (East Lansing, Mich.: Michigan State University Press, 1956), p. 177.

19 Following along the trail of other mass media aimed at youth (e.g., dime novels, comic books, radio, and film), television became a particular

2

said to cause passive and addictive behavior which would in turn disrupt good habits of nutrition, hygiene, social behavior, and education. In 1951, *Better Homes and Gardens* claimed that television's "synthetic environment" produced children who refused to sleep, eat, or talk as they sat passively "glued" to the set. Similarly, in 1950 *Ladies' Home Journal* depicted a little girl slumped on an ottoman and suffering from a new disease called "telebugeye" (figure 2). The caption described the child as a "pale, weak, stupid looking creature" who grew "bugeyed by looking at television too long." As the popular wisdom often suggested, the child's

. . . . . . . . . . . . .

concern of parents, educators, clergy, and government officials. The classic tirade against mass culture during the period was Frederic Wertham's *Seduction of the Innocent* (1953; New York: Rinehart and Company, 1954), the eighth chapter of which was entitled, "Homicide at Home: Television and the Child."

passive addiction to television might itself lead to the opposite effect of increased aggression. In 1955, for example, *Newsweek* reported on young Frank Stretch, an eleven-year-old who had become so entranced by a television western that "with one shot of his trusty BB gun [he] demolished both villain and picture tube."[20]

Metaphors of disease went beyond these hyperbolic debates on human contamination to the more mundane considerations of set repair. Discussions of technology went hand in hand with a medical discourse which attributed to television a biological (rather than technological) logic. A 1953 Zenith ad declared, "We test TV blood pressure so you'll have a better picture." In that same year *American Home* suggested that readers "learn to diagnose and cure common TV troubles," listing symptoms, causes, treatments, and ways to "examine" the set. Thus the television set was itself represented as a human body, capable of being returned to "health" through proper medical procedures.[21]

Anxieties about television's contaminating effects were based on a larger set of confusions about the spaces that broadcast technology brought to the home. Even before television's innovation in the postwar period, popular media expressed uncertainty about the distinction between real and electrical space and suggested that electrical pollutants might infiltrate the physical environment. *Murder By Television,* a decidedly B film of 1935, considered the problems entailed when the boundaries between the television universe and the real world collapsed. The film featured Bela Lugosi in a nightmarish tale about a mad corporate scientist who transmits death rays over electrical wires. In an early scene, Professor Houghland, the benevolent inventor of television, goes on the air to broadcast pictures from around the world. But as he

. . . . . . . . . . . .

20 William Porter, "Is Your Child Glued to TV, Radio, Movies, or Comics?" *Better Homes and Gardens* (October 1951): 125; *Ladies' Home Journal* (April 1950): 237; "Bang! You're Dead," *Newsweek,* March 21, 1955, p. 35. For more information on this, see my dissertation "Installing the Television Set" and my article "Television in the Family Circle: The Popular Reception of a New Medium," in *Logics of Television,* ed. Patricia Mellencamp (Bloomington: Indiana University Press, 1990), pp. 73–97.

21 *Better Homes and Gardens* (September 1953): 154; John L. Springer, "How to Care for Your TV Set," *American Home* (June 1953): 44.

marvels at the medium's ability to bring faraway places into the home, his evil competitor, Dr. Scofield, kills him by sending "radiated waves" through the telephone wires and into the physical space of the television studio where the unfortunate Professor Houghland dies an agonizing death.

While less extreme in their representation of threatening technology, film comedies of the thirties and forties contained humorous scenes that depicted confusion over boundaries between electrical and real space. In the farcical *International House* (1933), for example, businessmen from around the globe meet at a Chinese hotel to witness a demonstration of the first fully operating television set. When Dr. Wong presents his rather primitive contraption to the conventioneers, television is shown to be a two-way communication system that not only features entertainment but can also respond to its audiences. After a spectator (played by W. C. Fields) ridicules the televised performance of crooner Rudy Vallee, Vallee stops singing, looks into the television camera, and tells Fields, "Don't interrupt my number. Hold your tongue and sit down." Later, when watching a naval battle on Wong's interactive television set, Fields even shoots down one of the ships in the scene. Similarly, in the popular film comedy serial, *The Naggers,* Mrs. Nagger and her mother-in-law confuse the boundaries between real and electrical space in a scene that works as a humorous speculation about television ("The Naggers Go Ritzy," 1932). After the Naggers move into a new luxury apartment, Mr. Nagger discovers that there is a hole in the wall adjacent to his neighbor's apartment. To camouflage the hole, he places a radio in front of it. When Mrs. Nagger turns on the radio, she peers through the speaker in the receiver, noticing a man in the next apartment. Fooled into thinking that the radio receiver is really a television, she instructs her mother-in-law to look into the set. A commercial for mineral water comes on the air, claiming, "The Cascade Spring Company eliminates the middle-man. You get your water direct from the spring into your home." Meanwhile, Mrs. Nagger and her mother-in-law gaze into the radio speaker hoping to see a televised image. Instead, they find themselves drenched by a stream of water. Since a prior scene in the film shows that the next-door neighbor is actually squirting water at the Naggers through the hole in the adjacent wall, the joke is on

the technically illiterate women who can't distinguish between electrical and real space.[22]

By the late 1940s, the confusion between spatial boundaries at the heart of these cinematic jokes was less pronounced. People were learning ways to incorporate television's spectacles within the contours of their homes. As I have shown elsewhere, postwar home magazines and handbooks on interior decor presented an endless stream of advice on how to make the home into a comfortable theater.[23] In 1949, for example, *House Beautiful* advised its readers that "conventional living room groupings need to be slightly altered because televiewers look in the same direction and not at each other." *Good Housekeeping* seconded the motion in 1951 when it claimed that "television is theatre; and to succeed, theatre requires a comfortably placed audience with a clear view of the stage."[24] Advertisements for television sets variously referred to the "chairside theater," the "video theater," the "family theater," and so forth. Taken to its logical extreme, this theatricalization of the home transformed domestic space into a private pleasure dome. In 1951, *American Home* displayed "A Room that Does Everything" which included a television set, radio, phonograph, movie projector, movie screen, loud speakers, and even a barbecue pit. As the magazine said of the proud owners of this total theater, "The Lanzes do all those things in *The Room*."[25] In fact, the ideal home theater was precisely "the room" which one need never leave, a perfectly controlled environment of wall-to-wall mechanized pleasures.

But more than just offering family fun, these new home theaters provided postwar Americans with a way to mediate relations between public and private spheres. By turning one's home into a

. . . . . . . . . . . . .

22   A similar scene is found in *The Three Stooges* comedy short "Scheming Schemers" (ca. 1946) when the Stooges, posing as plumbers, mistakenly squirt a gush of water through the television set of a wealthy matron who is showing her guests a scene of Niagara Falls on TV.

23   See my "Installing the Television Set: Popular Discourses on Television and Domestic Space, 1948–55" and my dissertation "Installing the Television Set: The Social Construction of Television's Place in the American Home."

24   *House Beautiful* 91 (August 1949): 66; "Where Shall We Put the Television Set?" *Good Housekeeping* (August 1951): 107.

25   *American Home* (May 1951): 40.

theater, it was possible to make outside spaces part of a safe and predictable experience. In other words, the theatricalization of the home allowed people to draw a line between the public and the private sphere–or, in more theatrical terms, a line between the proscenium space where the spectacle took place and the reception space in which the audience observed the scene.

Indeed, as Lawrence Levine has shown, the construction of that division was central to the formation of twentieth-century theaters.[26] Whereas theater audiences in the early 1800s tended to participate in the show through hissing, singing, and other forms of interaction, by the turn of the century theaters increasingly attempted to keep audiences detached from the performance. The silent, well-mannered audience became a mandate of "good taste," and people were instructed to behave in this manner in legitimate theaters and, later, in nickelodeons and movie palaces. In practice, the genteel experiences that theaters encouraged often seem to have had the somewhat less "tasteful" effect of permitting what George Lipsitz (following John Kasson) has called a kind of "privacy in public."[27] Within the safely controlled environment of the nickelodeon, audiences—especially youth audiences—engaged in illicit flirtation. At a time of huge population increases in urban centers, theaters and other forms of public amusements (most notably, as Kasson has shown, the amusement park) offered people the fantastic possibility of being alone while in the midst of a crowd. Theaters thus helped construct imaginary separations between people by making individual contemplation of mass spectacles possible.

In the postwar era, this theatrical experience was being reformulated in terms of the television experience. People were shown how to construct an exhibition space that replicated the general design of the theater. However, in this case, the relationship

. . . . . . . . . . . . .

26   Lawrence W. Levine, *Highbrow/Lowbrow: The Emergence of Cultural Hierarchy in America* (Cambridge, Mass.: Harvard University Press, 1988).
27   George Lipsitz, *Time Passages: Collective Memory and American Popular Culture* (Minneapolis: University of Minnesota Press, 1990), p. 8. Also see John F. Kasson, *Amusing the Million: Coney Island at the Turn of the Century* (New York: Hill and Wang, 1978) and Kathy Peiss, *Cheap Amusements: Working Women and Leisure in Turn-of-the-Century New York* (Philadelphia: Temple University Press, 1986).

between public/spectacle and private/spectator was inverted. The spectator was now physically isolated from the crowd, and the fantasy was now one of imaginary unity with "absent" others. This inversion gave rise to a set of contradictions that weren't easily solved. According to the popular wisdom, television had to recreate the sense of social proximity that the public theater offered; it had to make the viewer feel as if he or she were taking part in a public event. At the same time, however, it had to maintain the necessary distance between the public sphere and private individual upon which middle-class ideals of reception were based.

The impossibility of maintaining these competing ideals gave rise to a series of debates as people weighed the ultimate merits of bringing theatrical experiences indoors. Even if television promised the fantastic possibility of social interconnection through electrical means, this new form of social life wasn't always seen as an improvement over real community experiences. The inclusion of public spectacles in domestic space always carried with it the unpleasant possibility that the social ills of the outside world would invade the private home. The more that the home included aspects of the public sphere, the more it was seen as subject to unwelcome intrusions.

This was especially true in the early years of innovation when the purchase of a television set quite literally decreased privacy in the home. Numerous social scientific studies showed that people who owned television receivers were inundated with guests who came to watch the new set.[28] But this increased social life was not always seen as a positive effect by the families surveyed. As one woman in a Southern California study complained, "Sometimes I

· · · · · · · · · · · ·

28  After reviewing numerous studies from the fifties, Bogart claims in *The Age of Television,* "In the early days, 'guest viewing' was a common practice" (p. 102). For a summary of the actual studies, see Bogart, pp. 101–107. For additional studies that show the importance of guest viewing in the early period, see John W. Riley et al., "Some Observations on the Social Effects of Television," *Public Opinion Quarterly* 13, no. 2 (Summer 1949): 233 (this article was an early report of the CBS-Rutgers University studies begun in the summer of 1948); McDonagh et al., "Television and the Family," p. 116; "When TV Moves In," *Televiser* 7, no. 8 (October 1950): 17 (a summary of the University of Oklahoma surveys of Oklahoma

get tired of the house being used as a semiprivate theater. I have almost turned the set off when some people visit us."[29] Popular media were also critical of the new "TV parties." In 1953, *Esquire* published a cartoon that highlighted the problem entailed by making one's home into a TV theater. The sketch pictures a living room with chairs lined up in front of a television set in movie theater fashion. The residents of this home theater, dressed in pajamas and bathrobes with hair uncombed and feet unshod, are taken by surprise when the neighbors drop in—a bit too soon—to watch a wrestling match on television. Speaking in the voice of the intruders, the caption reads, "We decided to come over early and make sure we get good seats for tonight's fight." In that same year, a cartoon in *TV Guide* suggested a remedy for the troublesome neighbors which took the form of a hand-held mechanical device known as "Fritzy." The caption read, "If your neighbor won't buy his own set, try 'Fritzy.' One squeeze puts your set on the fritz."[30]

Such popular anxieties are better understood when we recognize the changing structure of social relationships encountered by the new suburban middle class. These people often left their families and life-long friends in the city to find instant neighborhoods in preplanned communities. Blocks composed of total strangers represented friendships only at the abstract level of demographic similarities in age, income, family size, and occupation. This homogeneity quickly became a central cause for anxiety in the suburban nightmares described by sociologists and popular critics. In *The Organization Man* (1957), William H. Whyte argued that a sense of community was especially important for the newcomers who experienced a feeling of "rootlessness" when they left their old neighborhoods for new suburban homes. As Whyte showed, the developers of the mass-produced suburbs tried to smooth the tensions caused by this sense of rootlessness by promising increased community life in their advertisements. For example, Park Forest, a Chicago suburb, assured consumers that "Cof-

. . . . . . . . . . . . .

City and Norman, Oklahoma); Philip F. Frank, "The Facts of the Medium," *Televiser* (April 1951): 14; and "TV Bonus Audience in the New York Area," *Televiser* (November 1950): 24–25.

**29** McDonagh et al., "Television and the Family," p. 116.

**30** *Esquire* (July 1953): 110; Bob Taylor, "Let's Make Those Sets Functional," *TV Guide*, August 21–27, 1953, p. 10.

feepots bubble all day long in Park Forest. This sign of friendliness tells you how much neighbors enjoy each other's company–feel glad that they can share their daily joys–yes, and troubles, too."[31] But when newcomers arrived in their suburban communities, they were likely to find something different from the ideal that the magazines and advertisements suggested. Tiny homes were typically sandwiched together so that the Smiths' picture window looked not onto rambling green acres, but rather into the Jones' living room–a dilemma commonly referred to as the "goldfish bowl" effect. In addition to this sense of claustrophobia, the neighborhood ideal brought with it an enormous amount of pressure to conform to the group. As Harry Henderson suggested in his study of Levittown (1953), the residents of this mass-produced suburb were under constant "pressure to 'keep up with the Joneses'," a situation that led to a "kind of superconformity" in which everyone desired the same luxury goods and consumer lifestyles. In his popular critique of the new suburbia, aptly entitled *The Crack in the Picture Window* (1956), John Keats considered the tedium of this superconformity, describing the life of Mary and John Drone who lived among a mob of equally unappealing neighbors. And in *The Split-Level Trap* (1960), Richard Gordon and others used eight case studies to paint an unsettling picture of the anxieties of social dislocation experienced in a suburban town they called "Disturbia."[32]

These nightmarish visions of the preplanned community served as an impetus for the arrival of a surrogate community on television. Television provided an illusion of the ideal neighborhood–the way it was supposed to be. Just when people had left their life-long companions in the city, television sitcoms pictured romanticized versions of neighbor and family bonding. When promoting the early domestic comedy, *Ethel and Albert,* NBC told viewers to tune into "a delightful situation comedy that is returning this weekend . . . Yes, this Saturday night, *Ethel and Albert*

. . . . . . . . . . . .

31  William H. Whyte, *The Organization Man* (Garden City, N.Y.: Doubleday, 1957), p. 314.

32  Harry Henderson, "The Mass-Produced Suburbs," *Harper's* (November 1953): 25–32, and "Rugged American Collectivism," *Harper's* (December 1953): 80–86; John Keats, *The Crack in the Picture Window* (1956; Boston: Houghton Mifflin, 1957); Richard E. Gordon, M.D., et al., *The Split-Level Trap* (New York: Dell, 1960).

come into view once again to keep you laughing at the typical foibles of the kind of people who might be living right next door to you." The idea that television families were neighbors was also found in critical commentary. In 1953, *Saturday Review* claimed, "The first thing you notice about these sketches [*The Goldbergs, The Adventures of Ozzie and Harriet, Ethel and Albert,* and the live *Honeymooners* skits] is that they are incidents; they are told as they might be told when neighbors visit (in the Midwest sense of the word) on the front porch or the back fence." Indeed, since many of the comedies had been on radio in the thirties and forties, the characters and stars must have seemed like old friends to many viewers. Then too, several of the most popular sitcoms were set in urban and ethnic locales, presenting viewers with a nostalgic vision of neighborhood experiences among immigrant families.[33] Even the sitcoms set in suburban towns externalized the private world by including neighbor characters who functioned as life-long friends to the principle characters.[34] The opening credits of fifties sitcoms further encouraged audiences to perceive television's families as neighbors, linked through electrical wires to their own homes. Typically, the credit sequences depicted families exiting their front doors (*Donna Reed, Leave It to Beaver, Make Room for Daddy, Ozzie and Harriet*) or greeting viewers in a neighborly fashion by leaning out their windows (*The Goldbergs*), and the programs often used establishing shots of the surrounding neighborhoods (*Father Knows Best, Ozzie and Harriet, Leave It to Beaver, Make Room for Daddy, The Goldbergs*).

Early television's most popular situation comedy, *I Love Lucy,* is a perfect–and typical–example of the importance attached to the theme of neighborhood bonding in the programs. The primary characters, Lucy and Ricky Ricardo, and their downstairs land-

. . . . . . . . . . . . .

**33** "NBC Promo for *Ethel and Albert* for use on the *The Golden Windows,*" Clyde Clem's Office, August 31, 1954, NBC Records Box 136: Folder 15, State Historical Society, Madison, Wisconsin; Gilbert Seldes, "Domestic Life in the Forty-ninth State," *Saturday Review,* August 22, 1953, p. 28. For a fascinating discussion of nostalgia in early ethnic situation comedies see Lipsitz, "The Meaning of Memory: Family, Class and Ethnicity in Early Network Television," in *Time Passages,* pp. 39–76.

**34** *I Married Joan's* Aunt Vera, *My Favorite Husband's* Gilmore and Myra Cobbs, *Burns and Allen's* Harry and Blanch Morton, and *Ozzie and Harriet's* Thorny Thornberry were faithful companions to the central characters of the series.

lords, Ethel and Fred Mertz, were constantly together, and the more mature Mertzes served a quasi-parental role so that neighbors appeared as a family unit. In 1956, when the Ricardos moved from their Manhattan apartment to an idyllic Connecticut suburb, Lucy and Ricky reenacted the painful separation anxieties that many viewers must have experienced over the previous decade. In an episode entitled "Lucy Wants to Move to the Country," Lucy has misgivings about leaving the Mertzes behind and the Ricardos decide to break their contract on their new home. But at the episode's end, they realize that the fresh air and beauty of suburban life will compensate for their friendships in the city. After learning their "lesson," the Ricardos are rewarded in a subsequent episode ("Lucy Gets Chummy With the Neighbors") when they meet their new next-door neighbors, Ralph and Betty Ramsey, who were regularly featured in the following programs. While the inclusion of these neighbor characters provided an instant remedy for the painful move to the suburbs, the series went on to present even more potent cures. The next episode, "Lucy Raises Chickens," brings Ethel and Fred back into the fold when the older couple sell their Manhattan apartment to become chicken farmers in the Connecticut suburb–and of course, the Mertzes rent the house next door to the Ricardos. Thus, according to this fantasy scenario, the move from the city would not be painful because it was possible to maintain traditional friendships in the new suburban world.

The burgeoning television culture extended these metaphors of neighborhood bonding by consistently blurring the lines between electrical and real space. Television families were typically presented as "real families" who just happened to live their lives on TV. Ricky and Lucy, Ozzie and Harriet, Jane and Goodman Ace, George and Gracie, and a host of others crossed the boundaries between fiction and reality on a weekly basis. Promotional and critical discourses further encouraged audiences to think that television characters lived the life of the stars who played them. For example, when writing about the *Adventures of Ozzie and Harriet,* a critic for a 1953 issue of *Time* claimed that the "Nelson children apparently accept their double life as completely natural." In that same year, the *Saturday Review* commented, "The Nelsons are apparently living their lives in weekly installments on

the air . . . ." In a 1952 interview with the Nelsons, *Newsweek* explained how "Ricky Nelson kicks his shoes off during the film- ing, just as he does at home, and both boys work in front of the cameras in their regular clothes. In fact, says Harriet, they don't even know the cameras are there." Even those sitcoms that did not include real-life families were publicized in this fashion. In 1954, *Newsweek* assured its readers that Danny Thomas was a "Two Family Man," and that "Danny's TV family acts like . . . Danny's Own Family." One photograph showed Danny in a family por- trait with his television cast while another depicted Danny at his swimming pool with his real family. The reviewer even suggested that Danny Williams (the character) resembled Danny Thomas (the star) more than Gracie Allen resembled herself on *The Burns and Allen Show*.[35]

These televised neighbors seemed to suture the "crack" in the picture window. They helped ease what must have been for many Americans a painful transition from the city to the suburb. But more than simply supplying a tonic for displaced suburbanites, television promised something better: it promised modes of spec- tator pleasure premised upon the sense of an illusory–rather than a real–community of friends. It held out a new possibility for being alone in the home, away from the troublesome busybody neigh- bors in the next house. But it also maintained ideals of community togetherness and social interconnection by placing the commu- nity *at a fictional distance*. Television allowed people to enter into an imaginary social life, one which was shared not in the neighbor- hood networks of bridge clubs and mahjong gatherings, but on the national networks of CBS, NBC, and ABC.

Perhaps this was best suggested by Motorola television in a 1951 advertisement (figure 3). The sketch at the top of the ad shows a businessman on his way home from work who meets a friend while waiting at a bus stop. Upon hearing that his friend's set is on the blink, the businessman invites him home for an eve- ning of television on his "dependable" Motorola console. A large photograph further down on the page shows a social scene where

. . . . . . . . . . . . .

35 "The Great Competitor," *Time,* December 14, 1953, p. 62; Seldes, "Domestic Life in the Forty-ninth State," p. 28; "Normality and $300,000," *Newsweek,* November 17, 1952, p. 66; "Two-Family Man," *Newsweek,* April 5, 1954, p. 86.

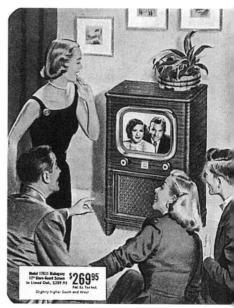

3 4

two couples, gathered around the television set, share in the joys of
a TV party (figure 4).[36] Thus, according to the narrative sequence
of events, television promises to increase social contacts. What is
most significant about this advertisement, however, is that the
representation of the TV party suggests something slightly differ-
ent from the story told by the ad's narrative structure. In fact, the
couples in the room do not appear to relate to one another; rather
they interact *with and through* the television set. The picture ema-
nating from the screen includes a third couple, the television stars,
George Burns and Gracie Allen. The couple on the left of the
frame stare at the screen, gesturing towards George and Gracie as
if they were involved in conversation with the celebrities. While
the husband on the right of the frame stares at the television set, his
wife looks at the man gesturing towards George and Gracie. In
short, the social relationship between couples in the room appears
to depend upon the presence of an illusion. Moreover, the illusion

. . . . . . . . . . . . .

**36** *Better Homes and Gardens* (November 1951): 162.

itself seems to come alive insofar as the televised couple, George and Gracie, appear to be interacting with the real couples in the room. Television, thus, promises a new kind of social experience, one which replicates the logic of real friendship (as told by the sequence of events in the advertisement's narrative), but which transforms it into an imaginary social relationship shared between the home audience and the television image (as represented in the social scene). In this advertisement as elsewhere, it is this idea of simulated social life which is shown to be the crux of pleasure in television.

Indeed, television—at its most ideal—promised to bring to audiences not merely an illusion of reality as in the cinema, but a sense of "being there," a kind of *hyperrealism*. Television producers and executives devised schemes by which to merge public and private worlds into a new electrical neighborhood. One of the central architects of this new electrical space was NBC's Pat Weaver who saw television as an extension of traditional community experiences. As he claimed, "In our entertainment, we . . . start with television as a communications medium, not bringing shows into the living room of the nation, but taking people from their living rooms to other places—theaters, arenas, ball parks, movie houses, skating rinks, and so forth."[37] Implementing these ideals in 1949, Weaver conceived *The Saturday Night Review*, a three-hour program designed to "present a panorama of Americans at play on Saturday night." The program took the segmented format of variety acts and film features, but it presented the segments as a community experience shared by people just like the viewers at home. As *Variety* explained, "For a film, the cameras may depict a family going to their neighborhood theatre and dissolve from there into the feature."[38] Thus, television would mediate the cultural transition from public to private entertainment by presenting an imaginary night at the movies.

While Weaver's plan was the most elaborate, the basic idea was employed by various other programs, particularly by television shows aimed at women. In 1952, New York's local station, WOR,

. . . . . . . . . . . .

37  Sylvester L. Weaver, "Thoughts on the Revolution: Or, TV Is a Fad, Like Breathing," *Variety*, July 11, 1951, p. 42.
38  "NBC to Project 'American Family' in 3-Hour Saturday Night Showcase," *Variety*, August 3, 1949, p. 31.

aired *TV Dinner Date,* a variety program that was designed to give "viewers a solid two-and-a-half hours of a 'night out at home.'"[39] CBS even promised female viewers an imaginary date in its fifteen-minute program, *The Continental.* Sponsored by Cameo Hosiery, the show began by telling women, "And now it's time for your date with the Continental." Host Renza Cesana (who *Variety* described as Carl Brisson, Ezio Pinza, and Charles Boyer all rolled into one) used a vampirelike Transylvanian accent to court women in the late night hours. Cesana addressed his romantic dialogue to an off-camera character as he navigated his way through his lushly furnished den, a situation designed to create the illusion that Cesana's date for the night was the home viewer.[40] Meanwhile, during daytime hours, numerous programs were set in public spaces such as hotels or cafes with the direct intention of making women feel as if they were part of the outside world. One of the first network shows, *Shoppers Matinee,* used a subjective camera that was intended to take "the place of the woman shopper, making the home viewer feel as if she were in the store in person."[41] In 1952, CBS introduced the daytime show, *Everywhere I Go,* boasting of its "studio without walls" that was designed to "create the illusion of taking viewers to the actual scene" of presentation. One segment, for example, used rear-screen projection to depict hostess Jane Edwards and her nine-year-old daughter against a backdrop of their actual living room.[42] More generally, locally produced "Mr. and Mrs." shows invited female viewers into the homes of local celebrities, providing women with opportunities imaginatively to convene in familiar family settings with stars that exuded the warmth and intimacy of the people next door.

. . . . . . . . . . . .

39  *Variety,* August 6, 1952, p. 26.
40  For a review of the show, see *Variety,* January 30, 1952, p. 31. Note that the particular episode I have seen clearly is aimed at a female audience with its pitch for women's stockings and its promise of a date with Cesana; however, Cesana addresses the home viewer as if she were a man, specifically his pal who has been stood up for a double date. Also note that there was a radio version of this program in which a female host courted male viewers in the late night hours. Entitled *Two at Midnight,* the program was aired locally on WPTR in Albany and is reviewed in *Variety,* October 22, 1952, p. 28.
41  "DuMont Daytime," *Telecasting,* December 12, 1949, p. 5.
42  "CBS-TV's 'Studio Without Walls' New Gitlin Entry," *Variety,* September 24, 1952, p. 43.

Television's promise of social interconnection has provided numerous postwar intellectuals–from Marshall McCluhan to Joshua Meyrowitz–with their own utopian fantasies. Meyrowitz is particularly interesting in this context because he has claimed that television helped foster women's liberation in the 1960s by bringing traditionally male spaces into the home, thus allowing women to "observe and experience the larger world, including all male interactions and behaviors." "Television's first and strongest impact," he concludes, "is on the perception that women have of the public male world and the place, or lack of place, they have in it. Television is an especially potent force for integrating women because television brings the public domain to women . . . ."[43] But Meyrowitz bases this claim on an essentialist notion of space. In other words, he assumes that public space is male and private space is female. However, public spaces like the office or the theater are not simply male; they are organized according to categories of sexual difference. In these spaces certain social positions and subjectivities are produced according to the placement of furniture, the organization of entrances and exits, the separation of washrooms, the construction of partial walls, and so forth. Thus, television's incorporation of the public sphere into the home did not bring "male" space into female space; instead it transposed one system of sexually organized space onto another.

Not surprisingly in this regard, postwar media often suggested that television would increase women's social isolation from public life by reinforcing spatial hierarchies that had already defined their everyday experiences in patriarchal cultures. The new family theaters were typically shown to limit opportunities for social encounters that women traditionally had at movie theaters and other forms of public entertainment. In 1951, a cartoon in *Better Homes and Gardens* stated the problem in humorous terms. On his way home from work, a husband imagines a night of TV wrestling while his kitchen-bound wife, taking her freshly baked pie from the oven, dreams of a night out at the movies (figure 5).[44] Colgate dental cream used this dilemma of female isolation as a way to sell its product. A 1952 advertisement that ran in *Ladies'*

. . . . . . . . . . . .
**43** Joshua Meyrowitz, *No Sense of Place: The Impact of Electronic Media on Social Behavior* (New York: Oxford University Press, 1985), pp. 223–224.
**44** *Better Homes and Gardens* (November 1951): 218.

5

*Home Journal* showed a young woman sitting at home watching a
love scene on her television set, complaining to her sister, "All I do
is sit and view. You have dates any time you want them, Sis! All I
get is what TV has to offer."[45] Of course, after she purchased the
Colgate dental cream, she found her handsome dream date. Thus,
as the Colgate company so well understood, the imaginary uni-
verse that television offered posed its own set of female troubles.
Even if television programs promised to transport women into the
outside world, it seems likely that women were critical of this,
that they understood television's electrical space would never ade-
quately connect them to the public sphere .

In 1955, the working-class comedy, *The Honeymooners,* dra-
matized this problem in the first episode of the series, "TV or Not
TV."[46] The narrative was structured upon the contradiction
between television's utopian promise of increased social life and

. . . . . . . . . . . . .

**45**   *Ladies' Home Journal* (January 1952): 64
**46**   *The Honeymooners* was first seen in 1951 as a skit in the live variety
show *Cavalcade of Stars* on the DuMont network. The filmed half-hour
series to which I refer aired during the 1955–56 season.

the dystopian outcome of domestic seclusion. In an early scene,
Alice Kramden begs her husband Ralph to buy a television set:

> I . . . want a television set. Now look around you, Ralph. We don't
> have any electric appliances. Do you know what our electric bill was
> last month? Thirty-nine cents! We haven't blown a fuse, Ralph, in
> ten years . . . . I want a television set and I'm going to get a television
> set. I have lived in this place for fourteen years without a stick of fur-
> niture being changed. Not one. I am sick and tired of this . . . . And
> what do you care about it? You're out all day long. And at night what
> are you doing? Spending money playing pool, spending money
> bowling, or paying dues to that crazy lodge you belong to. And I'm
> left here to look at that icebox, that stove, that sink, and these four
> walls. Well I don't want to look at that icebox, that stove, that sink
> and these four walls. I want to look at Liberace!

Significantly, in this exchange, Alice relates her spatial con-
finement in the home to her more general exclusion from the mod-
ern world of electrical technologies (as exemplified by her low
utility bills). But her wish to interconnect with television's electri-
cal spaces soon becomes a nightmare because the purchase of the
set further engenders her domestic isolation. When her husband
Ralph and neighbor Ed Norton chip in for a new TV console, the
men agree to place the set in the Kramden's two-room apartment
where Norton is given visitation privileges. Thus, the installation
of the set also means the intrusion of a neighbor into the home on a
nightly basis, an intrusion that serves to take away rather than to
multiply the spaces which Alice can occupy. In order to avoid the
men who watch TV in the central living space of the apartment,
Alice retreats to her bedroom, a prisoner in a house taken over by
television.

Social scientific studies from the period show that the anxieties
expressed in popular representations were also voiced by women
of the period. One woman in a Southern California study con-
fessed that all her husband "wants to do is to sit and watch televi-
sion–I would like to go out more often." Another woman com-
plained, "I would like to go for a drive in the evening, but my
husband has been out all day and would prefer to watch a
wrestling match on television."[47]

· · · · · · · · · · · ·

47   McDonagh et al., "Television and the Family," pp. 117, 119.

A nationwide survey suggested that this sense of domestic confinement was even experienced by teenagers. As one respondent complained, "Instead of taking us out on date nights, the free-loading fellas park in our homes and stare at the boxing on TV." For reasons such as these, 80 percent of the girls admitted they would rather go to a B movie than stay home and watch television.[48]

If television was considered to be a source of problems for women, it also became a central trope for the crisis of masculinity in postwar culture. According to the popular wisdom, television threatened to contaminate masculinity, to make men sick with the "disease" of femininity. As other scholars have observed, this fear of feminization has characterized the debates on mass culture since the nineteenth century. Culture critics have continually paired mass culture with patriarchal assumptions about femininity. Mass amusements are typically thought to encourage passivity, and they have often been represented in terms of penetration, consumption, and escape. As Andreas Huyssen has argued, this link between women and mass culture has, since the nineteenth century, served to valorize the dichotomy between "low" and "high" art (or modernism). Mass culture, Huyssen claims, "is somehow associated with women while real, authentic culture remains the prerogative of men."[49] The case of broadcasting is especially interesting because the threat of feminization was particularly aimed at men. Broadcasting quite literally was shown to disrupt the normative structures of patriarchal (high) culture and to turn "real men" into passive homebodies.

In the early 1940s, this connection between broadcast technology and emasculation came to a dramatic pitch when Philip Wylie wrote his bitter attack on American women, *Generation of Vipers*. In this widely-read book, Wylie maintained that American society was suffering from an ailment that he called "momism." American women, according to Wylie, had become overbearing, domineering mothers who turned their sons and husbands into weak-kneed fools. The book was replete with imagery of apocalypse through technology, imagery that Wylie tied to the figure of

. . . . . . . . . . . .

48   Cited in Betty Betz, "Teens and TV," *Variety*, January 7, 1953, p. 97.
49   Andreas Huyssen, *After the Great Divide: Modernism, Mass Culture, Postmodernism* (Bloomington: Indiana University Press, 1986) p. 47.

the woman. As he saw it, an unholy alliance between women and big business had turned the world into an industrial nightmare where men were slaves both to the machines of production in the factory and to the machines of reproduction–that is, women–in the home.

In his most bitter chapter, entitled "Common Women," Wylie argued that women had somehow gained control of the airwaves. Women, he suggested, made radio listening into a passive activity that threatened manhood, and in fact, civilization. As Wylie wrote,

> The radio is mom's final tool, for it stamps everyone who listens to it with the matriarchal brand–its superstitions, prejudices, devotional rules, taboos, musts, and all other qualifications needful to its main- tenance. Just as Goebbels has revealed what can be done with such a mass-stamping of the public psyche in his nation, so our land is a living representation of the same fact worked out in matriarchal sen- timentality, goo, slop, hidden cruelty, and the foreshadow of national death . . . . [50]

In the annotated notes of the 1955 edition, Wylie updated these fears, claiming that television would soon take the place of radio and turn men into female-dominated dupes. Women, he wrote, "will not rest until every electronic moment has been bought to sell suds and every bought program censored to the last decibel and syllable according to her self-adulation–along with that (to the degree the mom-indoctrinated pops are permitted access to the dials) of her de-sexed, de-souled, de-cerebrated mate."[51] The mixture of misogyny and "telephobia" which ran through this passage was clearly hyperbolic; still, the basic idea was repeated in more sober representations of everyday life during the postwar period.

As popular media often suggested, television threatened to rob men of their powers, to usurp their authority over the image, and to turn them into passive spectators. This threat materialized in numerous representations that showed women controlling their husbands through television. Here, television's blurring of private

. . . . . . . . . . . . .

50    Philip Wylie, *Generation of Vipers* (New York: Holt, Rinehart and Winston, 1955), pp. 214–215.

51    Ibid., pp. 213–214.

and public space became a powerful tool in the hands of house-wives who could use the technology to invert the sexist hier-archies at the heart of the separation of spheres. In this topsy turvy world, women policed men's access to the public sphere and con-fined them to the home through the clever manipulation of televi-sion technology. An emblematic example is a 1955 advertisement for *TV Guide* that conspires with women by giving them tips on ways to "Keep a Husband Home." As the ad suggests, "You might try drugging his coffee . . . or hiding all his clean shirts. But by far the best persuader since the ball and chain is the TV set . . . and a copy of *TV Guide.*"[52]

This inversion of the gendered separation of spheres was repeated in other representations that suggested ways for women to control their husbands' sexual desires through television. A typ-ical example is a 1952 advertisement for Motorola television that showed a man staring at a bathing beauty on television while neglecting his real-life mate. The dilemma of "the other woman," however, was countered by the enunciative control that the house-wife had in the representation. While the man is shown to be a pas-sive spectator sprawled in his easy chair, his wife (who is holding a shovel) dominates the foreground of the image, and the caption, which speaks from her point of view, reads, "Let's Go Mr. Dreamer, that television set won't help you shovel the walk" (fig-ure 1). Similarly, a 1953 RCA advertisement for a set with "rotomatic tuning" shows a male spectator seated in an easy chair while watching a glamorous woman on the screen. But the house-wife literally controls and sanctions her husband's gaze at the tele-vised woman because she operates the tuning dials.[53] Then too, numerous advertisements and illustrations depicted women who censored male desire by standing in front of the set, blocking the man's view of the screen (figures 6, 7).[54] Similarly, a cartoon in a

. . . . . . . . . . . . .

52  *TV Guide,* January 29, 1955, back cover.
53  *Better Homes and Gardens* (February 1952): 154; *Better Homes and Gardens* (September 1953): 177.
54  See, for example, an advertisement for Durall window screens that shows a housewife blocking her husband's view of a bathing beauty on the television set in *Good Housekeeping* (May 1954): 187. A similar illustration appears in *Popular Science* (March 1953): 179. And an advertisement for Kotex sanitary napkins shows how a woman, by wearing the feminine hygiene product, can distract her husband's gaze at the screen; *Ladies' Home Journal* (May 1949): 30.

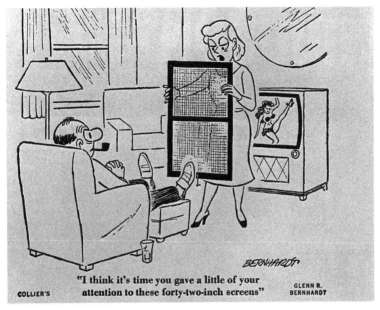

"I think it's time you gave a little of your
attention to these forty-two-inch screens"

COLLIER'S

GLENN R.
BERNHARDT

6

7

1949 issue of the *New York Times* magazine showed how a house-wife could dim her husband's view of televised bathing beauties by making him wear sunglasses, while a cartoon in a 1953 issue of *TV Guide* suggested that the same form of censorship could be accomplished by putting window curtains on the screen in order to hide the more erotic parts of the female body.[55] Television, in this regard, was shown to contain men's pleasure by circumscrib-ing it within the confines of domestic space and placing it under the auspices of women. Representations of television thus pre-sented a position for male spectators that can best be described as passive aggression. Structures of sadistic and fetishistic pleasure common to the Hollywood cinema were still operative, but they were sanitized and neutralized through their incorporation into the home.

In contemporary culture, the dream of social interconnection through antiseptic electrical space is still a potent fantasy. In 1989, in an issue entitled "The Future and You," *Life* magazine consid-ered the new electronic space that the home laser holographic movie might offer in the twenty-first century. Not coincidentally, this holographic space was defined by male desire. As Marilyn Monroe emerged from the screen in her costume from *The Seven Year Itch,* a male spectator watched her materialize in the room. With his remote control aimed at the set, he policed her image from his futuristic La-Z-Boy Lounger. Although the scene was clearly coded as a science-fiction fantasy, this form of home enter-tainment was just the latest version of the older wish to control and purify public space. Sexual desire, transported to the home from the Hollywood cinema, was made possible by transfiguring the celluloid image into an electrical space where aggressive and sadistic forms of cinematic pleasure were now sanitized and made into "passive" home entertainment. The aggression entailed in watching Monroe was clearly marked as passive aggression, as a form of desire that could be contained within domestic space. But just in case the desire for this electronic fantasy woman could not be properly contained, the article warned readers to "fasten the seatbelt on your La-Z-Boy."[56]

· · · · · · · · · · · ·

55  *New York Times,* December 11, 1949: magazine, p. 20; *TV Guide,* November 6, 1953, p. 14.
56  *Life* (February 1989): 67.

As this example shows, the utopian dreams of space-binding and social sanitation that characterized television's introduction in the fifties is still a dominant cultural ideal. Electronic communications offer an extension of those plans as private and public spaces become increasingly intertwined through such media as home computers, fax machines, message units, and car phones. Before considering these social changes as a necessary part of an impending "electronic revolution" or "information age," we need to remember the racist and sexist principles upon which these electrical utopias have often depended. The loss of neighborhood networks and the rise of electronic networks is a complex social phenomenon based on a series of contradictions that plague postwar life. Perhaps being nostalgic for an older, more "real" form of community is itself a historical fantasy. But the dreams of a world united by telecommunications seem dangerous enough to warrant closer examination. The global village, after all, is the fantasy of the colonizer, not the colonized.

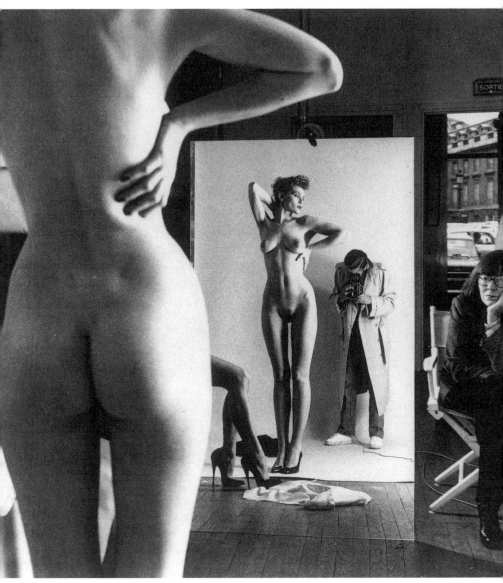

1  **Helmut Newton**
*Self-portrait with wife June and models, Vogue studio, Paris 1981.*

# Perverse Space

Victor Burgin

FIFTEEN YEARS AGO, in her ground-breaking essay "Visual Plea-
sure and Narrative Cinema,"[1] Laura Mulvey used Freud's paper
on "Fetishism" to analyze "the voyeuristic-scopophilic look that
is a crucial part of traditional filmic pleasure." Today, the influence
of Mulvey's essay on the critical theory of the image has not
diminished, nor has it evolved. Idealized, preserved in the form in
which it first emerged, Mulvey's argument has itself been
fetishized.[2] Fetishized, which is to say *reduced.* Mulvey broke the
ground for a psychoanalytically informed theory of a certain type
of image. Many of Mulvey's followers have since shifted the
ground from psychoanalysis to sociology, while nevertheless
retaining a psychoanalytic terminology. In the resulting confusion
sexuality has been equated with gender, and gender has been col-
lapsed into class. It has now become familiar to hear the authority
of Mulvey's essay invoked to equate a putative "masculine gaze"
with "objectification." Here, in a caricature of the psychoanalytic
theory on which Mulvey based her argument, "scopophilia" is
defined as a relation of domination-subordination between
unproblematically constituted male and female subjects, and
"objectification" is named only in order to be denounced. In his
preface to the 1970 edition of *Mythologies,* Roland Barthes wrote of
"the necessary conjunction of these two enterprises: no denuncia-
tion without an appropriate method of detailed analysis, no semi-
ology which cannot, in the last analysis, be acknowledged as *semi-
oclasm.*" Mulvey's essay is exemplary in the way it holds these
"two enterprises" in balance. If I "depart" from Mulvey's essay
now, it is not in order to criticize it—I learned much from it and still
agree with most of what she says. It is rather to travel further in the
direction it first indicated, towards a psychoanalytic consideration
of unconscious investments in looking. The route I have chosen is
by way of a photograph by Helmut Newton, as Newton is a pho-
tographer whose work so conspicuously attracts denunciation,
and so clearly lends itself to Mulvey's analysis.

. . . . . . . . . . . . .

1   Laura Mulvey, "Visual Pleasure and Narrative Cinema," *Screen* 16, no.
3 (Autumn 1975): 6–18; reprinted in her *Visual and Other Pleasures* (London:
Macmillan, 1989).
2   I would stress that I am speaking particularly of writing about "static"
visual representations—photographs and so on. Mulvey's essay provoked a
more nuanced debate among film theorists, but in terms very different
from those of this essay.

# Newton's Photograph

We know that Helmut Newton's photograph *Self-portrait with wife June and models, Vogue studio, Paris 1981*[3] had its immediate origin in a chance encounter (figure 1). In an interview with Newton, Carol Squiers asks: "One of your self-portraits shows you wearing a trench coat with a nude model, and your wife sitting off to one side. Does your wife sit in on photo sessions?" Newton replies: "Never. Ever. She had just come by for lunch that day."[4] In describing Newton's picture I shall recapitulate a certain history of semiology, that most closely associated with Roland Barthes, which sets the stage for the introduction of the subject of representation into critical theory of the image in the early 1970s. That is to say, I shall reconstruct the prehistory of Mulvey's introduction of psychoanalytic theory into a field of analysis dominated by linguistic models: models whose implicit spaces are classical, ordered according to binary logics—from the level of the phoneme to that of rhetoric—along the Cartesian coordinates of syntagm and paradigm. I shall begin with what we can actually see in this image.

. . . . . . . . . . . . .

**3**   *Self-portrait with wife June and models, Vogue studio, Paris 1981*, in Helmut Newton, *Portraits* (New York: Pantheon, 1987), plate 14.
**4**   Ibid., p. 14. Is the similarity of this image to the *Las Meninas* of Velásquez also due to chance? Commenting on one of his own dreams, Freud remarks that the dream was "in the nature of a phantasy," which "was like the façade of an Italian church in having no organic relation with the structure lying behind it. But it differed from those façades in being distorted and full of gaps, and in the fact that portions of the interior construction had forced their way through it at many points." Sigmund Freud, *The Interpretation of Dreams* (1900), in *The Standard Edition of the Complete Psychological Works of Sigmund Freud,* vol. 4 (London: Hogarth, 1955–74), p. 211. In his essay of 1908, "Creative Writers and Daydreaming," Freud describes the production of works of literature, and by implication other forms of art, in analogous terms: the foundation of the work is in unconscious materials, in an opportunistic relation to the conscious plan of the artist they enter the surface structure by means of the primary processes. As Sarah Kofman observes, "From inspiration, a concept belonging to the theological ideology af art, Freud substitutes the working concept of the primary process. The artist is closer to the neurotic ... and the child than to the 'great man.'" Sarah Kofman, *The Childhood of Art* (New York: Columbia University Press, 1988), p. 49. Artistic activity in the adult, then, is made from the same stuff as fantasy and has its childhood equivalent in play. The child in play is serious. In Kofman's

We see at the left the model's back and, in the center of the frame, her frontal reflection in a mirror. Helmut Newton's reflection, similarly full length, fits the space beneath the model's reflected elbow. The photographer is wearing a raincoat, and his face is hidden as he bends over the viewfinder of his Rolleiflex camera. The photographer's wife, June, sits just to the right of the mirror, cross-legged in a director's chair. Her left elbow is propped on her left knee, her chin is propped on her left hand, her right hand makes a fist. These are the elements of the picture which are most likely to come immediately to our attention. In addition, reflected in the mirror, we can see a pair of legs with very high-heeled shoes, whose otherwise invisible owner we assume to be seated. We also see, behind the figure of June, an open door through which we glimpse an exterior space–a city street, or square, with automobiles. Finally, we may notice a number of subsidiary elements: at the center, what appear to be items of clothing discarded on the floor; at the extreme right, other items of clothing on hangers; above the open door, the sign *sortie*; and so

. . . . . . . . . . . .

description, "the artist plays with forms and selects, among the preconscious processes, the structures which, in relation to his psyche and its conflicts, are perceived as the most significant." Ibid., p. 113. The word "selects" here might encourage an overestimation of the role of self-conscious deliberation. In an essay on Freud's aesthetics to which Kofman refers, Ernst Gombrich gives this gloss of Freud's model of the joke: "Take the famous answer to the question: 'Is life worth living?'–'It depends on the liver.' It is easy to see what Freud calls the preconscious ideas which rise to the surface in this answer–ideas, that is, which are not unconscious in the sense of being totally repressed and therefore inaccessible to us but available to our conscious mind; in this case the joy in lots of alcohol which the liver should tolerate and the even more forbidden joy in the aggressive thought that there are lives not worth living. Respectability has imposed a taboo on both these ideas and to express them too boldly might cause embarrassment. But in the churning vortex of the primary process the two meanings of 'liver' came accidentally into contact and fused. A new structure is created and in this form the ideas cause pleasure and laughter." E. G. Gombrich, "Freud's Aesthetics" (1966), in *Reflections on the History of Art* (New York: Phaidon, 1987), pp. 230–231. The import of the collision of signifiers must be recognized, "selected," in order to be given form in a work of art. As such works are produced at the "interface" of primary and secondary processes, however, it is never clear to what extent such recognition and selection is conscious.

on.[5] This initial description concerns what is least likely to be contested about this image, what classic semiotics would call its "denotations."

We may now consider what this same early semiotics called the "connotations" of the image, meanings which we may also take in "at a glance" but which are more obviously derived from a broader cultural context beyond the frame of the image.[6] We may additionally consider the rhetorical forms in which the "signifiers of connotation" are organized. The image of the model reflected in the mirror is the very iconogram of "full frontal nudity": an expression, and an indeterminate mental image, which entered popular memory in the 1960s from discussions in the media about "sexual freedom" in cinema and the theater. The model's pose is drawn from an equally familiar, and even older, paradigm of "pin-up" photographs. The cliché position of the model's arms serves the anatomical function of lifting and leveling her breasts, satisfying the otherwise contradictory demand of the "pin-up" that the woman's breasts should be both large and high. The lower part of the model's body is similarly braced for display by means of the black and shiny high-heeled shoes. These shoes exceed their anatomical function of producing muscular tension in the model, they are drawn from a conventional repertoire of "erotic" items of dress. This reference is emphasized by "repetition" in the shoes on the disembodied legs which appear to the left of the main figure, where the evenly spaced "side-elevation" depiction of the excessively elevated heels (another repetition) diagrams the primacy of erotic meaning over function (these shoes were not made for walking). The shoes encourage an understanding of the model as "naked" rather than "nude," which is to say they gesture towards scenarios of sexuality rather than of "sublimation" (for example, the high-minded artist's "disinterested" aesthetic contemplation

. . . . . . . . . . . .

5   I am aware that we do not *see* that the photographer is Helmut Newton. We must choose to believe what the caption tells us; we do not *see* that the camera is a Rolleiflex, this must be added from a store of specialist knowledge; and so on. But skepticism must end somewhere–after all, we do not *see* that the "people" in this image are not in fact wax figures.
6   In the setting of psychoanalytic theory, "topographically," such connotations belong to the preconscious; to the extent that they are commonly available we might therefore speak of a "popular preconscious."

of the female form). The sexual connotation is further anchored[7] by the apparently "hastily discarded" garments at her feet.[8]

The figures of repetition in this photograph, and there are others, are articulated as subsidiary tropes within an overall structure of antithesis. The antithesis "naked"/"clothed" divides the picture plane along its vertical axis. By contrast with the model, who thereby appears all the more naked, Newton is absurdly overdressed. The model's nakedness is moreover already amplified by being monumentally doubled and presented from both front and back. Newton's pole of the "naked"/"clothed" antithesis is itself augmented by repetition in the jacketed and booted figure of June. There are further such rhetorical structures to be identified in this image; to enumerate them all would be tedious. It is enough to note that the apparent strength of many images derives from our "intuitive" recognition of such structures. Perhaps one more is worthy of comment, if only in passing. The discarded garments in the mirror set up a subsidiary "combined figure" of chiasmus ("mirroring") and antithesis about the axis established where the background paper meets the studio floor: a dark garment on a light ground; a light garment on a dark ground (the areas and shapes involved being roughly analogous). This reinforces my tendency, otherwise not strong, to read the two pairs of models' legs in terms of the opposition "light"/"dark"; it encourages the idea that the woman I can only partially see may be black. Here, clearly, I am at the periphery of the range of meanings in respect of which I may reasonably expect to meet a consensus agreement. To return to things on which we are more likely to

. . . . . . . . . . . . .

7  In his classic paper, "Rhetoric of the Image," Barthes spoke of the "anchorage" of the connotations of the image by means of the written text. It can easily be demonstrated however that an image may anchor the connotations of a text, or the connotations of another image (or another signifier within the same image). It should also be obvious that a "text" may anchor another text.

8  "CS: 'When you photographed yourself nude in 1976, your clothes were very neatly folded on a chair in the picture. But when you photograph women who are nude, their clothes are scattered everywhere...'
HN: 'I'm quite a tidy person. I would hate to live in disorder ... But this is interesting–I create that disorder–I want the model to take all her clothes off and just dump them'" (Newton talking to Carol Squiers, in *Portraits*).

agree, I shall close my list of connotations and the forms of their organization by commenting on the raincoat which Newton wears. In a sexual context, and this image is indisputably sexual, the raincoat connotes those "men in dirty raincoats" who in the popular imaginary frequent the back-rooms of "sex shops." In this same context, the raincoat is also the favored dress of the male exhibitionist, the "flasher."

It is not normal for the photographer to exhibit himself, as Newton does here. The mirror is there so the model can see *herself,* and thus have some idea of the form in which her appearance will register on the film. Normally, the photographer would have his back to the mirror, remaining outside the space of the image. Here, however, Newton has colonized the desert island of backdrop paper that is usually the model's sovereign possession in the space of the studio. He has invaded the model's territory, the domain of the visible. From this position, he now receives the same look he gives. The raincoat is Newton's joke at his own expense: he exhibits himself to his wife, and to us, as a voyeur. In his interview with Carol Squiers, Newton says, "I am a voyeur! ... If a photographer says he is not a voyeur, he is an idiot!" In *Three Essays on the Theory of Sexuality,* Freud remarks, "Every active perversion is ... accompanied by its passive counterpart: anyone who is an exhibitionist in his unconscious is at the same time a *voyeur.*" The photographer—a flasher, making an exposure—is here explicitly both voyeur *and* exhibitionist. His raincoat opens at the front to form a dark delta, from which has sprung this tensely erect and gleamingly naked form. The photographer has flashed his prick, and it turns out to be a woman.

Where am I in all this? In the same place as Newton—caught looking. At this point in my description I have caught myself out in precisely the position of culpability to which Mulvey's paper allocates me—that of the voyeur certainly, but also that of the *fetishist.* The provision of a substitute penis for the one the woman "lacks" is what motivates fetishism. The fetish allays the castration anxiety which results from the little boy's discovery that his mother, believed to lack nothing, has no penis. Mulvey writes, "The male unconscious has two avenues of escape from this castration anxiety: preoccupation with the re-enactment of the original trauma (investigating the woman, demystifying her mystery),

... or else complete disavowal of castration by the substitution of a fetish object or turning the represented figure itself into a fetish ... This second avenue, fetishistic scopophilia, builds up the physical beauty of the object, transforming it into something satisfying in itself."[9] If it is clearly the "second avenue" we are looking down in this picture, we must nevertheless acknowledge that it runs parallel with the "first." For who else wears a raincoat? A detective–like the one who, in all those old B movies, investigates the dangerously mysterious young woman. Following her, watching her until, inevitably, the *femme* proves *fatale*.

Caught looking, I (male spectator) must now suspect that I am only talking about this picture at such length in order to be allowed to *continue* looking. I remember one such instance of invested prevarication from my childhood. I was perhaps seven years old, and accompanying my mother on one of her periodic trips to visit my grandmother. The tramcar we rode stopped outside a music hall; it was here that we dismounted to continue on foot. On this occasion, the only one I remember, the theater was advertising its two main current attractions. One was a strongman and escape artist. The heavy chains and manacles of his trade were on public exhibition in front of the theater, in a glass-topped display case. On the wall behind this manly apparatus, and also under glass, were photographs of the theater's other main attraction–a striptease artist. I remember assuming an intense interest in the chains, regaling my mother with a barrage of questions and observations designed to keep her from moving on, while all the time sneaking furtive and guilty glances at the pictures of the half-naked woman. I could tell from my mother's terse replies that she knew what I was up to and I allowed myself to be tugged away, the sudden inexplicable excitement of the moment giving way to a terrible shame. The structure of that recollected space now maps itself onto the space of Newton's picture. I become the diminutive figure of Helmut, myself as child. June's lips, which I now interpret as tense with disapproval, are about to speak the words which will drag me away ... but from what?

If I was seven years old, then the year was 1948, the same year Robert Doisneau made his photograph, *Un Regarde oblique,* which

. . . . . . . . . . . . .

9   Mulvey, "Visual Pleasure and Narrative Cinema," pp. 13–14.

shows a middle-aged couple looking into the window of a picture dealer, the man's slyly insistent gaze on a painting of a seminaked young woman (figure 2). Whatever we may suppose to have been on the mind of Doisneau's "dirty old man," it is unlikely to have been within the repertoire of my own childish imaginings. For psychoanalysis, however, *consciousness* is not at issue. There would be no objection in psychoanalytic theory to seeing this "innocent" child of the latency period as caught on the same hook as Doisneau's adult; but neither is there any justification in psychoanalysis to reducing what is at stake here to a simple formula, whether it be the structure of fetishism or whatever else. We cannot tell what is going on in the look simply by looking at it.

Newton has made an indiscernible movement of the tip of one finger. The shutter has opened and paused. In this pause the strobe has fired, sounding as if someone had clapped their hands together, once, very loud. The light has struck a square of emulsion. Out in the street a driver in a stationary car has perhaps glimpsed, illuminated in this flash of interior lightning, the figure of a naked woman. Perhaps not. In his book *Nadja,* André Breton confesses, "I have always, beyond belief, hoped to meet, at night and in a woods, a beautiful naked woman or rather, since such a wish once expressed means nothing, I regret, beyond belief, not having met her." He then recalls the occasion when, "in the side aisles of the 'Electric Palace,' a naked woman ... strolled, dead white, from row to row"; an occurrence, however, he admits was quite unextraordinary, "since this section of the 'Electric' was the most commonplace sort of illicit sexual rendez-vous."[10] The final issue of *La Révolution Surréaliste* contains the well-known image in which passport-type photographs of the surrealist group, each with his eyes closed, frame a painting by Magritte (figure 3). The painting shows a full-length nude female figure in the place of the "missing word" in the painted sentence, "*je ne vois pas la ...cachée dans la forêt.*"[11] In looking there is always something which is not seen, not because it is perceived as missing–as is the case in fetishism–but because it does not belong to the visible.

. . . . . . . . . . . .

10  André Breton, *Nadja* (New York: Grove Press, 1960), p. 39.
11  *La Révolution Surréaliste,* no. 12 (December 15, 1929), p. 73. In the very first issue of the journal a similar arrangement of portrait photographs, a surrealist guard of honor to which in this case Freud has been conscripted, surround the picture of the anarchist assassin Germaine Berton.

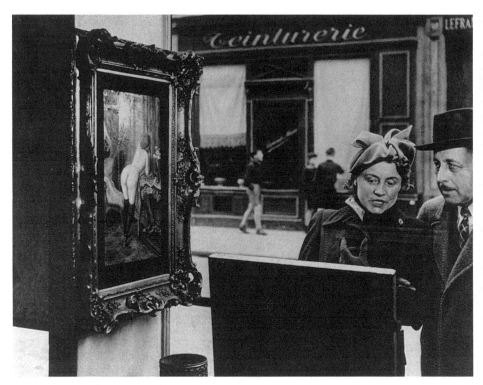

**2 Robert Doisneau**
*Un Regard oblique*, 1948.

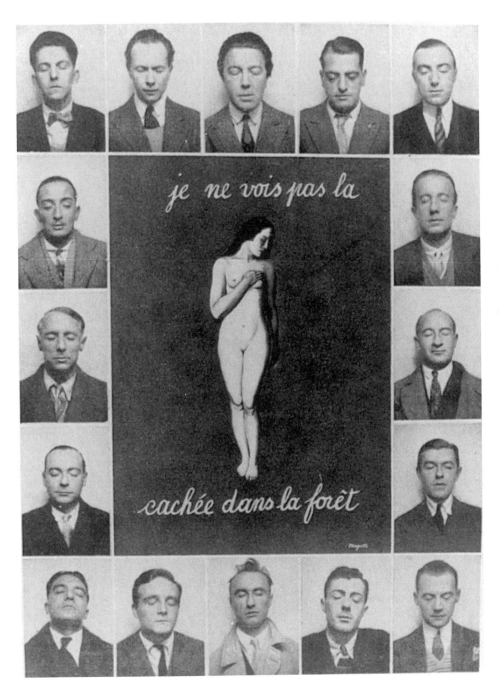

3 **La Révolution Surréaliste**
no. 12 (December 15, 1929).

## Optical Space, Psychical Space

Ironically, the reduction of looking to the visible, and to the register "objectification-exploitation," was inadvertently encouraged by the very "return to Freud" initiated by Jacques Lacan, to which Mulvey's paper contributed. In his first seminar, Lacan had urged that we "meditate on the science of optics."[12] In an essay of 1987 I commented that it was precisely the model of the "cone of vision," derived from Euclidean optics, which had provided the common metaphor through which emerging psychoanalytic theories of representation could be conflated with extant marxian theories of ideology, eventually leading to the "Foucauldianization" of psychoanalytic theory in much recent work on the image. In 1973, Roland Barthes had written, "there will still be representation for so long as a subject (author, reader, spectator, or voyeur) casts his gaze towards a horizon on which he cuts out the base of a triangle, his eye (or his mind) forming the apex."[13] As I noted in my article: "Barthes's optical triangle is ... one-half of the diagram of the camera obscura–a metaphor not unfamiliar to students of Marx." Furthermore, Laura Mulvey's essay was published in 1975, the same year as Michel Foucault's book *Discipline and Punish*.[14] As I further noted, "Barthes's 'eye at the apex' [the eye of Mulvey's male spectator] was therefore easily conflated with that of the jailor, actual or virtual, in the tower at the center of the panopticon [...which] contributed to the survival of that strand of theory according to which ideology is an instrument of domination wielded by one section of a society and imposed upon another."[15] I especially noted that

. . . . . . . . . . . . .

12  Jacques Lacan, *Le Séminaire, livre I: Les écrits techniques de Freud* (Paris: Seuil, 1975), p. 90.
13  Roland Barthes, "Diderot, Brecht, Eisenstein," in *Image-Music-Text* (New York: Hill and Wang, 1977), p. 69.
14  Michel Foucault, *Surveiller et punir: Naissance de la prison* (Paris: Gallimard, 1975); *Discipline and Punish: The Birth of the Prison* (London: Penguin, 1977).
15  Victor Burgin, "Geometry and Abjection," *AA Files–Annals of the Architectural Association School of Architecture*, no. 15 (Summer 1987) [1988]: 35; and in *Thresholds: Psychoanalysis and Culture*, ed. J. Donald (London: Macmillan, 1990); Andrew Benjamin and John Fletcher, eds., *Abjection, Melancholia and Love: The Work of Julia Kristeva* (London: Routledge, 1989).

what Barthes situates, indifferently, at the apex of his representa-
tional triangle is the subject's "eye or his mind." Here, I com-
mented, "Barthes conflates psychical space with the space of
visual perception, which in turn is modeled on Euclid. But why
should we suppose that the condensations and displacements of
desire show any more regard for Euclidean geometry than they do
for Aristotelian logic?"[16] The attraction of the cone-of-vision
model for a critical theory of visual representations is the explicit
place it allocates to the subject as an inherent part of the system of
representation. The major disadvantage of the model is that it
maintains the object as external to the subject, existing in an
untroubled relation of "outside" to the subject's "inside." As I
observed, the predominance of the optical model has encouraged
the confusion of real space with psychical space; the confusion of
the psychoanalytic object with the real object.

I have noted that Mulvey's use of Freud's 1927 paper on fetish-
ism has in turn been used to put a psychoanalytic frame around a
nonpsychoanalytic notion of "objectification," one derived from a
marxian idea of commodification–the woman packaged as object
for sale. What has been repressed in the resulting version of
"scopophilia" is that which is most central to psychoanalysis: the
unconscious, and therefore any acknowledgment of the active-
passive duality of the drives to which Freud refers in his remark on
the unconscious counterpart of exhibitionism. There is no objec-
tification without identification. Otto Fenichel begins his paper of
1935, "The Scoptophilic Instinct and Identification," by remark-
ing on the ubiquity of references to the incorporative aspects of
looking–for example, folk tales in which "the eye plays a double
part. It is not only actively sadistic (the person gazing puts a spell
on his victim) but also passively receptive (the person who looks is
fascinated by that which he sees)."[17] He adds to this observation a
reference to a book by Géza Róheim on "looking-glass magic";
the mirror, Fenichel observes, by confronting the subject with its
own ego in external bodily form, obliterates "the dividing-line
between ego and non-ego." We should remember that Lacan's

. . . . . . . . . . . .

16  Burgin, "Geometry and Abjection," p. 38.
17  Otto Fenichel, "The Scoptophilic Instinct and Identification," in *The
Collected Papers of Otto Fenichel,* First Series, ed. H. Fenichel and D.
Rapaport (London: Norton, 1953), p. 375.

paper on the mirror-stage, also invoked in Mulvey's paper, con-
cerns a *dialectic* between alienation and identification, an identi-
fication not only with the ideal self, but also, by extension, with
other beings of whom the reflected image is a simulacrum—as in
the early phenomenon of transitivism. Fenichel writes: "one looks
at an object in order to *share in* its experience ... Anyone who
desires to witness the sexual activities of a man and woman really
always desires to share their experience by a process of empathy,
generally in a homosexual sense, i.e. *by empathy in the experience of
the partner of the opposite sex*"[18] (my emphasis).

## The Object of "Objectification"

The concept of "empathy" which Fenichel invokes here is not yet,
in itself, psychoanalytic. To make psychoanalytic sense of the dia-
lectic of objectification-identification to which he refers we need a
psychoanalytic definition of the object. In Freud's description, the
"object" is first the object of the *drive*—a drive whose "source" is in
a bodily excitation, whose "aim" is to eliminate the consequent
state of tension, and whose "object" is the more or less contingent
agency by which the reduction of tension is achieved. In Freud's
succinct definition: "The object of an instinct is the thing in regard
to which or through which the instinct is able to achieve its
aim."[19] The original object is not sexual, it is an object of the self-
preservative instinct alone. The neonate must suckle in order to
live. The source of the self-preservative drive here is hunger, the
object is the milk, and the aim is ingestion. However, ingestion of
milk and excitation of the sensitive mucous membranes of the
mouth are inseparable events. Fed to somatic satisfaction, and
after the breast has been removed, the infant may nevertheless
continue to suck. Here the act of sucking, functionally associated
with the ingestion of food, becomes enjoyed as "sensual sucking,"
a pleasure in its own right. In this description, sexuality emerges
in a "peeling away" from the self-preservative drive in the process

............

18   Ibid., p. 377.
19   Sigmund Freud, "Instincts and their Vicissitudes" (1915), in *The
Standard Edition of the Complete Psychological Works of Sigmund Freud*, vol. 14
(London: Hogarth, 1955–74), p. 122.

known as "anaclisis" or "propping."[20] Insofar as the somatic experience of satisfaction survives, it does so as a constellation of visual, tactile, kinaesthetic, auditory, and olfactory memory-traces. This complex of mnemic elements now comes to play the part, in respect of the sexual drive, that the milk played in regard to the self-preservative drive. This is to say, there has been a metonymical displacement from "milk" to "breast" and a metaphorical shift from "ingestion" to "incorporation." The object termed "breast" here does not correspond to the anatomical organ but is fantasmatic in nature and internal to the subject; this is in no way to reduce its material significance. In his book, *The First Year of Life,* René Spitz describes the primacy of the oral phase in human development. He writes, "...all perception begins in the oral cavity, which serves as the primeval bridge from inner reception to external perception."[21] In this context, Laplanche stresses that,

> The object ... this breast is not only a symbol. There is a sort of coalescence of the breast and the erogenous zone ... the breast inhabits the lips or the buccal cavity ... Similarly the aim ... undergoes a radical change. With the passage to incorporation, suddenly something new emerges: the permutability of the aim; we pass from "ingest" not to "incorporate" but to the couple "incorporate/be-incorporated" ... in this movement of metaphorization of the aim, the subject (the carrier of the action) suddenly (I do not say "disappears," but) loses its place: is it on the side this time of that which eats, or the side of that which is eaten?[22]

This ambivalence, then, marks sexuality from the very moment it emerges *as such,* "the moment when sexuality, disengaged from any natural object, moves into the field of fantasy *and*

. . . . . . . . . . . .

**20** This account contradicts the hypothesis that the infant initially exists in an "objectless state" of autoerotism. As Laplanche and Pontalis write: "the self-preservative instincts have a relationship to the object from the start; consequently, in so far as sexuality functions in anaclisis with these instincts, it too must be said to have a relationship to objects; only after detaching itself does sexuality become auto-erotic." J. Laplanche and J.-B. Pontalis, *The Language of Psycho-Analysis* (London: Norton, 1973), p. 31.
**21** René A. Spitz, *The First Year of Life* (New York: IUP, 1965), p. 62.
**22** Jean Laplanche, *La sublimation* (Paris: puf, 1980), p. 62.

*by that very fact becomes sexuality*" (my emphasis).[23] We cannot therefore posit a simple parallelism: on the one hand, need, directed towards an object; on the other hand, desire, directed towards a fantasy object. As Laplanche and Pontalis put it, fantasy, "is not the object of desire but its setting. In fantasy the subject does not pursue the object or its sign: he appears caught up himself in the sequence of images."[24] Thus Laplanche writes:

> The signs accompanying satisfaction (the breast accompanying the offering of nursing milk) will henceforth take on the value of a fixed arrangement, and it is that arrangement, a fantasy as yet limited to several barely elaborated elements, that will be repeated on the occasion of a subsequent appearance of need . . . with the appearance of an internal excitation, the fantastic arrangement–of several representative elements linked together in a short scene, an extremely rudimentary scene, ultimately composed of partial (or "component") objects and not whole objects: for example, a breast, a mouth, a movement of a mouth seizing a breast–will be revived.[25]

Thus, "... at the level of sexuality ... the object cannot be grasped separately from the fantasy within which it is inserted, the breast cannot be grasped outside of the process of incorporation-projection where it functions."[26]

I have been speaking of infantile autoerotism, in which polymorphous "component instincts" (oral, anal, phallic) seek satisfaction on sites ("erotogenic zones") of a neonate body experienced only as a fragmentary constellation of such sites. In Freud's account of the subsequent development of sexuality, the passage from infantile autoerotism to adult object-choice is described as routed by way of narcissism. The phase of "narcissism," as the term suggests, coincides with the emergence of a sense of a coher-

. . . . . . . . . . . .

**23**   J. Laplanche and J.-B. Pontalis, "Fantasy and the Origins of Sexuality," in *Formations of Fantasy,* ed. V. Burgin, J. Donald, and C. Kaplan (London and New York: Methuen, 1986), p. 25.
**24**   Ibid., p. 26.
**25**   Jean Laplanche, "The Ego and the Vital Order," in *Life and Death in Psychoanalysis* (Baltimore: Johns Hopkins University Press, 1976), p. 60.
**26**   Laplanche, *La sublimation,* p. 66. This account of the emergence of sexuality as inseparable from the emergence of fantasy works against the prevailing understanding of the fetishistic relation to an object as "frozen," motionless.

ent ego (a "body-ego") through the agency of an internalized self-representation: the newly unified drive now takes as its object the child's own body *as a totality*. In adult "object-choice" an analogously whole *other* person is taken as particular love-object, within the parameters of a general *type* of object-choice (heterosexual, homosexual; anaclitic, narcissistic). By this point, Freud seems to have offered contradictory descriptions of the object: on the one hand, initially, the object is that which is most contingent to the drive; on the other, later, it is that which "exerts the sexual attraction." As Laplanche comments: "if the object is at the origin of sexual attraction, there is no place for thinking of it as contingent, but on the contrary that it is narrowly determined, even determining, for each of us." In response, Laplanche proposes the notion of the *source-object* of the drive: "The source being defined here as a point of excitation implanted in the organism as would be a foreign body."[27] He sees the example of the internal breast as the prototype of such a source-object. By way of illustration, he suggests the analogy of the scientific experiment in which an electrode, implanted in the brain of an animal, is capable of being stimulated by a radio signal.[28]

I have not yet mentioned the place of vision in all this. In Freud's thought a wide range of distinct forms of behavior are seen as deriving from a small number of component drives. The sexually invested drive to see, however, is not reduced to any such component instinct; rather it takes its own independent place alongside them. The physiological activity of seeing clearly presents itself as self-preservative in function. The sexualization of vision therefore comes about in the same process of "propping" of the libido on function as has already been described. Freud refers to looking as analogous to *touching;* Laplanche writes:

> Imagine ... the horns of a snail which would be moving with a sort of going-out and coming-in motion; in fact, precisely, the horns of the snail carry eyes. There we have the image of what Freud means in relating vision to exploratory groping [*tâtonnement*], and in comparing it to a collecting of samples [*prise d'échantillons*] in the exterior

. . . . . . . . . . . .

27  Ibid., p. 65.
28  I understand this idea much as I understand Barthes' notion of punctum; see, "Diderot, Barthes, *Vertigo,*" in *Formations of Fantasy*.

world. Thus the nonsexual activity of looking, in the movement of propping, becomes the drive to see in the moment when it becomes *representative,* that is to say the interiorization of a scene. I recall the primacy of vision in the theory of the dream, but equally in the theory of the unconscious, for that which Freud calls thing-presentations, the very substance of the unconscious, are for a large part conceived of on the model of visual representation.[29]

It has been observed that the scopic drive is the only drive which must keep its objects at a distance. This observation implies a definition of the object that is more bound to physical reality than psychoanalysis can ever afford to be. Certainly the look puts out its exploratory, or aggressive, "shoots" (in Lacan's expression) but it equally clearly also takes in objects, from physical space into psychical space–just as surely as it projects unconscious objects into the real.

## Enigmatic Signifiers, Perverse Space

Freud describes infantile sexuality, the common basis of the sexuality of us all, as "polymorphously perverse." Formed in the paths of the vicissitudes of the drives, all human sexuality is deviant. Nothing about it belongs to anything that could be described as a "natural," instinctual process. In the natural world instinctual behavior is hereditary, predictable, and invariant in any member of a given species. In the human animal, what might once have been instinct now lives only in shifting networks of symbolic forms, from social laws to image systems: those we inhabit in our increasingly "media-intensive" environment, and those which inhabit us–in our memories, fantasies, and unconscious formations. Human sexuality is not natural, it is cultural. Freud inherited comprehensive data on "sexual perversions" from nineteenth-century sexologists such as Krafft-Ebing and Havelock Ellis, who viewed the behaviors they catalogued as deviations from "normal" sexuality. Freud however was struck by the ubiquity of such "deviations"–whether in dramatically pronounced form, or in the

. . . . . . . . . . . . .

**29**  Laplanche, *La sublimation,* pp. 102–103.

most subdued of ordinary "foreplay." It was Freud who remarked that the mingling of entrances to the digestive tract that we call "kissing" is hardly the most direct route to reproductive genital union. In his 1905 *Three Essays on the Theory of Sexuality* he observed, "the disposition to perversions is itself of no great rarity but must form a part of what passes as the normal constitution." In opposition to the sexologists, who took socially accepted, "normal" sexuality as inherent to human nature, Freud stated that, "from the point of view of psychoanalysis the exclusive sexual interest felt by men for women is also a problem that needs elucidating and is not a self-evident fact." Sexuality in psychoanalysis is not to be reduced to the biological function of perpetuation of the species; as Laplanche emphasizes, "the currency of physical reality is not in use in psychoanalysis which is simply not concerned with the domain of adaptation or biological life."[30] If the word "perversion" still has an air of disapprobation about it today, this is not the fault of psychoanalytic theory; it is due to the sense it takes in relation to social law, written or not. Considered in its relation to social law we might ask whether fetishism should really be considered a perversion, at least in that most ubiquitous non-clinical form accurately described by Mulvey: that idealization of the woman in the phallocratic Imaginary which is precisely the inverted image of her denigration in the Symbolic.[31] The Symbolic however is not seamless. For the Symbolic to be seamless, repression would have to be totally effective. If repression were totally effective we would have no return of the repressed, no symptom, and no psychoanalytic theory. As an expression of the overvaluation of the phallic metaphor in patriarchy, the fetishistic component of Newton's photograph is perfectly normal—but only when we fetishize it, only when we isolate it from the space within which it is situated.

· · · · · · · · · · · ·

30   Jean Laplanche, *New Foundations for Psychoanalysis* (Oxford and Cambridge, Mass.: Macmillan, 1989), p. 23.

31   Freud explicitly noted that the clinical fetishists he encountered in his practice did not come to him because of their fetishism. They were content to be fetishists. Freud assumes this is to be explained by the ease with which the fetishist may obtain his object, but surely we can think of other perversions which are equally "facile" but which engender shame and the wish to be cured.

The space of Newton's photograph is not normal. The only clear thing about this picture is the familiar "pin-up" pose of the model. According to the conventions of the genre, we would expect to see *only* the model: isolated against the seamless background paper, cut off from any context by the frame of the image. Such a familiar space is alluded to in the rectangle of the mirror, which approximates the familiar 2:3 ratio of a 35mm shot. But the isolating function of the framing edge has failed here, and it is precisely *this* function that a fetishistic relation to the image would demand. Elements which are normally excluded, including the photographer himself, have tumbled into the space framed by the mirror. This space is in turn set within a larger context of other elements which would normally be considered out of place. The resulting jumble is counterproductive to fetishism. Where fetishism demands coherence (for this is its very founding principle), this image has a different productivity; it functions as a *mise-en-scène,* a staging, of the fundamental incoherence of sexuality: its heterogeneity, its lack of singularity, its lack of focus. Commenting on Freud's *Three Essays on the Theory of Sexuality,* Laplanche writes:

> The whole point is to show that human beings have lost their instincts, especially their sexual instinct and, more specifically still, their instinct to reproduce ... With its descriptions of the sexual aberrations or perversions ... the text is an eloquent argument in favour of the view that drives and forms of behaviour are plastic, mobile and interchangeable. Above all, it foregrounds their ... vicariousness, the ability of one drive to take the place of another, and the possibility of a perverse drive taking the place of a non-perverse drive, or vice versa.[32]

In this photograph, as with the drives, there is much mobility: Helmut Newton stands in the model's space; June Newton occupies Helmut's place. Things are started—like the pair of disembodied legs—which are brought to no particular conclusion and are of indeterminate significance. The looks which are given by the protagonists neither meet nor converge, and they add up to nothing in particular. June is positioned as voyeur at a piece of sexual

. . . . . . . . . . . .

32  Laplanche, *New Foundations for Psychoanalysis,* pp. 29–30.

theater; Helmut is both voyeur and exhibitionist; a familiar form of denunciation of this image would simply assume that the model is the victim of a sadistic attack, a casualty of an economy to which "sexploitation" is central, but we might equally suspect a perverse component of exhibitionism in her being there to be looked at–an exhibitionism likely to provoke a mixture of desire, envy, and hostility in male and female viewers alike. At first glance it might seem that the viewer of this image is invited to focus unswervingly on this central figure of the model, reduced to a visual cliché with no more ambiguity than a target in a shooting gallery. But the very banality of this central motif encourages the displacement of our attention elsewhere. But where? Nowhere in particular. In the space of events in which this vignette is situated nothing is fixed, everything is mobile, there is no particular aim; it is a perverse space.

For the human animal, sexuality is not an urge to be obeyed so much as it is an enigma to unravel. Jean Laplanche has identified the early and inescapable encounter of the subject with "primal seduction," the term he gives to "that fundamental situation where the adult presents the infant with signifiers, nonverbal as well as verbal, and even behavioral, impregnated with unconscious sexual significations."[33] It is these that Laplanche calls "enigmatic signifiers": the child senses that such signifiers are addressed to it, and yet has no means of understanding their meaning; its attempts at mastery of the enigma, at symbolization, provoke anxiety and leave unconscious residues. Such estrangement in the libidinal relation with the object is an inescapable condition of entry into the adult world, and we may expect to find its trace in any subsequent relation with the object, even the most "normal." It is this trace of the encounter with the enigma of sexuality that is inscribed in Newton's picture. Reference to fetishism alone cannot explain why this picture looks the way it does. The concept of fetishism makes the whole question a purely genital matter. In a book on the erotic imagery of classical Greece and Rome, Catherine Johns remarks: "The vulva is rarely seen: its situation makes it invisible in any normal position even to its owner."[34] It is in this

. . . . . . . . . . . .

33  Jean Laplanche, *Noveaux fondements pour la psychanalyse* (Paris: puf, 1987), p. 125; my translation differs from the English edition cited in note 30.
34  Catherine Johns, *Sex or Symbol* (London: British Museum, 1982), p. 72.

purely relative "nothing to see" that the male fetishist sees the woman's sex only in terms of an absence, a "lack." All men are fetishists to some degree, but few of them are full-blown clinical fetishists. Most men appreciate the existential fact of feminine sexuality *as* a fact, albeit one which is not to be grasped quite as simply as their own. The surrealists could not see what was "hidden in the forest" until they closed their eyes in order to imagine it; even then they could not be sure, for there are other forests to negotiate, not least amongst these the "forest of signs" which is the unconscious. Sooner or later, as in Newton's image, we open our eyes, come back to a tangible reality: here, that of the woman's body. That which is physical, that which reflects light—which has here left its trace on the photosensitive emulsion. But what the man behind the camera will never know is what her sexuality means to her, although a lifetime may be devoted to the enquiry. Perhaps this is the reason why, finally, Helmut Newton chooses to stage his perverse display under the gaze of his wife.

# Bodies-Cities

## Elizabeth Grosz

### I Congruent Counterparts

FOR A NUMBER OF YEARS I have been involved in research on the
body as sociocultural artifact. I have been interested in challenging
traditional notions of the body so that we can abandon the opposi-
tions by which the body has usually been understood—mind and
body, inside and outside, experience and social context, subject
and object, self and other, and underlying these, the opposition
between male and female. Thus "stripped," corporeality in its
sexual specificity may be seen as the material condition of subjec-
tivity, that is, the body itself may be regarded as the locus and site
of inscription for specific modes of subjectivity. In a "deconstruc-
tive turn," the subordinated terms of these oppositions take their
rightful place at the very heart of the dominant ones.

Among other things, my recent work has involved a kind of turning *inside out* and *outside in* of the sexed body, questioning how the subject's exteriority is psychically constructed, and conversely, how the processes of social inscription of the body's surface construct for it a psychical interior. In other words, I have attempted to problematize the opposition between the inside and the outside by looking at the outside of the body from the point of view of the inside, and looking at the inside of the body from the point of view of the outside, thus reexamining and questioning the distinction between biology and culture, exploring the way in which culture constructs the biological order in its own image, the way in which the psychosocial simulates and produces the body as such. Thus I am interested in exploring the ways in which the body is psychically, socially, sexually, and discursively or representationally produced, and the ways, in turn, bodies reinscribe and project themselves onto their sociocultural environment so that this environment both produces and reflects the form and interests of the body. This relation of introjections and projections involves a complex feedback relation in which neither the body nor its environment can be assumed to form an organically unified ecosystem. (The very notion of an ecosystem implies a kind of higher-order unity or encompassing totality that I will try to problematize in this paper.) The body and its environment, rather, produce each other as forms of the hyperreal, as modes of simulation which have overtaken and transformed whatever reality each may have had into the image of the other: the city is made and made over into the simulacrum of the body, and the body, in its turn, is transformed, "citified," urbanized as a distinctively metropolitan body.

One area that I have neglected for too long–and I am delighted to have the opportunity here to begin to rectify this–is the constitutive and mutually defining relation between bodies and cities. The city is one of the crucial factors in the social production of (sexed) corporeality: the built environment provides the context and coordinates for most contemporary Western and, today, Eastern forms of the body, even for rural bodies insofar as the twentieth century defines the countryside, "the rural," as the underside or raw material of urban development. The city has become the defining term in constructing the image of the land and the landscape, as well as the point of reference, the centerpiece of a notion

of economic/social/political/cultural exchange and a concept of a "natural ecosystem." The ecosystem notion of exchange and "natural balance" is itself a counterpart to the notion of a global economic and informational exchange system (which emerged with the computerization of the stock exchange in the 1970s). The city provides the order and organization that automatically links otherwise unrelated bodies. For example, it links the affluent lifestyle of the banker or professional to the squalor of the vagrant, the homeless, or the impoverished without necessarily positing a conscious or intentional will-to-exploit. It is the condition and milieu in which corporeality is socially, sexually, and discursively produced. But if the city is a significant context and frame for the body, the relations between bodies and cities are more complex than may have been realized. My aim here will be to explore the constitutive and mutually defining relations between corporeality and the metropolis, if only in a rather sketchy but I hope suggestive fashion. I would also like to project into the not-too-distant future some of the effects of the technologization and the technocratization of the city on the forms of the body, speculating about the enormous and so far undecidable prosthetic and organic changes this may effect for or in the lived body. A deeper exploration would of course be required to elaborate the historico-geographic specificity of bodies, their production as determinate types of subject with distinctive modes of corporeality.

Before going into any detail, it may be useful to define the two key terms I will examine today, *body* and *city*.

By *body* I understand a concrete, material, animate organization of flesh, organs, nerves, muscles, and skeletal structure which are given a unity, cohesiveness, and organization only through their psychical and social inscription as the surface and raw materials of an integrated and cohesive totality. The body is, so to speak, organically/biologically/naturally "incomplete"; it is indeterminate, amorphous, a series of uncoordinated potentialities which require social triggering, ordering, and long-term "administration," regulated in each culture and epoch by what Foucault has called "the micro-technologies of power."[1] The body becomes

............

1   See, in particular, *Discipline and Punish* (New York: Vintage, 1979) and *The History of Sexuality,* Vol. 1: *An Introduction* (New York: Pantheon, 1978).

a *human* body, a body which coincides with the "shape" and space of a psyche, a body whose epidermic surface bounds a psychical unity, a body which thereby defines the limits of experience and subjectivity, in psychoanalytic terms, through the intervention of the (m)other, and, ultimately, the Other or Symbolic order (language and rule-governed social order). Among the key structuring principles of this produced body is its inscription and coding by (familially ordered) sexual desires (the desire of the other), which produce (and ultimately repress) the infant's bodily zones, orifices, and organs as libidinal sources; its inscription by a set of socially coded meanings and significances (both for the subject and for others), making the body a meaningful, "readable," depth-entity; and its production and development through various regimes of discipline and training, including the coordination and integration of its bodily functions so that not only can it undertake the general social tasks required of it, but so that it becomes an integral part of or position within a social network, linked to other bodies and objects.

By *city,* I understand a complex and interactive network which links together, often in an unintegrated and de facto way, a number of disparate social activities, processes, and relations, with a number of imaginary and real, projected or actual architectural, geographic, civic, and public relations. The city brings together economic and informational flows, power networks, forms of displacement, management, and political organization, interpersonal, familial, and extra-familial social relations, and an aesthetic/economic organization of space and place to create a semipermanent but ever-changing built environment or milieu. In this sense, the city can be seen, as it were, as midway between the village and the state, sharing the interpersonal interrelations of the village (on a neighborhood scale) and the administrative concerns of the state (hence the need for local government, the preeminence of questions of transportation, and the relativity of location).

## II  Body Politic and Political Bodies

I will look at two pervasive models of the interrelation of bodies and cities, and, in outlining their problems, I hope to suggest alternatives that may account for future urban developments and their corporeal consequences.

In the first model, the body and the city have merely a de facto or external, contingent rather than constitutive relation. The city is a reflection, projection, or product of bodies. Bodies are conceived in naturalistic terms, predating the city, the cause and motivation for their design and construction. This model often assumes an ethnological and historical character: the city develops according to human needs and design, developing from nomadism to sedentary agrarianism to the structure of the localized village, the form of the polis through industrialization to the technological modern city and beyond. More recently, we have heard an inverted form of this presumed relation: cities have become (or may have always been) alienating environments, environments which do not allow the body a "natural," "healthy," or "conducive" context.

Underlying this view of the city as a product or projection of the body (in all its variations) is a form of humanism: the human subject is conceived as a sovereign and self-given agent which, individually or collectively, is responsible for all social and historical production. Humans *make* cities. Moreover, in such formulations the body is usually subordinated to and seen merely as a "tool" of subjectivity, of self-given consciousness. The city is a product not simply of the muscles and energy of the body, but the conceptual and reflective possibilities of consciousness itself: the capacity to design, to plan ahead, to function as an intentionality and thereby be transformed in the process. This view is reflected in the separation or binarism of design, on the one hand, and construction, on the other, the division of mind from hand (or art from craft). Both Enlightenment humanism and marxism share this view, the distinction being whether the relation is conceived as a one-way relation (from subjectivity to the environment), or a dialectic (from subjectivity to environment and back again). Nonetheless, both positions consider the active agent in social production (whether the production of commodities or in the production of cities) to be the subject, a rational or potentially rational consciousness clothed in a body, the "captain of the ship," the "ghost in the machine."

In my opinion, this view has at least two serious problems. First, it subordinates the body to the mind while retaining a structure of binary opposites. Body is merely a tool or bridge linking a nonspatial (i.e., Cartesian) consciousness to the materiality and

coordinates of the built environment, a kind of mediating term between mind on the one hand and inorganic matter on the other, a term that has no agency or productivity of its own. It is presumed to be a machine, animated by a consciousness. Second, at best, such a view only posits a one-way relation between the body or the subject and the city, linking them through a causal relation in which body or subjectivity is conceived as the cause, and the city its effect. In more sophisticated versions of this view, the city can have a negative feedback relation with the bodies that produce it, thereby alienating them. Implicit in this position is the active causal power of the subject in the design and construction of cities.

Another equally popular formulation proposes a kind of parallelism or isomorphism between the body and the city. The two are understood as analogues, congruent counterparts, in which the features, organization, and characteristics of one are reflected in the other. This notion of the parallelism between the body and social order (usually identified with the state) finds its clearest formulations in the seventeenth century, when liberal political philosophers justified their various allegiances (the divine right of kings, for Hobbes; parliamentary representation, for Locke; direct representation, for Rousseau, etc.) through the metaphor of the body-politic. The state parallels the body; artifice mirrors nature. The correspondence between the body and the body-politic is more or less exact and codified: the King usually represented as the head of the body-politic,[2] the populace as the body. The law has been compared to the body's nerves, the military to its arms, commerce to its legs or stomach, and so on. The exact correspondences vary from text to text, and from one political regime to another. However, if there is a morphological correspondence or parallelism between the artificial commonwealth (the "Leviathan") and the human body in this pervasive metaphor of the body-politic, the body is rarely attributed a sex. If one presses this metaphor just a little, we must ask: if the state or the structure of the polis/city mirrors the body, what takes on the metaphoric function of the genitals in the body-politic? What kind of genitals are they? In other words, does the body-politic have a sex?

. . . . . . . . . . . . .

2   The king may also represent the heart. See Michel Feher, ed., *Fragments of a History of the Human Body,* vol. 1 (New York: Zone, 1989).

Here once again, I have serious reservations. The first regards the implicitly phallocentric coding of the body-politic, which, while claiming it models itself on the *human* body, uses the male to represent the human. Phallocentrism is, in my understanding, not so much the dominance of the phallus as the pervasive unacknowledged use of the male or masculine to represent the human. The problem, then, is not so much to eliminate as to reveal the masculinity inherent in the notion of the universal, the generic human, or the unspecified subject. The second reservation concerns the political function of this analogy: it serves to provide a justification for various forms of "ideal" government and social organization through a process of "naturalization": the human body is a natural form of organization which functions not only for the good of each organ but primarily for the good of the whole. Similarly, the body politic, whatever form it may take,[3] justifies and naturalizes itself with reference to some form of hierarchical organization modeled on the (presumed and projected) structure of the body. A third problem: this conception of the body-politic relies on a fundamental opposition between nature and culture, in which nature dictates the ideal forms of culture. Culture is a supercession and perfection of nature. The body-politic is an artificial construct which replaces the primacy of the

. . . . . . . . . . . .

**3**  There is a slippage from conceptions of the state (which necessarily raise questions of legal sovereignty) and conceptions of the city as a commercial and cultural entity:

> The town is the correlate of the road. The town exists only as a function of a circulation and of circuits; it is a singular point on the circuits which create it and which it creates. It is defined by entries and exits; something must enter it and exit from it. It imposes a frequency. It effects a polarization of matter, inert, living or human. . . It is a phenomenon of transconsistency, a network, because it is fundamentally in contact with other towns. . . .
>
> The State proceeds otherwise: it is a phenomenon of ultraconsistency. It makes points resonate together, points . . . very diverse points of order–geographic, ethnic, linguistic, moral, economic, technological particulars. The State makes the town resonate with the countryside. . . the central power of the State is hierarchical and constitutes a civil-service sector; the center is not in the middle but on top because [it is] the only way it can recombine what it isolates . . . through subordination (Gilles Deleuze and Félix Guattari, "City/State," *Zone* 1/2 [1986]: 195–197).

natural body. Culture is molded according to the dictates of nature, but transforms nature's limits. In this sense, nature is a passivity on which culture works as male (cultural) productivity supercedes and overtakes female (natural) reproduction.

But if the relation between bodies and cities is neither causal (the first view) nor representational (the second view), then what kind of relation exists between them? These two models are inadequate insofar as they give precedence to one term or the other in the body/city pair. A more appropriate model combines elements from each. Like the causal view, the body (and not simply a disembodied consciousness) must be considered active in the production and transformation of the city. But bodies and cities are not causally linked. Every cause must be logically distinct from its effect. The body, however, is not distinct, does not have an existence separate from the city, for they are mutually defining. Like the representational model, there may be an isomorphism between the body and the city. But it is not a mirroring of nature in artifice. Rather, there is a two-way linkage which could be defined as an *interface,* perhaps even a cobuilding. What I am suggesting is a model of the relations between bodies and cities which sees them, not as megalithic total entities, distinct identities, but as assemblages or collections of parts, capable of crossing the thresholds between substances to form linkages, machines, provisional and often temporary sub- or microgroupings. This model is a practical one, based on the practical productivity bodies and cities have in defining and establishing each other. It is not a holistic view, one that stresses the unity and integration of city and body, their "ecological balance." Instead, I am suggesting a fundamentally disunified series of systems and interconnections, a series of disparate flows, energies, events or entities, and spaces, brought together or drawn apart in more or less temporary alignments.

The city in its particular geographical, architectural, spatializing, municipal arrangements is one particular ingredient in the social constitution of the body. It is by no means the most significant. The structure and particularity of, say, the family is more directly and visibly influential, although this in itself is to some extent a function of the social geography of cities. But nonetheless, the form, structure, and norms of the city seep into and effect all the other elements that go into the constitution of corporeality

and/as subjectivity. It effects the way the subject sees others (domestic architecture and the division of the home into the conjugal bedroom, separated off from other living and sleeping spaces, and the specialization of rooms are as significant in this regard as smaller family size[4]), as well as the subject's understanding of, alignment with, and positioning in space. Different forms of lived spatiality (the verticality of the city, as opposed to the horizontality of the landscape–at least our own) effect the ways we live space, and thus our comportment and corporeal orientations and the subject's forms of corporeal exertion–the kind of terrain it must negotiate day by day, the effect this has on its muscular structure, its nutritional context, providing the most elementary forms of material support and sustenance for the body. Moreover, the city is, of course, also the site for the body's cultural saturation, its takeover and transformation by images, representational systems, the mass media, and the arts–the place where the body is representationally reexplored, transformed, contested, reinscribed. In turn, the body (as cultural product) transforms, reinscribes the urban landscape according to its changing (demographic, economic, and psychological) needs, extending the limits of the city, of the sub-urban, ever towards the countryside which borders it. As a hinge between the population and the individual, the body, its distribution, habits, alignments, pleasures, norms, and ideals are the ostensible object of governmental regulation, and the city is a key tool. [5]

### III   Body Spaces

*Some general implications:*
First, there is no natural or ideal environment for the body, no "perfect" city, judged in terms of the body's health and well-being. If bodies are not culturally pregiven, built environments cannot alienate the very bodies they produce. However, what may prove unconducive is the rapid transformation of an environment, such that a body inscribed by one cultural milieu finds itself in

. . . . . . . . . . . . .

4   See Jacques Donzelot, *The Policing of Families* (New York: Pantheon, 1979).
5   See Foucault's discussion of the notion of biopower in the final sections of *The History of Sexuality*.

another involuntarily. This is not to say that there are not *uncon-*ducive city environments, but rather there is nothing intrinsically alienating or unnatural about the city. The question is not simply how to distinguish conducive from unconducive environments, but to examine how different cities, different sociocultural environments actively produce the bodies of their inhabitants as particular and distinctive types of bodies, as bodies with particular physiologies, affective lives, and concrete behaviors. For example, the slum is not inherently alienating, although for those used to a rural or even a suburban environment, it produces extreme feelings of alienation. However, the same is true for the slum dweller who moves to the country or the suburbs. It is a question of negotiation of urban spaces by individuals/groups more or less densely packed, who inhabit or traverse them: each environment or context contains its own powers, perils, dangers, and advantages.

Second, there are a number of general effects induced by cityscapes, which can only be concretely specified in particular cases. The city helps to orient sensory and perceptual information, insofar as it helps to produce specific conceptions of spatiality, the vectorization and setting for our earliest and most ongoing perceptions. The city orients and organizes family, sexual, and social relations insofar as the city divides cultural life into public and private domains, geographically dividing and defining the particular social positions and locations occupied by individuals and groups. Cities establish lateral, contingent, short- or long-term connections between individuals and social groups, and more or less stable divisions, such as those constituting domestic and generational distinctions. These spaces, divisions, and interconnections are the roles and means by which bodies are individuated to become subjects. The structure and layout of the city also provide and organize the circulation of information, and structure social and regional access to goods and services. Finally, the city's form and structure provide the context in which social rules and expectations are internalized or habituated in order to ensure social conformity, or position social marginality at a safe or insulated and bounded distance (ghettoization). This means that the city must be seen as the most immediately concrete locus for the production and circulation of power.

I have suggested that the city is an active force in constituting

bodies, and always leaves its traces on the subject's corporeality. It follows that, corresponding to the dramatic transformation of the city as a result of the information revolution will be a transformation in the inscription of bodies. In his paper, "The Overexposed City," Paul Virilio makes clear the tendency toward hyperreality in cities today: the replacement of geographical space with the screen interface, the transformation of distance and depth into pure surface, the reduction of space to time, of the face-to-face encounter to the terminal screen:

> On the terminal's screen, a span of time becomes both the surface and the support of inscription; time literally . . . surfaces. Due to the cathode-ray tube's imperceptible substance, the dimensions of space become inseparable from their speed of transmission. Unity of place without unity of time makes the city disappear into the heterogeneity of advanced technology's temporal regime.[6]

The implosion of space into time, the transmutation of distance into speed, the instantaneousness of communication, the collapsing of the workspace into the home computer system, will clearly have major effects on specifically sexual and racial bodies of the city's inhabitants as well as on the form and structure of the city. The increased coordination and integration of microfunctions in the urban space creates the city not as a body-politic but as a political machine—no longer a machine modeled on the engine but now represented by the computer, facsimile machine, and modem, a machine that reduces distance and speed to immediate, instantaneous gratification,. The abolition of the distance between home and work, the diminution of interaction between face-to-face subjects, the continuing mediation of interpersonal relations by terminals, screens, and keyboards, will increasingly affect/infect the minutiae of everyday life and corporeal existence.

> With the advent of instantaneous communications (satellite, TV, fiber optics, telematics) arrival supplants departure: everything arrives without necessarily having to depart . . . Contributing to the creation of a permanent present whose intense pace knows no tomorrow, the latter type of time span is destroying the rhythms of a society which has become more and more debased. And "monument,"

. . . . . . . . . . . . .

6   Paul Virilio, "The Overexposed City," *Zone* 1/2 (1986): 19.

no longer the elaborately constructed portico, the monumental pas-
sageway punctuated by sumptuous edifices, but idleness, the monu-
mental wait for service in front of machinery: everyone bustling
about while waiting for communication and telecommunication
machines, the lines at highway tollbooths, the pilot's checklist, night
tables as computer consoles. Ultimately, the door is what monitors
vehicles and various vectors whose breaks of continuity compose
less a space than a kind of countdown in which the urgency of work
time plays the part of a *time center,* while unemployment and vacation
time play the part of the periphery–*the suburb of time*: a clearing away
of activity whereby everyone is exiled to a life of both privacy and
deprivation.[7]

The subject's body will no longer be disjointedly connected to
random others and objects according to the city's spatio-temporal
layout. The city network–now vertical more than horizontal in
layout–will be modeled on and ordered by telecommunications.
The city and body will interface with the computer, forming part
of an information machine in which the body's limbs and organs
will become interchangeable parts with the computer and with
the technologization of production. The computerization of labor
is intimately implicated in material transformations, including
those which pose as merely conceptual. Whether this results in the
"cross-breeding" of the body and machine–that is, whether the
machine will take on the characteristics attributed to the human
body ("artificial intelligence," automatons) or whether the body
will take on the characteristics of the machine (the cyborg,
bionics, computer prosthesis) remains unclear. Yet it is certain that
this will fundamentally transform the ways in which we conceive
both cities and bodies, and their interrelations.

. . . . . . . . . . . . .

**7**   Ibid., pp. 19–20.

*References*

Sue Clifford. "Common Ground." *Meanjin* 47, no.4 (Summer 1988): 625–636.

Philip Cook. "Modernity, Postmodernity and the City." *Theory, Culture and Society* 5 (1988): 475–493.

Manuel De Landa. "Policing the Spectrum." *Zone* 1/2 (1986): 176–193.

Gilles Deleuze and Félix Guattari. "City/State." *Zone* 1/2 (1986): 194–199.

Jon Jerde. "A Philosophy for City Development." *Meanjin* 47, no. 4 (Summer 1988): 609–614.

Michel Foucault. *Discipline and Punish: The Birth of the Prison.* Trans. Alan Sheridan. New York: Vintage, 1979.

Michel Foucault. *The History of Sexuality,* Vol. 1: *An Introduction.* Trans. Robert Hurley. New York: Pantheon, 1978.

Sanford Kwinter. "La Città Nuova: Modernity and Continuity." *Zone* 1/2 (1986): 80–127.

Alison Sky. "On Site." *Meanjin* 47, no. 4 (Summer 1988): 614–625.

Paul Virilio. "The Overexposed City." *Zone* 1/2 (1986): 14–39.

David Yencken. "The Creative City." *Meanjin* 47, no. 4 (Summer 1988): 597–609.

H. Where the mule kicked me.

I

# Initial Proprieties:
# Architecture and the Space of the Line

## Catherine Ingraham

I STARTED THINKING about this subject of sexuality and space in connection with that very strange autobiographical text by Marie-Henri Beyle Stendhal: *The Life of Henry Brulard*.[1] In this text, Stendhal, who is speaking of himself in the first person but under a different name–Henri Brulard[2]–presents along with the written text a series of drawn sketches, mostly floor plans and site plans with some elevations, of the house and village where he grew up. These sketches initially caught my attention because of their architectural oddity. Stendhal generally labels the spaces of these plans narratively as in "My father in an arm-chair," or "Grandfather's green bedroom," or "Where the mule kicked me." On the surface, the drawings corroborate the autobiographical locale of the text that they interrupt as images. The author places himself in these drawings by designating a space marked by an initial "H." and the single word "Me" (figures 1, 2).

. . . . . . . . . . . . .

1   Marie-Henri Beyle Stendhal, *The Life of Henry Brulard,* trans. Jean Stewart and B.C.J.G. Knight (Chicago: University of Chicago Press, 1986). Stendhal wrote his autobiography between November 1835 and March 1836, but it was not published until 1890. All citations are taken from this volume unless otherwise noted.

2   The matter of the name will prove particularly interesting. The translators of this edition suggest in the short introduction that he chose the name Brulard "from a family name on his mother's side."

Now the word "me" has a special repugnance for Stendhal. As he is preparing to write his memoirs, Stendhal says to himself (as he tells us in this autobiography): "I liked this idea [of writing my memoirs]. Yes, but what an appalling quantity of I's and me's!"[3] At another point, when he is thinking about but not yet writing his memoirs, he realizes his "life could be summed up by [these] . . . names, the initials of which" he writes in the dust with his walking stick. The initials are those of his mistresses:

[V. Aⁿ. Aᵈ. M. Mⁱ. Aˡ. Aᵐᵉ. Aᵖᵍ. Mᵈᵉ. C.G. Aᵘʳ. (Mme Azur whose Christian name I have forgotten).]

This episode causes Stendhal to reflect on the "astonishing stupidities and follies" these women made him commit. One of these stupidities is, no doubt, the writing of the memoirs themselves, the launching of Stendhal into the appalling number of I's and me's that he so abhors in order to "sum his life up" by telling about his passions for women. "In actual fact," he explains, "I only possessed six of these women whom I loved . . . my greatest passion was either for Melanie 2, Alexandrine, Matilde or Clementine 4."[4]

The connection between the "me" in the elevations and floor plans and the initials of the mistresses scratched in the dust–initials that are printed in the text in facsimile handwriting just as the drawings are faithful reproductions of Stendhal's "hand"–is that

. . . . . . . . . . . .

3  Stendhal, *The Life of Henry Brulard*, p. 3.
4  Stendhal's writing, especially here, always forces one into the ironic space between fiction and autobiography. Are we really to believe that he started writing his memoirs by this melodramatic act of etching the forbidden names in the dust? We have only his word for it and his word is already suspect because not only is he adopting the false honesty of self-confession, but he tells us point blank that he has committed many "stupidities," under which it is impossible not to include lies and deceptions. In this essay, I am not setting out, per se, to unfurl all the multiple layers of false truths in this text, but of course I depend on those very layers in order to make my point.

[*Courtyard.—Pantry.—Kitchen.—Dark pantry.—H. Me.—A. Cupboard.*]

2

both the "me" and the initials hold down a certain space, different from the space of the narrative sections of the memoir. Through their positioning, these marks become (improperly) the names of spaces rather than people. The pronoun "me," which can never itself be a proper name but only refer to the realm of the proper name, and the initial letter, which is only the first letter, the beginning of the proper name, achieve an illicit common status in Stendhal's drawings by becoming the proper names of the spaces they hold down in a plan, on the ground, on the paper. At the same time, these improper proper names conceal or bury in the spaces that they are occupying the so-called whole names to which they supposedly refer . . . the name Henri Brulard/Stendhal or the surname of the mistress, which in some cases is the surname of the husband who is being cuckolded. 5 Once the text resumes its typographic propriety–the justified typeset line and printed text we are

. . . . . . . . . . . .

5   According to the translators, the reprinting of the text with facsimile handwriting/drawing is meant to convey the sense of the original manuscript–to be a "faithful rendering." Stendhal apparently abbreviated parts of words "for convenience or caution." The initials of mistresses might fall into the latter category.

familiar with–the proper names of the subject of the autobiogra-
phy, Henri Brulard (Stendhal), and the objects of his love, the mis-
tresses, can reenter and be named.

Now what I want to say is that if this minor drama of conceal-
ment and revelation is accurate, the subjects and objects that the
proper name names are without the power of inhabitation (with-
out a "spatial" stake or property) except at the moment when a
certain kind of drawn space interrupts their narrative existence. To
take a place (hold down a space), however, is paradoxically to lose
your proper name and to assume an acronym, initial, or pro-
noun–an abbreviation, epigram, or mark. If we enter into Sten-
dhal's account of the origins of this text–the mistresses' initials
drawn in the dust with a walking stick–we might also imagine
that the loss of narrative propriety inaugurates the loss of one's
"full" name and the beginning of an illicit sexual transaction. The
interruption of "linear" writing by drawing, spatiality, vol-
umetrics, may also be a moment of breach that is inevitably sexual
(the imprint of the body or shape upon the clean page). The space
that is missing (or rather repressed) in the typographically proper
sections of this text (the written rather than the drawn sections)
might be something we could call the architectural space, the
house, of the sexual. Here the sexual can only make itself known
through the power of the abbreviation (the opening provided by
the shortfall, the epigram, the mark). I don't want to be misun-
derstood as suggesting here that drawings are ultimately more
spatial than writing, but, rather, that the subject–the sexual sub-
ject in particular (the "me" and the "mistresses")–in architectural
space is constituted differently and repressed differently than in
writing, although architecture is certainly a kind of writing and
writing is a kind of architecture.[6] I am suggesting, for one thing,
that in architectural space the sexual subject might be constituted
through the technical acts that construct and name space–acts
that, in effect, bring the mark "me" (Stendhal) into a spatial rela-
tion with the marks of Melanie, Adele.

. . . . . . . . . . . .

**6**  I am skirting the vital issue here of how writing and drawing are
exactly the same from a textuality standpoint. Neither are linear structures,
neither are representational in the way they claim. But I want to
temporarily uphold the difference (a different difference) between writing
and drawing in order to bring their narrow conventions into play on behalf
of architecture.

The interesting thing about Stendhal's drawings is that he seems to already know about, indeed cultivate, the sexual potential of the intersection of a kind of writing and a kind of drawing. The "me" that stands in for the author and the A's and M's of the Adeles and Madelines do not seem significantly different from the numbers, scale, dimension, and banal labeling (the kitchen, the bathroom, the living room, the bedroom, the family room, the office, the utility closet)–that are a familiar part of the architectural denotative system. The initials in particular seem numerological, with their serial character, their exponents of "d" and "m" (mistress raised to the power of wife, for example), and the aggregation, the "summing up" they designate. In fact, this relation between the numbers, the "me," and the initials is not a particularly strange one in this text since Stendhal was a mathematician before he became a writer; that is, he had a passion for mathematics before he had a passion for women.

Without discussing at length the mathematical passion of Stendhal's youth (which takes up a good part of this autobiography), the main point seems to be that mathematics, like women, ultimately fail Stendhal in the same way (through the force of "folly"). As Stendhal recounts it, he discovered an unsolvable perplexity at the heart of the mathematical axiom that two negative numbers multiplied together always produce a positive number. Stendhal represents this problem graphically as follows. He draws the line RP, above which is the "positive" square C, below which are the "negative" squares A and B.

Let RP be the line separating the positive from the negative, all that is above it being positive, all that is below negative, how, taking the square B as many times as there are units in the square A, can one make it change over to the side of square C?

As he asks, how does multiplying the negative squares A and B together permit you to cross over (to go up to) the positive side of C? Not finding a satisfactory answer to this question, Stendhal searches elsewhere for the logic that drives his love of the discipline. He recovers, for a time, a kind of belief in his work through a father who also, in a different way, is obsessed with the relation between A, B, and C—mainly Pythagoras and the Pythagorean theorem, $a^2 + b^2 = c^2$. Actually the father to whom Stendhal might have looked for reassurance was Descartes, for it was Descartes who insisted on the separation between "modes of extension" (the sensible—figure, shape, size) and "modes of thought" (the intelligible—thinking, feeling). It is precisely Stendhal's inability to keep these things separate that shapes his eventual "career" as disillusioned mathematician, forever frustrated Casanova, and successful writer. By choosing Pythagoras (vis-à-vis the Pythagorean theorem), one might say that Stendhal asked for what he got out of mathematics. Pythagoras, of all the pre-Socratics, might be said to have aided and abetted the "fall" from mathematical equations into the arms (the initials) of women. Pythagoras' school (which operated sometime around 530 B.C.) was notable for its coupling of the principles of mathematics with strict principles of sexual and bodily conduct. One particularly telling rule of conduct was the smoothing out of the imprint of the body upon leaving the bed. Indeed, one might say, it is precisely the imprint of the (sexually rumpled) body on the rectilinear bed plane that is later smoothed out once and for all by Descartes.

Like all formulas, the Pythagorean theorem uses letters rather than numbers to indicate its general form, and it is these letters that return one in Stendhal's text, inevitably, to the "me" and the mistresses' initials. Is it perhaps Adele or Angela 1 or 2 (Angela squared) plus Brulard (squared as Stendhal) that yields Clementine 1 or 2 (Clementine squared)? Or some other sexual equation? Can we move, one might ask, from underneath, from the negative and hidden structure/space of the line (the shadow bed, the ground plane of the architectural plan) to above the line, to the positive and additive structure/space line (the bed itself, the aboveground of the architectural elevation, the building) through the act of sexual multiplication and addition, through geometry (figure 3)? And, if so, at what level can one begin to talk about the relation of sexu-

[*Slate.*]

3

ality to architectural space, geometry, mathematics, technique, which, as Stendhal has shown us, are tied to the utterance of the proper name, the drawing of the initial letter, the "codes" of geometry and mathematics, the inscribing of the "me" into space, the mark of the letter, the confusion of modes of extension with language and thinking, and so on? These are some of the initial proprieties that I refer to in the title of this essay and want to examine more fully, although now in a different direction.

How does one begin to connect sexuality with the traditionally asexual—or at least sexually indeterminate—character of

architectural space, which is the space shaped by the line into a volume, the so-called neutral space produced by geometry and technique? Using an old Freudian/Derridean strategy, I want to suggest that it is precisely the *absence* of sexuality in traditional conceptions of architectural space that gives us the first clue to its presence. How can it possibly be that sexuality is put out of play by spatiality, a spatiality arrived at, designed, and constructed out of a political/cultural context, an economy of desire, and so forth?

Architecture traditionally has insisted on the neutrality of the category of space in order, I believe, to mute and neutralize both the political and analogic power of the sexual. To put it another way, by casting space as neutral, architecture is able to avoid the *specificity* of difference that is the very structure of sexuality, insofar as sexuality is paradigmatically about the specificity of, identity through, and competition between gender differences. Because the idea of sexuality (which I believe one must be careful to keep enriched with all the conceptual life it engenders and is part of: the marking of gender, its psychoanalytic, biological, and metaphoric life, the politics of desire, issues of representation, language, being, and so on), because the very idea of sexuality invokes this paradigmatic realm of difference, it stands in some sense for the possibility of all difference, of *différance* itself.

Architecture, then, has traditionally relied on an immunological system (consisting of the "technical," the "geometric," the "spatial") to keep the problem of difference, and specifically of sexual difference, from contaminating its practice and theory. As if—one could ask from a different vantage point—sexuality had nothing of the technical, the aesthetic, the spatial in it. One might point, not by way of illustration but just as a point of curiosity, to Lacan's portrayal of the infamous two doors labeled "Ladies and Gentleman" (figure 4). The doors are identical, even down to the placement of the doorknob. It would be generally preposterous to suggest that the doors and the position of the doorknob have equivalent analogic power to the difference between the signs "Ladies" and "Gentlemen"—although the doorknob corresponds generally (coincidentally?) with the position of both male and female genitals on the body. One reaches one's hand down to open the door at about genital level. Part of my question has to do with why the sexual analogy, as an analogy of position, direction,

## LADIES        GENTLEMEN

4

placement, is forbidden in architecture. In what sense, I might ask, are the doors immunized (in their formal sameness) against the difference that the labeling argues for?

While "sexuality"–as the politicized cluster of issues we know from contemporary theory–has only (relatively) recently become a focus of critical work in architecture, there have been periods in architectural history when the *theme* of sexuality has had a tacit force. I am thinking of those incredible studies of women as "domestic engineers," the era of Taylorism and fantasies of modernist efficiency, when the specific organization of the, especially female, spaces of the house came under scrutiny. But while the practices of modernist architecture were significantly influenced by these so-called sociological and scientific studies, there is never any suggestion that the architectural conception and management of space itself might have something to do with the character of the sexuality and gender difference that gets played out in it.[7]

Another kind of work that has been done with respect to sexuality and space in architecture concerns the history of architectural

. . . . . . . . . . . . .

7   These domestic efficiency studies seem especially chilling because, under the guise of science, the woman as domestic engineer–as a suddenly useful cog in the great social and economic machinery–was granted all the legitimacy of a good and proper member of society without any of its benefits (no wages, no property, and so on). The woman became a statistical pleasure model. Statistics, like geometries, are never innocent.

practices. These studies attempt to locate, in the profession, a sexual agenda. As with other professions, this has included the historical recovery of women who had substantial architectural practices but were tokenized or entirely left out of the profession's history; an important, but not yet sufficiently revealing recovery. For the most part, the women architects of the last two centuries have been able to say very little directly about the problem of sexuality in architecture (probably for political reasons). Indirectly, they may have a good deal to say and this represents a whole sphere of work that remains to be done. In general, architectural culture has kept the sexuality of space repressed, kept space sterilized as a technical economy under the control of the mythological design architect.

As is evident, then, I want to move my discussion away from functionalist accounts and histories of architectural practice into that very geometric/technical space that seems so inviolate. Recently I have been thinking, in particular, about the "line" and the way in which linear apparatuses seem to work in architecture. That architecture is a discipline that defines its boundaries and design capacities according to the workings of orthogonality (strictly defined, the right-angledness of the line) seems indisputable. Modes of representation in architecture–drawing and model-building, for example–are the literal examples of this orthogonal dedication, but even in epistemological and representational accounts of its own artistic practice, architecture relies on a kind of orthogonality, a linear movement from drawing to building, architect to drawing. In the most common of these accounts the building is understood as the inevitable, the right and proper, endpoint of the intention of the architect.

The technical realm of architecture is, of course, mathematical and geometrical. The geometric line, in particular–that cool, rigorous line drawn, usually, with a fine-pointed pen or pencil–spatially defines the shape and relationship between parts and whole. It organizes structure, it resolves in its representations the play of forces in nature (gravity, compression, tension), it inscribes the design, it upholds the structure of meaning and ontology in the profession, defines the epistemological character of architecture as compositional, and exhibits the skill of the architect. You may object to the use of the word "it"–as if no one were wielding the

instrument of geometry–and to be sure, geometry cannot be considered separately from the geometer. But in a way that we can all recognize, geometry seems to subsist as a system beyond each of its individual executions. When architecture goes through a stylistic or philosophical change, the polemics launched against the transgressors rarely touch overtly on the line–the linear apparatus itself seems to slip away untouched. And yet, if we were to look closely at Le Corbusier, Piranesi, Alberti, Mies van der Rohe–look at their buildings and their drawings and their writings–it would be hard to say that the architectural use of the line has, in fact, remained the same over time. The more I look at the line in architectural theory and practice, the more it seems that just at the moment the line begins to "sterilize the technical and scientific economy it most favors,"[8] it also begins to fertilize itself as an "improper" architectural figure, a space, a genealogical entity, a wall, an anatomy–something fleshy or animal.[9]

In other words, at the moment that the geometric line achieves its greatest propriety–in the architectural drawing–it reveals another part of its ethos. It reveals the wall, the path, the joint or fissure, the materiality that is its substance and denotative content. When Le Corbusier, for example–whose heated polemic in *The City of Tomorrow* is for the power of the right angle and the straight line–aligns the waywardness of cities in the past with the "pack-donkey's way," he stumbles into a too fertile linearity.[10] The donkey's path, which is a double line inscribed on the ground by the legs of the animal (and the legs of human beings), is indistinguishable (its curvilinearity notwithstanding) from the double line of the wall in the architectural plan. One might say (thinking about the etymological connection of *locus*/place to locking up[11]) that

. . . . . . . . . . . . .

**8**   Jacques Derrida, "Of Grammatology as a Positive Science," in *Of Grammatology,* trans. Gayatri Chakravorty Spivak (Baltimore: Johns Hopkins University Press, 1976), p. 86.

**9**   See Catherine Ingraham, "Lines and Linearity: Problems in Architectural Theory," in *Drawing/Building/Text,* ed. Andrea Kahn, (New York: Princeton Architectural Press, 1991).

**10**   See Catherine Ingraham, "The Burdens of Linearity," in *Strategies of Architectural Thinking,* ed. John Whiteman et al. (Cambridge, Mass.: MIT Press, 1991).

**11**   I am indebted to Peter White for pointing out this connection to me.

locked inside the line is the space of the wall and locked inside the wall is the animal, not the wild animal of sexual fantasy but the domestic animal of sexual reproduction and labor. And, returning to Stendhal, the animal, like the woman, can only be named as an originary mark of a vitality that shares domestic space without a stake in the property.

Generally, if one were asked to describe the space of architecture, one would point to voids created by the walls of a building, not the walls themselves. The spatial experience always issues from the visible "center" of this architectural space. In fact, I believe that the spatial force of architecture has little to do with this "center" since, in most ways, this center is only the uncontrollable result of what is happening elsewhere, in the walls that surround and outline this space, in the treatment of this wall as form, surface, ornament—as material and geometric entity. As I have begun to suggest, I believe it is in the space of the line, the wall, that the architectural drama between sexuality and spatiality begins to get played out. We know, from a number of sources (Louis Sullivan, Louis Kahn, Alberti among them) that the wall is a primary anatomy, a fundamental condition of architectural spatial sensibilities. This wall, which always dreams of itself as the sexless geometric line, is where the differences of sexuality begin to be homologized as material differences, albeit in complex ways. One might generally point to the extremely interesting arguments in architecture about form and ornament, presence and absence, structure and surface, inside and outside, intensification and passivity, in order to see how such differences manifest themselves. Most of these arguments (especially about ornament and structure) must contend with the problem of the material in its most blunt form. Indeed, even as architecture is refusing a specific sexuality in space, it is nurturing an entire material vocabulary of the sensual in its practices. Here the mythology of "touch," for example, might come into play, as well as the very well-developed discourse of materials (steel, stone, glass, wood, brick, cloth, brass, aluminum, slate, lead, and so on). This vocabulary is sensual without being explicitly sexual but, ironically, it is here that the geometric line first clarifies itself as not only not being in opposition to this order of the sensual but, in fact, extending this sensuality to the sphere of the sexual by giving a vital structure—a body—to this sur-

face erotica. (And, it turns out, this surface erotica tells us a good deal about the aspirations of that body.) The cool geometric line in architecture, in fact, harbors a hot materiality.

If architecture situates, and then represses, sexuality in the line and wall–deflecting the question of space from its main sexual precinct–then how can architectural design and/or analysis unveil this relationship? I don't have a theory of design to offer; indeed, theories of design are not really the point here. In Stendhal, this relationship wrote itself out in his drawings through a confusion of the initial letter of the proper name with the initial letter of the mathematical equation. In other places, this relationship may write itself through other means. I, like others, am intrigued by the possibility of a revealed and revealing domesticity. Jennifer Bloomer and I have had conversations about this–and in these conversations we have begun thinking about the different "registers" of the household. Emanating from the wall–and acting within the wall–are a series of conduits or outlets that govern a series of actions: appliances, opening and closing of doors, heating and cooling, and so forth. Crudely, one could say that at each point of registration, a different kind of spatial configuration is produced both in the "rooms" of the house and within the sexual politic of the house–the register of the toilet seat, for example, or the opening of a door or a cupboard. While the issue of registration seems to have a certain potential for a critique of the sexuality of the house, Roz Chast, who I would call the cartoonist of "domesticity," has, I believe, taken this issue of registration a necessary step further. She draws, in one cartoon, what she calls the "natural phenomena" of Apartment 15-E (figure 5). Hanging plants are "hanging gardens," refrigerator magnets are "magnetic fields," a man sitting in a chair reading the paper with his legs extended onto an ottoman is "a natural bridge." Here the spatial registration is not between the two façades of a door or the two elevations of a toilet seat, but between two scales of inquiry–the "domestic" and the "natural." The temporary, always changing, registration of connection and difference in domestic space is homologized to other orders of difference in "nature" (this is a structural and morphological analogy above all). What is especially interesting in these cartoons is how the frames of the cartoon themselves reorder and wall off certain domestic incidents as "phenomena"–as events.

**5    Roz Chast**
*Natural Phenomena of 15-E*, 1989.

The free-standing refrigerator, the place of the cat, the juxtaposition of two speakers, the space between the chair and the ottoman, are all hermetically sealed off from one another as if they were separate "rooms" all to themselves. Like Stendhal's drawings, the walling off of these events presents them as spaces operating under a more local law than that of the proper typography/typology of the house.

One might, in keeping with my comments on animals, suggest that there are a million houses housed by the walls themselves. At one point, I became quite fascinated–like the women in the William Gass story, "The Order of Insects"–with the way in which the Palmetto bugs in Florida houses flatten themselves into invisible rooms of the wall: the moulding, the heating duct. Or, in a gesture whose architecturality is perhaps suspect, one might turn the walls of the house into the house–turn the house (or office, or museum) literally inside out as Jana Sterbak has done so shockingly with the *Flesh Dress* (figure 6). The New Museum

**6   Jana Sterbak**
*Vanitas–Flesh Dress for an Albino Anorectic,"* 1987–88.
Flank steak on wire mesh, dimensions vary daily.

could not exhibit this dress, as the curator remarked, because in New York one never "knows what is going to crawl out of the wall."

The issues of domesticity, architectural registers, the sexuality of space, are unresolved here. Stendhal's final comment on the matter of mathematics turns out to have been the beginning of my troubles–so it is perhaps appropriate to cite it here as an ending to this paper. The climax of Stendhal's rendezvous with mathematics centers on the problem of parallel lines meeting or not meeting in infinity. Do parallel lines rendezvous in infinity or not? His teachers contradict themselves, the textbooks contradict themselves. "I nearly gave it all up," Stendhal writes. "A confessor who was skilful and a good Jesuit . . . could have converted me at that moment by [saying]: 'You see that everything is fallacious, or rather that there is nothing false and nothing true, everything is a matter of convention. Adopt the convention which will get you the best reception in society . . . we'll find some means to send you

A: Moment of birth.—B: Roads taken at 7 years old, often unconsciously. It is supremely absurd to try, at 50, to leave road R or road P for road L. Frederick II never got himself read, and since the age of 20 he's been dreaming of road L. [*Road to public esteem.—Road taken by good Prefects and State Councillors: MM. Daru, Roederer, Français, Beugnot.—Road to money: Rotschild.—Road to the art of getting oneself read: Tasso, J.-J. Rousseau, Mozart.—Road to Madness.*]

7

to Paris and introduce you to influential ladies." "If this had been said enthusiastically," he writes, "I should have become a scoundrel . . . and extremely rich."[12] As it was, however, Stendhal's main problem was neither parallel lines nor convention but converging lines and the "Road to the art of getting oneself read" or, perhaps, the "Road to Madness."

. . . . . . . . . . . .
12  Stendahl, *The Life of Henry Brulard,* p. 262.

1   **Philipp Hackert**
*Temple of Hercules at Agrigento*, 1777.

# Architecture and Phallocentrism in Richard Payne Knight's Theory

## Alessandra Ponte

MY INTENTION in presenting this paper is to trace the development in the eighteenth century (an age that witnessed the foundation of modern art history and aesthetics) of two opposing interpretations of the origins of architecture. [1] The first, which we may call Vitruvian, is very well known and I need only recall here that it is based on the theory of the "double imitation," that is, the imitation of both the primitive hut and the "well-built" human male figure. The second, which until recently has received very little attention from art historians, opposes the idea of the mimetic origin of architecture, focusing instead on the idea of its symbolic origin. [2] Through a comparative study of the religion and art of the ancients (Egyptians, Greeks, Romans), the advocates of the second thesis discovered at the origins of these different cultures a common religion founded on the worship of a generative power: a universal god of creation symbolized by the male organ of reproduction, the union of the male and female sexual organs, or (eventually) other emblems of fertility.

Many antiquarians and historians have contributed to the elaboration and dissemination of the symbolic interpretation of the origin of architecture, but here I will focus on one: Richard Payne Knight. An Englishman and a dilettante, Richard Payne Knight (1751–1824) today is best known for the design of his house, Downton Castle (Herefordshire), a milestone in the history of British picturesque architecture; for his didactic poem on landscape gardening, "The Landscape" (1794); and for many other publications, some of which became best sellers during his lifetime. He also published a book on the worship of Priapus (1786, distributed in 1787). [3]

I shall begin by analyzing one of his first writings, a record of
. . . . . . . . . . . .

1   This paper is the result of research, still in progress, begun during the writing of my dissertation, "Il viaggio alle origini: Il diario siciliano di Richard Payne Knight e il neoclassicismo pittoresco in Inghilterra," Istituto Universitario di Architettura di Venezia, 1987.
2   On the problem of the symbolic in eighteenth-century aesthetics, see T. Todorov, *Theories of the Symbol* (Ithaca, N.Y.: Cornell University Press, 1984).
3   For a recent appraisal of Richard Payne Knight's work, see *The Arrogant Connoisseur: Richard Payne Knight, 1751–1824,* exhibition catalogue edited by M. Clarke and N. Penny (Oxford: Manchester University Press/The Alden Press, 1982).

his journey to Sicily, which Knight undertook in 1777 accompanied by two painters: a professional, Philipp Hackert, and a dilettante, Charles Gore (figure 1). While Hackert and Gore had the task of recording views of the classical sites they visited, Knight was busy writing a learned report on the precious remains of the Greek colonies. Knight's Sicilian journal has a curious history. Although most likely Knight intended the journal for publication, it was not in fact published by the writer himself, but by J. W. Goethe (in an abridged German translation) as part of the biography of Hackert.[4] The manuscript remained in the Goethe archive in Weimar and was considered lost until a few years ago when Claudia Stumpf exhumed and published the completed journal under the title *Richard Payne Knight Expedition into Sicily* (1986).[5] Enthusiastic about the "discovery," Stumpf seems nevertheless disappointed by the document: "Knight's diary," she writes in the introduction, "may be an entertaining piece of eighteenth-century literature, but it is not a masterpiece by any means."[6] She fails to recognize, however, that in the last pages of the journal–the very pages suppressed by Goethe–Knight gives

. . . . . . . . . . . .

**4**  J. W. von Goethe, *Philipp Hackert: Biographische Skizze, meist nach dessen eigenen Aufsätzen entworfen, von Goethe* (Tübingen, 1811), reprinted in *Goethe Berliner Ausgabe* (Berlin: Aufbau-Verlag, 1985), vol. 19, pp. 521–721.

**5**  For a "history" of Knight's journal, see Ponte, "Il viaggio alle origini," chapter 1. The journal is mentioned as lost in: C. Hussey, *The Picturesque: Studies in a Point of View* (1927), 3d ed. (London: F. Cass & Co., 1983), p. 124; N. Pevsner, "Richard Payne Knight," *Art Bulletin* 31 (December 1949): 293 (as an appendix to the article, Pevsner published an English translation of Goethe's German edition of the journal, pp. 311–320); F. J. Messmann, *Richard Payne Knight: The Twilight of Virtuosity* (Paris: Mouton, 1974), chapter 1. The German translation is also quoted in: D. Watkin, *The English Vision: The Picturesque in Landscape and Garden Design* (London: John Murray, 1982); C. F. Bell and T. Girtin, "The Drawings and Sketches of John Robert Cozens," *Walpole Society* 23 (1934–35): 11, note 3; G. Massara, "L'immagine letteraria di Paestum," in *La fortuna di Paestum e la memoria moderna del dorico, 1750–1830,* exhibition catalogue (Florence: Centro Di, 1986). The original document is described or mentioned in: R. Michea, *Le "Voyage en Italie" de Goethe* (Paris: Aubier, 1945), p. 353; H. Tuzet, *La Sicile au XVIIIe siècle par les voyageurs étrangers* (Strasbourg: P. H. Heitz, 1955); P. D. Frazer, "Charles Gore and the Willem Van de Veldes," *Master Drawings* 15 (1977): 375–389.

**6**  C. Stumpf, ed., *Richard Payne Knight Expedition into Sicily* (London: British Museum Publications, 1986), p. 8.

us a key to understanding his subsequent studies and the reasons for his journey to the "origins."[7]

Reading the report, laced with the standard erudition of the time, we may discern, in fact, a framework within which Knight tries to explain the greatness of the Greek arts. Knight does not appreciate the age of tyranny, in which the Greek colonies lost that splendid vitality which had marked their beginning; corrupted by luxury and weakened by vice, the Greeks did not know how to defend their magnificent and glorious cities against attacks by uncultured barbarians. He laments that the Greek "genius," which had "always aimed at the sublime," very rarely had the time to manifest itself in its entirety because of rivalries among the various states into which the nation was divided. On the other hand, he recognizes that, thanks to the freedom which the Greeks enjoyed, the arts were able to achieve such excellence. While admiring the remains at Selinunte, Knight observes:

> . . . the foundations are immensely deep, & the whole built with the greatness & stability that surpass even the noblest works of the Roman Emperors. So much the more wonderful as they were the production of the Republic, that existed but a short time, & which was never much more than a trading Company. While one views them, one cannot but reflect how inestimable is the blessing of Liberty that enables so small a State as Selinus, whose dominions extended but a few miles, to perform what the mighty Lords of the Earth have scarcely equalled.[8]

Freedom is therefore the first requisite of achieving greatness. What are the others? We are able to catch glimpses of Knight's thoughts on this throughout the journal, for instance, in his harsh attacks on the Spanish monarchy, his vicious criticism of Catholi-

. . . . . . . . . . . . .

7   On the "quest for origins" in the eighteenth century, I recall only a few among many publications: J. Starobinski, "Le mythe au XVIIIe siècle," *Critique* 33 (1977); J. Baltrusaitis, *La quête d'Isis: Essai sur la légende d'un mythe* (Paris, 1967, 1985); J. Baltrusaitis, *Aberration: Jardin et pays d'illusion* (Paris, 1957 and 1985); *La fortuna di Paestum e la memoria moderna del dorico,* op. cit.; *Primitivisme et mythes des origines dans la Frances des Lumières, 1680–1820,* ed. C. Grell and C. Michel (Paris: Presses de l'Université de Paris Sorbonne, 1989).

8   *Richard Payne Knight Expedition into Sicily,* pp. 41–42.

2   **Comte de Borch**
Balustrade of the Palace of the Prince of Palagonia.

cism and superstition, his reflections on the degeneration of the
population and the death of trade, and so forth. But, as I men-
tioned before, we must reread the last pages, those which Goethe
omitted from his translation, in order to understand to what
extent these observations, apparently marginal, become the cen-
tral themes, the nucleus of Knight's thesis on art and on the pro-
gress of civilization.

When Knight visited the fatherland of the Greeks, to admire
the ruins of the culture, he saw alongside them the products of the
modern era: an uneducated and impoverished populace, corrupt
and superstitious, that admired the monstrous, the whimsical, the
conspicuous in the arts. All of modern Sicily was nothing more
than an immense Villa Bagaria, the so-called Villa of the Monsters
(figure 2). Built on the outskirts of Palermo during the second half
of the eighteenth century by the Prince of Palagonia, an eccentric
member of the Palermitan aristocracy, the villa was visited by
many travelers and often described with expressions of amaze-
ment and alarmed wonder.[9] For Knight and other visitors, the

. . . . . . . . . . . .
9   On Villa Bagaria and its eighteenth-century visitors, see Tuzet, *La
Sicile au XVIIIe siècle*.

degenerate taste of the Prince of Palagonia did not represent an isolated instance of madness, but rather reflected the insanity of the entire populace.

Knight notes the evils of Sicily and proposes some remedies: good government, properly administered justice, the introduction of scientific exploration, free commerce, a just spirit of competition equal to that which animated the Greek colonies, a proper idea of morality. He criticizes the conventional association between climate and the character and taste of Sicilians which identifies them with indolence, fear of change, and love of the artificial: "But the climate of Sicily was the same anciently as at present, tho' the national Character is totally changed. The Sicilian Greeks were remarkable above all others for the elegance & refinement of their pleasures, & all the monuments of their taste, that are come down to us are distinguished by an excess of purity & simplicity, & if they have any fault it is too great a neglect of minute ornaments."[10] One of the probable causes of the degeneration is, in his opinion, love for the new: "... human Affairs are in a perpetual State of fluctuation. They rise gradually to the utmost perfection that they are capable of, & then by endeavoring to surpass it, run into affectation & extravagance ... The Space of perfection is very narrow between negligence & affectation, & we easily run into rudeness on one side, or excess of refinement on the other."[11] In other words, Knight follows Montesquieu, Winckelmann, and Gibbon inasmuch as he gives a cyclical interpretation of history, and within it, the history of art, in terms of a regular rise and fall, a revolutionary motion like that of the heavenly bodies.

The second cause of the decline of the arts can be traced to the difference between religions. "The elegant Mythology of the Greeks & Romans, whose Deities were moral and physical Virtues personified, afforded every possible advantage to art: Wisdom, Virtue, Majesty, Strength & Agility were all represented under the persons of different divinities."[12] Artists worked for the state and their production had to propitiate the gods; therefore, artists were educated and treated not as servants of the powerful but as their equals.

. . . . . . . . . . . . .

10   *Richard Payne Knight Expedition into Sicily,* p. 65.
11   Ibid.
12   Ibid.

. . . [artists] were deeply read in History, Poetry and Philosophy. Their Imaginations were thus elevated and corrected, and their Works were the product of long Study as well as accurate execution. When those noble Master-pieces were placed in the Temples the People at large had an opportunity of examining their beauties & their eyes became accustomed to elegant & simple forms. Hence good taste became general ... The same taste extended to every thing, & dress, Household-furniture, & even Kitchen Utensils were distinguished by purity and elegance of design. [13]

According to Knight, the bitter mythologies of the Christians killed everything. Beauty was condemned as impious and profane. The models of art were no longer the majestic and wise Greek divinities or their splendid heroes, but rather contemptibly humble and submissive saints. Instead of exalting nature, artists were obliged to diminish it, to cover human forms with heavy clothing, to portray anguished and sorrowful faces.

Knight adds a final cause to his list of reasons for the decline of the arts: the corruption of language.

. . . as words are the signs of Ideas, & the principal means by which we abstract and compound them, a want of precision in one produces a want of precision in another. Thus languages have a very considerable influence upon National Characters ... illiterate Barbarians totally destroyed the purity of the Latin tongue, which tyranny and oppression had long before impaired. This evil was soon after increased, when the rude & warlike Nations of the North overran the Empire & mixed their own barbarous Jargon with the noble & expressive Languages of the Ancients. A general confusion of terms ensued, & tho' the modern dialects, that have sprung from the ruins, are better than could have been expected, they never can arrive at the force, majesty & precision of the Greek & Latin. [14]

The diary ends with Knight's paradoxical statement that a return to the original purity of taste would require "... nothing less than another general Revolution in Europe ... and that does not seem likely to happen." [15] The year is 1777–the French Revolution is on the horizon.

. . . . . . . . . . . .
13  Ibid., p. 66.
14  Ibid.
15  Ibid.

Origin and revolution: the two terms are linked to the anxiety of beginning, or rebeginning, to the anxiety of regeneration. It is the anxiety of the century: one looks to the past–to origins–for a new beginning. Knight anticipates the thoughts of Goethe and Quatremère de Quincy: the former, during his trip to Italy, meditates continually on primitive vegetation, the mythic archetype from which the infinite variety of vegetable organisms have their origin; the latter, a French follower of Winckelmann, claims that the duty of the artist is to "rekindle the torch of Antiquity."[16]

Religion and language: the beauty and purity of language and of Greek mythology were obscured and corrupted by the barbarians. Knight will write treatises on these subjects: on the Greek alphabet and on the origin of the arts in relation to religion. The last of these treatises was clearly inspired by the work of Pierre-François Hugues, the so-called Baron d'Hancarville (1719–1805). Knight writes at the beginning of his dissertation on the worship of Priapus: "… it is to him [d'Hancarville] that we are indebted for the only reasonable method of explaining the emblematical works of the ancient artists."[17] D'Hancarville, antiquarian and adventurer of Lorraine origin, was the author of the text that accompanied one of the most beautiful publications of the eighteenth century, the *Collection of Etruscan, Greek and Roman Antiquities from the Cabinet of the Hon.ble Wm. Hamilton, His Britannick Majesty's Envoy Extraordinary at the Court of Naples* (four volumes edited between 1767 and 1776); of two pseudo-erudite (but actually pornographic) illustrated volumes on the vices of the ancient Romans, the *Monuments de la vie privée des douze Césars* and the *Monuments du culte secret des dames romaines* (figures 3, 4); and of a long dissertation (published thanks to the financial support of Knight and his friend Charles Townley, the British dilettante and collector, a portrait of whom may be seen in a famous painting by Zoffany[18]) on the ori-

. . . . . . . . . . . . .

**16**   See J. Starobinski, *1789: Les emblèmes de la raison* (Paris, 1979).

**17**   Richard Payne Knight, *A Discourse on the Worship of Priapus and its Connection with the Mystic Theology of the Ancients,* in *Two Essays on the Worship of Priapus* (London: privately printed, 1865; 1st ed., 1786, distributed in 1787), p. 15.

**18**   On d'Hancarville's relations with Sir William Hamilton, Richard Payne Knight, and Charles Townley, see: B. Fothergill, *Sir William Hamilton Envoy Extraordinary* (London: Faber & Faber, 1969); P. Funnell, "The Symbolical Language of Antiquity," in *The Arrogant Connoisseur;* B. F. Cook, *The Townley Marbles* (London: British Museum Publications, 1985).

3   **Baron d'Hancarville (Pierre-François Hugues)**
Caesar with an obscene object arranged like a crown of laurels.

4   **Baron d'Hancarville**
Augustus and Livia.

gins of the arts and their connection to religion, the *Recherches sur l'origine, l'esprit et les progrès des arts de la Grèce; sur leurs connections avec les arts et la religion des plus anciens peuples connus; sur les monuments antiques de l'Inde, de la Perse, du reste de l'Asie, de l'Europe et de l'Egypte.*[19] Appearing in 1785, the *Recherches* was to be the most famous of d'Hancarville's antiquarian efforts. Drawing from heterogeneous sources–linguistic texts, travelogues, fragments of ancient literature, engraved collections of "monuments"–he tried to demonstrate that everywhere it was possible to find the same image, that of a bull breaking an egg (figure 5). The bull was interpreted as the symbol of the generative power of the Creator. Thus, to his initial belief that the origin of all arts, in every culture, was a common primitive religion, he now added the conviction that this religion was one of sexuality. If the *Recherches* represents the culmination of d'Hancarville's work, it is in the text for the volumes of the *Collection of Etruscan, Greek and Roman Antiquities* that, starting from a quite conventional theory of imitation, we see the slow emergence of a rather confused thesis on the relation between art, religion, language, and symbol. It is here, also, that d'Hancarville began to accumulate figurative "proofs" to back up his hypothesis (figure 6).

D'Hancarville was not alone in subscribing to the notion of a primitive revelation. For instance, Rabat Saint-Etienne and before him Bailly, the astronomer and mayor of Paris during the Revolution, were enthusiastic supporters of the idea, and Antoine Court de Gébelin believed that ancient peoples had received intact the totality of knowledge and of art; this intuition, or original revelation, was then obscured by barbarians, by absolute power, by history. For Rabat Saint-Etienne, the Greek myths are a corrupt version of ancient allegorical writings, while for Court de Gébelin the origin of language and writing is necessarily related to the languages and monuments of antiquity, since for him all people speak the same language, the universal linguistic sign which differs only in appearance. Discourse is but a type of painting: it depends on nature and therefore cannot be arbitrary or conventional.[20]

. . . . . . . . . . . . .

**19** On d'Hancarville, see also: F. Haskell, "The Baron d'Hancarville: An Adventurer and Art Historian in Eighteenth-Century Europe," in *Past and Present in Art and Taste* (New Haven: Yale University Press, 1987), pp. 30–45.

**20** On these themes, see the citations in note 7.

**5    Baron d'Hancarville**
Bull breaking an egg.

**6    Baron d'Hancarville**
Vase.

D'Hancarville elaborates his thesis in a similar vein. He writes:

> To the extent that it is probable that men began to express themselves by means of gestures, it is certain that they began to write and represent by means of signs the things which writing illustrated later on through characters which it had created ... the articulate sounds, substituting gestures, formed the languages; the letters, used in place of signs, illustrated precisely such articulated sounds; they painted the word and they gave, if you will, a body to the discourse. Shape and color, used in place of the sign, which could only give an arbitrary and indistinct idea of the object which it was indicating, produced sculpture, painting, and the arts relating to both.[21]

Knight does not fully agree with d'Hancarville. Commenting on the multitude of representations symbolizing the same creative divinity, he says:

> Mr d'Hancarville attributes the origins of all these symbols to the ambiguity of words; the same term being employed in the *primitive* language to signify God and Bull, the Universe and the Goat, Life and Serpent. But words are only types and symbols of ideas, and therefore must be posterior to them, in the same manner as ideas are to their objects. The words of a primitive language, being imitative of the ideas from which they sprung, and of the objects they meant to express, as far as the imperfections of the organs of the speech will admit, there must necessarily be the same kind of analogy between them as between the ideas and objects themselves.[22]

Only in *secondary* languages, Knight insists, do words become "arbitrary signs," since in these kinds of languages they are collected from various sources and blended together "without having any natural connection."[23] As for the use of symbols, Knight states: "They [the artists] thus personified the epithets and titles applied to him [the Creator] in the hymns and litanies, and conveyed their ideas of him, by forms, only intelligible to the initiated, instead of sounds, which were intelligible to all."[24] The

. . . . . . . . . . . . .

21  P. F. Hugues, Baron d'Hancarville, *Collection of Etruscan, Greek and Roman Antiquities from the Cabinet of the Hon.ble Wm. Hamilton, His Britannick Majesty's Envoy Extraordinary at the Court of Naples,* 4 vols. (Naples, 1767–76), vol. 3, p. 7.
22  Knight, *A Discourse on the Worship of Priapus,* p. 23.
23  Ibid., p. 24.
24  Ibid., p. 16.

symbols of ancient worship "were intended to express abstract ideas by objects of sight, the contrivers of [these symbols] naturally selected those objects whose characteristic properties seemed to have the greatest analogy with the Divine attributes which they wished to represent."[25] From this assumption, Knight will proceed with his research on the art and religion of the ancients.

In 1781, from Naples, the British ambassador Sir William Hamilton writes a letter to Sir Joseph Banks (1743–1820), explorer, Cook's travel companion, president of the Royal Society between 1778 and 1820, and secretary of the Society of the Dilettanti. In the letter, Hamilton confirms to Banks–a longtime friend who shares his numerous interests–the recent discovery at Isernia of the survival of the cult of Priapus. Several months later, Hamilton sends a detailed report on this matter to the Society of the Dilettanti, explaining that the discovery offered new proof of the similarities between the pagan religion and the papist one, similarities, Hamilton points out, already brought to light by Dr. Conyers Middleton (1683–1750), a librarian at Cambridge University and author of a "celebrated" Letter from Rome (1729) as well as *A Free Inquiry into the Miraculous Powers which are supposed to have subsisted in the Christian Church* (1749). Even before the discovery at Isernia, Hamilton had observed among the lower classes of Campania the custom of wearing decorations with phallic symbols against bad luck. In the small town of Molise, cut off from the principle means of communication, a custom had been observed which was even more overtly connected to a cult of very ancient origin: at Isernia, during the course of an annual religious festival, wax phalluses of various sizes were offered to Saints Cosma and Damiano, to promote fertility and the healing of various types of sexual disorders. To substantiate his story, in 1784 Hamilton personally brought to London several of these offerings, delivering them to the British Museum. Hamilton's report to the Society of the Dilettanti was published several years later as a preface to the first published work by Knight, *A Discourse on the Worship of Priapus and its Connection with the Mystic Theology of the Ancients* (figure 7).[26] The dissertation would be distributed in 1787, in a limited edition, to members of the Society of the Dilettanti and other aristocratic and erudite individuals. The preceding year, in a letter to his friend Townley,

. . . . . . . . . . . . .

25  Ibid., p. 17.
26  On the history of the publication of the *Discourse on the Worship of Priapus,* see *The Arrogant Connoisseur.*

Fig.1.

7   **Richard Payne Knight**
Votive offerings of wax.

Knight confessed that, although initially determined to limit his analysis to one cult (that of Priapus), he had found himself presenting an entire summary of ancient religion, a complex and intricate system governed by a limited number of principles.

The treatise begins with a postulate common to eighteenth-century aesthetics, philosophy, and anthropology and on which are founded all the "primitivist" theses on the "natural" origins of art, language, and religion: "Men, considered collectively, are at all times the same animals, employing the same organs, and endowed with the same faculties: their passions, prejudices and conceptions, will of course be formed upon some internal principles, although directed to various ends, and modified in various ways, by the variety of external circumstances operating upon them."[27] In general, Knight continues, the domain of the passions and of prejudice is circumscribed and checked by the evidence of the senses and by the exercise of reason; the latter, however, is unable to control the visions of the imagination. Religion functions on the dark side of the human mind, pushing people toward fanaticism and intolerance. Therefore, everyone tries to impose his own dogma without evaluating the reasons and principles which govern other religions and without understanding that, in

. . . . . . . . . . . .

**27**  Knight, *Discourse on the Worship of Priapus,* p. 13.

the beginning, all creeds had one and the same meaning–they "differ in appearance only." The original meaning, in Knight's opinion, was hidden by mythologies and rituals: the former degenerated into the superstitions of those who did not go beyond appearance and did not interpret the meaning of the representations of symbolic personifications of the divinity; the latter became instruments of power of the priestly castes which reproduce, often without understanding them, the "celebrations" of ancestors, cloaking them in mystery in such a way as to increase the value of their role in the eyes of the uneducated.

For Knight, in the beginning each religion was "natural." From the observation of nature, men infer the existence of a single divinity, or better still, of a single principle creator who is able to manifest itself in both creative and destructive forms. The spirit is universal and manifests itself in every object of creation. For the ancients, the "ethereal spirit" spreads itself through the universe, "giving life and motion to the inhabitants of earth, water and air, by a participation of its own essence, each particle of which returned to its native source, at the dissolution of the body which it animated. Hence, not only men, but all animals and even vegetables, were supposed to be impregnated with some particles of the Divine Nature infused into them, from which their various qualities and dispositions, as well as their powers of propagation, were supposed to be derived."[28] Animals, plants, and parts of the human body which appeared to be dominated by one of the attributes of the god were therefore the *symbol* of such an attribute and not *actual* gods. Therefore, educated and rational people respected the sacred animals, while ignorant people, confusing the symbol for a god, worshiped them. Since these symbols were inspired by the observation of nature and had consequently a universally understandable character, they could easily be interpreted by anyone who was to regard nature with the same attention as that of the ancients.

Among Knight's several examples, we shall summarize the one that best illustrates his thesis on the symbolic nature of religious architecture. One should keep in mind that although he focuses on Greek culture, Knight aims to show that the intellectuals, poets, and artists who gave life to the most perfect of all civilizations were driven by the same principles that guided the people

. . . . . . . . . . . . .
**28**   Ibid., p. 30.

8  **Pierre Sonnerat**
*Lingam.*

9  **Richard Payne Knight**
Indian temple, showing the *Lingam.*

of other cultures. He therefore bases his learned and very detailed argument on a comparative study of symbols repeatedly found in coins, sculpture, architecture, and in historical and epic texts of all the modern and ancient cultures of which he is aware. Among his sources, in fact, we find the most heterogeneous studies and reports; for example, *A Description of the East and Some Other Countries* by Richard Pococke, *The History of Japan* by Engelbertus Kaempfer, the *Description de l'Arabie* by Carsten Niebuhr, the *Travels into Moscovy, Persia and Part of the East Indies* by Cornelius Le Bruyn, and *Le Voyage en Sibérie* by Jean Chappe d'Auteroche, among others. Beginning with the observations found in one of these travel reports, the *Voyage aux Indes Orientales, à la Nouvelle Guinée* (1782) by Pierre Sonnerat, Knight establishes a surprising series of comparisons which allow him to trace the origin of the Corinthian order and, more generally, the built form of temples in various civilizations.[29]

In Indian temples, Sonnerat maintained, the most sacred and secret recess was meant to preserve the procreative and creative attribute of the god, represented by the union of the female and the male sexual organs (figure 8). Such a symbol was called the *Lingam* by the indigenous population. Knight identifies the *Lingam* as the central sculpture of the "portable" Indian temples that had been recently acquired by the British Museum (figure 9). The four figures at the corners of the square base represent the different attributes of the divinity. The elephant, which personifies strength and wisdom but also destructive power, corresponds to Minerva in Western mythology. The Brahma, with his four heads, is Pan, master of the four elements. The "cow of abundance," feminine symbol of procreative and nutritive power, has several equivalents, among them the golden calf of the Jews. Finally, the female figure is the feminine counterpart of the destructive power and the wisdom of the elephant. Around the central symbol is a serpent, universally recognized as the symbol of life and eternity. Under its body blooms the lotus, or "Nelumbo of Linnaeus," which one finds also in the upper part of the *Lingam*, where it is fused with the female sexual organ.

. . . . . . . . . . . .

29  On travel, travelers, and religions, see: Baltrusaitis, *La quête d'Isis;* P. Mitter, *Much Malign'd Monsters* (New York: Oxford University Press, 1977); F. E. Manuel, *The XVIIIth Century Confronts the Gods* (Cambridge, Mass.: Harvard University Press, 1959); B. M. Stafford, *Voyage Into Substance: Art, Science, Nature, and the Illustrated Travel Account, 1760–1840* (Cambridge, Mass.: MIT Press, 1984).

Thanks to scientific information received from Banks, Knight was able to describe the peculiar reproductive process of the lotus:

> This plant grows in water, and, amongst its broad leaves, puts forth a flower, in the center of which is formed the seed-vessel, shaped like a bell or inverted cone, and punctuated on the top with little cavities or cells, in which seeds grow. The orifices of these cells being too small to let the seeds drop out when ripe, they shoot forth into new plants, in the places where they were formed; the bulb of the vessel serving as a matrices to nourish them, until they acquire such a degree of magnitude as to burst it open and release themselves; after which, like other aquatic weeds, they take root wherever the current deposits them. This plant therefore, being productive of itself, and vegetating from its own matrices, without being fostered in the earth, was naturally adopted as the symbol of the productive power of the waters, upon which the active spirit of the Creator operated in giving life and vegetation to matter.[30]

According to Knight, this line of reasoning had been followed in practically all cultures; he found evidence of it in the cultures of the Tartars, Japanese, Indians, and Egyptians. In support of his thesis, he cites, with regard to the first three, the works of Kaempfer, Chappe d'Auteroche, and Sonnerat; for Egyptian culture, he refers to the famous *Isiac Table*, with which the Italian antiquarian Pignoria had dealt at length. The figure of Isis represented there holds the stem of the lotus in one hand, crowned by the cone in which the seeds grow, and in the other hand an object in the shape of a "T" representing the male sexual organ, subsequently transformed into a cross by the Christians. This figure represents for Knight "the universal power, both active and passive, attributed to that goddess." The lotus can also be recognized in the shape of the Egyptian columns portrayed on the *Isiac Table*: the stem is thicker in order to insure the necessary stability. Moreover, by comparing the progressive development of Egyptian columns, one can discover the origin of the Corinthian order. Initially, the columns simply repeat the form of an inverted cone; subsequently, the cone is surrounded by leaves of other plants which change according to the different meaning that these supplementary symbols are meant to express (figures 10, 11, 12). Knight continues:

. . . . . . . . . . . .

30  Knight, *Discourse on the Worship of Priapus,* p. 50.

**10 Richard Payne Knight**
Egyptian figures and ornaments.

**11 Richard Payne Knight**
Egyptian figures and ornaments.

12 **Richard Payne Knight**
The lotus, with medals of Melita.

The Greeks decorated it [the capital] in the same manner, with the leaves of the acanthus, and other sorts of foliage; whilst various other symbols of their religion were introduced as ornaments on the entablature ... One of these, which occurs most frequently, is that which the architects call the honey-suckle, but which, as Sir Joseph Banks ... clearly shewed me, must be meant for the young shoots of this plant [the lotus], viewed horizontally, just when they have burst the seed-vessel, and are upon the point of falling out of it.[31]

Knight further points out that it was more difficult to interpret
. . . . . . . . . . . . .
**31** Ibid., p. 54.

correctly the symbolic meanings of the vegetal and animal ele-
ments appearing on Greek monuments because the Greeks liked
to mix different components in order to make a more articulated
statement.

Having thus traced the origin of the Corinthian order and of
vegetal patterns in the sacred architecture of ancient civilizations,
Knight resumes his examination of the small Indian temple. Its
shape indicates that it was once filled with water which cascaded
from above the *Lingam* (the symbolic meaning of such a flow of
water is obvious). The same kind of structure can also be found in
another small "portable" temple in Greece, devoted to "the cult of
Priapus or of the Lingam" (figure 13), as well as in many speci-
mens of Greek coins and in the so-called Temple of Serapis near
Pozzuoli (figure 14), which Knight ascribes to the cult of Bacchus.
The building was actually a Roman public market, built at the
time of the Flavi; like many other buildings of this type, it had a
square plan, surrounded by an arcade with shops opening alter-
natively on the interior and exterior. The *macellum* (meat market)
was entered from the side facing the sea; the opposite side opened
up into a niche surrounded by statues. At the center of the court-
yard stood a circular podium on which towered sixteen Corin-
thian columns. These columns held a trabeation and a dome.
Inside the dome was a fountain surrounded by statues.

As we have seen, Knight believed this building to be a temple,
and traced its origin to the sacred architecture of the Persians, who
worshiped the "ethereal fire" in round temples constructed only
with columns, without walls or ceilings. The ancient Greeks built
similar places of worship. Although recognizing the Roman con-
struction of the Temple of Serapis, Knight consistently attributes
to it a far more ancient origin, perhaps going back to the time of
the Celtic temples, as portrayed in the drawings by William
Stukeley, the English doctor and antiquarian who had conducted a
pioneer study of the architecture of the Druids (figure 15). Stone-
henge, the Temple of Serapis, the Persian sanctuaries, the portable
Egyptian and Greek temples: playing a game of fanciful compari-
son, Knight demonstrates the universality of the symbol and "nat-
ural religion." As he explains in a letter to Townley, in which he
requested that Townley send the drawings of "curious" sculptures
from the latter's collection, his dream was to analyze system-

**13 Richard Payne Knight**
Portable temple dedicated to Priapus or the *Lingam*.

**14 Richard Payne Knight**
Temple dedicated to Bacchus at Pozzuoli.

15  **Richard Payne Knight**
Celtic temple and Greek medals.

atically the monuments and artifacts of antiquity (especially antique coins and medals), comparing the results of his study with the data provided by the ancients. He would thus be able to decipher the "hieroglyphics" in which the Greeks encoded the belief system of their mystical cults.[32]

In 1785, after completing Downton Castle, Knight officially began his collection of antiques by acquiring the bronze head of a fighter, a valuable Etruscan work of the second or third century B.C., sent to him by Thomas Jenkins from Rome. In the following years, Knight collected mostly bronze artifacts, especially small ones–gems, cameos, medals, and coins. Knight was especially fascinated by coins as he believed that, since they had been commissioned by kings, governments, and state departments, they (more so than other works of art) were free from the whims and the idiosyncrasies of the artist, and therefore provided the purest testimony of the symbolism of the ancients.[33]

The publication of *A Discourse on the Worship of Priapus* was a social disaster. From that moment, the author was nicknamed "Priapus Knight" and his bold assertions used as ammunition in satirical attacks on his later writings (figure 16). The effect of d'Hancarville's *Recherches* was less explosive, probably because of the turgid and illegible character of his prose. However, his reputation and the publication of the two "pornographic" books mentioned above could hardly have recommended his works to the "serious" reader.

Nevertheless, I repeat, d'Hancarville and Knight's analyses are not unique, nor are they exceptional. During the same period, Sir William Jones (1746–1794), the most important British linguist of the eighteenth century, read to the Asiatic Society his famous lecture *On the Gods of Greece, Italy and India*. In this lecture, Jones established comparisons among the various mythologies, which today are more acceptable than those made by Knight or d'Hancarville. It is also during this period that the French theologian, revolutionary, lawyer, and scholar Charles-François Dupuis (1742–1809) began to elaborate his monumental work on the ori-

. . . . . . . . . . . . .

32  I would like to thank Gerard Vaugham for information on the correspondence between Knight and Charles Townley.

33  On Knight's collections, see N. Penny, "Collecting, Interpreting, and Imitating Ancient Art," in *The Arrogant Connoisseur,* pp. 65–81.

[ 22 ]

(Think not thy modefty fhall 'fcape us)*
The *God of Gardens* thou fhalt ftand,
To fright improvers from the land,┼
A huge and terrible *Priapus.*

* This alludes to the delicacy, or *mauvaife bonte*, as the *French* would call it, of a late celebrated charaĉter, which prevented his friends from ereĉting a ftatue to his honour in St. George's Fields.

┼ —— " Deus inde ego *furum*—
" Maxima formido."—                                            HORACE, Sat. 8. lib. 1.
Such being a principal part of the office affigned to the God of Gardens, the Author of THE LANDSCAPE will allow *fures* to be tranflated *improvers*; and, it is thought, he can have no objeĉtion to the propofed apotheofis.

**16   Attributed to J. Matthews**
Page from *A Sketch from the Landscape, a Didactic Poem Addressed to R. P. Knight Esq.,* 1794.

gin of religions. It was published in 1795 as *L'Origine de tous les cultes ou religion universelle.*[34] One could also cite the theses by Humbert de Superville,[35] or works by Knight's followers, for example, James Christie (1773–1831). The latter, an antiquarian and son of the founder of the famous auction house, published in 1814 *An Essay on the Earliest Species of Idolatry, the Worship of the Elements*, where he aims to show the existence of common elements in Western and Eastern religions on the basis of a presumed original fall of man from God's grace.[36] The more prosaic Humphry Repton, fashionable "professional" landscape gardener of the turn of the century, naively tried to find in nature the origin of the Greek, Gothic, and Indian styles. And one can even find "literal" interpretations of the sexual-symbolic thesis or, at least, speculate on the possible relation between such a hypothesis and the famous "phallic" project of Claude-Nicolas Ledoux, published as *Oikema: Fragments d'un monument grec* (figure 17), and the drawing (executed in Rome in 1779 and resumed in *Sketches,* 1793) by Sir John Soane for a mausoleum or "National Monument" (figure 18).

But there are more precise and interesting correspondences. In 1787, the very same year in which Knight's *Discourse* was released, Jean-Louis Viel de Saint-Maux published the last and complete edition of *Lettres sur l'architecture des Anciens et celle des Modernes dans lesquelles se trouve développé le génie symbolique qui préside aux Monuments de l'Antiquité.*[37] The *Lettres* illustrate a different symbolic interpretation of the sacred architecture of the ancients, in that they trace its origin to the universal cult of the earth's fertility. Viel de Saint-Maux affirms that Vitruvius narrated absurd fables, underestimating the genius of the Greeks and of other primitive peoples. At the beginning of the great civilizations, the farmers built temples in which simple stones marked the passing of time and seasons and the eternal recurrence of the natural cycles on which the harvests depended and which structured their life. Nat-

. . . . . . . . . . . .

**34** On Jones and Dupuis, see note 29.
**35** See B. M. Stafford, *Symbol and Myth: Humbert de Superville's Essay on Absolute Signs in Art* (London: Associated University Press, 1979).
**36** See Funnell, "The Symbolical Language of Antiquity."
**37** On Viel de Saint-Maux, see J. R. Mantion, "La solution symbolique. Les lettres sur l'architecture de Viel de Saint-Maux (1787)," *URBI* 9 (1984): xlvi–lviii; Anthony Vidler, "Symbolic Architecture: Viel de Saint-Maux and the Decipherment of Antiquity," in *The Writing of the Walls* (Princeton: Princeton Architectural Press, 1987), pp. 139–146.

17  **Claude-Nicolas Ledoux**
*Oikema: Fragments d'un monument grec.*

**18   Sir John Soane**
  "National Monument" or mausoleum.

ural symbols and easily decipherable hieroglyphics embellished these sanctuaries, transforming them into books of stone. Viel de Saint-Maux's sources (mainly travel diaries) almost coincide with Knight's. Equally essential to the elaboration of his thesis is the use of Sonnerat's description of the *Lingam*. Also similar is Viel de Saint-Maux's interpretation of the symbolism of the column (figures 19, 20). Viel writes: "Phalli, for ancient Peoples, were the representation or rather the symbol of male fecundity and fructification. Phalli which, by way of columns, supported Temples in Assyria, as well as in other countries."[38] Finally, Knight and Viel de Saint-Maux draw similar conclusions. Both, in fact, are forced to introduce a distinction between public and private architecture. But while Viel de Saint-Maux seems to deny to domestic buildings the status of art works, Knight attempts to define the distinctive characteristics of the two categories or types of construction.

For Viel, "The Ancients did not confuse, as we do, sacred Architecture with the art of building residences; the latter had no relationship with the Architecture of Temples and Monuments."[39] For Knight, who analyzes in particular the sources of English domestic architecture, "The system of regularity, of which the moderns have been so tenacious in the plans of their country houses, was taken from the sacred, and not from the domestic architecture of the ancients; from buildings, of which the forms were prescribed by the religion, to which they were consecrated; and which, as far as they were ornamental, were intended to adorn streets and squares, rather than parks and gardens."[40] With such an observation, Knight intends to justify the irregular planning of his country house, Downton Castle. A more involved discussion is devoted to explaining why the apparently medieval exterior

. . . . . . . . . . . .

**38** Jean-Louis Viel de Saint-Maux, *Lettres sur l'architecture des Anciens et celle des Modernes dans lesquelles se trouve développé le génie symbolique qui préside aux Monuments de l'Antiquité* (1st complete ed. 1787; reprint, Geneva: Minkoff, 1974), Letter VII, p. 57.

**39** Ibid., Letter II, p. 18, note 1.

**40** R. P. Knight, *An Analytical Inquiry into the Principles of Taste* (3d ed., London, 1806), pp. 167–168. For a recent interpretation of Knight's thesis on domestic architecture and the design of Downton Castle, see A. Ballantyne, "Downton Castle: Function and Meaning," *Architectural History* 32 (1989): 105–130.

19   Comte de Caylus
Plan and view of 11 alignments of 370 stones found standing at Karnak
on a length of 360 *troises*.

**20  R. Pococke**

Views of sepulchral monuments near Aradus. X: plan of an open
temple. T: view of a throne. C: the Island Aradus.

actually followed the principle of construction and adornment of the country houses of the ancients, not their sacred architecture. But a recapitulation of Knight's thoughts on this subject lies outside the scope of this paper. One can, however, summarize his thesis on domestic architecture by saying that, for him, modern country houses, like the ancient ones, should have been irregular, defensive, and picturesque.

Thus, in their attempts to delineate a genealogy of the origins of architecture, both Viel de Saint-Maux and Knight addressed a fundamental distinction between religious and domestic architecture. Both spoke of sacred, religious, symbolic architecture as if architecture were a body, an indivisible unity, not to be "entered." One cannot "visit" the religious buildings, nor can one "use" them. One can only "read" them. The columns, the capitals, the entablatures, and so forth, must be interpreted through a process of revelation of the mystery. Their structural character is considered secondary, almost as a casual side effect. Both of the writers actually insist on the irrelevance of occupiable space in the ancient shrines. While there are spaces that can be entered, it is not their occupation that participates in the experience of the shrine, but their reading, the reading of all the other elements. The plan is a symbol to be read, not a space to be inhabited.

Conversely, domestic architecture must be "functional" and inhabited. Livable or functional space disembowels the architectural body, transforming architecture in construction, establishing a weaker foundation for a different kind of architecture–the domestic. Moreover, in symbolic interpretations, the architectural body presents itself as a metonymical representation. Knight is conscious of this. "It was," he writes, "no uncommon practice, in these mystic monuments, to make a part of a group represent the whole." As we have seen, in most of the cases, such a "part" was the phallus, or at least a symbol of its generative powers.

Any interpretation of the "origin" of Architecture–either Vitruvian or symbolic–was intrinsically wedded to narration. For Viel de Saint-Maux and Knight, as for many of their contemporaries (e.g., Etienne-Louis Boullée, who thought the dwellings were "sterile subjects"), the "original sin" of Vitruvian interpretation was that it associated the beginning of the Art of Building with the primitive hut, which was in a way a primitive domestic

space, an *oikos,* the foundation for an *oikonomia* (in Greek, the laws of the household). At the base of the Vitruvian mimetic system, one would find economical principles. The doctrine of *imitatio naturae* would bring to the foundation an "economimesis," as Jacques Derrida has called it. Symbolic interpretations affirm instead that Art signifies without imitating, extracting the notion of "original architecture" from the primitivist and rationalist (debased and weak) model: the primitive original domestic house. Though both interpretations–Vitruvian and symbolic–are equally logocentric, the symbolic one uncovers the significance of the phallic symbol. For an interpretation of the beginning of the discipline of architecture, of the foundation of its body (and its body-ness), the symbolic interpretations represented an interesting shift from logocentrism to a precise phallocentrism.

# "In the absence of the parisienne. . . "

## Molly Nesbit

*Question:* Given that space and sexuality need to be thought in combination, where do we find the combination?

*Answer:* Paris.

*Question:* How in the combination are we to identify sexuality and space, by what figures, through what concepts?

*Answer:* There is, for starters, the *parisienne.*

*Question:* Can Paris be separated from the *parisienne*? What would she (for Paris is a woman) suffer from that loss of femininity? Would there be a woman left if the *parisienne* were to go? Would Paris revert to the antique character, to the man?

*Answer:* Let us turn to the documents, Atget's documents, where urban space is rendered pictorial. And to a preliminary formulation.

1 **Eugène Atget**
   *Corsets.*

THE PRELIMINARY FORMULATION. In 1911, after a beginning that we might go so far as to call a false start, Eugène Atget's project (one of many projects, by the way) to photograph the modern life and mores of Paris moved into a second phase. There it cut the umbilical cord to the bourgeoisie, to its modern, and to one of the bourgeoisie's favorite ideas, *viz.* that in Paris modernity was all that revolved around fashion, really the fashionable female body, or the *parisienne*.[1] The *parisienne* was far more than a type; she stood for the city's women of whatever class so long as they were beautiful and a little bit tart; finally she came to stand for the city itself. The city was forever confused with these women; the tourists were confused by them. One of Joyce's Dubliners, the gaudy Ignatius Gallagher, summed up the wonders of the city by marveling, "There's no woman like the Parisienne—for style, for go."[2] Yet Atget could see a Paris beyond sexuality. He allowed the image of the *parisienne* to flutter weirdly for a moment in three pictures taken of shops just off of the grand boulevard (figure 1), but only as a mannikin, as if to remind the viewer just how far from the clichés this project had come. No go. The *parisienne*'s body disappeared altogether from the project; the emptiness that had always characterized his documents deepened; they took on the color of grief, repression, loss, and then lack. (A lack, it should be added, of femininity.) This Paris was neither *vieux* nor particularly gay. Atget was isolating a third city, a city that wore neither its heart nor its mores on its sleeve, and perhaps because of this it seemed unsettled, contorted, plagued by a persistent, whistling *ostranenie.*

The process of separating space from sexuality was done, then, in the interest of isolating the third city, which potentially held an unfettered image of modernity. The process was not particularly quick nor was it smooth, in part because the image of the third city had to be discovered. In all, there were some five hundred photographs made between 1910 and 1915. Atget built from what can

· · · · · · · · · · · ·

1 For a sustained and elegant analysis of the *parisienne* and her significance for the image of modernity, see Leila Kinney, "Boulevard Culture and Modern Life Painting" (Ph.D. dissertation, Yale University, forthcoming); Andreas Huyssen, "Mass Culture as Woman," in his book *After the Great Divide: Modernism, Mass Culture, Postmodernism* (Bloomington: Indiana University Press, 1986), pp. 44–62.

2 James Joyce, *Dubliners* (1914; St. Albans: Panther, 1967), p. 70.

now be seen as his preliminary work on modernity, the interiors and the vehicles. Those first projects lay in effect like a plane inside his practice, inside his usual web of exchanges and regular labors. The next stage in his work on modernity took that web as a given; it never actually broke with it and sometimes participated in its design, but mainly it did not. As a first step, the *moeurs* project was expanded from sets into a large number series. Ever frugal, even with his own series, Atget did not give the series a new name but instead revised an existing series, the *Paris pittoresque,* the one which had held the *petits métiers* like the lampshade man and the *crèmière* and which had also held the scenes of crowds like the group watching the harpist and the puppets in the Luxembourg, a series which had lain inactive for almost a decade. The revision was drastic; with it came the focus on the third city and a different sense of the placement of the plane. The series twisted away from the old web of practice, rotating the plane like the dial on a padlock. At that point the web was twisted away from its usual relation to knowledge and stretched. The entire series strained to communicate the modernity of the third city. But before any com-munication could be made, Atget had to bring modernity into the document somehow; increasingly he did so by setting out absence, seeing modernity as vacant hollow space.

In the new phase of his project Atget began to define modern-ity by cutting into the signs of his document, as if to trim them down, and he extended the principle of cutting to his sample, which he was to slice more and more sharply. The eighteenth-century *tableau de Paris* was shortened; the nineteenth-century *physiologies* were a dimming precedent; a panorama was never con-sidered.[3] The emptiness that was now being hewn was almost progressive. The emptiness was the form that had to make the connection to knowledge, though the mechanics of the connection

. . . . . . . . . . . . .

3   On the tradition of *tableau de Paris,* the inventories of the population according to their occupations, see Karlheinz Stierle, "Baudelaire and the Tradition of the Tableau de Paris," *New Literary History* 11 (1980): 345–361. See also Walter Benjamin, *Charles Baudelaire: A Lyric Poet in the Era of High Capitalism,* trans. Harry Zohn (London: New Left Books, 1973); Louis Chevalier, *Classes laborieuses et classes dangereuses: à Paris pendant la première moitié du XIXe siècle* (Paris: Plon, 1958); T. J. Clark, *The Painting of Modern Life: Paris in the Art of Manet and His Followers* (New York: Knopf, 1984); Robert Herbert, *Impressionism: Art, Leisure, and Parisian Society* (New Haven: Yale University Press, 1988).

were never systematized and that problem would bother Atget for the remainder of the series. The technical links with which he was familiar could not be expected to control this space; there was no hypothetical panoptic structure at the bottom of this void. Instead a kind of chaos and a primordial air. But modernity was not simply a chaos; what was knowable went hand in hand with what was not, "man" walked arm in arm with the *impensé*. But if modernity was known through the *parisienne,* what happened to knowledge in her absence? Could another knowledge-figure be found? This is not a question to be answered quite yet. Let us say something else instead: the document was being moved back to its original condition of blankness, back to the time when it was prior to knowledge.

This blankness was not just substituted for the *parisienne*–no neat case of replacement or even of displacement here. It was the product of a series of acts of rejection. What kind of weight did Atget cast off when he dislodged the *parisienne,* what ballast? First and foremost the myth that saw modernity as the life led along the grand boulevard, the line of wide streets that stretched from the Madeleine to the Bastille (and afterwards often found itself driving through the Bois). The grand boulevard was famous for its attractions: the night life, the banking, the *grand magasins,* the offices of the press, the theater district, were all located along its axis. In 1908 Léon Descaves tried to explain its quality to the hypothetically ignorant British reader:

> In the eyes of the provincial and the foreigner, all Parisian life seems to center there–in its shop windows, the terraces of its cafés, and the doors of its theaters, amid the rush of vehicles and the glare of those illuminated signs which, in the evening and from a distance, appear like the celestial bill-posting foreseen by Villiers de l'Isle Adam in one of his *Contes Cruels.*

> And, after all, are not these crowded, dusty side-walks the spot where spring comes earliest, as if Paris communicated its excitement to the mounting sap and the bursting buds? Do not business activities, great reputations, journalism, gossip, all the sparks and flashes of the life of a great city, radiate from this focus? So be it. That little line of boulevards, arched in the middle and curving at the corners, forms, if you like, the lips of Paris–those facile, tireless lips, which

never weary if too much talking and of laughing at all things. And
the universal infatuation for this one feature of an immense, many-
sided city can no more be explained than can the kindred phenome-
non expressed in Sully Prudhomme's lines:
> "Toi qui fait les grandes amours,
> Petite ligne de la bouche!"[4]

The myth had developed out of the boulevard hype, the adverts
that spoke of the faerie of the department store and its wealth of
goods, the press that gossiped openly about the latest theater and
the indiscretions of the stars, the entertainments being offered to
the tourist, the citified pleasures of gas lights, electricity, and the
magnetism of a crowd. The *parisienne,* for lack of any other solid
symbolic structure, was brought forward as the figure for this
*entire* culture.[5] Her body became the trope; its beauty and lenience
spoke for mores in all spheres; it was the *humoristes'* favorite mate-
rial. Their fascination with her sexuality grew obsessive in the
decade just before the First World War.

> Albert Guillaume nous donne la Parisienne dernier "bâteau," à la
> mignonne frimousse émergeant d'un fouillis de dentelles; toujours
> flanquée de fils à papa aux "huit reflects" impeccables. Elle semble
> d'autant plus délicieuse qu'ils paraissent grotesques. Toujours riante,
> ouvrant toute grande une adorable bouchette tandis qu'ils n'osent
> même sourire, figés qu'ils sont en leur trop haut faux-col! Avec Fer-
> dinand Bac, c'est la mondaine ultra élégante qui fait tout ce qu'il faut
> afin qu'on la prenne pour une . . . dit-on encore horizontale? . . . et
> qui ne tarde pas d'ailleurs à le devenir. Le "flirt" est sa seule préoc-
> cupation et ce flirt, commencé dans un salon, finit en une garcon-
> nière. La Parisienne qui va nez au vent, les yeux "à la perdition de son
> âme" comme disent les vieilles bonnes femmes, bien en chair forte
> . . . en beaucoup de choses, cette Parisienne-là, c'est là votre ami Ger-
> bault; on se retourne lorsque'elle passe et l'on dit "Fichtre! . . . " Le
> Boulevard en possède le monopole, c'est sa marque de fabrique.[6]

. . . . . . . . . . . .

**4** Léon Descaves, "Of Open Spaces," in Académie Goncourt, *The Colour
of Paris* (London: Chatto & Windus, 1908), pp. 56–57.
**5** Gustave Kahn, *La femme dans la caricature française* (Paris: Mericant,
1907), p. 5.
**6** Lucien Puech, *L'album I - XVIII* (Paris: Tallardier, 1901–1902), preface.

Corporeal and ephemeral, the *parisienne* set the stage for many of the young Marcel Duchamp's cartoons. Others would move their characters through the scenes that form the main material of the *Paris pittoresque* series, like shopwindows and market stands (figures 2 and 3). All of them were translating *moeurs* into the bedroom farces of the standard social types, what the *humoristes* themselves called the *types éternels*.[7] Many of these *humoristes* were Atget's clients.

The abiding concerns of his illustrator clients appeared less and less in this series as it progressed, though the document for artists remained the basic formal unit. But the document paid less and less attention to the standard work of clearing a stage for the arrival of comic types; the absences carved into these documents were less and less dictated by the artists' needs. When he went and dislodged the *parisienne* and then ignored the boulevard, her favorite haunt, Atget was refusing business. So it would go. He abandoned his illustrators and their frivolous boulevard to the breach and continued on his course. Still, Atget could not completely avoid this mythology even as he rejected it. His new series was always suffering from its exclusion of boulevard and *parisienne;* to the native French viewer, a man like Descaves, for example, their absence would be remarkable and glaring; it left a vacuum, a subnormal pressure in the pictures as visible as a footprint. Not for nothing have these pictures been compared to scenes of a crime. The bourgeoisie was too powerful *not* to be felt, even here, in a series full of radical ambition. But it was felt as a cut. Atget was doing revolutionary dream-work, displacing the bourgeoisie and its obsessively genital *idées fixes* and leaving the whole lot to hang, outside his document, in their own thin air. In his series, sexuality would not sum up the mores of Paris. Mores would be expressed not through bodies but through the redeployment of city space in the photographic document.

But this is an assertion more than a historical argument. The

. . . . . . . . . . . . .

7   Louis Morin, *Le dessin humoristique* (Paris: Laurens, 1913), pp. 16, 26. See also "La gaieté de nos humoristes," in *Lectures pour tous* (1911), pp. 625–633; Camille Bellanger, *L'art du peintre, 3e partie* (Paris: Garnier Frères, 1911), p. 30; Emile Bayard, *L'illustration et les illustrateurs* (Paris: Delagrave, 1898), p. 18ff.; Hector MacClean, *Photography for Artists* (London, 1896), pp. 15–16.

2   **Cardona**
    "Insinuation," *Le Rire,* no. 362 (January 8, 1910).

3   **Fabiano**
    "Péchés par actions," *Le Rire,* no. 337 (July 17, 1909).

time has come to make something more of the formulation, to turn it toward the particular case.

Atget was himself no boulevardier. His was the city of small shops, vendors, ragpickers, cabarets, and circuses, a pair of boys selling roses at the edge of the city, a circus attraction in the morning light (figures 4 and 5). They plotted an axis through the modern that for Atget replaced all the others. Atget did not depend upon the clichés or the maps that for others said Paris. His Paris was more than a map; the hollowness here was not a topographical form; the tracks were not meant to coalesce, beating a path to a zeitgeist. His axis for the modern struck out in another direction. This axis, which filled in what for lack of a better term we shall continue to call the third city, fell into line as the exclusions became evident. The exclusions were many and useful for marking off the limits of the third city.

Atget's new series had little use for types, tropes, and myths, even though they had been, some of them, the substance of his old *Paris pittoresque*. The new series was interested to feature the conditions of lower-class modernity but a single figure for class did not enter to replace the *parisienne*. The new *Paris pittoresque* tried to take the life of the lower class in another way, starting from scratch, without types and without the support of any other dictionarylike structure. Atget did not work with the kind of countermythology of the laboring classes elaborated by Steinlen's pictures and Zola's novels. As a general rule Atget's new series took the modest PLACES like the kiosk, the circus, or the garbage dump. He was operating in certain neighborhoods more than others, favoring the area around the central market, Les Halles, the historic working-class neighborhood that moved along the spine of the Montagne Ste. Geneviève and the rue Mouffetard, the quays of the Seine and the Canal de l'Ourcq, and the *zone militaire,* a ring of ragged fortifications that lay just at the city limits, their military function somewhat of a formality ever since the Germans had scaled them in 1870. Nonetheless the place name did not replace the types: neither was assumed capable of defining *moeurs*. Atget's series had to find other ways to communicate.

No *parisiennes*. No characters. No plots. No Nadja. Only spaces off the boulevard, walled in, closed by the surfaces of a working-class city. The series presented emptiness so that it

**4   Eugène Atget**
*Marchand Fleurs,* 1912.

5 **Eugène Atget**
*Fête de Vaugirard, avenue de Breteuil, Cirque Manfreta—1913*
*(15e arr).*

would become a barricade to knowledge. Captions were minimal and not revealing. Emptiness was itself the figure of modernity, the figure for ignorance, a figure that did not reproduce mores but produced them. Such a statement does not follow from itself. The series was designed to be seen by the man in the library, the place where the social panorama was consulted and preserved. Remember Walter Benjamin's long days of work in the Bibliothèque Nationale. Atget's new series was designed for the print room of the Bibliothèque Nationale. In the files of the print room *moeurs* and *modes,* mores and fashion were classed as if they were the same thing.

The *parisienne* is implicit in the category of the archive. A figure given to the person in the library, the viewer Atget knew waited for this work. That viewer was almost always going to be a bourgeois. But instead of the lady, Atget gave the bourgeois the third city. Instead of the completeness, Atget gave the viewer ignorance. No go.

The mobilization of emptiness literally reproduced the local social relations: that is to say, the viewer's look was socially constructed by the kind of emptiness in the document. But in addition, the document enabled the city's space to intersect with the library space through the mind and body of the beholder. The mobilization of emptiness in the new series grew increasingly extreme. It was never an arbitrary emptiness. Consider the views of bridges and quays. The bridges and quays were photographed in units that overlapped and repeated; on the whole it is enough to say that they worked the distance between the Pont des Invalides and the Pont Sully, with a late interest in La Villette. The Seine, even in the center of Paris, was very much a working river. Atget concentrated on the evidence of work in the space. He even included the working painter, the kind that put the old bridge into a Vieux Paris-style picturesque view, and Atget's first bridge pictures showed such a painter, dwarfed always by the surrounds, for instance, a large dark tree that floated like a caption or a cloud (figure 6). The quays were not meant for the promenades of genteel folk: the river quays were not to be confused with the quay-streets that ran parallel to them; guidebooks explained that the quays below were beneath notice and that the quays above kept one at the appropriate spiritual distance: "Le quai est trop haut et la rivière

6  **Eugène Atget**
*Terre plein du Pont Neuf—1911 (1e arr).*

est trop loin. Entre elle et le passant aucune familiarité."[8] Down by the river was another world where barges purposefully glided in to unload and to load. On the Quai de la Tournelle Atget found a cart and a parking sign for the barges (figure 7). The Quai de la Tournelle was not unusual in this regard; all along the Seine goods came into town; each port had its specialties; at the Quai de la Tournelle they were sand, stones, plaster, chalk, wood, and sugars.[9] The document worked with these details, but not in a methodical way. At the Pont Marie, Atget spun the bridge across his photograph, anchoring it in the corners with the heads of three passersby peering over to watch at the upper left and at the lower right with the painted white buttress featuring the measuring stick by which the level of the Seine could be exactly known (figure 8)—important information, for the Seine had overflowed its banks during the winter of 1910 in a famous Paris flood. In the distance of that same view of the Pont Marie were *bateaux lavoirs* and *bains,* public washhouses and baths. A sample was being circumscribed in these pictures, all of them 1911 ones. By 1913, the project was slanted toward the hard labor on the quays. At the Port des Invalides Atget took the new, overdecorated Pont Alexandre III showered in light; below the workers stopped loading rock for a moment to pose (figure 9). They were the poses of laboring men at labor, the pause between loads that were going off to build a better Paris like the bridge shimmering above. Atget pointed to a moment in the process of building the city and indeed building the image of the city, a moment which was analogous to the moment at which the document made its contribution to the production process, a moment where the labor was ephemeral, not inscribed in the product as anything more than a fetish or a wage relation. Atget took his picture before labor was fully transformed, before the gaiety of Paris congealed into spectacle, a moment when the third city showed raw.

Among his last pictures was a floating bar at the Port des Champs-Elysées, one in a series of short boats plastered with signs for aperitifs, chocolate, and life insurance, down below the Pont Alexandre III on the other side of the river, down next to the docks

. . . . . . . . . . . . .

8   Gabriel Hanotaux, *La Seine et les quais* (Paris: Daragon, 1901), p. 21.
9   Gustave Pawlowski, *Les ports de Paris* (Paris: Berger-Levrault, 1910), p. 41.

7   **Eugène Atget**
    *Un coin du quai de la Tournelle—1911 (5e arr).*

8   **Eugène Atget**
    *Quai d'anjou, Pont Marie—1911 (4e arr).*

9 **Eugène Atget**
   *Port des Invalides—1913 (7e arr).*

10 **Eugène Atget**
   *Port des Champs-Elysées—1913 (8e arr).*

where the arm of the big crane could still be seen alongside a mountain (figure 10). These were the bars for the people who worked on the waterfront. Nothing more than the boats was shown however; separated off from the laborer now and the rituals of custom, they alone had to give *moeurs;* the things of this world were to speak in the absence of any other voice. Dubonnet, Byrrh, Bière du Lion. The brand names were not saying much; the works were as thick as the surfaces. The surfaces, like the silences, were simply the boundaries of the emptiness, but they had been given critical duty. They had circumscribed a nonbourgeois low modernity, what can now be identified, though nebulously, as the *populaire*. For Atget, the third city was a means to the *populaire*.

The *populaire* was extremely problematic as a part of modernity. Knowledge of it did not ever come easily; mostly it existed as a lunar *impensé*. What this meant for the document is better seen, because literally seen, in the view across the barges taken at the great dock of La Villette (figure 11). For Paris had some forty-two kilometers of waterway of the Seine and fourteen more of canals; all in all they handled thirteen million tons of goods in 1909. La Villette lay at the north on the canals, where they widened into a big basin, where the exchange of goods was monumental. One writer who saw it in 1910 tried to summarize them objectively:

> Le traffic concerne surtout les houilles du Nord, pierres de Valois, denrées coloniales du Havre, produits industriels des Ardennes, grains de Picardie, pour les arrivages; pour les expéditions, articles de Paris, produits manufacturés. Sur les quais achalandés on aperçoit de-ci de-là: "articles de menage, voitures d'enfants, machines à coudre, machines agricoles, verrerie, conservés, chiffons, papiers, bambous et rotins d'Extrême-Orient, fibres, feuilles de palmiers, cires, colle, pétroles, avoines, farines, sucres, eaux minérales, fruits des pays chauds, phosphates, saumons de métals, légumes, fruits secs, pâtes, liquers, miel, etc." Neuf hangars–insuffisants–ont été ét des baraquements. [10]

Oranges, wax, sewing machines, and fancy dress goods could fasten onto sailor romance and exotic fantasy and turn picturesque

. . . . . . . . . . . . .

10   Ibid, p. 59.

11  **Eugène Atget**
*Bassin de la Villette*, ca. 1914–1925.

12  **Eugène Atget**
*Belleville. Emplacement du massacres des Otages 85 rue Haxo (20e)*, 1901.

very easily. And Atget, of course, took a defensive tack over the top of a barge whose goods were either gone or still untouched. The top was the thickest of surfaces, with its ropes and poles and mysterious holds, only for the experienced sailor; in the distance, leaning on the rail of a second barge there were two sailors, no more than shadowy figures, who offered no help in crossing. Their distance was not the far distance, however; the farthest distance was a role given to Paris, reduced to a group of small, enigmatic buildings disappearing into the mist. Paris has retreated. Though it was Atget who had retired it from active service in the document, just as he had seen to it that the sailors stood at the far edge. The things he showed were primarily traces; the photograph alluded to knowledge that it would scarcely show. It took the visible tip, a detail or a surface, and found other ways to indicate what was not there, what had been relegated to the distance, when not altogether cut. That was the thrust of the emptiness in the third city. The document communicated the existence of a knowledge in the *populaire*, but only the existence. The *populaire* remained vaporous and enigmatic. The barge top did not, for example, portray a recognized battleground of class struggle, like the Mur des Fédérés in Père Lachaise (figure 12), the place where the Communards were executed en masse, a place with a commemorative plaque, a place shown by Atget as a brute and now bloodless wall on a cheerless winter day, an official Vieux Paris image for an official history. The barge tops would not be written into history so easily; they lay outside it and its procedures, holding in their breath of *savoir,* holding the *populaire* to the *impensé.* The *impensé* might possibly be postulated as a *savoir* or a low sublime, but in any case it was not a *savoir* with disciplines like history, science, and the arts, nor did it require documents. As a result it seemed formless. Perhaps it was. But it was part of a dialectic in the file. Where, one might ask, is *la mode*?

The historical argument brings with it pointed conclusions. Atget's demonstrations with the document's emptiness left ignorance of the working-class place of the subject-category, MODERN LIFE. The void of ignorance was, however, left by the *parisienne*. Even if Atget had tried, it would have been difficult to fill her void. She was the necessary figure for thinking the city—no alternative could exist without recourse to her and her class. And so the

third city exists as unfilled, but it is marked by a specifically female absence. This third city is not-female. Knowledge was denied. But SHE had to be denied in the process. And yet because of the very dialectic in the file, the denial of the *parisienne* could never be complete.

1   **Israhel van Meckenem,** *Amorous Couple,* c. 1480.
In the new space of sexuality, the wife literally holds all the keys.

# Untitled: The Housing of Gender

## Mark Wigley

*People are in general not candid over sexual matters. They do not show their sexuality freely, but to conceal it they wear a heavy overcoat woven of a tissue of lies, as though the weather were bad in the world of sexuality. Nor are they mistaken.*

Sigmund Freud[1]

. . . . . . . . . . . . .

1   Sigmund Freud, "Five Lectures on Psychoanalysis," in *The Standard Edition of the Complete Psychological Works of Sigmund Freud,* trans. James Strachey (London: Hogarth, 1959), vol. II, p. 41.

# I

WHAT IS IT to talk of sexuality and space here, in this space, or rather spaces, this room but also the space of architectural discourse and that of the university, to name but two? Sexuality is not so easily accommodated here. The subject is still without title in architecture, that is, it is still without a proper place.

Of course, this displacement of sexuality occurs within every department of the university, even, if not especially, those in which it appears to be addressed in the most rigorous terms. Through the intricate and oblique operations of each disciplinary apparatus, sexuality is privatized without being housed. Institutional practices transform it into some kind of object that appears to be controllable inasmuch as it can be hidden inside or excluded. This is more than simply the defense of a conservative institution in the face of the convoluted topology of desire that threatens to destabilize it. Rather, it is to do with the constructions of sexuality implicit in the constitution of those very institutional practices, constructions whose strength is produced in the moment of denial.

The exclusion of sexuality is itself sexual. The university is an elaborate system of representation, a mechanism that sustains a system of spaces, an architecture, by masking the particular constructions of sexuality that make those spaces possible. Thus the word "sexuality," when it is spoken of in the university, when it can be passed from one space to another, marks only that which does not threaten the architecture of the institution, the construction of those very spaces. Our concern today cannot simply be to make a place for sexuality here, to give it a title, but rather to pay attention to what would be excluded by such a title: the sexuality of place itself. The space of the university is made possible by masking the exclusion of particular sexualities that makes certain theoretical constructs exchangeable, whether overtly or covertly, within it. The exclusive architecture of these constructs, which are organized around that of gender, has to be interrogated.

To talk of "Sexuality and Space" here, within the academic space of architectural discourse, is therefore complicated. After all, this is the discourse that advertises itself as concerned primar-

ily with space. In a sense, this is the space of space. The question of sexuality must be as much about the space of the discourse as with what can be said within that space.

In these terms, my concern here is to trace some of the relationships between the role of gender in the discourse of space and the role of space in the discourse of gender. That is to say, with the interrelationships between how the question of gender is housed and the role of gender in housing.

The active production of gender distinctions can be found at every level of architectural discourse: in its rituals of legitimation, hiring practices, classification systems, lecture techniques, publicity images, canon formation, division of labor, bibliographies, design conventions, legal codes, salary structures, publishing practices, language, professional ethics, editing protocols, project credits, etc. In each site the complicity of the discourse with both the general cultural subordination of the "feminine" and the specific subordination of particular "women" can be identified, often explicitly but usually by way of covert social mechanisms that sustain bias at odds with overt formulations. Such readings would reproduce in architecture readings that have been made of other discourses. This work is necessary and overdue. But at the same time it is equally necessary to think about why it is overdue, why this discourse has been so resistant, its silence getting louder, such that the question of "Sexuality and Space" is being asked in this way, now, here. What specific forms of resistance to this inquiry does the discourse employ? And to what extent was it established as precisely such a resistance?

Since these particular forms of resistance mark the disciplinary role of architecture in our culture, the question becomes what exactly is being protected here, in this space, for whom? To simply reproduce the analyses of other discourses may be to preserve this secret. Architectural discourse is clearly defined more by what it will not say than what it says. But what it cannot say may bear a relationship to what can be said in those discourses. Architectural discourse plays a strategic role in guaranteeing assumptions that are necessary to the operation of other discourses. It is precisely these assumptions, whose protection defines its identity, that it addresses most obliquely, if at all. Their very need for protection, their vulnerability, prohibits their exposure. They are exemplified

in architectural discourse rather than examined. Indeed, the discourse routinely applies to itself the very concepts that it unwittingly guarantees. Its institutional limits are defined by its capacity to mask its complicity in the construction of the concepts it employs. Gender is such a concept, underpinned by a spatial logic that is masked in the moment of its application to architecture, as an extra-, or rather, pre-architectural given. The question of sexuality and space here is that of the structure of this mask.

To interrogate this institutional mask necessitates running the risk of returning to the all too familiar scene of the patriarchal construction of the place of woman as the house precisely at the moment in which the many dangers of such a return are being articulated. The introduction to a recent anthology on feminism and psychoanalysis, for example, describes how feminist theory domesticates itself inasmuch as it both assumes a familial relationship to other discourses, like psychoanalysis, and focuses within that theoretical couple on "private relations." In so doing it occupies a "stereotypically feminine space," "situating" itself "in the sexualized, emotionalized, personalized, privatized, erratic sphere of the home and bedchamber rather than in the structured, impersonal, public realm."[2] This domestic space is maintained by not engaging critically with "third terms" (like "theory, philosophy, history, language, and law") which despite being (in the Lacanian sense) constitutional in any binary relationship, are traditionally identified with a public sphere outside the private world of the theoretical couple. Such terms are said to have been increasingly problematized in contemporary work in order to avoid this habitual withdrawal into a "comfortable," "safe" space which "insulates" critical theory from the very political effectivity it seeks:

> In recent years, feminist psychoanalytic critiques have passed beyond these issues ... Emerging from the household, shifting from the illusion of privatized and public spheres, from the family to the acknowledgement of an open confrontation with the interlocutory terms of cultural mediation.[3]

. . . . . . . . . . . .

2   Richard Feldstein and Judith Roof, eds., *Feminism and Psychoanalysis* (Ithaca, N.Y.: Cornell University Press, 1989), p. 2.
3   Ibid., p. 3.

While such a move from domestic space to the "patriarchal grid within which it fits" seems necessary in order to resist the domestication of theory, certain questions about space remain unasked. The implied familial narrative of feminism growing up and leaving the secure private domain of the house for the public sphere exempts the house itself from analysis. While the new space of feminist theory is seen to be beyond the distinction between public and private, that distinction is restored inasmuch as that space is seen to be simply "beyond" that of the house. Consequently, the boundaries that define the house are at once left behind as an "illusion" and restored. Domestic space can only pose a danger inasmuch as the illusions that sustain it, like all enfranchised cultural images, are real. Indeed, the spatial rhetoric employed–"passed beyond," "emerging from," "situates," "fitting within," "closed," "open," "insulates"–restores the very space being critiqued. It reconstructs the house as the paradigm of the definition of space in the very gesture of leaving it behind. The house is literally left behind, intact, as if innocent of the violence it appears to frame. But the house is itself a third term. The specific mechanisms with which it constructs space need to be interrogated before its effects can be resisted.[4]

But even though the definition of space is ostensibly the subject of architectural discourse, it cannot simply be interrogated by that discourse. On the contrary, it is protected from analysis by that very discourse. Buildings, as such, are not simply available either to the critical theories that uncritically leave them behind nor to the discourse that claims them as its own. It is precisely in this uncanny inaccessibility that the house is produced as a cultural artifact. This sense that buildings precede theory is a theoretical effect maintained for specific ideological reasons. Likewise, and it is the relation between them that is the issue here, the sense of a building's detachment from sexual politics is produced by that very politics.

. . . . . . . . . . . . .

**4** Such a complication of the "home" can be seen in some current revisions of identity politics, but still the question is not yet architectural–*home,* not *house.* The house remains unrevised.

## II

Take, for example, a canonic text like Alberti's fifteenth-century treatise, *On the Art of Building in Ten Books,* which was crucial to architecture's promotion into the liberal arts and therefore eventually into the academy and, more recently, into the university and finally into this room. Its fifth book, when discussing the design of "private" houses, contains an overt reference to architecture's complicity in the exercise of patriarchal authority by defining a particular intersection between a spatial order and a system of surveillance which turns on the question of gender. Women are to be confined deep within a sequence of spaces at the greatest distance from the outside world while men are to be exposed to that outside. The house is literally understood as a mechanism for the domestication of (delicately minded and pathologically embodied) women:

> I recall reading in the historian Memilius Probo that it was the custom in Greece for women not to be admitted to table, except for meals with relatives, and the custom too for certain parts of the house, where the women resided, to be out of bounds to all but closest kin. And certainly, to my mind, any place reserved for women ought to be treated as though dedicated to religion and chastity; also I would have the young girls and maidens allocated comfortable apartments, to relieve their delicate minds from the tedium of confinement. The matron should be accommodated most effectively where she could monitor what everyone in the house was doing. But in each case we should abide by whatever may be the ancestral custom.
>
> The husband and wife must have separate bedrooms, not only to ensure that the husband be not disturbed by his wife, when she is about to give birth or is ill, but also to allow them, even in summer, an uninterrupted night's sleep, whenever they wish. Each room should have its own door, and in addition a common side door, to enable them to seek each other's company unnoticed. ... Off this should be the strong room; here the boys and young men should pass the night, the girls and maidens in the dressing room, and next to them the nurse. Guests should be accommodated in a section of the house adjoining the vestibule, where they are more accessible to visi-

tors and less of a disturbance for the rest of the family. The young men of over seventeen should be accommodated opposite the guests, or at least not far from them, to encourage them to form an acquaintance.[5]

This passage participates in the production of the artifact "woman" by high discourse and therefore has, at best, a complicated relationship to the historically, geographically, and class-specific regimes of social control and forms of resistance to them.[6] But within that discursive scene of production it plays a strategic role. It occupies Alberti's treatise in a symptomatic way. It is insulated from the main body of the text, framed three times by the first sentence. Firstly, it is presented as but a recollection, then it is of another writer who in turn is referring to ancestral custom. Responsibility for the argument is successively passed from Alberti to the ancestors. In a familiar circle, the exercise of patriarchal authority is authorized by the fathers. By being insulated in this way, the passage is located within some pre-architectural domain of social order. Alberti only reinserts himself ("And, certainly, to my mind …") in order to offer additional isolated spaces and levels of comfort to reinforce an unquestionable "custom." The house enforces a preexisting law. The law of the house precedes the house.

This pre-architectural law is spelled out in Alberti's earlier dialogue, *Della Famiglia,* in its third book entitled "Liber Tertius Familie: Economicus" (literally, the law [*nomos*] of the household [*oikos*]) which, other than discussing the siting of the family house, does not appear to address architecture:

. . . . . . . . . . . .

5   Leon Battista Alberti, *On the Art of Building in Ten Books,* trans. Joseph Rykwert, Neil Leach, and Robert Tavernor (Cambridge, Mass.: MIT Press, 1988), Book V, p. 149.
6   On the specific relationships between ideology and behavior in the Renaissance throughout the geographical space over which Alberti's writing exercised such influence, see Judith C. Brown, "A Woman's Place Was in the Home: Women's Work in Renaissance Tuscany," in *Rewriting the Renaissance: The Discourses on Sexual Difference in Early Modern Europe,* ed. Margaret Ferguson et al. (Chicago: University of Chicago Press, 1986), pp. 206–224.

> I agree, for you are, indeed, precisely of the opinion of the ancients. They used to say that men are by nature of a more elevated mind than women ... The character of men is stronger than that of women and can bear the attacks of enemies better, can stand strain longer, is more constant under stress. Therefore men have the freedom to travel with honor in foreign lands. Women, on the other hand, are almost all timid by nature, soft, slow, and therefore more useful when they sit still and watch over things. It is as though nature thus provided for our well-being, arranging for men to bring things home and for women to guard them. The woman, as she remains locked up at home, should watch over things by staying at her post, by diligent care and watchfulness. The man should guard the woman, the house, and his family and country, but not by sitting still.[7]

Here, in opposing male mobility in the exterior to female stasis in the interior, Alberti's text closely follows Xenophon's fifth-century treatise *Oeconomicus,* which at once naturalizes and spatializes gender: "The gods made provision from the first by shaping, as it seems to me the woman's nature for indoor and the man's for outdoor occupations."[8] Xenophon prohibits any confusion of this gender-space division, whether it be the man's occupation of the interior or the woman's occupation of the exterior.[9] Such a spatial reversal does not just go against their respective natures. The spaces literally produce the effect of gender, transforming the mental and physical character of those who occupy the wrong place: "compelled to sit indoors, the body becomes effeminate and mind loses its strength."[10] This claim is enthusiastically repeated by Alberti:

> It would hardly win us respect if our wife busied herself among the men in the marketplace, out in the public eye. It also seems some-

· · · · · · · · · · · ·

7   Leon Battista Alberti, *Della Famiglia,* trans. Renée Neu Watkins as *The Family in Renaissance Florence* (Columbia: University of South Carolina Press, 1969), Book III, p. 207.
8   Xenophon, *Oeconomicus,* trans. H. G. Dakyns as "The Economist," in *The Works of Xenophon* (London: Macmillan and Co., 1897), vol. 3, p. 229.
9   "Thus for a woman to bide tranquilly at home rather than roam abroad is no dishonor; but for a man to remain indoors, instead of devoting himself to outdoor pursuits is a thing discreditable." Ibid., p. 231.
10   Ibid., p. 213.

what demeaning to me to remain shut up in the house among women when I have manly things to do among men ... Those idle creatures who stay all day among the little females or who keep their minds occupied with little feminine trifles certainly lack a masculine and glorious spirit. They are contemptible in their apparent inclination to play the part of women rather than men. ... if he does not shun trifling occupations, clearly he does not mind being regarded as effeminate. ... I believe that a man who is the father of a family not only should do all that is proper to a man, but that he must abstain from such activities as properly pertain to women.[11]

Such a spatial confusion is explicitly understood as sexual and is identified with femininity. The threat of being in the wrong place is not just the feminization of the man, but the feminine per se. If the woman goes outside the house she becomes more dangerously feminine rather than more masculine. A woman's interest, let alone active role, in the outside calls into question her virtue.[12] The woman on the outside is implicitly sexually mobile. Her sexuality is no longer controlled by the house. In Greek thought women lack the internal self-control credited to men as the very mark of their masculinity. This self-control is no more than the maintenance of secure boundaries. These internal boundaries, or rather boundaries that define the interior of the person, the identity of the self, cannot be maintained by a woman because her fluid sexuality endlessly overflows and disrupts them. And more than this, she endlessly disrupts the boundaries of others, that is, men, disturbing their identity, if not calling it into question. In these terms, self-control for a woman, which is to say the production of her identity as a woman, can only be obedience to external law. Unable to control herself, she must be controlled by being

. . . . . . . . . . . . .

11   Alberti, *Della Famiglia,* Book III, p. 207.
12   "I often used to express my disapproval of bold and forward females who try too hard to know about things outside the home and about the concerns of their husband and of men in general ... wise men say a woman who spies too much on men may be suspected of having men too much on her mind, being perhaps secretly anxious whether others are learning about her own character when she appears too interested in them. Think for yourself whether either of these passions is becoming to a lady of unblemished honor." Ibid., Book III, p. 209.

bounded. Marriage, understood as the domestication of a wild animal, is instituted to effect this control. As the mechanism of, rather than simply the scene for, this control, the house is involved in the production of the gender division it appears to merely secure.

In these terms, the role of architecture is explicitly the control of sexuality, or, more precisely, women's sexuality, the chastity of the girl, the fidelity of the wife. Just as the woman is confined to the house, the girl is confined to her room. The relationship of the house to the public sphere is reproduced on its interior. In Alberti's account, the boys are positioned near the guests, the outsiders, to encourage contact and mobility while the girls are positioned at the other end of the house.

In Xenophon, the social institution of marriage is naturalized on the basis of the spatial division of gender. This division is written into the concept of marriage even as it is defined as a couple "under the same roof." The purpose of the institution is reproduction, which requires a shelter, a "roofed homestead."[13] Marriage is the reason for building a house. The house appears to make a space for the institution. But marriage is already spatial. It cannot be thought outside the house that is its condition of possibility before its space. The word *oikos* refers to the identity between the physical building and the family it houses. Equally, it refers to their hierarchical division. The word for the dweller of the house becomes "husband," such that the art of economy which orders the *oikos* is literally that of "husbandry." While the house protects the children from the elements, its primary role is to protect the father's genealogical claims by isolating women from other men. Reproduction is understood as reproduction of the father.[14] The law of the house is undoubtedly no more than the law of the father. The physical house is the possibility of the patriarchal order that appears to be applied to it.

. . . . . . . . . . . .

13  "Too much cold or too much sun, rain, and the wild blowing of a storm are harmful to children. Woman, therefore, did first find a roof under which to nourish and protect herself and her offspring. There she remained, busy in the shadow, nourishing and caring for her children. And since woman was busy guarding and taking care of the heir, she was not in a position to go out ..." Ibid., Book II, p. 111.

14  The house emerges from the first of the precepts that provide a "sound and firm foundation": "In the family, the number of men must not diminish but augment," Xenophon, *Oeconomicus,* p. 227; and Alberti prays for "many male children," *Della Famiglia,* Book III, p. 212.

In fact, it is the man that is immobile, fixed to the house—in the sense of both family and building. The woman is mobile. Her "natural" immobility in the interior is enforced in the face of her mobility between houses. The apparent mobility of the man is produced by the confinement of the woman, who is, as Ann Carson argues, at once necessary to the maintenance of the house and the greatest threat to it:

> From birth the male citizen has a fixed place in the *oikos* ("household") and *polis* ("city-state"), but the female moves. At marriage a wife is taken not just (and perhaps not at all) into her husband's heart but into his house. This transgression is necessary (to legitimate continuation of the *oikos*), dangerous (insofar as the *oikos* incorporates a serious and permanent crisis of contact), and creates the context for illicit varieties of female mobility, for example that of the adulteress out of her husband's house, with attendant damage to male property and reputation.[15]

The house can only operate as such if the woman's sexuality, which threatens to pollute it (pollution being, for the Greeks, no more than things out of place), is contained within and by it. The convoluted spatiality of a violation of the house necessary to its integrity as such is dealt with by the complex social rituals around thresholds, rooms, streets, veils, beds, hygiene, etc., that constitute the marriage ceremony. Only when these rituals domesticate the perceived threat to spatial integrity can the house literally provide the boundaries which control female sexuality. The house then assumes the role of the man's self-control. The virtuous woman becomes woman-plus-house or, rather, woman-as-housed, such that her virtue cannot be separated from the physical space.[16]

. . . . . . . . . . . .

15 Ann Carson, "Putting Her in Her Place: Woman, Dirt, and Desire," in *Before Sexuality: The Construction of Erotic Experience in the Ancient Greek World,* ed. David M. Halperin et al. (Princeton: Princeton University Press, 1990), p. 136. On the relationship between the questions of gender and architecture in Greek mythology, see Ann Bergren, "Architecture, Gender, Philosophy," in *Strategies of Architectural Thinking,* ed. John Whiteman et al. (Cambridge, Mass.: MIT Press, 1991).

16 The spatial order of the house is understood as the control of sensual "appetites": "managing one's own possessions, ruling and moderating the affections of the spirit, curbing and restraining the appetites of the body" (Alberti, *Della Famiglia,* Book III, p. 207), in the same way as the "bringing-up" of a girl: "For in control of her appetite, Socrates, she had

At the same time, that space is insufficient. Boundaries are only established by the intersection between a walled space and a system of surveillance which monitors all the openings in the walls. The spatial structure of the house is maintained by both the systems of locks, bars, bolts, and shutters that seal the openings and a controlling eye. In this way, the woman can be held to the thresholds of the house, the doors and windows. Likewise, the girl is confined to an inner room away from even the windows, guarded by a "watchful eye" (like that of the "matron," the women outside the economy of reproduction, that Alberti installs in a strategic position as a security device to "monitor what every-one in the house was doing") and is only brought formally to the window in order to attract a suitable husband to whose house she will then be ceremonially escorted. The word for raising a female child being literally that for "surveillance."

But this surveillance is not simply carried out by the eye, and the spaces it controls are not simply physical. The capacity of the house to resist the displacing effects of sexuality is embedded within a number of systems of control—mythological, juridical codes, forms of address, dress codes, writing styles, superstitions, manners, etc.—each of which takes the form of surveillance over a particular space, whether it be the dinner table, the threshold, the church, the fingertips, the bath, the face, the street. These apparently physical spaces requiring supplementary control in turn participate in a broader ideological field.

Xenophon's argument about the role of the physical space of the house, for example, is framed, and apparently subordinated, by a more general argument about the house. His text begins by defining "house" as a man's estate rather than a physical building and "economy" as the management of such a house, as distinct from its construction. The economist is explicitly defined in contrast to the architect-builder. The house is the collection of useful possessions, of which the building is but one, that need to be managed.

Nevertheless, the law of the father, which governs this broader

. . . . . . . . . . . .

been excellently trained, and this sort of training is, in my opinion, the most important to man and woman alike" (Xenophon, *Oeconomicus,* p. 227).

sense of house, is already architectural. It is itself understood as the intersection of a spatial system and a system of surveillance. When identifying the role of the father as the center of the family ("head" of the household established by controlling the "body" that is woman), Alberti employs the analogy of the spider whose house is a system of surveillance:

> You know the spider and how he constructs his web. All the threads spread out in rays, each of which , however long, has its source, its roots or birthplace, as we might say, at the center. From there each filament starts and moves outward. The most industrious creature himself then sits at that spot and has his residence there. He remains in that place once his work is spun and arranged, but keeps so alert and watchful that if there is a touch on the finest and most distant thread he feels it instantly, instantly appears, and instantly takes care of the situation. Let the father of a family do likewise. Let him arrange his affairs and place them so that all look up to him alone as head, so that all are directed by him and by him attached to secure foundations.[17]

The "residence," the physical house, is at the center of the network in the same way that the man is the center of the family. The man must "place" his affairs such that he both is, and is at, the center. But ironically, unlike the spider, he cannot simply occupy the center of his web, the interior of the physical house, without losing his masculinity. The woman literally stands in his place. But she does not simply look outside. While Alberti, citing Xenophon's recommendations on siting the house, specifies the need for it to have extensive views over its site, it does not command a view of the "outside," the public world beyond that site. And yet, it is not simply cut off from that world either. On the contrary, Alberti's whole argument turns on the claim that public life follows from, and depends upon, the domestic.[18] The virtuous public figure is one who simply tries to be a "good householder." The surveillance of the exterior depends upon the surveillance of the

. . . . . . . . . . . .
**17**  Alberti, *Della Famiglia,* Book III, p. 206.
**18**  "Do not abandon your private concerns to guide public affairs. I remind you of this; for if a man finds that he has less than he needs in his home, he will find still less outside; nor will the public power he has redeem his private necessity." Ibid., Book III, p. 179.

interior. The wife assumes this burden of internal surveillance as the "overseeing eye" monitoring the house, which is no more than a nested system of enclosed spaces, each with a lock, from its one locked front door down to the small locked chests at the foot of the beds, which contain the most valued possessions. As the "guardian of the laws" responsible for this elaborate system, she literally holds all the keys, guarding the house in the same way that her husband guards her (figure 1).

The "rule of the household" she enforces is no more than the law of place itself: "each thing in its place." Alberti closely follows Xenophon's account of "training" a girl-bride to be a wife by taking her around the house on a tour of inspection, identifying the "appropriate place" for each possession, starting with the rooms, and then the "classes" or "divisions" within them down to the subdivisions of the smallest chest.[19] Everything is "assigned to separate places" which are then given the husband's seal of approval: "he will write over each as it were, 'examined and approved.'"[20] The spaces are classified. But his classification is not simply added to the spatial system. On the contrary, it is seen to be already inscribed into it: "everything is orderly arranged, not in the first chance place, but in that to which it naturally belongs."[21] There is a "natural" relationship between the system of classification, the spaces, and that which is being classified. The wife learns her "natural" place by learning the place of things. She is "domesticated" by internalizing the very spatial order that confines her. Having been "trained" as an inspector of the house who can read its signs, the girl ironically becomes a woman by assuming some of the masculine virtues of a military commander—"a brave and masculine intelligence she has"[22]—and is given command over the interior spatial order.

. . . . . . . . . . . .

**19**  On the brutality of Alberti's "training" method (which dehumanizes the wife through a process of humiliation and "turns on the inculcation of pervasive feelings of guilt … forgiven when she behaves like a dog: scolded, she lowers her eyes; after an appropriate interval, she raises them again in a chastened attitude"), see Constance Jordan, *Renaissance Feminism: Literary and Political Models* (Ithaca, N.Y.: Cornell University Press, 1990), p. 52.

**20**  Xenophon, *Oeconomicus,* p. 236.

**21**  Ibid., p. 209.

**22**  Ibid., p. 244.

For Xenophon this spatial order is itself a thing of beauty. The gaps between spaces, the "interspace," which is no more than the spatial structure, the "neat array" within which possessions may be placed, becomes a beautiful figure, which "owns a separate charm." In fact, it is more beautiful than any of the possessions it orders.[23] Indeed, nothing can be more beautiful.[24] But this beauty is not simply independent of the possessions it exceeds. The spaces it defines visually represent what is proper to them: "The very look of them proclaimed what suited each chamber best,"[25] and so reveal the status of the estate. When something is missing, the "gaping space will cry out." The structure is therefore a mechanism of detection: "the mere look and aspect of things will detect what needs attention."[26] The house is itself a way of looking, a surveillance device monitoring the possessions that occupy it. It is really the house, provided by the man, that stands in his place. It is his eye. The wife merely maintains the very surveillance system she is placed in and by.

Indeed, she is one of the possessions whose status the house monitors and is exposed by the structure of the house she maintains. It is this exposure by a system of classification, rather than a simple enclosure by walls, that entraps her. Just as the gap between spaces, the divisions of the house, represent both the order and that which is ordered, Alberti monumentalizes the space between genders by differentiating between male and female spaces in terms of location, access, and levels of comfort.

This reaches its extreme in his division between the husband and wife's bedroom. But while the separate doors to the bedrooms publicize the split between genders, the door between them is privatized: "Each room should have its own door, and in addition a common side door, to enable them to seek each other's company

. . . . . . . . . . . .

**23**　When discussing an estate, Xenophon prefers the beauty of "The accuracy of the spacing, the straightness of the row, the regularity of the angles" to the possessions it orders: "I really do admire these lovely things, but I am more impressed with your skill in measuring and arranging everything so exactly." Ibid., p. 217.

**24**　"After all, my wife, there is nothing in human life so serviceable, nought so beautiful as order." Ibid., p. 234.

**25**　Ibid., p. 240.

**26**　Ibid., p. 236.

unnoticed."[27] Sexuality is privatized in the very gesture which makes the difference between the sexes public. This double gesture marks Alberti's contribution to the emerging ideal of the family based around the physical and psychological privatization of the sexuality of the married couple with "visible and invisible walls"[28]–what Philippe Ariès refers to as the "invention" of the family[29]–which originated in the fifteenth century but was not established until the nineteenth century.

Alberti's text does not simply occupy the traditional art historical categories that have been used to frame it, especially that of the "Renaissance," a category that is not only indebted to the reading of Alberti's texts but is built into the constitution of art history, organizing its operations rather than simply being one of the subjects it examines. Alberti's text cannot easily be separated from the systems of distinctions that are applied to it.[30] As responsible for the logic of historical placement as it is for that of spatial placement, it cannot itself be easily placed. It employs late medieval arguments to stitch together fragments of classical texts into a structure which carries within its seams traces of critical displacements that would be instituted in the following centuries. The text is strangely suspended between the classical arguments it appropriates and those identified with the nineteenth century.

While Xenophon makes a space for sexuality–the house–Alberti veils that space within the house. This veiling is not simply the demarcation of a space for sexuality, a private domain in which

. . . . . . . . . . . .

27  Alberti, *On the Art of Building,* Book V, p. 149.

28  "In the civilizing process, sexuality too is increasingly removed behind the scenes in social life and enclosed in a particular enclave, the nuclear family. Likewise, the relations between the sexes are isolated, placed behind walls in consciousness." Norbert Elias, *The Civilizing Process,* Vol. 1: *The History of Manners,* trans. Edmund Jephcott (New York: Pantheon Books, 1978), p. 180.

29  "Not that the family did not exist as a reality ... But it did not exist as a concept." Philippe Ariès, *Centuries of Childhood: A Social History of Family Life,* trans. Robert Baldick (New York: Alfred A. Knopf, 1962), p. 405.

30  As Michael Ann Holly argues, the position of the art historian is that of the Albertian spectator located in perspectival space, a "totalizing scheme of spatial construction" which is appropriated "not just as a painterly divide that permits the artist to locate objects spatially in a certain manifest scheme of relationships but also as a kind of cognitive map for the cultural historian whose directive is to relate events, attitudes, and

the couple is free from external restraint. On the contrary, it is a resistance to sexuality as such. Alberti is everywhere opposed to sensual pleasure, describing it as a "vile appetite," "lascivious and brutish," "shameful and immodest," "bestial and merciless lust." Sexual desire is natural in animals but in humans it is unnatural because it goes beyond the honorable work of procreation into the degenerate realm of erotic play. Alberti condemns excess pleasure or, more precisely, pleasure understood as excess. Such pleasure is dangerous because it makes men lose their reason and become the "effeminate" servants of women.[31] Desire is itself a woman that masters men–"truly she is a master to be fled and hated"[32]–and can only be controlled by the strict enforcement of masculine reason. Alberti distinguishes "erotic life" from "friendship" and identifies marriage as a form of friendship which resists sexuality rather than houses it: "A most appropriate reason for taking a wife may be found in what we were saying before, about the evil of sensual indulgence."[33] Marriage is an institution of reason which transforms sexual play's confusion of gender roles into the virtuous work of procreation, which is seen to depend upon the maintenance of those roles.

But Alberti's house even veils this virtuous labor of procreation by veiling the opening in the wall between the bedrooms. It is precisely such unsupervised openings that make possible the new sense of privacy, beyond that of a closed room, on which the emerging ideology of the individual subject depends.

. . . . . . . . . . . . .

personalities in a coherent temporal architectonic. ... the works of art of the period rhetorically prefigured their own historiographical response." Michael Ann Holly, "Vision and Revision in the History of Art," in *Authority/Vision/Politics,* ed. Martin Kreiswirth and Mark A. Cheetham (Ann Arbor: University of Michigan Press, 1990), p. 160.

**31** "We might add that an overindulgence in anything concerned with pleasure is, according to Crates, harmful to old and young alike: it makes the old cruel and the young effeminate." Alberti, *On the Art of Building,* Book IV, p. 95.

**32** Alberti, *Della Famiglia,* Book II, p. 105.

**33** Ibid., Book II, p. 112. Constance Jordan points out that the friendship Alberti promotes "is an emotion felt by men primarily for men, and it is expressed by agreements about how women are to be shared and exchanged. In practice it has nothing to do with feelings that a husband and wife have for each other." *Renaissance Feminism,* p. 42.

The invention of personal privacy is marked by a new attitude to the body which is written into Alberti's argument. The body now needs to be cleansed. Or, rather, social order has to be cleansed of the body. Architecture is established as such a purification. It must be sited, organized, and maintained with technical strategies like drains, windows, and cremation, which preserve the "purity of the air." The body itself emerges as a threat to the purity of space, the "cleanliness of buildings." This cleanliness is more than simply a resistance to the infections of the plague that Alberti repeatedly warns against. He is concerned to control the refuse of the body by isolating it from the building because it literally threatens the structure of the building, both its physical structure (urine, for example, is to be channeled away from walls because it deteriorates them[34]) and its abstract order. The devices that control the refuse are the servants of that order. By detaching architecture from the body, these services make the representation of immaterial order possible.[35] Before it can defend the body, architecture must defend itself against the body by ordering it. The body threatens only inasmuch as it is mismanaged: "although the sweat or breath is itself not the least bit bad, it may be infected by the odor of the garments, and smell foul."[36] It is the clothing that smells, exposing the space to the disorder latent within the body it covers. Purification must begin with the outer coverings, starting with the building itself. The mechanisms of this detachment, from sewers to toilets, would become known as "closets." They literally closet away the abject domain from the spatial representation of pure order. This masking of the abject cannot be represented as such. It is a subordinate system which makes space for the dominant representation.

. . . . . . . . . . . .

**34**  "I would recommend that drains for the disposal of urine be kept well away from the walls, as the heat of the sun may corrupt and infect them very much." Alberti, *On the Art of Building*, Book IV, p. 114.

**35**  In describing Serlio's displacement of the high architectural mode canonized by Alberti into the inferior phenomenal realm of the "ordinary," the "poor," the "abnormal," etc., Tafuri notes that "The idealization of architecture, which had found exceptional exponents in Marsilio Ficino and Leon Battista Alberti, collapsed when it came into contact with human feces." Manfredo Tafuri, *Venice and the Renaissance,* trans. Jessica Levine (Cambridge, Mass.: MIT Press, 1989), p. 69.

**36**  Alberti, *On the Art of Building*, Book X, p. 322.

Alberti's discomfort with the smells of the "secret privies" located "almost below our beds"[37] points to the desire to establish a new sense of privacy in the house, literally a secret privacy. The smell gives away the presence of that which should be hidden. Like the other bodily functions in the bedroom, it must be doubly privatized. Architecture no longer simply reveals what it houses. This new sense of privacy was gradually produced throughout the next centuries by redefining the spaces of the house into a complex order of layered spaces and subdivisions of spaces that map a social order by literally drawing the lines between hierarchies of propriety. Eventually, the supplementary closet that had made the order of the house possible became the new order of the house. A new kind of space emerged in which distance is no longer the link between two visible objects in space but is the product of a mask whose surface is scrutinized for clues about what lies beyond it but can never simply be seen. An economy of vision founded on a certain blindness. Without such vigilant control of the surface, the disorder of the body can infect ethical, aesthetic, political, and juridical regimes. Order in general depends upon an ordering of the body, which is to say, a detachment from it. It is this detachment that makes the individual subject possible. Architecture was used to effect it as the agent of a new kind of modesty and in so doing played an active part in the constitution of the private subject. It clothed the body in a way that redefined it, at once constructing the body as dangerous and containing that threat.

This disciplining of the body is an extension of the traditional disciplining of the cultural artifact "woman," authorized by the claim that she is too much a part of the fluid bodily world to control herself. The privatization of sexuality, where sexuality is understood as feminine, is used to produce the individual subject as a male subject and subjectivity itself as masculine. This subject is specific to that privatization. The new conditions of privacy mark a new subjectivity rather than simply modify a preexisting one. While ancient texts like Xenophon's identify that sexual activity needs to be subjected to an economy which would control its excesses, by literally identifying it with a marriage-house, this is not simply the sexuality that would later be veiled within that

. . . . . . . . . . . .

37   Ibid., Book V, p. 151.

house with similar arguments. What is common to the arguments is not the sexuality whose space is being defined but that their respective spaces are instituted to construct their specific senses of self. As Foucault argues:

> The way in which sexual activity was constituted, recognized, and organized as a moral issue is not identical from the mere fact that what was allowed or prohibited, recommended or discouraged is identical. ... The sexual austerity that was prematurely recommended by Greek philosophy is not rooted in the timelessness of a law that would take the historically diverse forms of repression, one after the other. It belongs to a history that is more decisive for comprehending the transformations of moral experience than the history of codes: a history of "ethics," understood as the elaboration of a form of relation to self that enables an individual to fashion himself into a subject of ethical conduct. [38]

The interrelated terms "sexuality," "body," and "privacy" are fundamentally historical. Alberti's design should not be understood as the privatization of a preexisting sexuality. Rather, it is the production of sexuality as that-which-is-private. The body that is privatized is newly sexualized. [39] Indeed, it is a new body. The new sexuality is produced in the very moment of its privatization. All of the ensemble of strategic mechanisms that define and constitute the house are involved in the production of this sexuality as such.

These mechanisms appear to exceed the physical space of the house which is unable to expose and legislate against the sexual excess on whose elimination its very structure depends because it veils sexuality. This veiling marks a spatial and moral limit to the architecture of reason. The new privacy creates the possibility of an illegitimate sexuality that must be controlled by other means.

. . . . . . . . . . . . .

**38** Michel Foucault, *The History of Sexuality,* Vol. 2: *The Use of Pleasure,* trans. Robert Hurley (New York: Pantheon Books, 1985), p. 251.
**39** The medieval body being displaced by Alberti is not simply sexual: "The recent outpouring of work on the history of the body, especially the female body, has largely equated body with sexuality and understood discipline or control of the body as the rejection of sex or of woman. We must wipe away such assumptions. Medieval images of the body have less to do with sexuality than with fertility and decay." Caroline Walker Bynum, "The Female Body and Religious Practices in the Later Middle Ages," *Zone: Fragments for a History of the Human Body,* Part 1, ed. Michel Feher (New York: Zone, 1989), p. 162.

Theoretical texts and religious institutions must take over the responsibility of supervising a space whose openings are no longer visible.

But these systems of representation cannot be separated from that space. The mechanisms that define the house cannot be divided into those that are spatial and those that are representational. The space in which the privatization of sexuality could occur is literally produced by transformations in representational systems and, equally, those systems are made possible by that space.

The space depends, for example, on the production of new kinds of writing, the necessary spatial conditions of which are written into the very passage of Alberti's treatise on the subordinate place of woman in the house. An even more extreme form of privacy is inscribed in the spatial system in order to supervise the space of sexuality it at once produces and veils.

While one of the first signs of the growing desire for privacy for the individual, such that "a privacy *within* the house developed beyond the privacy of the house,"[40] was the separation of the bedrooms that Alberti prescribes, which established a masculine space, this space is not completely private, since women can enter it, albeit only when allowed. The first truly private space was the man's study, a small locked room off his bedroom which no one else ever enters, an intellectual space beyond that of sexuality.[41] Such rooms emerged in the fourteenth century and gradually became a commonplace in the fifteenth century. They were produced by transforming a piece of furniture in the bedroom—a locked writing desk—into a room, a "closet" off the bedroom.[42] Indeed, it was the first closet. The space of writing could now be

· · · · · · · · · · · · ·

**40**   Charles de La Ronciere, "Tuscan Notables on the Eve of the Renaissance," in *A History of Private Life*, Vol. 2: *Revelations of the Medieval World*, ed. Georges Duby (Cambridge, Mass.: Harvard University Press, 1988), p. 212.

**41**   "He passed from chambre to chambre tyle he come yn to hir secreet study where no creature used to come but hir self allone." *Life of St. Kath*, 1430 (Roxb), p. 14, cited *O.E.D.* (Oxford: Clarendon Press, 1933), Vol. X, p. 1181.

**42**   The word "closet" was used in this way in the sixteenth century but became a commonplace in the seventeenth century: "We doe call the most secret place in the house appropriate unto our owne private studies … a closet." A. Day, *English Secretary* (1586), p. 103, cited *O.E.D.*, Vol. II, p. 520. On the study, see Orest Ranum, "The Refuges of Intimacy," in *The*

entered. In Alberti's account, the husband is given this space of immaterial knowledge while the wife is given a dressing room, space of material masks, off her bedroom. But her space is not private, as the young children, girls, and nurse sleep in it. The study is the true center of the house. This new space marks the internal limit to the woman's authority in the house. She does not command the whole space. Her disciplinary gaze operates between the inner locked door of the study and the outer locked door of the house.

Having given his wife apparent authority over the house on which his public authority depends, the *paterfamilias* consolidates his control by secreting the family documents–the interrelated financial and genealogical records–in a locked chest in his study. The whole economy of the household is literally written down at the hidden center of the space it organizes. The image of the house is hidden within it, just as the image of the public space is hidden within the house. The woman maintains a system without access to its secrets. "Locked up and arranged in order,"[43] these documents are subjected to the very spatial order they at once represent and authenticate. But they are not just stored in this space. They are literally produced there. The private space is the space of private writing. It makes available the new literary form of the *memoir* which began as a record and consolidation of the family but increasingly became a celebration of the private individual. Originally the man withdrew from the family into this space in order to reconstruct that family through elaborate records: collecting documents, contracts, records, family trees, anecdotes about, and prescriptions for, good family life, details of private relationships, ancestors, etc., to be passed on to the oldest male child, and kept away from the woman because her convoluted boundaries prevent her from keeping a secret and she is in any case the representative of another patriarchal line.[44] But these private records were

. . . . . . . . . . . .

*History of Privacy,* Vol. 3: *Passions of the Renaissance,* pp. 225–227; W. Liebenwien, *Studiolo: Die Entstehung eines Raumtyps und seine Entwicking bis zum 1600* (Berlin: Mann, 1977); and Patrick Mauries, "Il teatro dell'errore," in *Il progetto domestico: La casa dell'uomo: Archetipi e prototipi,* ed. Georges Teyssot (Milan: Electa, 1986), pp. 52–55.

**43** Alberti, *Della Famiglia,* Book III, p. 209.
**44** "Memoirs of a lineage, these albums (*ricordanze, ricordi*) helped to create an informed and personal appreciation of the family past, thus extending the private realm backward in time." De La Ronciere, "Tuscan Notables," p. 257.

increasingly transformed into a confirmation of the status of the individual rather than the family. When they started to become public, the representations literally constructed the private individual as a new cultural artifact with more influence over the very public world from which it appears to be withdrawn than those who simply occupy that world.[45] This new form of privacy was produced, and only then could it be in any way "occupied," when it was inscribed in the public domain.

Alberti's writings played a crucial role in this inscription, at once prescribing and exemplifying it. His dialogue on the family, for example, is at once a memoir of his own family and a prescription for private life which he claims resulted from him "withdrawing" for ninety days to write.[46] Throughout his texts, he repeatedly specifies the need for the writer to isolate himself from the public world by withdrawing into the house, and from the domestic world by withdrawing into the study: "they should close themselves up at home and keep away everything that is elegant, pleasurable, and admired, so as to confine themselves to knowledge of literature."[47] Detached from bodily pleasure, particularly the "noxious influence of Venus," the writer is free to "marry literature" in secret.

But even then, the writing that results from this secret romance is not simply produced within a private space. It is responsible for producing that very sense of privacy. The construction of private space as such cannot be separated from the construction of the ideology of privacy. The possibility of that space is inscribed into the written texts that circulate in public,

. . . . . . . . . . . . .

**45**  "The tension between the desire to withdraw from the crowd while at the same time maintaining control over the world is probably symbolic of the absolute liberty made possible by commerce with books, hence of the possibility of complete self-mastery without constraint or supervision ... Thus there emerges a strange alliance between reading, that most private and hidden practice, and true effective power, power far more effective than that of public office." Robert Chartier, "The Practical Impact of Writing," in *A History of Private Life,* Vol. 3: *Passions of the Renaissance,* pp. 135–137.

**46**  Anicio Bonucci, *Opere Volari di Leon Battista Alberti* (Florence: Tipografia Galileina, 1843), part 1, p. xciv, cited by Mark Jarzombek, *On Leon Baptista Alberti: His Literary and Aesthetic Theories* (Cambridge, Mass.: MIT Press, 1989), p. 88.

**47**  Leon Battista Alberti, *De commodis litterarum atque incommodis,* cited in Jarzombek, *On Leon Baptista Alberti,* p. 7.

whether or not such spaces exist. The new sense of privacy depends upon that inscription. The space is therefore as much the product of the texts as its condition of possibility. The new forms of writing both depend on, and assist in, the cultural construction of those spaces. They are literally part of the spaces.

The complicated history of this sense of privacy, leading up to its formal establishment in the nineteenth century, involves this kind of convoluted exchange between spatial and ideological transformations. The new spaces of everyday life cannot be understood as either the physical consequence of new forms of representation or their condition of possibility. Rather, they are themselves forms of representation. Each shift in the emergence of private space involves transformations of such systems (private correspondence, portraits, the bellcord, the diary, the corridor, the novel, the cabinet). The house is never a self-sufficient spatial device. It requires a multiplicity of systems which are not simply added to a physical form. Architectural discourse, the theory offered by Alberti, for example, is but one of these systems.

Place is not simply a mechanism for controlling sexuality. Rather, it is the control of sexuality by systems of representation that produces place. The study, like all spaces, is not simply entered. Rather, it is (re)produced. As such, the issue here is not simply the existence of studies in houses but the ideological construction of the study which is at once the construction of a gendered subjectivity that "occupies" it.

These systems can never be separated from what they represent. The ideological constructions which make available the building as a social agent are transformed by the very privacy they make possible. Alberti's discourse, for example, does more than define the ways in which architecture can veil sexuality. Sexuality is also privatized in his very discourse. Even where *Della Famiglia* explicitly addresses sex in order to transform it from feminine erotic play to masculine work, that is, to desexualize it by specifying the appropriate time, mood, and temperature for intercourse, the text becomes cryptic. In the face of the uncontrollable enigma of having to make public that which should be hidden precisely in order to hide it, he introduces a veil into his own writing, approaching sex as:

a topic which one might perhaps skip over on account of certain con-
siderations. I shall, however, discuss this vital subject in so veiled and
so compressed a manner that for anyone who does not like it it will
be as if I had not spoken.[48]

Enclosed by this way of speaking silently, sexuality is pri-
vatized from both the emerging intellectual discourse that at once
defines and constitutes a new public realm and from the private
household inscribed within that realm. The masculine self-control
that the texts promote as a bounding of sexuality through the
maintenance of order is exemplified by the structure of those very
texts. They repress the traces of sexuality on their own surfaces.
This repression is even greater in the text on architecture in which
sexuality is not even named but has its space defined in a mar-
ginalized passage. The discourse remains outside the locked space
it names. It literally locks that space. Desire only surfaces by way
of prohibition. In this way, the text itself is able to assume the
architectonic condition it prescribes, presenting itself as an orderly
structure of proper places.[49] It uses the same language to describe
its own structure as it uses to describe architecture.

This detachment of space from sexuality, such that space can
be used to house sexuality and theories of sexuality can leave the
house behind, is crucial to Alberti's claim that the capacity for a
building to define place precedes representation. The sense of a
physical space independent of representation is precisely an effect
of veiled representational strategies turning on the question of sex-
uality. The arguments about sexuality which underwrite the
explicit but apparently marginal passage on gender in Alberti's
treatise which we have been following here can be traced through-
out that treatise.

· · · · · · · · · · · ·

**48**   Alberti, *Della Famiglia,* Book II, p. 120.
**49**   Even Alberti's choice to write his treatise on the family in the less
ornate vernacular is a sign of this prohibition. His aesthetic treatises
assume an architectonic structure by sustaining the very veiling of
sexuality they prescribe.

## III

Alberti's celebrated theory of harmony–every part in its "proper place"–for which he was canonized by the tradition, is no more than an elaboration of the beauty of domestic order, the discrete charm of domestication. Xenophon's claim that the look of a domestic space represents what it "husbands" sustains Alberti's promotion of architecture as a public articulation of difference which both embeds architecture in, and enables it to act as a privileged figure for, cultural life. This capacity to both maintain and represent social order cannot be separated from the general control of the feminine nor from the attempt to control specific women in cultural life. The aesthetic ideal with which architecture was elevated above the mechanical arts depends upon particular mechanisms of domestication. The aesthetic eye cannot be detached from the woman's confinement by the eye. The rhetoric of the "proper place" is that of husbandry. In order to assume cultural status by defining place, the elements of architecture must be themselves placed with "moderation." The role of the architect is:

> to consider whether each element has been well defined and allocated its proper place ... to take care that nothing is included except what is choice and well proven, and that everything fits together so well, in terms of dignity and grace, that were you to add, change, or take anything away, it would be to the detriment of the whole.[50]

This is, after all, no more than the principle of economy. The propriety of place derives from the elimination of all excess.[51] As in the house, excess is understood as sensuality, an improper pleasure to be regulated and displaced into the intellectual pleasure of the regulations themselves: the architect should "condemn unruly passion for building: each part should be appropriate and only in the end is pleasure provided for, while pleasure itself never fails to shun every excess."[52] The building itself is subjected to the economic regime it enforces. Just as the house is a mechanism for the

............

50  Alberti, *On the Art of Building*, Book II, p. 37.
51  On the architectural chains binding family, proper, propriety, and property, see Catherine Ingraham, "The Faults of Architecture: Troping the Proper," *Assemblage*, no. 7 (1988): 7–14.
52  Alberti, *On the Art of Building*, Book I, p. 24.

domestication of women, it is itself understood as a domesticated woman. Just as the woman whose excessive sexuality is transformed into economic work can become a surrogate figure of control for the man, the house is itself feminine, and can only become a surveillance mechanism when its excesses have been controlled by the architect.

Alberti's text begins with its well-known division of architecture into "lineaments," which derive from the mind, and "matter," which derives from nature. The lineaments are the order of lines that prescribes the "appropriate place" for the building and all its parts. Formulated in the masculine mind of the architect, this geometric order controls the feminine body of the building that has been appropriated from Mother Nature. While describing architecture as the imitation of nature, Alberti argues that "the building is very like an animal" and uses the example of men who choose their wives on the basis of the shape of their bodies. The beautiful body, whether it be of a building or a women, is "regulated" in a way that immediately "arouses," "provokes," and "excites" the reasoning faculty of the mind. It is man's "nature to desire the best and cling to it with pleasure."[53] Such a beauty, which derives from the rules whose control of nature makes her "the spouse of the soul and of reason," is "the main object of the art of building, and the source of *her* dignity, charm, authority and worth."[54] The arousal here comes from the order that controls the sensuous surface. The source of her dignity is his law, the beauty he desires is his own.

Of course, the role of the text is to provide the rules with which the building can be controlled, regulations which define the place of every part and control every surface. In so doing, Alberti defines a place for architecture in the academy. The institution of architectural discourse is made possible by the subordination and control of the feminine that detaches it from the inferior bodily realm of the mechanical arts.

Arguing that architecture began with simple buildings that provided material shelter, in the form of roof and walls, before gradually entering the realm of "pleasure" through the successive

. . . . . . . . . . . .

**53**   Ibid., Book IX, p. 302.
**54**   Ibid., Book IX, p. 303 (author's emphasis).

addition of decoration, the treatise begins with the construction of the basic building as a form of shelter, its siting, foundations, its division into rooms, materials, etc. It describes how to organize the materials in order to define secure space. The building elements which constitute the basic body of the building are then to be covered with a "skin" made up of "coats of plaster." He describes in detail the production of this skin. The last and thinnest "coat should gleam like marble: for this a finely crushed white stone is used instead of sand."[55] This white skin is a pure surface, a thin screen, like the white cloth Alberti describes earlier in the text through which water is passed because it leaves a mark if it is contaminated.[56] It is a mechanism of purification, a filter.[57] Its unmarked surface screens off the bodily condition of the body and yet reveals its formal order.

The feminine materiality of the building is given a masculine order and then masked off by a white skin. The skin effaces the transformation from feminine to masculine and maintains a division, a visible line, between structure and decoration as a gender division. This overt difference veils the fundamental ambivalence of the building's identity. The white surface both produces gender and masks the scene of that production, literally subordinating the feminine by drawing a line, placing the ornament just as the walls place the possessions in the house. The ornament becomes a possession of the structure, subject to its order. Like the woman in the house, it is given responsibility for sustaining the very structural order that restrains it.

Alberti argues that the body of the building is "constructed naked, and clothed later." After putting on its thin white layer, it is "dressed with ornament." The white skin divides the body from its clothes, isolating the representational system of ornamentation from the presence of the building. But precisely because ornament is representational, it is dangerous. The building can dress up in a way that leads the eye away from the inner order, producing disor-

. . . . . . . . . . . .

**55** Ibid., Book VI, p. 175.
**56** Ibid., Book I, p. 14.
**57** The purity of the whiteness can again be found in Alberti's account of the principles of hygiene associated with the founding of a city and the marking of the "line of the intended wall with a trail of powdered white earth, known as 'pure.'" Ibid., Book IV, p. 101.

der by dissimulating, like the improper decoration of an architectural model which has been

> colored and lewdly dressed with the allurement of painting ... striving to attract and seduce the eye of the beholder, and to divert his attention from a proper examination of the parts to be considered ... the architect ... is one who desires his work to be judged not by deceptive appearances but according to certain calculated standards.[58]

The threat of ornament is its sensuality, which distracts the proper eye. The need to appropriate architecture from the feminine domain of pleasure has its risks, the risk precisely of seduction. The deception of superficially "pleasing appearance" interferes with the truth of the "proper place." The risk of ornament is an impropriety in which the sensuality of the body confuses the mind that seeks to control it. As always, reason is threatened by the fantasized sexual mobility of the feminine.

These arguments reproduce those of *Della Famiglia* in which ornament is explicitly identified with sexuality. The woman's use of decoration and makeup is condemned because its dissimulation calls into question her chastity. It "excites numerous lustful men" until she inevitably "falls into real disgrace." In the intimacy of marriage, the husband cannot be deceived by makeup. Being on the inside, he can see through it. Privacy here, for the man, is access to inner secrets. Repeatedly arguing that outer appearances should be subordinated to inner truth, he argues that "your real adornment and your real beauty are found in your modesty and virtue."[59] The wife's beauty is that of moderation. Instead of wearing makeup, she should "just wash and keep clean with water alone."[60] Visible cleanliness becomes a mark of her inner cleanliness. The white surface of a building effects that same purification.

In this, Alberti is again closely following Xenophon, who condemns feminine makeup in favor of masculine transparency which discloses "our belongings just as they are, without boasting

. . . . . . . . . . . . .

**58**  Ibid., Book IV, p. 34.
**59**  Alberti, *Della Famiglia,* Book III, p. 227.
**60**  Ibid.

of imaginary possessions or concealing any part of what we have, or by trying to trick you with an exaggerated account."[61] The wife is treated as a possession to be exposed as much by her own surfaces as by those of the house. The principle of economy requires the subordination of exterior surfaces to inner purity: "For it is not through outward comeliness that the sum of things good and beautiful is increased in the world, but by the daily practice of the virtues."[62] Even when the wife "was much enamelled with white lead, no doubt to enhance the natural whiteness of her skin," she is seen to be wearing a dissimulating mask as sexually provocative as the red rouge she added to it.[63] All disguise, of which the "painted counterfeits of womanhood" is the paradigm, is sexual. The beauty of a "human body undisguised" is opposed to the woman "painted like a fraudulent hussie." Xenophon's whole argument turns on economy as a form of resistance to the "despotic mistress" of desire whose pleasure is but a pain in disguise: "deceitful mistresses that pretend to be pleasures ... really pains concealed beneath a thin veneer of pleasures."[64] Economy is no more than the control of the veneer, the representational surface exposed to the eye. Gender in ancient Greece is independent of anatomy and is produced on the external surfaces of the body, which are closely monitored for signs of eye movement, grooming, shaving, posture, gait, etc.[65]

This applies to the house itself, which must not be decorated. Indeed, when first arguing for the basic necessity for economy, Xenophon uses the "useless house" as his first example, comparing it to a house which does not have "everything neatly arranged

. . . . . . . . . . . .

61  Xenophon, *Oeconomicus*, p. 447.
62  Ibid., p. 233. "So human beings find the human body undisguised most delightful. Tricks like these may serve to gull outsiders, but people who live together are bound to be found out, if they try and deceive one another." Ibid., p. 246. Alberti refers to "ancient authors" on the question of makeup as a question of virtue, arguing that nothing is as important as a wife's chastity: "her purity has always far outweighed her beauty." *Della Famiglia*, Book III, p. 213.
63  Xenophon, *Oeconomicus*, p. 244.
64  Ibid., p. 371.
65  See Maud W. Gleason, "The Semiotics of Gender: Physiognomy and Self-Fashioning in the Second Century C.E.," in *Before Sexuality*, ed. David M. Halperin et al., p. 411.

in some place ... not just anywhere."[66] The capacity for a house to place things is related to its utility, its efficiency rather than its excess, its lack of ornamentation. It should "contain few elaborate decorations ... but the rooms are designed simply with the object of providing as convenient receptacles as possible for the things that are to fill them, and thus each room invited just what was suited to it."[67] In so doing, it acts as a resistance to the despotic queen of desire. The rule of the house is explicitly set up in opposition to the "rule of the passions" she enforces.

Symptomatically, when addressing architecture Alberti prohibits a "well-known harlot" from building a monument for her husband whereas a virtuous woman is allowed to. The woman can represent the man only when virtuous, immobile, nonexchangeable. The task of architectural theory becomes that of controlling ornament, restricting its mobility, domesticating it by defining its "proper place" (bondage to the ground, faithful representative of the presence of a building) in opposition to the impropriety of the prostitute (mobility, detachment from the ground, independence, exchangeability). The practices of ornamentation are regulated so that ornament represents and consolidates the order of the building it clothes, which is that of man. It is used to make that order visible. The domesticated woman is the mark of man, the material sign of an immaterial presence.

In fact, classical architectural theory dictates that the building should have the proportions of the body of a man, but the actual body that is being composed, the material being shaped, is a woman. Clothes maketh the man, but they are woman. Man is a cultural construction which emerges from the control of the feminine.

It is not that the building is being thought of as a body with the classical analogy. Rather, the body is thought of as a building. The discourses of space and sexuality cannot be separated. The Christian sexual morality formulated in the fourth century which Alberti is elaborating in spatial terms was itself originally spatial. The public spatial rituals of marriage were desexualized and to abstain from sexual play within marriage was understood to

. . . . . . . . . . . .

66   Xenophon, *Oeconomicus*, p. 383.
67   Ibid., p. 439.

"build a wall for the city."[68] Having closeted sex within the house, resistance to it is seen as architectural long before architectural discourse attempts to detach architecture from sexuality.

Such "metaphors" can be traced all the way up to the time Alberti was writing, when the body was itself thought of as a building. The first treatise on the interior of the body, which is to say, the treatise that gave the body an interior, written by Henri De Mondeville in the fourteenth century, argues that the body is a house, the house of the soul, which like any house can only be maintained as such by constant surveillance of its openings. The woman's body is seen as an inadequate enclosure because its boundaries are convoluted. While it is made of the same material as a man's body, it has been turned inside out.[69] Her house has been disordered, leaving its walls full of openings. Consequently, she must always occupy a second house, a building, to protect her soul.[70] Gradually this sense of vulnerability to the exterior was extended to all bodies which were then subjected to the kind of supervision traditionally given to the woman. The classical argument about her lack of self-control had been generalized.

The link between the treatment of the body as a building and the attempt to privatize bodies with buildings can be traced throughout the history of privacy. The body was increasingly sub-

. . . . . . . . . . . . .

**68**   Musonious Rufus, fr. 14, cited by Peter Brown, "Bodies and Minds: Sexuality and Renunciation in Early Christianity," in *Before Sexuality,* ed. David M. Halperin et al., p. 488. Brown also identifies this moment in which the body becomes the "temple of the holy spirit," the "sacrosanct dwelling place" housing the spirit, with the increased identification of the body with sexuality, such that "nudity, also, ceased to be a form of dress," and with the fixing of gender divisions which are literally spatialized, as in the "high wooden railing [that] now stood between the men and the women in the great church of Antioch." Ibid., p. 490.

**69**   The material of the body, considered as a house, is seen as feminine but its physiological structure is male. Maleness is the structuring of the body. See Bynum, "The Female Body and Religious Practices in the Later Middle Ages," p. 187. "Perhaps as early as the third or fourth century B.C.E. and certainly from the time of Galen, it was a medical commonplace that men are–anatomically–women turned inside out ... Masculinity in the ancient world was an achieved state, radically underdetermined by anatomical sex." Gleason, "The Semiotics of Gender," p. 390.

**70**   "The surveillance of women concentrated upon three specific areas: the mouth, chastity, the threshold of the house. These three areas were frequently collapsed into each other." Peter Stallybrass, "Patriarchal

jected to the very same regimes of hygiene, order, discipline, and prohibition as buildings. The arguments for the propriety of white surfaces employed by Alberti, for example, became the basis of the arguments about the cleanliness (*propre*) of the body that played such an important role in the constitution of private space in the sixteenth and seventeenth centuries.

The dominant figure for the body remained that of the house. But with the plague, the very walls of that house are seen as porous. As any kind of opening constituted the possibility of a medical "disorder," the monitoring of the body's multiplying openings demands a greater vigilance against infiltration. This necessitates social isolation achieved through the addition of a smooth, supplementary layer of clothing. White linen took over the role of the porous surface it protected. It literally became the body. Its cleanliness stood for the purification of the body. The surfaces it did not cover, the face and hands, were cleansed by being wiped with a white cloth and the exposed hair was covered with a white powder. The white surface was a critical device with which a detachment from the body, understood as a feminine surface, a discontinuous surface vulnerable to penetration, could be effected. In introducing a distinction between the body and its decoration, it literally produced the distinction between inside and outside as a cultural artifact. Gradually becoming more and more visible as private space was established, the white surface is bound into the concept of the interior. But it was only able to do so inasmuch as it was placed within a particular economy of vision:

> But, above all, the white introduced depth to clothes, and testified to an "underneath." It was as if, through it, the surface of the skin was delegated to the surface of the clothes. What had been hidden now emerged. What was not seen became partially visible. The material that touched the skin became a witness, discrete or emphatic, on the borders of clothing. It revealed what clothes concealed. The white, in this case, signified a particular cleanliness, that of the inside. This additional attribute made it possible to invoke the intimate.[71]

. . . . . . . . . . . . .

Territories: The Body Enclosed," in *Rewriting the Renaissance,* ed. Margaret W. Ferguson et al., p. 126.

**71** Georges Vigarello, *Concepts of Cleanliness: Changing Attitudes in France Since the Middle Ages,* trans. Jane Birrell (Cambridge: Cambridge University Press, 1988), p. 62.

This architecture of vision was already in place in Alberti's text in which the status of the white wall depends upon "the keenest of the senses" with which the rational mind (which is to say, the masculine eye) is said to "immediately" comprehend the immaterial order within a material object. But the wall is not simply looked at, inspected by a detached eye. Its white surface actively assists the eye by erasing its own materiality, its texture, its color, its sensuality, as necessarily distracting forms of dirt. The smooth surface exposes the condition of both the structure behind its walls and the status of things in front of it; which is to say, both the status of the building and whatever is inside or outside it. It frames a view rather than simply submits to one, directing the eye through all the representational layers. A way of looking, a "witness," it is itself not simply seen. Neither material nor immaterial, it is meant to be seen through. By effacing itself before the eye it makes possible, it produces the effect of an eye detached from what it sees. The white surface is crucial to establishing the by now familiar sense of the building as an object available for appropriation by a detached eye that made architecture's claim for a spot in the liberal arts, and eventually its establishment as an academic discipline, possible. Its visuality liberated architecture from the feminine domain of material by enabling institutions to see through the materiality of buildings. It is the white surface, the thin white line between structure and decoration, that domesticates building in order to make a place for the discipline of architecture.

## IV

But despite the fact that the discipline of architecture domesticates building by submitting it to the visual order of man, that discipline remains itself a woman, a woman giving pleasure:

> uniting use with pleasure as well as honor ... architecture, if you think the matter over carefully, gives comfort and the greatest pleasure to mankind, to individual and community alike; nor does she rank last among the most honorable of the arts.[72]

. . . . . . . . . . . .

72  Alberti, *On the Art of Building,* Prologue, p. 2.

The discipline of architecture, organized by man for man, is feminine.

This is consistent with Xenophon's description of the very art of "husbandry" as a woman: "the mother and nurse of all the other arts."[73] The art of the house is itself housed while preparing the other arts for the outside world. Like the wife it houses, it is shaped into a man. Indeed, it is based on the "stores of knowledge" preserved by nature, that good woman, the "sweet mistress who keeps open house for the stranger" but who "suffers not her gifts to be received effeminately."[74] The feminine knowledge of the art of order, housed within and by nature, must be appropriated in a masculine way. But while the public dignity of the other arts depends upon it, it must loyally remain "in the shadows."

Likewise for Alberti, architecture is bound to natural order and is explicitly the mother of the arts. The pleasure she gives is precisely not sexual. It is the repressive pleasure of the image of the modest wife, a representation of purity that is necessarily violently enforced. The iconographical figure of architecture in all the Renaissance treatises was the figure of a virtuous woman, literally, the "queen of virtues." The discipline is itself disciplined, given and confined to a place, literally domesticated in the academy.

The academy is a system of such places that is not only organized by a particular theory of vision but understands theory, the means by which the academy's own place is established, as itself a kind of vision. Architecture is subordinated by the very look that gives it a place. Exercising limited control over and from this place, it is able to theorize itself but only within certain limits. There are spaces it cannot enter and spaces it cannot leave. This institutional confinement of architecture is effected when the organizing theory of vision is identified with the other arts it mothers. Indeed, this theory is explicitly identified with Alberti's earlier text on painting, *De Pictura,* a handbook for students which introduced and codified the theory of perspective and identifies painting as "the master art" from which architecture is even said

· · · · · · · · · · · ·

73   Xenophon, *Oeconomicus,* p. 405.
74   Ibid., p. 219. As a good woman, nature maintains a "house" by refusing masks in favor of transparency. She "never plays tricks, but reveals frankly and truthfully what she can and what she cannot do ... she conceals nothing." Ibid., p. 283.

to have taken "architraves, bases, capitals, columns, facades and other similar things" such that "whatever beauty is found [in architecture] can be said to be born of painting."[75] Architecture is again subordinated to a prior text which presents a theory of vision that is seen to precede it. But it is a theory that cannot be separated from the overdetermined space of the study (or "studio") which detaches the theorist-father-husband-artist from the world precisely in order that he can master that world by viewing it through some kind of disciplinary frame, whether a painting, a theoretical manuscript, memoir, or account book (figures 2, 3, 4).

This economy of vision is of course written into the more recent institutions of art history, the philosophy of art, art criticism, the museum, and the gallery, and continues to locate architecture institutionally.[76] Architecture is understood as a kind of object to be looked at, inhabited by a viewer who is detached from it, inhabited precisely by being looked at, whether it be by the user, visitor, neighbor, critic, or reader of architectural publications.[77] This general model of visuality still dominates current critical, theoretical, and historical discourse even by those that claim to have abandoned it, usually in favor of the "political." The assumptions about visuality and architecture which are written into the construction of theory remain unexamined and usually return to tacitly organize theoretical work. But, of course, as contemporary feminist discourse has demonstrated, the political lives precisely within the socially constructed mechanisms of representation, of which vision is often the most privileged.

The particular economies of desire sustained by the instability

. . . . . . . . . . . .

**75**  Leon Battista Alberti, *On Painting,* trans. John R. Spencer (New Haven: Yale University Press, 1966), p. 64. As D. R. Wright demonstrates, *De Pictura* is not a treatise on the theory of painting, as it is conventionally described, but a pedagogic manual for students based on Quintilian's course of instruction in Rhetoric. See "Alberti's *De Pictura*: Its Literary Structure and Purpose," *Journal of the Warburg and Courtauld Institutes* 47 (1984): 52–71.

**76**  Clearly this account of vision undergoes historical transformations which are necessarily institutional transformations, but the perspective model does not simply go away and architecture is implicated in each transformation.

**77**  On the construction of architecture within the spaces of different systems of representation, see Beatriz Colomina, "*L'esprit nouveau*: Architecture and *Publicité*," in *Architecture/Production,* ed. Colomina (Princeton: Princeton Architectural Press, 1988), pp. 56–99.

**2  Albrecht Durer,** *Draftsman Drawing a Reclining Nude,* c. 1527.
A representation of Alberti's perspective apparatus.

**4  L. Ch.A. Steinheil.** *Durer's Studio,* undated
(Louvre, Paris). The gendering space of
perspective presupposes the space of the study.

**3  Albrecht Durer,** *Saint Jerome in His Study,*
c. 1514. St. Jerome was the standard subject
of Renaissance representations of the study.

of the visuality written into architectural discourse could clearly be analyzed in terms of the readings of the politics of the image that have been made in other discourses. The gaze that places the subject (or, rather, divides and displaces the subject) in a sexual economy can be identified with the view at, through, of, and from places that are inscribed within most institutional discourses. Certainly, as a scene, it seems all too familiar.

But here we must hesitate. The theory of vision that defines institutions like architecture cannot simply be equated with theories of subjectivity in a psychoanalytic sense. At the same time, it is not coincidental that so much of the respective scenes, and the language used to construct them, is common. Some kind of relationship operates here which can be explored in a way that neither simply imposes recent psychoanalytic accounts of visuality onto architectural discourse nor simply demonstrates that those accounts are somehow already embedded within that discourse. Rather, it involves engaging with the specific constructions of vision inscribed within the architectural tradition, and that constitute it as such, in some unresolvable process of multiple translation.

This spatialized vision can be found written into every discourse but occupies architectural discourse in a unique way. Covert aspects of the discourse are involved in the production of that vision while more overt aspects import it as a readymade that is available to all discourses. To read the question of visuality in architecture involves tracing the fine and convoluted lines that divide the veiled scene of the production of an account of vision from that of its appropriation. It is the geometry of this line that defines the institutional role of the discourse.

The question becomes, what precisely is that role? How, for example, is architecture inscribed in that common element between architectural and psychoanalytic discourse? The visuality inscribed within architectural discourse not only produces the architectural "object" as such but cannot simply be separated from it. Logics of vision depend on theories of the object sustained and culturally guaranteed by architectural discourse. Vision cannot be separated from the construction of space, which in turn cannot be separated from the constructions of gender upon which sexuality is mapped, usually violently.

Alberti's canonic text on perspective codified the experiments of the architect Brunelleschi which were themselves clearly architectural. An architectural sensibility is everywhere written into the argument. The theory emerges from a certain thinking of, which is to say construction of, architectural space, which is then applied back onto architecture when particular building forms are used as primary examples.[78] An architectural theory of the object underpins the theory of vision which is then applied to architecture in order to construct an account of painting before an overt theory of architecture is constructed.

This theory is bound to the ideology of the white surface which Alberti also appropriated from Brunelleschi's practice. And it is this construction of a look at a white surface which is written into each of the institutions that frame architecture in the following centuries, whether it is the white surfaces of classical statues that produce the art historical eye, the walls of the gallery space that sustain the aesthetic eye, the white coats of the student in the Beaux-Arts Academy, the white walls of "modern" architecture, or even the white surface of the pages on which the theoretical eye is produced.

The dominant economy of vision turns on the white surface ideologically protected by the convoluted lines drawn by the institution architecture. Before defining this economy in psychoanalytic terms, it is necessary to identify the nature of that protection by tracing the way architectural discourse has attempted to resist the displacement of that ideology.

## V

The form of this resistance can be partially sketched here by looking at the response to the writing of the nineteenth-century architect Gottfried Semper, who attempted to displace the institutional location of architecture by displacing the theories of ornament and

. . . . . . . . . . . .

78   Beyond being primarily concerned with a certain kind of space, such that particular architectural spaces constitute the primary examples, the concepts it employs are explicitly architectural. Perspective itself is understood as the "construction" of a "pyramid" that is framed by an "open window," etc.

vision sustained by the emerging institutions of art. His texts even describe the operations of the very institutional mechanisms that would be used to resist them.

Semper opposed the hegemonic tradition of the white surface, whether it be in the practice of white buildings that he argues was instigated by Brunelleschi (in whose work "we find for the first time an unpainted, naked architecture"[79]) or in art history's dependence on the white surface, which he identifies with Winckelmann's canonic writing. But where the tradition following Brunelleschi made an "error" in its reconstruction of antiquity by "seeking Greek purity in the plain and unadorned,"[80] Winckelmann is seen to deliberately repress the evidence that was by then available: "The former masters had suppressed the truth with their error; he simply did not give truth its due."[81] Art theory constructs itself by actively repressing the structural role of decoration.

Semper's argument was based on the emerging archaeological evidence that the ancient buildings of antiquity only appeared to be "naked" white stone because their layers of colored paint had been weathered off. He interpreted this in a way that undermined the status of the building's structure to that of a mere prop for the layer of paint, arguing that white marble was only used by the Greeks precisely because it was a better "base material" for painting. The marble is transformed from the traditional paradigm of authenticity and exposure of the truth into a "natural stucco," a smooth surface on which to paint. Its smoothness is no longer identified with the purity of its forms, but as the possibility for a certain texture. Architecture is no longer the decoration of a naked structure. The sense of the naked is only produced within the supplementary layer itself. The body of the building never becomes visible, even where it coincides with the decorative layer: the places "where the monument was supposed to appear white were by no means left bare, but were covered with a white paint."[82] Difference is literally inscribed in the surface.

. . . . . . . . . . . . .

79 Gottfried Semper, "Preliminary Remarks on Polychrome Architecture and Sculpture in Antiquity," in *The Four Elements of Architecture and Other Writings,* trans. Harry Francis Mallgrave and Wolfgang Herrmann (Cambridge: Cambridge University Press, 1989), p. 56.

80 Ibid., p. 54.

81 Ibid., p. 57.

82 Ibid., p. 59.

This reading involves a fundamental transformation of the account of the origin of architecture on which traditional architectural discourse bases itself. Architecture is no longer seen to begin with naked structures gradually dressed with ornament. Rather, it begins with ornament.

Building originates with the use of woven fabrics to define social space (figures 5, 6). Specifically, the space of domesticity. The textiles are not simply placed within space to define a certain interiority. Rather, they are the production of space itself. Weaving is used "as a means to make the 'home,' the *inner life* separated from the *outer life,* and as the formal creation of the idea of space."[83] Housing is an effect of decoration. It is not that the fabrics are arranged in a way that provides physical shelter. Rather, their textuality defines a space of exchange. This primordial definition of inside and, therefore, for the first time, outside, with textiles not only precedes the construction of solid walls but continues to organize the building when such construction begins. Solid structure follows, and is subordinate to, what appear to be merely its accessories.[84]

The textile is a mask which dissimulates rather than represents the structure. The material wall is no more than a prop, a contingent piece of "scaffolding," "foreign" to the production of the building, merely a supporting player, playing the role of support, supporting precisely because it does not play. Architecture is located within the play of signs. Space is produced within language. As its origin is dissimulation, its essence is no longer construction but the masking of construction. Just as the institution of the family is made possible through the production of domestic space with a mask, the larger community is made possible

. . . . . . . . . . . . .

**83** Gottfried Semper, "Style: The Textile Art," in *The Four Elements of Architecture and Other Writings,* p. 254.

**84** "Hanging carpets remained the true walls, the visible boundaries of space. The often solid walls behind them were necessary for reasons that had nothing to do with the creation of space; they were needed for security, for supporting a load, for their permanence and so on. Wherever the need for these secondary functions did not arise, the carpets remained the original means of separating space. Even where building solid walls became necessary, the latter were only the inner, invisible structure hidden behind the true and legitimate representatives of the wall, the colorful woven carpets." Gottfried Semper, "The Four Elements of Architecture," in *The Four Elements of Architecture and Other Writings,* p. 104.

5   **Gottfried Semper,** Illustration in *Der Stil in der Technischen und Tektonischen Kunsten odor Praktische Aesthetik,* 1860–63.

through the production of public space through masquerade. Public buildings, in the form of monumental architecture, are seen to derive from the fixing in one place of the once mobile "improvised scaffolding" on which hung the patterned fabrics and decorations of the festivals that defined social life. The space of the public is that of those signs. Architecture literally clothes the body politic.

Semper identifies the textile essence of architecture, the dissimulating fabric, the fabrication of architecture, with the clothing of the body. He draws on the identity between the German words for wall [*Wand*] and dress [*Gewand*] to establish the Principle of Dressing [*Bekleidung*] as the "true essence" of architecture. But architecture does not follow or resemble clothing. On the contrary, clothing follows architecture. The definition of domestic interiority precedes the definition of the interiority of the body.[85] The clothing of the individual follows the clothing of

. . . . . . . . . . . .

85   "The art of dressing the body's nakedness (if we do not count the ornamental painting of one's own skin discussed above) is probably a later invention than the use of covering for encampments and spatial enclosures." Semper, "Style: The Textile Art," p. 254. "Tribes in an early stage of their development apply their budding artistic instinct to the braiding and weaving of mats and covers (even when they still go around completely naked)." Semper, "The Four Elements of Architecture," p. 103.

**6  Gottfried Semper,** Illustration in *Der Stil in der Technischen und Tektonischen Kunsten odor Praktische Aesthetik,* 1860–63.

the family. The body is only defined by being covered in the face of language, the surrogate skin of the building. The evolution of skin, the surface with which spatiality is produced, is the evolution of the social. The social subject, like the body with which it is associated, is a production of decorative surface. The idea of the individual can only emerge within the institutions of domesticity established by the construction of the textured surface that is the house. The idea of a speaker with an interior life only emerges within language. Interiority is not simply physical. It is a social effect marked on the newly constituted body of the individual. Culture does not precede its masks. It is no more than masking. The highest art form is not that which detaches itself from the primitive use of decorative masks but that which most successfully develops that practice by dissimulating even the mechanisms of dissimulation:

> I think that the *dressing* and the *mask* are as old as human civilization
> … The denial of reality, of material, is necessary if form is to emerge
> as a meaningful symbol, as an autonomous creation of man. Let us
> make forgotten the means that need be used for the desired artistic
> effect and not proclaim them too loudly, thus missing our part miserably. The untainted feeling led primitive man to the denial of reality in all early artistic endeavors; the great, true masters of art in

every field returned to it—only these men in times of high artistic development also *masked the material of the mask*.[86]

Semper's whole argument turns on the status of a coat of paint. He produces a history of paint within which the addition of a coat of paint to the surface of building is the way in which the original textile tradition was maintained in the age of solid construction. In this way, architecture, the "mother art," gives birth to the art of painting. This simulated textile, the painted text, becomes at once the new social language, the contemporary system of communication, and the new means by which space is constructed. Architecture is literally in the layer of paint which sustains the masquerade in the face of the new solidity because it is "the subtlest, most bodiless coating. It was the most perfect means to do away with reality, for while it dressed the material, it was itself immaterial."[87]

In so doing, he inverts the traditional architectonic, subordinating structure to decoration by demonstrating that the "false" accessories are the "true" essence of architecture. This inversion necessarily distorts the economy of vision based upon a certain figure of architecture in which what is seen on the outside articulates, and is subordinate to, some inner unseeable truth. The truth of architecture is now located in its visible outside. The inside is completely subordinated to that outside following the Greek "conviction … that inner content should conform to outer beauty."[88] The inside is at most a construction of the surface. The seductions of the surface displace the formal proportions worshiped by the institutions of art, producing a visuality so entangled with a sensuality that the feel, tactility, and smell of the cladding materials become part of the essence of a building.[89] The "visible spatial enclosure," the surface texture that constitutes the

. . . . . . . . . . . .

86  Semper, "Style: The Textile Art," p. 257.
87  Gottfried Semper, *Der Stil,* vol. 1, p. 445, cited by Henry Francis Mallgrave, "Gottfried Semper: Architecture and the Primitive Hut," *Reflections* 3, no. 1 (Fall 1985): 65.
88  Semper, "Preliminary Remarks on Polychrome Architecture," p. 55.
89  "To complete the image of an oriental residence one has to imagine the costly furnishings of gold-plated couches and chairs, divans, candelabras, all kinds of vases, carpets, and the fragrance of incense." Gottfried Semper, "Structural Elements of Assyrian-Chaldean Architecture," trans. Wolfgang Herrmann in *Gottfried Semper: In Search of Architecture*

architecture of the mask, is produced by this convolution of vision and sensuality. Architecture no longer simply occupies the visual. Its sensuality is not screened off by a white surface in the name of the uncontaminated eye. Visuality becomes a construction of necessarily sensuous social transactions.

This disruption of vision subverts the institutional placement of architecture which turns on its division by the regime of distinctions that all turn on the originary distinction between essential object and inessential accessory, structure and decoration. Semper argues that not only is architecture subordinated by being detached from its accessories and identified with its materiality, but that it becomes the paradigm of materiality while the arts that emerged from it are elevated to high art. Hence its "organizing and at the same time subordinate role" in the "household of the arts."[90] Architecture, the mother of the arts, is domesticated. But in order to be subordinated within the high arts, it first has to be detached from, and elevated above, the crafts from which it developed. Like the wife, it is at once confined, purified of its sensuality and given limited authority. Purified of its sensuous basis in the crafts, it is given the lowest place in the arts. Or, more precisely, it is literally suspended in the gap between the low crafts and the high arts. But clearly this is a strategic location. Just as the whole patriarchal order is traditionally seen to depend on its enforcement within the limited space allocated the wife, architecture assumes responsibility for the very division that at once places and subordinates it. To expose the flaws in the traditional account of architecture would be to subvert the whole system. This is precisely Semper's objective.

His texts everywhere oppose this division between high and low art by systematically inverting it. Craft, for example, is traditionally subordinated as merely "applied" but, for Semper, the

. . . . . . . . . . . .

(Cambridge, Mass.: MIT Press, 1984), p. 216. Semper cites Bruno Kaiser on speculative aesthetics: "If form, color, and quantity can only be properly appreciated after they have been sublimated in a test tube of categories, if the sensual no longer makes sense, if the body (as in this aesthetics) must first commit suicide to reveal its treasures—does this not deprive art of the basis for its independent existence?" Semper, "Style: Prolegomenon," p. 194.

90   Ibid., p. 183. Semper is referring to the title "Household of Art" that von Rumohr uses for his introduction in *Italienische Forschungen,* vol. 1 (Berlin, 1827). See editorial note, *The Four Elements of Architecture and Other Writings,* p. 304.

crafts are not "applied" art. He elaborates on the first craft, weaving, which is neither applied to something (it precedes that on which it is propped) nor is it detached from something else (it does not precede the enclosure it establishes). Weaving simply originates as building.[91]

Semper bases his theory of architecture on the low decorative arts, explicitly understood as feminine arts, rather than the monumental high arts–plaiting, for example, being "one of the earliest and most useful symbols of the technical arts that architecture borrowed" from "the mother of the human race," who "probably chose it as a hair adornment."[92] Indeed, in perfecting the techniques of plaiting appropriated by architecture, "hair stylists … have thereby controlled the taste of whole centuries."[93] The institutions of art and their theories are preceded and exceeded by the feminine practices they subordinate:

> Before this separation [of high and low art] our grandmothers were indeed not members of the academy of fine arts or album collectors or an audience for aesthetic lecturers, but they knew what to do when it came to designing an embroidery. There's the rub![94]

But this subordinated femininity is produced historically. The institutions do not simply appropriate the feminine domain they subordinate. When decoration originates, it is not even a domain, let alone feminine. Semper's account of the origin of decoration is not gendered. While the model for the historical transformation of decoration is the "primordial matriarch" of nature, she is not the source of its forms. Before the constitution of high institutions like "architecture," the adornment of the body followed that of building. The gender division only emerges with the institutions. Their gesture of appropriation is only possible when a certain gap has opened up, the gap between masculine and feminine, art and craft, form and color, structure and decoration … The feminine term in each case is produced as such in the very moment of its subordination by the other term which both depends upon it and upon a veiling of that dependence.

. . . . . . . . . . . .

**91** Semper, "Style: The Textile Art," p. 234. "It remains certain that the origin of building coincides with the beginning of textiles." Ibid., p. 254.

**92** Ibid., p. 220.

**93** Ibid., p. 221.

**94** Ibid., p. 234.

Unsurprisingly, Semper's position was completely intolerable to the tradition. Significantly, the main attack on his arguments was launched by Franz Kugler, the first person to assume a chair in art history.[95] In 1835 Kugler responded with an elaborate defense of the white surface, arguing that the "effect" of Greek buildings was "produced by a rich white marble in its own natural brilliancy: and when the materials employed were of a baser description, by a coating of stucco, which in its outward appearance did not much differ from the marble."[96] He concludes that the buildings exhibited this whiteness in their "essentials," the "principle parts," with color only being added to the "subordinated details."[97] This colored "embellishment" acts in a way that is either in support of the basic order of the forms, making its lines more "visible to the eye," or it is isolated from that order with some kind of frame as an "accessorial" decoration.[98] Semper engaged directly and systematically with each of Kugler's arguments[99] but already by 1843 Karl Schnaase had announced that the debate was over and presented its conclusion in basically Kugler's terms.[100] Semper is extensively criticized and dismissed by the

. . . . . . . . . . . .

**95** According to Nicholas Pevsner, Kugler "is the first man whom we can call an art historian, and who was [also] Professor of the History of Art," in "An Un-English Activity? Reflections on Not Teaching Art History," *The Listener* 48 (1952): 715, cited in David Watkin, *The Rise of Architectural History* (Chicago: University of Chicago Press, 1980), p. 8.
**96** Franz Kugler, "On the Polychromy of Greek Architecture," *Transactions of the Institute of British Architects of London Sessions* 1 (1835–1836): 73–79, 84.
**97** Ibid., p. 94. Kugler attempted to sustain the "fundamental maxim in the doctrine of Aesthetics, or the principles of taste, that the essential character of the architecture and plastic art of the Greeks was based singly and exclusively on form" (ibid., p. 7) rather than texture or color, employing a range of philological, etymological, and logical arguments to counter Semper's displacement of the aesthetic privilege of white, but concluding that "if a white marble temple is at once to be pronounced an ugly object, all we can say is, that it is a matter of taste." Ibid., p. 92.
**98** Even then, Kugler subdivides decoration itself into "ground color" and "ornamentation laid on it" (ibid., p. 96) in a way that reproduces at a smaller scale the same binary logic he uses to subordinate decoration itself.
**99** See particularly the arguments in "On the Study of Polychromy, and its Revival," *Museum of Classical Antiquities* 1 (1851), which are reproduced in Semper, "The Four Elements of Architecture," pp. 81–101.
**100** "The temples that were built of a noble material, especially of beautiful pentelic marble, appeared on the whole and in their essential parts

end of the nineteenth century and is largely effaced from the canon.

But this effacement takes a pathological form, whether within architectural discourse, as in Otto Wagner's *Modern Architecture,* or within art historical discourse, as in Alois Riegl's *Stilfragen.* In each case, an apparent defense of Semper is actually his displacement. Wagner presents his argument as an extension of Semper's original position, from which Semper is said to have "deviated." But the extension actually reverses Semper's central thesis.[101] Likewise, Riegl protects Semper from disciples ("Semperians") that misread him, and then goes on to reproduce the same misreading and to counter Semper with the very arguments that have been appropriated from him.[102] In each case, the relationship is

. . . . . . . . . . . . .

as white. To be sure, color was applied to individual smaller members, but never out of mere propensity for variegation, always for the definite reason of allowing the architectural form or its plastic expression to stand out." Karl Schnaase, *Geschichte der bildenden Kunste bei den Alten,* vol. 2 (1843), cited in Harry Francis Mallgrave and Wolfgang Herrmann, introduction to *The Four Elements of Architecture and Other Writings,* p. 16.

**101** "Need, purpose, construction, and idealism are therefore the primitive germs of artistic life ... No less a person than Gottfried Semper first directed our attention to this truth (even if he unfortunately later deviated from it) ... EVERY ARCHITECTURAL FORM HAS ARISEN IN CONSTRUCTION AND HAS SUCCESSIVELY BECOME AN ART-FORM ... It is Semper's undisputed merit to have referred us to this postulate, to be sure in a somewhat exotic way, in his book *Der Stil.* Like Darwin, however, he lacked the courage to complete his theories from above and below and had to make do with a symbolism of construction, instead of naming construction itself as the primitive cell of architecture." Otto Wagner, *Modern Architecture,* trans. Harry Francis Mallgrave (Santa Monica: Getty Center Publications, 1988), pp. 91–93.

**102** "The new theory of the techno-material origin of the most ornamental and artistic forms is commonly derived from Gottfried Semper, which is, however, as unjust as identifying modern Darwinism with Darwin. ... But we must distinguish clearly between Semper and the Semperians ... Whereas Semper asserted that in considering the realization of an artistic form materials and techniques must be accounted for, the Semperians simplistically state that every artistic form is the product of material and technique ... This surely did not come about in the spirit of the teaching of Gottfried Semper, who would certainly not have wanted a purely mechanical and material imitative impulse to supplant the creative free will of the artist. But the confusion had already taken hold which made this concept appear as the precise idea of the great art historian Semper." Alois Riegl, *Stilfragen* (Berlin, 1893).

complex. Wagner's theory and practice exemplify both the Semperian weaving motif and the modern white wall, while Riegl sustains both the Semperian commitment to decoration and anti-Semperian arguments (like the teleological progression from haptic to optic perception and the privileging of representational art). Through such complex gestures, Semper is at once appropriated and rejected.

These ambivalent gestures are repeated in almost every subsequent reference to Semper, including those more recent texts that note the ways in which his arguments were misread at the turn of the century. Semper is repeatedly identified with the very positions he criticizes. His work is rarely cited in accounts of the formation of twentieth-century architecture as either a proto-modernist or a counterfigure. It is effectively detached from the tradition and subjected to detailed but relatively autonomous monographical research. The few references in such a monumental body of literature employ variations of the institutionalized misreadings.

The resistance to Semper is therefore symptomatic. It takes more the form of repression than rejection. His work is not so much written out of the institutional discourse as buried within it. It is swallowed, neither to be digested nor to be thrown up.

This convoluted form of resistance is required because of the particular structure of Semper's argument. The deepest threat it poses is precisely that it does not simply articulate the antithesis of the tradition it critiques. Rather it develops certain details of the tradition in a way that calls it into question. Because the institutions constitute themselves by repressing the evidence of surface texture in favor of the smooth white wall, that texture is inscribed into their subconscious formation. The thought of architecture as masquerade articulated by Semper is the unconscious of the tradition. Traces of his arguments can be found within the very texts he undermines.

## VI

Such traces can be found in Alberti. Despite his rejection of all excess, Alberti is more critical of an unornamented building than an excessively ornamented one. Ornament is only forced to speak of the presence of order because there is some kind of absence in

the visual field. It is this visual absence of order that makes the inessential excess of ornament "necessary":

> There is a natural excellence and perfection that stimulates the mind; it is immediately recognized if present, but if absent is even more desired. The eyes are by their nature greedy for beauty ... Indeed, they sometimes find it impossible to explain what it is that offends us, apart from the one fact that we have no means of satiating our excessive desire to gaze at the beautiful. In view of all this, surely it is our duty to strive with all enthusiasm ... to make what we build as ornate as possible.[103]

What is being desired here which produces this pleasure and whose absence would be so painful, is precisely the regulation of ornament, the sense of order, which somehow is insufficient in the building itself. What is so attractive in the feminine is the advertised presence of the masculine. What the man is attracted to is his myth of himself.

This myth is a representation that can only be sustained by concealment. The necessity for such a concealment surfaces in Alberti's text in a small passage that defines ornament in a way that appears to contradict the overall thesis by approving of the use of ornament to mask rather than expose the building it is added to in order to reproduce the ideal beauty necessarily absent in a flawed world:

> Had ornament been applied by painting and masking anything ugly, or by grooming and polishing the attractive, it would have had the effect of making the displeasing less offensive and the pleasing more delightful. If this is conceded, ornament may be defined as a form of auxiliary light and complement to beauty.[104]

Order cannot simply be exposed. Rather, disorder is concealed, removed from the eye as "unsightly." The representation of exposure depends on a veil. Transparency is an effect of masking.[105]

. . . . . . . . . . . .

**103** Alberti, *On the Art of Building*, Book IX, p. 312.
**104** Ibid., Book VI, p. 156.
**105** This argument can also be traced in Alberti's *De Pictura*, which presents itself as a thesis of transparency. Everywhere it insists that the outside surface must articulate the inner order. Arguing against cross-

This subtext can be traced throughout the treatise by drawing on Manfredo Tafuri and Mark Jarzombek's revisions of the canonic reading of Alberti which places *De re aedificadore* in the context of all of Alberti's other writing, from which it is usually detached. Alberti's *Momus,* for example, which was written during the same years as the architectural treatise, argues that all of the humanist ideals are just that, impossible ideals in the face of the realities of the Renaissance politics of dissimulation. Its central character–Momus–literally descends to teach men and women the arts of dissimulation as the arts of human survival.[106] In these terms, Alberti's texts can be understood as themselves a specific form of dissimulation which produces the figure of the writer, the authorial subject, as a cultural artifact by promoting themselves as the expression of a private individual who has withdrawn from the dissimulating worlds of politics and sexuality to the ideal detached space of the study. Privacy is a public construction. In the public space of masks, that which is beyond that world and hidden from it, the private space and subject, can only be produced with a mask, the mask of that which is beyond masking. But this mask can never be removed to expose that which it represents. The writing and writer are pure artifice, constructed, as Jarzombek

. . . . . . . . . . . . .

dressing, the text specifies that not only must the clothes represent the body they cover, but that the skin of the body must represent the structure beneath: "Before dressing a man we must first draw him nude, then we enfold him in draperies. So in painting the nude we place first his bones and muscles which we then cover with flesh so that it is not difficult to understand where each muscle is underneath." *On Painting,* p. 74. But this commitment to transparency is juxtaposed with one of veiling–a principle of "shame and modesty" is added to that of "truth" in order to cover over the body's unsightly condition, its flaws, and its sexual marks: "But always make use of shame and modesty. The parts of the body ugly to see and in the same way others which give little pleasure should be covered with drapery ... these flaws which they wished to leave unnoticed they 'corrected' as much as they could while still keeping a likeness. Thus I desire, as I have said, that modesty and truth should be used in every *historia.*" Ibid., pp. 76–77.

**106** "What a splendid thing to know how to hide the most secret thoughts through the clever artifice of a painted and beguiling make-up." Leon Battista Alberti, *Momus,* cited in Manfredo Tafuri, "Discordant Harmony from Alberti to Zuccari," *Architectural Design* 49 (1979): 36.

suggests, by a "bizarre dance involving masking and counter-masking,"[107] as must be the spaces they "occupy."

Within this world of dissimulation, architecture is given a privileged role. It is implicated in the very economy of masks it appears to stand against. The architectural treatise which attempts to construct architecture as an effacement of masks that exposes an order which precedes representation is itself a mask which covertly prescribes a certain masking. Defining the ways in which architecture should be ordered, its own order, its architectonic appearance as a rationally subdivided treatise, is itself a mask. Its apparent unmasking of architecture, both by theorizing its essential condition and legislating against any masking practices, operates as the most sophisticated form of the mask described by Momus:

> There is no feeling that one cannot cover with perfection under the appearance of honesty and innocence. Adapting our words, we will brilliantly attain our image, and whatever particular externality of our persona, in a manner that seems similar to those who are believed to be beautiful and moderate.[108]

The image of aesthetic and ethical purism can cover anything. The treatise on architecture is produced in the newly reconstituted public sphere "*as if* society were functioning properly."[109] It presents the illusion of the very order that cannot be sustained. In similar terms, Tafuri has argued that this architecture of "*as though*" is "a 'theater' of rationality"[110] inserted into the reality of a Renaissance world in which "dissimulation and masks are openly seen as weapons of action, resistance and survival in relations with power."[111] Such an insertion is understood as an ethical assertion (a mark of the individual's self control) which assumes a strict and active relation with political power.

. . . . . . . . . . . . .

107  Jarzombek, *On Leon Baptista Alberti*, p. 4.
108  *Momus*, cited in Manfredo Tafuri, "*Cives esse non licere*: The Rome of Nicholas V and Leon Battista Alberti: Elements Towards a Historical Tradition," trans. Stephen Sartarelli, *Harvard Architectural Review* 6 (1987): 69.
109  Jarzombek, *On Leon Baptista Alberti*, p. 156.
110  Tafuri, "*Cives esse non licere*," p. 71.
111  Ibid., p. 69. "It may be that for Alberti architecture is a willed and therefore artificial defense which is in opposition to a subjective and

Buildings, like texts, are inserted into the world of dissimulation to speak of an unattainable order beyond it. The representational system of ornament is made to speak only of that order that exceeds it. In speaking this "truth," the appropriate ornamentation literally assumes the title of "the orders." The building masquerades as order. Order itself becomes a mask. This mask of order uses figures of rationality to conceal the essential irrationality of both individuals and society. Rationality is literally added to the building as the representation of the effacement of representation. In this sense, architecture is precisely not about the transparency it advertises: "Alberti's aesthetic theory does not propose to look behind the mask (it is, after all, a mask in its own right)."[112] Writing, the author's signature, the architectural treatise, and the building become figures for that which is beyond the world within which they are placed, the masks of the unmasked, the clothing that produces nakedness.

It is in these terms that the white surface assumes its authority. The white stucco layer is a supplement that speaks about an inaccessible order, an absence of supplements beyond it. It must be remembered that Brunelleschi's practice, which "restored" the ancient tradition of the "naked" building with its unmediated surfaces of white marble that Alberti so closely followed, actually involved the addition of a white layer of stucco (and only occasionally a cladding of thin marble panels) to an inferior stone. It is an architecture of the white shirt rather than the clean body. The fabric that looks more like what it covers than what it covers: "If the final coat of pure plaster is rubbed carefully, it will shine like a mirror. And...will achieve a sheen superior to that of marble."[113]

. . . . . . . . . . . .

provisional desire for reason—a defense against the absurdity of existence ... Architecture appears as the imposition of an order known to be fallible, on a life which explodes in nightmarish forms." Tafuri, "Discordant Harmony from Alberti to Zuccari," p. 36.

**112** Jarzombek, *On Leon Baptista Alberti*, p. 108.

**113** Alberti, *On the Art of Building*, Book VI, p. 176. Nevertheless, this art historical tradition founded itself on the privilege of the white block over the decorative surface that simulated it. Burckhardt, for example, begins Book II of his canonic text on Renaissance architecture (entitled "Decoration," which the text everywhere surbordinates to "Architecture," the subject of Book I) by asserting: "Although every material has its own proper qualities, which cannot be replaced by surrogate materials, it is important to note that in Tuscany, the center of progress, white marble

But this strategy of masking the mask only becomes possible by elevating the status of the arts and the artist and simultaneously limiting it. Artists, and in particular the architect, can only assume the responsibility for the ideal order, representing it in a disorderly world, if they have no access to the nature of that representation. As Jarzombek argues, "They are the implementors of an elaborately conceived literary strategy which places them in a privileged position. But in order for them to function within the strategy they must not be aware of the artifice."[114] Having identified the necessity of theory as the basis for the promotion of the arts, Alberti's texts go to some trouble to limit the artist's access to theory. The institution art is given authority on condition that it cannot inquire into the nature of that authority for fear that it will uncover the implausibility of some of its claims. It is this very innocence of the masquerade that makes possible the artist's mask of unmasking as a counterstrategy, such that "the unsuspecting artists, though maskless, serve as mask for the humanist."[115]

> Practicing simulation openly and as it were naively, they [painters and architects] are not perceived as a threat ... and thus unknowingly import the contraband ethics. They are a Trojan horse left behind by the Albertian humanist–the ultimate counter-deception in a deceptive world.[116]

Of these naively dissimulating arts, architecture is, as Momus argues, the paradigm. The architect acts as the key agent of the establishment, sustaining a mechanism of political order by both representing the possibility of order itself and enforcing specific orders. In producing this image of order, architecture, like the good wife, is at once elevated and subordinated. It can only guarantee an order by being denied access to its secrets. Just as the wife

. . . . . . . . . . . .

was (and remained) the principal material. ... Only white marble invited continuous refinement of forms and was capable of competing with the marble artifacts of Antiquity. Other types of stone, terra-cotta (whether plain or glazed), stucco, bronze, precious metals, wood, and even decorated painting, all benefitted from the leadership of this incomparable material." Jacob Burckhardt, *The Architecture of the Italian Renaissance,* trans. James Palmers (Chicago: University of Chicago Press, 1985), p. 193.

**114** Jarzombek, *On Leon Baptista Alberti,* p. 152.
**115** Ibid., p. 155.
**116** Ibid., p. 129.

must wear the "ornament of silence,"[117] the building must wear a white coat. The white wall is the mask of unmasking. Its ideological authority is bound to the production-domestication of woman, buildings, and the discipline responsible for them.

In this way, Semper's argument can be traced as a subtext of the historical traditions it critiques and those that would later efface it, whether it be Alberti's own text that apparently gave the space of perspective the transparency of an "open window," but turns on metaphors of weaving,[118] or the formative texts of modern architecture that gave the white wall another kind of transparency by explicitly rejecting Semperian masquerade but implicitly redeploy his theory of architecture as clothing.[119] The history of the white surface has to be taken in many directions at many levels and followed through its discontinuities in order to trace the role of sexuality in the construction of space.

## VII

But the concern here is not to simply import contemporary theories of sexuality, like those of masquerade, which could clearly be employed to reread these architectural texts in a more nuanced way, but rather to point to a certain intersection between questions

. . . . . . . . . . . .

**117**　Francesco Barbaro, *Directions for Love and Marriage*, G3v., cited in Jordan, *Renaissance Feminism*, p. 45.

**118**　In Alberti's text, the surfaces being looked at ("lines, like threads woven together in a cloth, make a plane," *On Painting*, p. 44)–which are identified with the planes of a building–and the mechanism of seeing ("The extrinsic rays, thus encircling the plane, one touching the other–enclose all the plane like the willow wands of a basketcage, and make, as is said, this visual pyramid," ibid., p. 47) and the device for recording that vision ("a thin veil, finely woven ... this veil I place between the eye and the thing seen, so the visual pyramid penetrates through the thinness of the veil," ibid., p. 68) are all woven.

**119**　These texts redefine the status of clothing in architecture rather than abandon clothing as such. Their particular defense of the white wall redeploys rather than rejects Semper's arguments to place architecture within the new fabrics, the new means of communication in the twentieth century: car, telegraph, radio, telephone, cinema, television, and computer. See Mark Wigley, "Philosophy After Architecture: Le Corbusier and the Emperor's New Paint," *Journal of Philosophy and the Visual Arts*, no. 2 (1990): pp. 84–95.

of space and sexuality which can be exploited, more as a way of understanding the spatiality of theories of sexuality than as a way of reading space sexually. This would involve interrogating the concepts of space in discourses like psychoanalysis and identity theory in the moment of "applying" them. Rethinking them by exposing the tacit spatial arguments they depend on for their own rigor.

For example, while beginning to think of space as another kind of masquerade available for a psychoanalytic reading in which masquerade is understood as the instrument of identity formation, there is a need to trace the layers of overt and covert spatiality inscribed within the concept of masquerade, and to establish their strategic role. In this way, conceptualizing the masquerade of space can be used to rethink both architecture and masquerade and, therefore, identity. Such a reading would repeatedly pass back and forth between architectural discourse and psychoanalytic theory, stitching them together by passing through particular folds whose location can only be pointed to here.

In the Lacanian account, for example, in which gender is understood as the product of masquerade, desire is precisely the extent to which the gaze exceeds the visuality sustained by classical space. Lacan explicitly identifies that classical understanding of vision in terms of a surface suspended between two points "in space" with Alberti and the tradition of architectural treatises from Vitruvius through to Blondel.[120] He repeatedly identifies this "optical structuring of space," which eventually makes possible the idea of the Cartesian subject, as itself a "construction" which is "simply the mapping of space, not sight."[121] It only deals with "vision in so far as it is situated in a space that is not in its essence the visual,"[122] such that a blind person is capable of "reconstructing … everything that vision yields to us of space."[123] The essence of the visual exceeds space and so cannot simply be "situated" or even "constructed." It is a product of the sensuous play of surface, a "play of light" rather than a "space of light," an intimate exchange in which the surface fills and overflows the eye, such that the viewer cannot be detached from the surface.

. . . . . . . . . . . . .

120 Jacques Lacan, *The Four Fundamental Concepts of Psycho-Analysis,* trans. Jacques-Alain Miller (New York: W. W. Norton, 1977), p. 86.
121 Ibid., p. 86.
122 Ibid., p. 94.
123 Ibid., p. 92.

Indeed, it is the surface that views and, in so doing, no longer simply occupies the preexisting space in which the architectural eye constructs it. Visuality is "not simply a constructed relation ... but something that is an impression, the shimmering of a surface that is not, in advance, situated for me in its distance."[124] The subject is to be found, if anywhere, within the surface itself, the mask located in space like a Semperian fabric hung on its scaffolding: "the being gives of himself, or receives from the other, something that is like a mask, a double, an envelope, a thrown-off skin, thrown off in order to cover the frame of a shield."[125] But while this surface is suspended in space, it does not simply have a front and back: "it is not in this dialectic between the surface and that which is beyond that things are suspended."[126] Lacan is not dealing with the traditional economy of representation in which the marked surface stands in the place of something else, a substitute for a spatially absent unity. Rather, the being is always already split. Its identity cannot be separated from the mask. The subject is not simply "behind" its mask nor in front of those of others. It can only be found "within" the nonplace of the mask itself. While the mask is "that beyond which there is the gaze," this "beyond," and the gaze it refers to, is not spatial. The mask inscribes the limit of space into space.

In this sense, space appears to be exceeded by subjectivity. The traditional gap between space and sexuality seems intact. Space appears as a frame occupied, and yet exceeded by, desire. It is no more than a prop. And yet subjectivity for Lacan is no more than the capacity to produce an effect of distance from the mask, which is to say, an effect of space:

> Only the subject—the human subject, the subject of desire that is the essence of man—is not, unlike the animal, entirely caught up in this imaginary capture. He maps himself in it. How? In so far as he isolates the function of the screen and plays with it. Man, in effect, knows how to play with the mask as that beyond which there is the gaze.[127]

The subjectivity that is beyond architectural space is precisely the capacity to define location, to map itself, by isolating itself

. . . . . . . . . . . .

124  Ibid., p. 96.
125  Ibid., p. 107.
126  Ibid., p. 106.
127  Ibid., p. 107.

from the mask in order to manipulate it. Lacan detaches the subject position from "real space" only to relocate it in another topography, that of "imaginary space."[128] The mask is suspended between these spatialities like a hinge. While Lacan keeps these spaces distinct, he explores the complications between them that the mask, understood as a kind of mirror, sustains, whereby the imaginary space not only inhabits the real space but displaces the objects within it into the imaginary.[129]

The ongoing revision of psychoanalysis that explicitly examines the psychic topography of the mask, by rereading the extent to which its manipulation both effects, and is the effect of, the con-

. . . . . . . . . . . . .

**128** "What is the image in the mirror? The rays which return on to the mirror make us locate in an imaginary space the object which moreover is somewhere in reality. The real object isn't the object that you see in the mirror. So here there's a phenomenon of consciousness as such. ... I hope you'll consider consciousness to occur each time—and it occurs in the most unexpected and disparate places—there's a surface such that it can produce what is called *an image*. ... All sorts of things in the world behave like mirrors. All that's needed is that the conditions be such that to one point of a reality there should correspond an effect at another point, that a bi-univocal correspondence occurs between two points in real space. ... I say in real space—I'm going too fast. There are two cases—either the effects occur in real space, or else they occur in imaginary space." Jacques Lacan, *The Seminar of Jacques Lacan, Book II: The Ego in Freud's Theory and in the Technique of Psychoanalysis 1954–1955*, trans. Sylvanna Tomaselli (New York: W. W. Norton, 1988), pp. 46–49.

**129** "For there to be an optics, for each point in real space, there must be one point and one corresponding point only in another space, which is the imaginary space ... Here too, the imaginary space and the real space fuse. Nonetheless they have to be conceived of as different ... On the other hand, there is in optics a set of phenomena which can be said to be altogether real since we are also guided by experience in this matter, but in which, nonetheless, subjectivity is implicated at every moment." Jacques Lacan, *The Seminar of Jacques Lacan: Book I: Freud's Papers on Technique 1953–1954*, trans. John Forrester (New York: W. W. Norton, 1988), p. 77. He describes an experiment with a mirror to show how this "real image" can be "stitched onto" real space. Later, he elaborates the same experiment in terms of the "lure," the "false image," the mask which organizes sexuality: "the physical phenomenon of the real image, which can be produced by the spherical mirror, be seen in its place, be inserted into the world of real objects, be accommodated in it at the same time as real objects, even bringing to those real objects an imaginary disposition, namely by including, excluding, locating and completing them." Ibid., p. 138.

struction of gender, has only tacitly engaged with its spatial prop. This leaves open the question of to what extent that prop is the possibility or product of the very economy of desire that appears to exceed it, given that Semperian space can no more be separated from the mask than Lacanian subjectivity.[130] One of the subtexts of contemporary accounts of masquerade is the possibility of folding psychic space back onto physical space.

Laura Mulvey's seminal essay on visual pleasure, for example, in examining one of the contemporary forms of wall painting—cinema—argues that the gaze is masculine inasmuch as it produces a subject position occupying three-dimensional "Renaissance space" and directing itself at two-dimensional surfaces of which the woman becomes one. In this sense, the feminine position is precisely not a position. The woman is not so much confined within the space as fetishistically flattened into its surfaces. She is the space rather than is in the space. The space is an illusion produced by cinematic conventions and the erasure of the physical space of the theater effected by turning out the lights. The viewer is constructed as a voyeur apparently detached from this illusion, looking into it, but looking precisely in order to see itself, as if in a mirror, occupying and controlling the space, which is to say, controlling its feminine surfaces.[131] Such a spectator is at once in, and looking into, the space.

But if this "illusion of natural space" is made possible by the specific technology of the camera, what is the status of "natural"

. . . . . . . . . . . .

130  For a reading of the way architectural space produces rather than simply houses the subject, see Beatriz Colomina, "Intimacy and Spectacle: The Interior of Adolf Loos," *AA Files*, no. 20 (1990): 5–15: "Architecture is not simply a platform that accommodates the viewing subject. It is a viewing mechanism that produces the subject. It precedes and frames its occupant" (p. 8).

131  "One part of a fragmented body destroys the Renaissance space, the illusion of depth demanded by the narrative; it gives flatness, the quality of a cut-out or icon, rather than verisimilitude, to the screen ... In contrast to the woman as icon, the active male figure (the ego ideal of the identification process) demands a three-dimensional space corresponding to that of the mirror recognition, in which the alienated subject internalized his own representation of his imaginary existence ... The male protagonist is free to command the stage, a stage of spatial illusion in which he articulates the look and creates the action." Laura Mulvey, "Visual Pleasure and Narrative Cinema," *Screen* 16, no. 3 (Autumn 1975): 12–13.

space before the lights are turned out? To what extent is it always already an illusion produced by specific technologies of representation that are not recognized as such in order to naturalize particular structures for specific ideological reasons?

In developing Mulvey's "alignment" of "spectatorial desire with a certain spatial configuration," Mary Ann Doane's account of masquerade argues that the gaze produces rather than simply occupies space.[132] It is the confinement of femininity to the texture of a two-dimensional surface like that of the cinematic screen that produces masculine "distance." Confined to that surface, the artifact "woman" has no space. Unable to establish any distance, her resistance to the patriarchal "positioning" by the controlling gaze can only be established on that very surface through the counter-ruses of masquerade which destabilize gender: "the masquerade, in flaunting femininity, holds it at a distance. Womanliness is a mask which can be worn or removed."[133] The mechanisms of the production of gender can be exposed as such in order to make a space for woman. The "decorative layer" which produces the space that houses man can equally be manipulated to produce other spatialities, which is to say, other sexualities.

While this account seems limited to discrete representational systems, like those of cinema, photography, painting, makeup, and clothing, these systems cannot be detached from those of architecture. Surfaces are not simply assembled architectonically to form a three-dimensional interior space controlled by the subjectivity that occupies it. The gaze is not simply directed across a space to a surface that is detached from it. Rather, the feminine surface "orchestrates" the very gaze apparently directed at it to produce the effect of interior, the space of masculinity. This "illusory" psychic space cannot be separated from the physical space of the so-called viewer. The viewer's position is itself a surface effect. In this sense, the illusion produced by the representational surface appears in front of it rather than behind it. The surface is more mirror than window.

But even then, the sense of front and behind is its first effect. Masquerade operates by masking the absence of the very identity

. . . . . . . . . . . . .

132  Mary Ann Doane, "Film and the Masquerade: Theorizing the Female Spectator," *Screen* 23, no. 3/4 (1982): 74–87.
133  Ibid., p. 81.

it appears to mask. The illusion of a presence behind the representational mask is the illusion of space itself. It is the ruse of surface to appear to be framed off as a discrete representational system that simply occupies the space it actually produces. The effect of the mask is that space appears to precede representation and therefore assumes a specific ideological function. The sense that architectural space has to be understood in different terms than representational systems is precisely the effect of such systems. The subject, like the surface, does not simply occupy space. Rather, the image of occupiable space wraps itself around the subject position. It is a kind of clothing.

This Semperian sense of decoration as the production of space is clearly written into Luce Irigaray's identification of the structural role of the mask. It is the woman's confinement to the decorative surface that actually provides the "prop," the "infrastructural" role of space which "underwrites" the patriarchal order and denies her any subjectivity understood as the control of space.[134] In this sense, the concept of place presupposes the absence of a place for woman: "The maternal-feminine remains the place separated from 'her' place, deprived of 'his' place. She is or becomes the place of the other who cannot separate himself from her."[135] As she is the house for man she does not have one herself other than the one she constructs with her own decoration. Lacking a "proper place," "it would be necessary for her to re-envelope herself with herself"[136] by wearing another decorative layer, a supplementary mask that at once produces and houses her own identity through a blurring of the tactile and visual. The imposed mask of femininity

. . . . . . . . . . . .

134 "But in fact that 'femininity' is a role, an image, a value imposed upon women by male systems of representation. In this masquerade of femininity, the woman loses herself, and loses herself by playing on her femininity. The fact remains that this masquerade requires an *effort* on her part for which she is not compensated ... So women have to remain an 'infrastructure' unrecognized as such by our society and our culture. The use, circulation of their sexualized bodies underwrite the organization and the reproduction of the social order, in which they have never taken part as 'subjects.'" Luce Irigaray, *This Sex Which Is Not One,* trans. Catherine Porter (Ithaca, N.Y.: Cornell University Press, 1985), p. 84.

135 Luce Irigaray, *L'Ethique de la différence sexuelle* (Paris: Les Editions de Minuit, 1984), p. 18, cited in Elizabeth Grosz, *Sexual Subversions* (Sydney: Allen and Unwin, 1989), p. 174.

136 Ibid.

can be reappropriated through masquerade to produce another spatiality, an "elsewhere."[137] But this "elsewhere" is not so much a place, as a displacement of place. The "distance" produced by the masquerade is necessarily improper and cannot be described with traditional theories of space.[138]

But no matter how improper, the image of the occupation of this supplementary "house," like the political arguments "behind" most theories of masquerade, inasmuch as they presuppose, even if only "strategically," the agency of a subject behind the mask who can manipulate its surface, raises the dilemma of essentialism whose complexity cannot be respected here other than to note that the question of essentialism is no more than the question of interiority. Which is to say that identity theory is necessarily spatial theory.

To rethink identity spatially would involve interrogating the multiplicity of decorative surfaces that produce the sense of sexuality installed, along with the institutions of private space, in the nineteenth century. Sexuality in the age of psychoanalysis is the sexuality of the interior. Each of the new regimes of classification—perversion, fetishism, homosexuality, voyeurism, etc.—presuppose the institution of some kind of "closet" that masks them, a supplementary realm of withdrawal. Like Alberti's space off the bedroom, it is a fold in the surface that defines the overt realm of "normal" (which is to say, compulsorily hetero) sexuality. Sexu-

. . . . . . . . . . . .

**137** "There is, in an initial phase, perhaps only one 'path,' the one historically assigned to the feminine: that of *mimicry*. One must assume the feminine role deliberately. Which means already to convert a form of subordination into an affirmation, and thus to begin to thwart it ... to make 'visible' by an effect of playful repetition, what was supposed to remain invisible: the cover up of a possible operation of the feminine in language. It also means 'to unveil' the fact that, if women are such good mimics, it is because they are not simply reabsorbed in this function. *They also remain elsewhere*." Irigaray, *This Sex Which Is Not One*, p. 76.

**138** The discourse of this spatiality "would privilege the 'near' rather than the 'proper,' but a 'near' not (re)captured in the spatio-temporal economy of philosophical tradition ..." Ibid., p. 153. "For to put the accent back on space was—perhaps—to restore some chance for the sexual pleasure of the other—woman. But to seek once again to make a science of it amounts to bringing it back inside the logic of the subject. To giving an over-and-beyond back over to the same." Ibid., p. 98.

ality becomes a pathology either veiled from the consciousness of the private individual by the censorship of the "surface" that is the ego, or veiled from the public by the dissimulating surfaces of the house and all the other forms of clothing.[139] As masks cannot be separated from what they mask, each pathology is closeted differently.

The question of sexuality and space becomes that of the multiplicity of mechanisms of representation that establish the subtle architecture of these psychospatial closets and whose contemporary displacement by new mechanisms in the age of electronic reproduction marks the space of new sexualities. An interrogation of these mechanisms is required in order to reread the spatial arguments inscribed within psychoanalytic theory before that theory can be applied to architecture in a way that does not simply reproduce the abrupt separation of space and sexuality on which both institutional discourses currently appear to depend.

But this involves more than simply making space the proper object of discourse by addressing its strategic role "in" theories of sexuality. As Irigaray points out, "the fact that Freud took sexuality as the object of his discourse does not necessarily imply that he interpreted the role of sexualization in discourse itself, his own in particular."[140] Likewise, discourses are spatial mechanisms that construct sexuality before giving either sexuality or space a title. Space is itself closeted. The question must shift to the elusive architecture of the particular closets that are built into each discourse, but can only be addressed with the most oblique of gestures.

. . . . . . . . . . . .

**139**  On the role of the architectural concept of surface in psychoanalytic theory, see Mark Wigley, "Theoretical Slippage: The Architecture of the Fetish," forthcoming in *Fetish, The Princeton Journal: Thematic Studies in Architecture* 4.

**140**  Irigaray, *This Sex Which Is Not One*, p. 152.

## SOURCES OF ILLUSTRATIONS

**MORRIS**
1: Courtesy Chris Hilton.

**MULVEY**
1, 2: Capital Cities/ABC, Inc., copyright renewed 1974.

**COLOMINA**
1, 2, 3, 5, 6, 9, 11, 12, 13, 14: Graphische Sammlung Albertina, Vienna; 4, 8, 15, 17: L. Münz and G. Künstler, *Adolf Loos* (1966); 7: M. Risselada, *Raumplan versus Plan Libre* (1988); 10: B. Rukschcio and R. Schachel, *Adolf Loos* (1982); 16: A. Ozenfant, *Foundations of Modern Art* (1931); 18: Österreichisches Museum für Angewandte Kunst, Vienna; 19, 26, 27, 29, 34: Le Corbusier, *Oeuvre complète 1929–1934* (1934); 20, 21, 22, 40: *L'Architecture Vivante* (1929–1931); 23: T. Benton, *Les Villas de Le Corbusier 1920–1930* (1984); 30: AMC, vol. 49; 31, 32, 33: *L'Architecte* (1932); 35, 36: Le Corbusier, *Une Petite maison* (1954); 37: Le Corbusier, *La Maison des hommes* (1942); 38, 39: Le Corbusier, *La Ville radieuse* (1933).

**BLOOMER**
1, 6: Courtesy the artist; 2: Larry Millett, *The Curve of the Arch* (St. Paul, Minn: Historical Society Press, 1985); 3: Collection Sandra Dijkstra Literary Agency; 4, 5: *Louis Sullivan: The Function of Ornament*, ed. Wim de Wit (New York: W. W. Norton and Co., 1986).

**BURGIN**
1: Courtesy the author; 2: Robert Doisneau, *Trois secondes d'eternité* (Paris: Contrejour, 1979), p. 67; 3: *La Révolution Surréaliste*, no. 12 (15 December 1929), p. 73.

**INGRAHAM**
1, 2, 3, 7: Marie-Henri Beyle Stendhal, *The Life of Henry Brulard*, p. 37; 4: Jacques Lacan, *Écrits* (New York: W. W. Norton and Co., 1977); 5: The New Yorker Magazine, Inc., copyright 1989; 6: Photo by Louis Lussier. Courtesy Galerie René Blouin, Montréal.

**PONTE**
1: Department of Prints and Drawings, Trustees of the British Museum, London; 2: Comte de Borch, *Lettres sur la Sicile et sur l'Ile de Malte, écrites en 1777* . . . , vol. 2 (Turin, 1782); 3: P. F. Hugues, Baron d'Hancarville, *Monuments de la vie privées des douze Césars, d'après une suite de pierre et médalles, gravées sous leur règne* (1782); 4: Baron d'Hancarville, *Monuments du culte secret des dames romaines* (1784); 5: Baron d'Hancarville, *Recherches sur l'origine, l'esprit et les progrès des arts de la Grèce; sur leurs connections avec les arts et la religion des plus anciens peuples connus; sur les monuments antiques de l'Inde, de la Perse, du reste de l'Asie, de l'Europe et de l'Egypte*, vol. 1 (London, 1785); 6: Baron d'Hancarville, *Collection of Etruscan, Greek and Roman Antiquities from the Cabinet of the Hon.ble Wm. Hamilton, His Britannick Majesty's Envoy Extraordinary at the Court of Naples*, vol. 4 (Naples, 1770); 7, 9, 10, 11, 12, 13, 14, 15: R. P. Knight, *A Discourse on the Worship of Priapus* (London, 1865); 8: P. Sonnerat, *Voyages aux Indes orientales* (1782); 16: Anonymous, attributed to J. Matthews, *A Sketch from the Landscape, a Didactic Poem Addressed to R. P. Knight Esq.* (1794); 19: Comte de Caylus, *A.C.P., Recueil d'Antiquités Egyptiennes, Etrusques, Grecques, Romaines et Gauloises*, vol. 6 (Paris, 1764); 20: R. Pococke, *A Description of the East and Some Other Countries*, vol. 2 (London, 1745).

**NESBIT**
1: The Art Institute of Chicago. Julien Levy Collection. Gift of Julien and Jean Levy; 2, 3: Bibliothèque Nationale, Paris; 4: The Museum of Modern Art, New York. The Abbott-Levy Collection. Partial gift of Shirley C. Burden; 5, 6, 7, 8, 9, 10: Bibliothèque Historique de la Ville de Paris; 11: The Museum of Modern Art, New York. Printed by Chicago Albumen Works, 1984; 12: Musée Carnvalet, Paris.

★ The essay by Patricia White, "Female Spectator, Lesbian Specter: *The Haunting*," is reprinted from *Inside/Out: Lesbian Theories, Gay Theories*, ed. Diane Fuss (New York and London: Routledge, 1991).